Avant-Garde FASCISM

Avant-Garde *FASCISM*

The Mobilization of
Myth, Art, and
Culture in France,
1909–1939

MARK ANTLIFF

Duke University Press Durham and London 2007

© 2007 Duke University Press

All rights reserved

Printed in the United States of America on acid-free paper ∞

Designed by Heather Hensley

Typeset in Minion Pro by Tseng Information Systems, Inc.

Library of Congress Cataloging-in-Publication Data appear on the last
printed page of this book.

Duke University Press gratefully acknowledges the support of the
Department of Art and Art History at Duke University, which provided
funds toward the production of this book.

FOR PATRICIA LEIGHTEN,
on our unfolding journey together

CONTENTS

LIST OF ILLUSTRATIONS

ACKNOWLEDGMENTS

This book had its kernel in a question: how was it that theories of ideology, violence, and creativity became conjoined over the course of the twentieth century? Over time I have learned much from friends and colleagues whose own ruminations on this troubling subject have profoundly influenced my own. I would like to thank Emily Braun, David Carroll, Emilio Gentile, Roger Griffin, Alice Kaplan, Claudia Koonz, Eric Michaud, Jeffrey Schnapp, and Zeev Sternhell for their groundbreaking scholarship: my meditations on fascism and cultural politics would not have been possible without their example. A grant from the John Simon Guggenheim Foundation facilitated my initial research in Europe, while residential fellowships at the Institute for Advanced Study in Princeton and the National Humanities Center in North Carolina gave me the chance to share my ideas with others as this project coalesced. In Princeton I benefited tremendously from my ongoing discussions with Mary Louise Roberts, as well as

from stimulating conversations with Ruth Abbey, Anat Biletski, Irving Lavin, Kenneth Mills, Philip Nord, Joan Scott, and Bette Talvacchia. A draft of the book was completed at the National Humanities Center, where my study was greatly enriched by exchanges with Frances Ferguson, Meredith Gill, Lisa Graham, Malachi Hacohen, Charlotte Sussman, Barbara Will, Eric Wilson, and Caroline Winterer. Among the center's staff I am especially indebted to Betsy Dain and Jean Houston for satisfying every quirky interlibrary loan request, and to Kent Mullikin for nurturing the sense of community that makes the Humanities Center such a wonderful institute. In France, the staffs at the Bibliothèque Nationale, the Archives Nationales, and the Musée Départemental Maurice Denis "Le Prieuré" were generous in facilitating my various requests and queries.

The development of this book project also resulted in various friendships that have helped to sustain me and encourage me to move forward. I am indebted to Matthew Affron and Emily Braun for our many conversations over the years. Eric Michaud and Maria Stavrinaki have both read my ongoing work and provided me with invaluable feedback as well as a cornucopia of new ideas. In England and Scotland, Clair Chinnery, Francis Frascina, Christopher Green, Tom Normand, Gill Perry, Anna Gruetzner-Robins, David Robins, Angela Smith, and Richard Thomson have all contributed to the book's development in various ways. In Canada Mark Cheetham has offered invaluable advice, and in the United States Richard Shiff has helped me to refine my ideas from the project's inception. Here at Duke my colleagues have been a constant stimulus: Claudia Koonz, Richard Powell, Helen Solterer, Kristine Stiles, Gennifer Weisenfeld, and Annabel Wharton, all deserve a note of thanks in this regard. Neil McWilliam's cogent reading of the manuscript aided me in innumerable ways, as did his own revelatory scholarship on the Action Française. Neil and Gennifer have been especially generous in sharing both resources and ideas. Robert L. Herbert also read the manuscript, helped to improve it, and affirmed my interdisciplinary orientation at a time when I encountered serious resistance among editors in the field of art history. In that regard I am especially thankful to Ken Wissoker of Duke University Press for welcoming the project, and to the book's anonymous readers whose valuable insights and suggestions further clarified my thinking.

These voices were supplemented by many others, especially when Patricia

Leighten and I settled in Kingston, Canada, for the summer to write, escape the Orwellian demagoguery of George W. Bush, and enjoy the company of longtime friends. Among the latter I would like to thank Richard Day (and his accordion), Pat Diamond, Alessandra Duncan, Colin Duncan, Kelly Goode, Alison Gowan (and her hurdy-gurdy), Mark Menlove, Laura Murray, Jed Rasula, Ruth Sandwell, Sergio Sismondo, Bill Thompson, and Suzi Wong. While I have thanked Phoebe in the context of another book, she deserves mention here as well: our daily walks in the happy company of George Kelly, Joe Piven, Ken Schoof, Barbara Ziff, and assorted dogs provided me with time to discuss and reflect on some of the manuscript's more difficult passages. Finally I would like to express my special gratitude to four individuals: Allan Antliff, Roger Griffin, Patricia Leighten, and Harold Mah. All four have had a lasting impact on my scholarship, vetted this manuscript, and acted as mentors throughout the process of research and writing.

If in some smothering dreams you too could pace

Behind the wagon that we flung him in,

And watch the white eyes writhing in his face,

His hanging face, like a devil's sick of sin;

If you could hear, at every jolt, the blood

Come gargling from the froth-corrupted lungs,

Bitter as the cud

Of vile, incurable sores on innocent tongues,—

My friend, you would not tell with such high zest

To children ardent for some desperate glory,

The old Lie: Dulce et decorum est

Pro patria mori.

WILFRED OWEN
FROM "DULCE ET DECORUM EST"
OCTOBER 1917

*D*ulce et decorum est pro patria mori: "It is sweet and proper to die for one's country." The contrast between this nationalist exhortation and the painful reality described in Wilfred Owen's "trench life sketch" from World War I well defines the terrain covered in this book.[1] To describe the grisly demise of a human being as an act of martyrdom, "sweet and proper," aestheticizes the violence entailed in death and puts the war dead back into military service, this time in the context of the secular religious myths promulgated by the nation-state to justify war itself. Such myths are commonly marshaled by nations in times of war, but in the case of fascism they became the defining characteristic of a movement that made the aestheticization of violence a fundamental tenet of its philosophy.

This book explores the merger of aesthetics and violence by examining the unrecognized yet central role theories of both the visual arts and creativity played in the development of fas-

cism in France. In the process I examine the aesthetic dimension of fascist myth-making in the context of an unfolding history of the avant-garde. Over the period from 1909 to 1939 a surprising array of modernists were implicated in this project, including such well-known figures as the symbolist Maurice Denis, architects Le Corbusier and Auguste Perret, sculptors Charles Despiau and Aristide Maillol, the "New Vision" photographer Germaine Krull, and fauve Maurice Vlaminck. The French fascists studied here appropriated the avant-garde aesthetics of cubism, futurism, surrealism, the so-called *Retour à l'ordre*, and, in one instance, even defined the "dynamism" of fascist ideology in terms of Soviet filmmaker Sergei Eisenstein's theory of montage. For these fascists, modern art was the mythic harbinger of a regenerative revolution that would overthrow existing governmental institutions, inaugurate an anticapitalist new order, and awaken the creative and artistic potential of the fascist "new man." In formulating the nexus of fascist ideology, aesthetics, and violence these fascists drew primarily on the writings of the French political theorist Georges Sorel (1847–1922), whose concept of revolutionary myth proved central to fascist theories of cultural and national regeneration in France.

My study will examine the impact of Sorel's theory of myth on three interwar promoters of both Sorel and fascism: Georges Valois (1878–1945), Philippe Lamour (1903–1992), and Thierry Maulnier (1909–1988). Valois created the first fascist movement in France, the Faisceau (1925–1928); Lamour, a follower of Valois, established the short-lived Parti Fasciste Révolutionnaire in 1928 before founding two fascist-oriented journals, *Grand'Route* (1930) and *Plans* (1931–1933); Maulnier forged a theory of fascism under the auspices of the journals *Combat* (1936–1939) and *Insurgé* (1937). As we shall see Valois, Lamour, and Maulnier all claimed allegiance to both Sorel and avant-garde art while developing widely divergent forms of fascism. Following Sorel, they all regarded art and culture as integral to their theory of total revolution.

Sorel himself was a prolific author whose tumultuous political evolution accounts for the fact that, following his death, activists across the full political spectrum laid claim to his philosophical legacy.[2] Born in Cherbourg the son of a bankrupt wine merchant, Sorel received technical training at the Ecole Polytechnique in Paris before becoming an engineer in 1870. From 1879 to his retirement in 1892, Sorel was ensconced in Perpignan in the eastern Pyrenees, and it was there, in 1889, that he published his first books, *Le procés de Socrate* and the *Contribution à l'étude profane de la Bible*. These texts laid the ground-

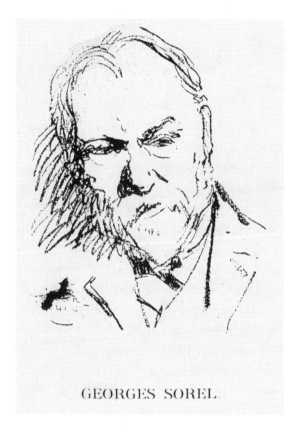

GEORGES SOREL.

Fig. 1. Jean Guiet,
Georges Sorel.
Reproduced
in *L'Indépendance*
(15 March 1912).

work for the "sociology of morals" that became the central preoccupation of all his later writing.[3] After his retirement he moved to Paris, where he first embraced orthodox Marxism before embarking on a revisionist interpretation of Marx that would culminate in his conversion to revolutionary syndicalism. Between 1893 and 1897 Sorel contributed to the ephemeral journal *L'Ère nouvelle* (1893–1894) and to the more successful *Le devenir social* (1895–1898). Concurrently he continued to reflect on moral issues, publishing a Marxian interpretation of early Christianity titled *La ruine du monde antique* (1901) and an important study of the eighteenth-century philosopher Giambattista Vico's notion of historical processes of "corsi" (decline) and "ricorso" (rebirth) (1896).[4] Having become disappointed with *Le devenir social*'s adherence to the orthodox Marxism of Karl Kautsky, Sorel resigned from the editorial board in 1897, began reading Marx in the original, and sided with Eduard Bernstein's attempt to restore moral integrity to Marxism.[5]

After 1902 Sorel parted ways with parliamentary socialism altogether,

claiming that the true legacy of Marx resided in the agitational, direct action politics of the French *syndicats* (trade unions) and their *bourses du travail* (meeting hall, cultural center, and labor exchange), which guaranteed their class autonomy. From 1902 to 1909 Sorel was an advocate of anarchosyndicalism, publishing articles in the syndicalist journal *Mouvement socialiste* (1899–1914) and its Italian counterpart, *Divenire sociale* (1905–1911). During this phase Sorel became enamored of the antirationalist philosopher Henri Bergson and regularly attended his lectures at the Collège de France. Subsequently he adapted Bergson's critique of scientific determinism, as well as his alternative theory of creative intuition, to his own radical revision of Marxism. Bergsonian thought, in conjunction with that of Vico, inspired Sorel's interpretation of the syndicalist general strike as a "myth" that would awaken the intuitive capacity of the proletariat and spark their ethical war against a decadent Third Republic and its plutocratic system of governance, parliamentary democracy. Sorel outlined this new theory in three interrelated books, all published in 1908: *La décomposition du Marxisme* (which extricated Marxism from political reformism), *Les illusions du progrès* (a critique of the Enlightenment and its legacy in the culture and politics of the bourgeoisie), and *Réflexions sur la violence* (his Bergsonian apologia of proletarian violence, which outlined his theory of myth and revolution).[6]

The period from 1909 to the outbreak of World War I in August 1914 constitutes the most hotly debated phase in Sorel's development.[7] Following the failure of strike activity in both Italy and France, Sorel abandoned the workers' movement and entered into a troubled alliance with a group of writers and activists affiliated with the antidemocratic royalist organization Action Française. Sorel, along with his syndicalist ally Edouard Berth, joined the monarchists Georges Valois and Jean Variot in planning a national syndicalist journal, *La Cité française* (1910); when that effort failed, Valois and Berth carried the national syndicalist project forward by establishing the *Cahiers du Cercle Proudhon* (1912–1914). Although the Cercle Proudhon group claimed Sorel as their mentor, he declined to participate, preferring instead to join Variot in founding a journal appropriately titled *L'Indépendance* (1911–1913). In *L'Indépendance*, and in related articles published in the newspaper *L'Action française*, Sorel celebrated the resurgence of French patriotism, the regenerative effects of classical culture and the Christian tradition on French society,

and the Action Française's tenacious opposition to the Third Republic. Sorel and Berth also wrote anti-Semitic texts, which attacked the "Jewish intellectual" as the enemy of French culture and the chief apologist for the Enlightenment and its plutocratic offspring, the Third Republic. With the outbreak of World War I, Sorel withdrew from the public arena and returned to socialism while maintaining his resolute opposition to parliamentary politics. It is in this context that he published his last two books: *Matériaux d'une théorie du prolétariat* (1919) and *De l'utilité du pragmatisme* (1921). Following Sorel's death in October 1922, Edouard Berth, who had returned to revolutionary syndicalism, published a collection of Sorel's early writings under the title *D'Aristote à Marx* (1935), while Jean Variot, now a convert to fascism, published his own reminiscence of conversations with Sorel the same year, *Propos de Sorel* (1935).

Despite the fact that Sorel wrote little on fascism, Valois, Lamour, and Maulnier all expressed their profound debt to Sorel, and drew on his thought to define their various fascisms. Indeed, retrospective claims by proponents of fascism—including Mussolini himself—that the movement took its inspiration from Sorel's writings before 1914 continue to provoke controversy in the historiography on French and Italian fascism. Much of this debate has revolved around the writings of historian Zeev Sternhell, whose analysis of the central role of Sorelian thought in the development of interwar French fascism has been clouded by his further claim that fascist ideology had already been fully developed by Sorel and his national syndicalist allies before 1914. By arguing that the Sorelian synthesis of nationalism and socialism forged under the auspices of the Cercle Proudhon was taken up with little revision by French fascists—including Valois, Lamour, and Maulnier—Sternhell seemed to implicate Sorel himself in the very formation of fascist ideology.

In a series of books Sternhell analyzed the ideological factors that led Sorelians like Georges Valois to become full-fledged fascists after the First World War.[8] Crucial among these was a belief in violence as an ethical and regenerative force in itself and as the key to national renewal and unity. For Sternhell, prewar Sorelians and Sorel's postwar followers shared a desire for "regeneration" that was "simultaneously spiritual and physical, moral, social and political" as well as a totalizing "revolt against decadence."[9] Thus when Valois founded the first fascist movement in France in 1925, the Faisceau, he

hoped to unite a regenerated proletariat and bourgeoisie in an alliance prem-
ised, in part, on the "spirit of victory" created by the war effort. As Sternhell
and Emilio Gentile have pointed out,[10] violence for early fascists in France
and Italy was not only a means to a particular political end; it was also a moral
value crucial to the perpetuation of the fascist state even after the Italian Fas-
cists were firmly in control of the state apparatus. Furthermore, violence was
not only the vehicle of social revolt and regeneration; it was also the authentic
source of creative energy in a fascist order, with the ability to transform the
individual. Thus, far from being an-art-for-art's-sake attitude that excluded
all other values from the political agenda,[11] the fascist aestheticization of vio-
lence had a moral import that was crucial to the fascist project. It is this ethical
factor that accounts for the appeal, in fascist circles, of Sorel's *Reflections on
Violence*. To be truly beautiful, Sorelian violence had to express the creative
and moral transformation of each individual, otherwise it would resemble the
brutal, immoral violence of the tyrant. As Roger Griffin points out in his ex-
emplary study of generic fascism, "palingenetic"—that is, regenerative—myths
of renewal and rebirth are central to fascist ideology, so that fascists "believe
the destruction unleashed by their movement to be the essential precondition
to reconstruction" that gives rise to a "creative nihilism."[12]

To make his case regarding the importance of antimaterialist and ethical
revolt as a defining trait of fascist ideology, Sternhell demonstrated how the
Sorelian doctrine of national socialism, established in France, was flourishing
in Italy before 1914.[13] Sternhell argued that fascist ideology had its origins in
the post-1909 alliance of integral nationalists associated with Charles Maur-
ras's royalist Action Française and revolutionary syndicalists formally affili-
ated with the syndicalist journal *Mouvement socialiste* (1899–1914). Thus the
founding of the Cercle Proudhon in late 1911 by monarchists in conjunction
with Sorel's close syndicalist ally Edouard Berth constitutes a defining moment
in Sternhell's history of fascism's French origins. Sternhell argued that Sorel
himself signaled his own shifting allegiances by replacing his earlier anarcho-
syndicalist myth of the general strike with the myth of an integral nation-state
as the ideological motor of social regeneration. Sorel's national socialist allies
in the Cercle Proudhon condemned democracy as a doctrine of ultraindi-
vidualism, one that served both to atomize society and to replace those ethical
values that give individuals a sense of community, with a capitalist material-

ism wholly concerned with self-interest. Thus the pride of syndicated workers in their particular métier, or the religious values that united French Catholics in a spirit of community, were undermined when the "integral," antimaterialist values of the syndicalist or Catholic were replaced by the materialist ones of the reigning "plutocracy." In addition, democratic materialism was associated with a political tradition grounded in Enlightenment rationalism; the national socialists therefore turned to the antirationalism of figures such as the sociologist Gustave Le Bon, or philosophers Henri Bergson and Friedrich Nietzsche, to justify their theories of spiritual transformation. Concurrently Sorel critiqued the economic materialism and historical determinism of Marx on the basis of Bergsonian anti-intellectualism, and defined an agitational role for mythic structures as the "intuitive" motivators best able to provoke a revolutionary situation. Sorelian national socialists, to quote Reed Dasenbrock, thus "seemed to give mythmakers, hence artists, an important role in social life," which accounts in part for fascism's appeal in artistic circles.[14]

This national socialist synthesis had its Italian counterpart in the collaboration between revolutionary syndicalists such as Arturo Labriola and Roberto Michels, and the ultranationalist Enrico Corradini, who founded the Associazione Nazionalista Italiana in December 1910 to propagate his Sorelian conception of Italy as a "proletarian nation" that should pursue a colonial and imperialist course in conflict with "plutocratic nations." That same year Corradini joined forces with the Sorelian syndicalists Paolo Orano and Labriola in founding the Florentine journal *La lupa*. Like their French counterparts within the Action Française and the Cercle Proudhon, Corradini and Orano regarded war waged in the name of antimaterialist, antiplutocratic values to be of positive import; appropriately they exalted Italy's 1911 military intervention in Libya as evidence of the decay of democratic values and their replacement by Sorelian virtues that could potentially be turned against the democratic system. As Sternhell demonstrates, Mussolini himself came to embrace the same ideology. With the founding of *Il popolo d'Italia* in 1914 and the Fasci di Combattimento, Mussolini joined Corradini and Orano in advocating war between nations as a route to antiparliamentary revolution at home. In this regard Sternhell followed the lead of A. J. Gregor, who also argued that Mussolini had developed a coherent ideological system during the war years.[15] Gregor in turn has made judicious use of Sternhell's findings in his own assessment of

fascist ideology in his study of Sorelian Sergio Panunzio's doctrine of national syndicalism and the leftist corporativism of Ugo Spirito.[16]

Although Sternhell's model has been undeniably influential, that interpretation of fascist ideology has met with important criticism from historians of fascism. Some perceive a failure to relate theory to praxis; others ask Sternhell to account for the transformation of fascism's ideological underpinnings once Fascists gained power in Italy and, with Valois's Faisceau, became a fully developed movement in France.[17] Sternhell's critics argue that while his model of fascism can be legitimately applied to the study of idealists associated with fascism's origins, it is ill suited to be a method for understanding the large-scale movement that brokered power with Italy's conservative elite in 1922. Thus historians such as Jacques Juillard assert that Sternhell's "history of ideas" is divorced from any history of fascism based on historical events, with the result that Sternhell has "artificially separated fascist ideology from fascism itself."[18] In a related argument, historian Robert Soucy goes even further by claiming that Sternhell takes "too much of fascism's rhetoric about national 'socialism' at face value, thereby ignoring many of the rationalizations and mystifications perpetrated by such propaganda."[19] Citing the example of Faisceau, Soucy argues that the monetary support Valois received from industrialists such as Eugène Mathon and François Coty, combined with the lower-middle-class makeup of the fascist rank and file, meant that the ideology of national socialism mapped out by Sternhell was so much window dressing for a fundamentally conservative movement, whose members were threatened by the rise of communism and socialism within France.[20] "What separated French fascists from French parliamentary conservatives," Soucy claims, "was primarily issues of tactics and style: fascists were more eager to abandon political democracy and resort to paramilitary force than conservatives, and their style was more military than bourgeois in tone."[21] By arguing that the supporters of fascism came primarily from the right, Soucy joins a number of scholars who would question Sternhell's thesis that French fascism's adherents were dissident leftists advocating a doctrine of Marxist revisionism.[22]

By claiming that the leftist pretensions of fascist theory were divorced from the economics of fascist praxis, Soucy not only reiterated the familiar Marxist correlation of fascism with the politics of the *petite bourgeoisie*; he also denied that the doctrine of "national socialism" outlined by Sternhell had any im-

pact on historical developments. However, in not taking theories of national socialism at "face value," Soucy goes to the extreme of not granting that discourse any value at all, even when it affected the historical evolution of a given movement. For instance, if one studies the rise and fall of Valois's Faisceau, it is clear that the ideology of the movement economically undermined its viability, for Valois's attacks on the Action Française, and his repeated attempts to win over syndicalists as well as industrialists in the name of Sorelian national socialism, eventually alienated financial backers, such as the royalist sympathizers Coty and Mathon.[23] These industrialists, like Soucy, may have initially thought Valois's Sorelianism mere "rhetoric"; however, historical events were to prove otherwise, and Valois's leftism eventually led him to abandon fascism altogether in favor of Sorelian syndicalism rather than Sorelian national socialism.[24] Thus to claim that Sternhell's "history of ideas" is divorced from historical events by labeling such ideas mere "rhetoric" is to underestimate the role ideology could play in historical developments and, in Soucy's case, to give too much weight to an analysis of base structure economics. Similar qualifications apply to Robert Paxton, who, like Soucy, views fascist theory as a rhetorical veil shrouding and distorting the "true" history of fascism in action.

Historians who agree with Sternhell's affiliation of fascism with left-wing politics nevertheless follow Soucy and Paxton in faulting him for overvaluing the ideological dimension of fascism. As Robert Paxton has noted, Sternhell's model "puts more weight upon origins than upon later developments, and it rates the thinkers as more authentically fascist than the doers." By emphasizing theory over praxis, other historical factors that may have contributed to the rise of fascism seemed to be excluded: thus, since fascist ideology, in Sternhell's account, was fully developed before 1914, the historical circumstance of World War I provided its practitioners "only with auspicious circumstances and new recruits."[25] To account for the evolution of fascism from its documented beginnings as a doctrine of antimaterialist revolution advocated by small dissident groups to a totalitarian state in Italy, historians such as Pierre Milza have spoken of a "first" (idealist) and "second" (pragmatic) fascism.[26] In this reading the antimaterialist ideals that animated Italian Fascists during fascism's first phase were incrementally reduced after 1922 to rhetorical slogans that served to hide a fundamentally conservative agenda. Antimateri-

alism now served to justify a corporativism that undermined syndicalism; and heroic violence was put to use in attacks on the pacifist Socialist Party and its affiliated unions. In this scenario Italian fascism's true believers were gradually pushed aside once Mussolini moved to placate the conservative Italian elite. Unlike Soucy, Milza argues that we should take the leftist aspirations of fascist ideology seriously, but only during the period before the Fascist push to gain power in Italy. As for France, it has been argued that "first fascism" survived simply because fascism itself was a marginal element on the French political landscape. "Wherever fascism remained pure," states Robert Paxton, "it remained limited to cafés, struggling newspapers, and the occasional street demonstration."[27]

However valuable Milza's distinction is, the bifurcation between "first" and "second" fascism downplays ongoing attempts, following Mussolini's ascent to power in 1922, to reconcile the movement's idealist aims with governmental policy (the debate over corporativism, which lasted into the early 1930s, is a case in point). Moreover Paxton's reformulation of Milza's distinction with reference to "pure" French fascism seems to imply that cultural matters only preoccupied small fascist groupings outside Italy and Nazi Germany, when in fact Mussolini and Hitler utilized culture to express their fascist ideals. One has only to think of the symbolic linkage established between the Fascist regime and the Roman Empire through Mussolini's massive renovations of Rome, the 1932 Exhibition of the Fascist Revolution, which attracted millions to the Fascist capital, or the Nazis' equally influential exhibition of Degenerate Art (Entartete Kunst), which opened in Munich in 1937. Rather than relegating culture to the realm of "pure" or "first" fascism, I would argue that fascist theory and praxis were always symbiotic, and that fascist theories of culture were both influenced by and influential on evolving historical developments throughout Europe. Like Sternhell we need to take the cultural dimension of fascist ideology seriously, but we should not lose sight of the interrelation that ideology had to the broader historical events that shaped Europe following the outbreak of the First World War.

My own assessment of Sternhell's groundbreaking, yet controversial scholarship, focuses on two issues: his claim that the national socialism developed by the Cercle Proudhon amounted to a form of fascist ideology *avant la lettre*, and his argument that French fascism, in part, had its origins in the

Sorelians' cultural revolt against the Enlightenment and parliamentary democracy. Unlike past writers who have examined Sternhell's thesis I will consider the aesthetic dimension of Sorelian ideology to evaluate the degree to which we can establish a continuity between Sorel's own thought, that of the *avant-guerre* Cercle Proudhon, and those Sorelians claiming allegiance to fascism after World War I. While I concur with Sternhell's conclusion that theories of culture were essential to the Sorelians' notion of fascist revolution, I would argue that, to fully grasp the ramifications of this cultural rebellion, we need to attend more carefully to the cultural politics of Sorel himself and of those interwar fascists who endorsed his anti-Enlightenment project. No scholar to date has fully grasped the profound involvement of Valois, Lamour, Maulnier, or Sorel in the visual culture of their era. As a result a whole dimension of Sorel's ideological legacy, as manifested in art criticism, painting, sculpture, architecture, and film, has been virtually ignored in the historiography on French fascism.[28] This situation is even more striking when one contrasts this state of affairs with the rich discourse devoted to Sorel's impact on French literary fascism initiated by scholars such as Alice Kaplan, Jeffrey Mehlman, and Sternhell himself.[29]

This book addresses that lacuna by examining the role of Sorel's thought and that of his avant-guerre followers in the development of fascist aesthetics in France. I chart the history of a variety of fascisms in the making by extracting the Sorelian aestheticization of violence from the realm of the generic in order to examine the plurality of mythic and cultural constructs developed by Sorel and his followers in the period before World War II. This history reveals the shifting emphases among the "common denominators" uniting modernist aesthetics and the Sorelian fascisms extant in France. Chapter 1 posits a conceptual model for the study of fascist cultural politics in Europe that serves as a blueprint for subsequent chapters devoted to the aesthetic theory of Sorel and his fascist followers. My consideration of the nexus between fascism, modernism, and modernity merges Sternhell's anti-Enlightenment thesis with Roger Griffin's broader definition of generic fascism as a form of palingenetic ultranationalism. When combined, these two models underscore the integral relation of fascism to culture and make plain the need for historians to address the cultural aspect of Sorel's thought when evaluating his impact on fascist theory and praxis in Europe.

Chapter 2 focuses on Sorel's own writings and their relation to the art and ideology promoted by syndicalists and monarchists associated with the journal *L'Indépendance* (1911–1913) and the study group known as the Cercle Proudhon (1911–1914). I analyze the development in these circles of a Sorelian myth that condemned the Jewish community for precipitating the destruction of the creative force that the postsyndicalist Sorel allied to a theory of class-consciousness, neo-Catholicism, classicism, and revolution. This chapter also considers the involvement of prominent artists in Sorel's circle, most notably the symbolist painter Maurice Denis, the composer Vincent d'Indy (founder of the Schola Cantorum), and the dramatist Paul Claudel. By probing the continuity uniting Sorel's syndicalist and postsyndicalist writings, the function of his critique of the Enlightenment in the broader cultural agenda promoted by *L'Indépendance*, and the impact of that discourse on Sorel's principle disciple, Edouard Berth, I will fully reveal the ideological import of Sorel's aestheticized politics for the first time.

Chapter 3 turns to the period after World War I through an examination of the Sorelian myth of "la cité française" and related theories of art and urbanism. This alterative myth was developed by the Faisceau (1925–1928), the movement founded by the former royalist and Cercle Proudhon adherent Georges Valois. Like Mussolini, Valois defined fascism as an alliance of wartime combatants and "producers," but he additionally claimed that the Sorelian "spirit of victory" resulting from the war effort had a constructive complement in postwar technocratic society. In this chapter I explore the role that Sorel's evolving notions of "la cité" and of the "producer" played in Valois's association of creativity with theories of industrial production, and the latter's vision of a future society to be transformed by an elite group of workers, industrialists, technocrats, and engineers. In the process I unveil the impact of prominent cultural arbiters, such as Le Corbusier, F. T. Marinetti, and art critic Jean-Loup Forain, on the Faisceau's aesthetics, as well as the conflicting views over the merits of modernism—and related debates between left and right factions within the movement—that heralded the Faisceau's demise in 1928. The Faisceau's ode to Le Corbusier, when compared to Sorel's prewar promotion of French symbolism, makes plain the radical difference between Valois and Sorel's vision of national regeneration, despite their shared allegiance to the myth of "la cité française."

The fourth chapter considers the fascist myth of a generational revolt propagated by the Sorelian Philippe Lamour, and the "machine aesthetic" that was its cultural correlate. A former member of Valois's Faisceau, Lamour founded the Parti Fasciste Révolutionnaire in 1928 and the journals *Grand'Route* (1930) and *Plans* (1931–1933) to advertise his generational politics. Over the same period he promoted the work of a surprising array of major modernists, including the photographer Germaine Krull, filmmaker Sergei Eisenstein, and architects André Lurçat and Le Corbusier. To date, historians have studied Mussolini's use of generational theory and the cult of youth in Italy, but scholars have not analyzed avant-garde variants on the theme developed in France. As I demonstrate, Lamour transformed Sorel's myth of class conflict into an epic confrontation between generations and associated the dynamism of *jeunesse* (youth) with the emergence of a new aesthetic sensibility, manifest in automotive design, montage techniques in film and photography, and cubist aesthetics and modernist architecture. Lamour asserted that such agitational "dynamism" was intrinsic to the thought processes of Sorel himself, which meant that for Lamour the theory of revolution in Sorel's *Reflections on Violence* (1908) embodied the same "eternal youthfulness" that Il Duce associated with Italian fascism.

The final chapter moves forward chronologically to probe the theory of fascism developed by a group of writers affiliated with the journals *Insurgé* (1937) and *Combat* (1936–1939), including the literary critic Thierry Maulnier, polemicist Pierre Andreu, and art critic Pierre Loisy. Maulnier and his colleagues looked back to the prewar writings of Sorel and of Edouard Berth, rather than to the interwar fascisms of Lamour or Valois, to forge their unique version of Sorelian fascism. They asserted that fascism first emerged in France in 1913, when members of the Cercle Proudhon reportedly synthesized the precepts of Action Française founder Charles Maurras with those of syndicalist Georges Sorel to construct a doctrine of "classical violence." Citing Edouard Berth's Nietzschean claim that the Cercle Proudhon fused Maurras's love of "beauty" with Sorel's restless pursuit of the "sublime," they traced the genealogy of such thinking back to the classicism of seventeenth-century dramatist Jean Racine, and still further to Homer's epic celebration of "military virtue" and the birth of tragedy in classical Greece. Having embedded classical violence in the history of French and European culture, the *Combat* group then

set about utilizing that doctrine as a galvanizing Sorelian myth with which to transform contemporary French society. Thus *Combat*'s campaign operated on two fronts: that of politics and that of culture. Maulnier hoped to resuscitate the Cercle Proudhon's alliance of the antidemocratic bourgeoisie and proletariat to combat the collusion between socialists, communists, and working-class unions that had resulted in the Popular Front government of Léon Blum (1936–1937). To rally his troops Maulnier described the Blum government as nothing short of a reprise of the same plutocratic politics that had driven Sorel away from syndicalism in 1909 and into the fold of the Sorelian royalists. This plutocratic conspiracy supposedly led to decadence in the cultural sphere, as manifest in the Popular Front's eclectic endorsement of extreme forms of abstraction, slavish academicism, or the Soviet-sanctioned theory of socialist realism. As I demonstrate, the Paris World's Fair of 1937 served as a lightning rod for Maulnier's group, for the exhibition itself was deemed the perfect example of how "decadence" in the realm of politics could infect the cultural arena. In response Maulnier's team called for adherence to Sorelian classicism, and they identified the sculptors Charles Despiau and Aristide Maillol and architect Auguste Perret as contemporary torchbearers for their aesthetic ideals. More surprisingly, even ironically, Maulnier's circle also asserted that their doctrine of "classical violence" could prepare a reinvigorated France to resist the threat posed by the authoritarian and collectivist fascisms of Nazi Germany and Fascist Italy. In the mid-1920s and early 1930s Valois and Lamour could still regard Fascist Italy as a benevolent ally in the fascist cause, but Maulnier did not enjoy that luxury after the establishment of the Rome-Berlin axis in November 1936 and Hitler's incursions into Austria and Czechoslovakia in 1938. As a result, ancient Greece, rather than contemporary Rome, served as Maulnier's European ally in the realm of cultural politics.

In sum this book not only addresses the "image" or "myth" of Georges Sorel fabricated by his fascist disciples; it also probes the ideas informing that relationship by examining the myriad ways in which Sorel's political theories were selectively appropriated, reinterpreted, or ignored by the very fascists that claimed an allegiance to him.[30] By examining the role of Sorelian theory in the formation of fascist movements in France, I aim to counter those historians who assert that fascist ideology was only so much retrospective window dressing for a movement whose origins resided in "praxis" alone.[31] I hope to

shift the contemporary debate on fascism by revealing the centrality of theories of art and of creativity to the fascist project initiated by Sorel's followers in France. As Griffin has pointed out, the palingenetic myths so fundamental to fascism gave rise to an association of destruction itself with an act of creation,[32] and this paradigm arguably found perfect expression in the aestheticized politics of Sorel and his fascist acolytes. As I demonstrate, the paradox at the heart of Sorelian fascism, exemplified by the "creative" function of violence, was part and parcel of a whole series of polarities that fascism claimed to transcend, from left and right factionalism, to the separation of socialists from nationalists, to the avant-gardist opposition to tradition.[33] I argue that creativity itself served as a binding mechanism in this reconciliation of political *and* aesthetic polarities, and therefore that art's function was central—not marginal—to an understanding of fascist ideology.

FASCISM, MODERNISM, AND MODERNITY

The terms "fascism" and "modern art" used to seem com-fortingly opposed to each other, but the last two decades of scholarship in history, art history, and literature have radi-cally revised that postwar complacency. An understanding of the profound interrelation of these two terms is now a precon-dition for an appraisal of modernism in any historicized sense. This has led historians to examine the relation of both avant-garde art and fascism to broad socioeconomic, cultural, and philosophical trends pervading European society in the wake of the industrial revolution. For example, in her introductory essay for the 1991 exhibition catalog *"Degenerate Art": The Fate of the Avant-Garde in Nazi Germany*, Stephanie Barron rightly identified the 1937 Entartete Kunst (Degenerate Art) exhibi-tion organized by the Nazis as "the most virulent attack ever mounted against modern art."[1] At first glance such a statement seemed to confirm the common assumption that fascism and modernism were mutually exclusive and that the Nazis' con-

certed efforts, after 1933, to vilify modern art evinced an unbridgeable chasm between fascists and the European avant-garde. Barron, however, tells a more complicated story, noting that attempts to condemn pictorial abstraction as evidence of the "degenerate" condition of its creators were countered within the Nazi movement by those who valued the art of such modernists as Ernst Barlach and Emil Nolde as "regenerative."[2] This latter camp praised German expressionism as attuned to the spiritual values of the German folk, claiming that this avant-garde art embodied a Nordic artistic heritage with roots in the Gothic era. Indeed, Nolde, who became a charter member of the North Schleswig branch of the German National Socialist Party in 1920, saw no contradiction between Nazism and modern art.[3] No less a figure than Joseph Goebbels—future minister for public enlightenment and propaganda in the Third Reich—actively sided with German expressionism's defenders, and, as Barron notes, Nolde's art met with rejection in Nazi circles only after Hitler's September 1934 condemnation of modern art at a party rally in Nuremberg.[4] Thus, before 1934 some factions within the Nazi movement seemed in tune with the cultural politics of Italian fascism under Benito Mussolini, finding in German expressionism an artistic counterpart to the Italian fascists' promotion of all strands of modernism, from the Le Corbusier-inspired architecture of the Italian rationalists to futurism and the art of the Novecento.[5]

Such complications are further compounded when we consider the incorporation of modernist formal aesthetics into the design of household goods under the Third Reich. As John Heskett concluded in his study of modern design in Nazi Germany, the Nazis' closure of the Bauhaus in 1933 has obscured the relation of Nazi industrial design to that developed under the Weimar Republic and the degree to which the Nazi regime actively embraced modernity.[6] Espousing "blood and soil" tribalism even as it constructed autobahns, engineered the Volkswagen, and developed advanced methods of factory organization, the Nazi regime—like its Italian counterpart, and fascist movements in France—looked to a mythic past and a technological future in a manner that seems highly contradictory. The pivotal role of modern art in that matrix will be the focus of this chapter as I examine new approaches to modernism through the lens of fascism's cultural politics. This historiographical overview will set the stage for the chapters that follow, whose focus will be on the development of fascist aesthetics in France.

Central to this problematic is the function of both fascism and modernism in the development of modernity, that is, the socioeconomic transformation of Europe and the world following the industrial revolution of the eighteenth and nineteenth centuries, the birth of democracy in the wake of the Enlightenment and the French Revolution of 1789, and the subsequent globalization of capitalism.[7] Scholars now recognize the role of both fascism and modernist aesthetics in the emergence of anti-Enlightenment movements opposed to the democratic tradition that was the heritage of Enlightenment thought. Indeed the rise of fascism in Europe responded to a widespread search for spiritual values and "organic" institutions capable of counteracting what was considered the corrosive effects of rationalism (and capitalism) on the body politic. As Pierre Birnbaum notes, democracy's opponents repudiated the Enlightenment principle of a rationalism inherent in human nature and the legitimizing principle of "one man, one vote."[8] In its stead they posited ethnic, regional, and religious forms of national identity, antithetical to political democracy's universalist and rationalist precepts. The Enlightenment's adversaries also came to associate capitalism with the homogenizing effects of rationalism, since the only value recognized by capital was that of quantifiable monetary exchange. In this regard, Marxists Michael Löwry and Robert Sayre have configured fascism as one manifestation of what they call "Romantic anti-capitalism," an umbrella term for an opposition to capitalism in the name of pre-capitalist values on the part of intellectuals associated with a broad political spectrum, including Marxism, anarchism, and socialism.[9] They associate this worldview with hostility toward a "capitalist present" that reduced human relations to a matter of "exchange value" with no regard for the social divisiveness and alienation resulting from monetary competition.[10] For Löwry and Sayre this worldview precipitated a "nostalgia" for a "pre-capitalist past, or at least for one in which capitalism was less developed." Capitalism had reportedly stifled our imaginative capacity by immersing human subjectivity and emotions in a system based on "extreme mechanization," and "quantitative calculation and standardization," thus instigating a "yearning for unity" both with "the universe of nature" and "the human community."[11] The marshaling of "human values" identified with that past served either to resist a capitalist present or as a springboard for "a dreamed-of future beyond capitalism" inscribed "in the nostalgic vision of the pre-capitalist era." This appeal to past values in

the name of a noncapitalist future society is a key characteristic of fascism, though Löwry and Sayre fail to recognize this when they claim that fascism—as exemplified by German Nazism—was predominantly hostile to the "modern world" and fully restorationist in orientation.[12]

Indeed, fascists, though opposed to Enlightenment ideals and capitalist precepts, were eager to absorb those aspects of modernity (and modernist aesthetics) that could be reconfigured within their antirational concept of national identity. Thus, historian Jeffrey Herf has documented the Nazis' thorough acceptance of modern design and industrialism, which has led him to coin the term "reactionary modernism" to describe those thinkers and ideologues under the Weimar Republic and the Third Reich "who rejected liberal democracy and the legacy of the Enlightenment, yet simultaneously embraced the modern technology of the second industrial revolution."[13] As Paul Jaskot points out, the use of technocratic systems of organization and accountancy reached a horrific extreme with the mobilization by the Schutzstaffel (ss) of forced labor in the mass production of dressed stone for Albert Speer's monumental building campaigns; in like fashion, Barbara Lane has analyzed the Nazis' adaptation of Bauhaus design techniques to industrial construction in response to Hitler's call, in 1933, for an architecture of "crystal clear functionalism."[14]

Emilio Gentile has reached similar conclusions with regard to Italian fascism, noting that Mussolini and his allies among the futurists cast themselves as "antagonists of that perverse modernity that stemmed from Enlightenment values of liberal reason." Claiming that the principle of democracy valued individual freedom to the detriment of "spiritual" values with the capacity to unify Italy's body politic, the Fascists gave "absolute primacy" to notions of "national collectivity as organised by the totalitarian state."[15] Zeev Sternhell, in an important anthology devoted to this issue,[16] outlines what was at stake for the Enlightenment's adversaries:

> The Enlightenment was the age of criticism. . . . The principal ideas of the modern age—progress, revolution, liberty, democracy—ensued from criticism. It was the rational criticism of certitudes and traditional values—and in the first place religion—which produced the theory of the rights of man, the primacy of the individual with regard to society. . . . It was the rational criticism of the existing order which allowed so-

ciety to be conceived as an aggregate of individuals and the state as an instrument in the hands of the individual.[17]

To contravene this new social and political order, the Enlightenment's critics turned to alternative philosophical strands from which they constructed new social systems attuned to the industrial revolution, yet opposed to the democratic tradition. Antirationalist philosophers and activists such as Maurice Barrès, Friedrich Nietzsche, Georges Sorel, and Henri Bergson, as well as antidemocratic sociologists such as Gustave Le Bon and Vilfredo Pareto and racial theorists such as Arthur de Gobineau, inspired the anti-Semitic "blood and soil" politics of the Nazis, the creation of fascist myths under Mussolini, the socioeconomics of corporativism, and the theatrical mass politics of fascist regimes and movements throughout Europe. Moreover, concepts associated with modernist aesthetics—including regeneration, spiritualism, primitivism, and avant-gardism—were integrated into the anti-Enlightenment pantheon of fascist values, with the result that many artists found common ground with these new movements. Over the course of the 1990s historians of fascism began probing this cultural matrix, and journals such as *Modernism/Modernity* (founded in 1994) and the *Journal of Contemporary History* (begun 1966) have played a seminal role in providing art historians, literary critics, and historians with a forum in which to examine the specifically *modernist* dimension of fascism's cultural politics. In short, we now recognize that many of the paradigms that spawned the development of modernist aesthetics were also integral to the emergence of fascism, and that the internalization of these paradigms as operative assumptions were a stimulus for alliances between modernists and anti-Enlightenment ideologues throughout the nineteenth and twentieth centuries.

Common denominators uniting modernist aesthetics and fascism include concepts of cultural, political, and biological regeneration; the avant-garde techniques such as montage; notions of "secular religion"; primitivism; and anticapitalist theories of space and time. I will treat these five themes separately, considering the implications of each paradigm for the study of modern art and architecture while recognizing their synergetic confluence within the matrix of fascism's cultural politics. The principal framework in which I will situate fascist modernism will be the definition of generic fascism outlined by Roger Griffin in his book *The Nature of Fascism.*[18] In that volume Grif-

fin developed a heuristic model for the study of fascism's internal workings; scholars have found this approach compelling because it lends coherence to the vast and disparate writings on fascism and has proven to be constructive in subsequent evaluations of fascist aesthetics. As we shall see, the above categories gain conceptual consistency when analyzed from the perspective of Griffin's definition of fascism as "a genus of political ideology whose mythic core in its various permutations is a palingenetic form of populist ultranationalism."[19] I will begin by considering Griffin's definition of myth before exploring the ramification of "palingenesis" (rebirth) for the first of our categories: that of regeneration.

Myth

By claiming that fascism possessed a "mythic core" Griffin highlights the irrationalism behind fascist ideology and the function of myths as motivating factors among fascism's adherents. He turns to the theory of myth propounded by French political theorist Georges Sorel to define the fascists' specialized use of this concept—an appropriate association, given Mussolini's self-professed debt to the author of *Reflections on Violence* (1908) and the impact of Sorel's views in Germany between the wars.[20] Sorel concluded that the revolutionary transformations instigated by religious sects and political movements arise from the emotive impact of their core myths, defined as those visionary principles that inspire immediate action.[21] For Sorel, myths were decidedly instrumental; rather than providing people with a social blueprint for a future to be created incrementally through political reform and rational planning, myths presented the public with a visionary ideal whose stark contrast with present reality would agitate the masses. In his *Reflections on Violence*, Sorel underscored the emotive and intuitive nature of myth by defining it as "a body of images capable of evoking all the sentiments which correspond to the different manifestations of the war undertaken by socialism against modern society."[22] Having condemned parliamentary socialists for employing rational argumentation to promote social change, Sorel lauded the mythic power of the French anarchosyndicalist vision of a general strike for its ability to instill revolutionary fervor among the working class. If all workers believed their strike action would spark similar acts throughout France and that the proliferation of such strikes would result in the downfall of capitalism, then the evoca-

tion of such an apocalyptic general strike would inspire workers to engage in heroic forms of violent resistance to the capitalist status quo. Sorel viewed the general strike as only the latest manifestation of the power of mythic images to transform individual consciousness and ultimately, whole societies. Other examples included the Christian belief in Christ's imminent return; the various utopic images that had inspired the citizen-soldiers of France to defend the Revolution of 1789; and Giuseppi Mazzini's visionary call for a united Italy, which had motivated the common people to take up arms during the Risorgimento (1861–1870). In each case, myth makers drew a strong contrast between a decadent present, rife with political and ethical corruption, and their vision of a regenerated future society, premised, in no small part, on the spiritual transformation of each individual within the body politic.

At the heart of Sorel's theory of myth was a notion of aestheticized violence that served to distinguish his proletarian insurrection from the state's barbaric use of "force." "Proletarian violence," wrote Sorel, "carried on as a pure and simple manifestation of the sentiment of class war, appears thus as a very beautiful and very heroic thing; it is at the service of the immemorial interests of civilization.... [I]t may save the world from barbarism."[23] Proletarian violence was motivated by a desire for justice, it was a disciplined activity "carried on without hatred or a spirit of revenge." By contrast the "essential aim" behind the repressive violence meted out by monarchs, or bourgeois Jacobins during the Terror in 1793, "was not justice, but the welfare of the State."[24] Syndicalist violence, therefore, "must not be confused with those acts of savagery," and Sorel felt justified in hoping "that a Socialist revolution carried out by pure Syndicalists would not be defiled by the abominations which sullied bourgeois revolutions."[25] Sorelian violence, to quote historian David Forgacs, was "more image than reality," and supposedly minimal in its bloodshed by virtue of the sense of discipline and justice animating its practitioners.[26] In effect Sorel displaced the violent act from an infliction of bodily harm to an imaginary realm described as an act of heroism, a form of beauty, a civilizing force able to heal society. Forgacs sees a comparable operation at work in Italian fascism, citing for instance Mussolini's declaration in 1928 that fascist violence "must be generous, chivalric, and surgical."[27] Despite the fact that Sorel sought to minimize violence while Italian fascism exalted it, both forms of violence operated "at the level of the imaginary," wherein violence was displaced "into something

other: a social medicine, a creation of order, a revolution-recomposition."[28] As we shall see similar transmutations were operative in the various fascisms developed by Sorel's French followers, who saw art and artistic consciousness as integral to their theory of revolution.

Heroism in the realm of labor unrest had a constructive complement in the creativity of the industrial worker, whose interaction with modern machinery galvanized a workers' potential for invention. To Sorel's mind the ethical violence of the worker merged with the creativity of the industrial producer; Mussolini (and his French fascist counterpart, Georges Valois) appropriated this aspect of Sorel's theory when he described the fascist movement as an alliance of combatants and producers.[29] At its most extreme a society built around such myths would no longer support institutions structured on Enlightenment precepts; parliamentary democracy would cede to the creation of a new form of politics, such as fascism. As belief systems that served as catalysts for activism, myths not only nurtured social cohesion among disparate constituencies; they also made social and industrial dynamism, and the potential for violent upheaval, core aspects of any ideology employing such mythic images to achieve its objectives.[30]

The significance ascribed by Griffin to the revolutionary import of Sorel's theory of myth is confirmed by historian Zeev Sternhell's thesis that fascist ideology had its genealogy in the "antimaterialist" revolt against parliamentary politics forged by Sorel and his French and Italian followers before World War I.[31] In a series of books devoted to the development of fascism in France[32] and Italy, Sternhell has documented the alliance formed between antiparliamentary nationalists, anarchists, and Sorelian syndicalists, noting that a doctrine of national socialism was first developed when Sorel and his followers forged links with members of the monarchist Action Française (including the future fascist Valois) before 1914. In 1910, Sorel, who had abandoned hope that the proletariat constituted a revolutionary force, joined fellow syndicalist Edouard Berth, monarchist Valois, and royalist sympathizers Jean Variot and Pierre Gilbert in attempting to launch an organ of national syndicalism titled La Cité française. When that journal failed due to internal dissension, Sorel joined Variot and a group of monarchists in creating L'Indépendance (1911–1913), while Berth and Valois, in conjunction with monarchist Henri Lagrange, established the study group Cercle Proudhon and a related journal, Les Cahiers

du Cercle Proudhon (1912–1914). In Sternhell's estimation *L'Indépendance* failed to arrive at a coherent doctrine, whereas the Cercle Proudhon succeeded in achieving a "syndicalist-nationalist synthesis." Although neither Maurras nor Sorel joined the Cercle, their followers combined Maurras's integral nationalism—with its "organic" and "tribal" implications—with Sorel's critique of the rationalism and the Hegelian foundations of Marxism. The result was an antimaterialist theory of national socialism, the precepts of which were elaborated in the *Cahiers*, and in Edouard Berth's seminal text, *Les Méfaits des intellectuels* (1914).[33] On a controversial note Sternhell has asserted that this doctrine reiterated "the essential features of fascism," and—though "the term did not exist yet"—provided future fascists in Italy and France with "a solid conceptual framework" on which to base their movements.[34] In his book on fascist ideology in France, Sternhell noted that Sorelians allied to the fascist cause—most notably Georges Valois, Hubert Lagardelle, and Thierry Maulnier—all referred back to this "pre-1914 fascism"[35] in defining their own versions of national socialism. They in turn were part of a broader constituency whose antimaterialist critique of democratic precepts undermined the Third Republic during the years leading up to World War II.

Similar alliances were developed in Italy when Sorel's followers—including the formerly socialist Mussolini—joined the ultranationalist Enrico Corradini (who founded the Associazione Nazionalista Italiana in 1910), anarchist-oriented futurists Umberto Boccioni, Carlo Carrà, and F. T. Marinetti, and Florentine critics Giovanni Papini and Ardengo Soffici in advocating an Italian version of national socialism. Claiming that Italy was a "proletarian nation" locked in conflict with richer "plutocratic" countries, they exalted war—whether in the guise of imperialist conquest in Libya (1911), irredentist warfare with Austria, or military intervention in World War I—as a catalyst for Italy's spiritual unification.[36] Once Marinetti formed the Futurist Party in 1918–1919 he entered into an alliance with the Association of the Arditi (World War I assault units), and Mussolini's Fasci di Combattimento (Battle Fasces) to embark on a campaign for national revolution outside the parliamentary framework. The futurists' anarchist leanings made for stormy relations with Mussolini following the creation of the National Fascist Party (Partito Nazionale Fascista) in 1921, but the Italian Fascists' public admiration for Sorel's mythic politics continued to draw dissident leftists to their ranks throughout the 1920s.[37] Al-

though Sternhell's thesis has come under criticism for insufficiently relating fascist theory to praxis, for claiming that "fascist ideology" existed before the historical birth of fascism, and for subsuming too wide an array of intellectual "nonconformists" under the rubric of fascist "antimaterialism," his analysis of Sorel's impact on the *development* of fascism has met with widespread acceptance.[38] Most important for our purposes Sternhell has rightly highlighted fascism's status as a form of "cultural rebellion," whose Sorelian roots proved attractive to the European avant-garde.[39]

Regeneration

According to Griffin the mythic core of fascism was that of national palingenesis. "Etymologically," states Griffin, "the term 'palingenesis,' deriving from palin (again, anew) and genesis (creation, birth), refers to the sense of a new start or of a regeneration after a phase of crisis or decline which can be associated just as much with mystical (for example the Second Coming) as secular realities (for example the New Germany)."[40] Notable here is the Janus-faced nature of fascism's regenerative nationalism: to reinvigorate the body politic, fascists looked beyond a decadent present to past eras, but they did not advocate a nostalgic return to, say, the era of imperial Rome. Instead they sought to incorporate qualities associated with the past into the creation of a radically new society, fully in tune with twentieth-century industrialism and technology. In Sorelian fashion, selective moments from a nation's history were utilized for their mythic appeal as a catalyst for the radical transformation of present society. Griffin has underscored this point in a critique of the exhibition catalog *The Romantic Spirit in German Art, 1790–1990*, which characterized Nazi art and art policy as profoundly antimodern while claiming that works such as Oskar Martin-Amorbach's *The Sower* (1937) were indicative, in both style and content, of the reactionary and restorationist outlook of a regime harking back to an agrarian, medieval past.[41] By contrast Griffin notes that the role of the past in Nazi ideology was rather to supply values that would facilitate the nation's rebirth, pointing out that "the Nazis no more wanted to return Germany to the period of the Völkswanderungen (tribal migrations) or the Holy Roman Empire than the [Italian] fascists wanted to return literally to the age of the Romans or the Renaissance."[42] Instead, fascists selectively plundered their historical past for moments reflective of the val-

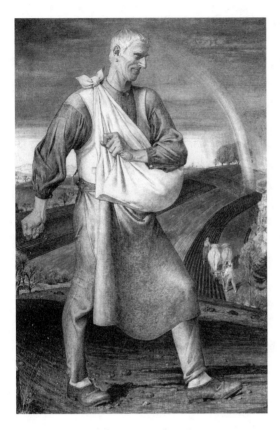

Fig. 2. Oskar Martin-Amorbach, *The Sower*, 1937. Peissenberg, Ernst Reinhold/ Artothek.

ues they wished to inculcate for their radical transformation of national consciousness and public institutions. Thus Martin-Amorbach's pictorial ode to Germany's preindustrial peasantry, executed in a style reminiscent of northern Renaissance "primitives," referred metaphorically to the organic, corporative, and racial order the Nazis would impose on all aspects of the German economy, including the agrarian, the governmental, and the industrial. The decidedly modern function of this mythic *Sower* is affirmed by its original placement in the Beyreuth House of German Education, where it was meant to encourage teachers to "sow" National Socialist values among the German youth.[43] Nazi imagery used the countryside as "the focus for the palingenetic myth of renewal and sustenance, not for a retreat from the twentieth century." Similarly, the Nazi celebration of Athenian society and Greek sculpture as an aesthetic ideal was wed to the modern pseudoscience of eugenics; the sculpture of classical Greece functioned as a mythic prototype for the fascist "new

man" who was destined to inhabit an industrialized Third Reich, devoid of "degenerate" races.[44]

Art historians have lent further credence to Griffin's model in the exhibition catalog *Art and Power: Europe under the Dictators* (1995).[45] Iain Boyd Whyte's essay "National Socialism and Modernism" vividly documents the continued usage of modernist-inspired building techniques in the Nazi construction of power plants, airfields, youth facilities, and sports centers. Moreover, architects involved in such projects had modernist pedigrees; to cite two examples, Hans Dustmann, a former head of Walter Gropius's design office, became *Reicharchitekt* of the Hitler Youth, while Gropius associate Herbert Rimpl headed a team that designed an ultramodern Heinkel aircraft factory north of Berlin.[46] Whyte also notes the combination of "the ultra-modern with the ultra-historicist" in Albert Speer's Hitler-approved plans for the rebuilding of Berlin, which envisioned a north-south axis composed of classicizing monumental structures anchored at its extremities by railway stations, an adjacent airport, and an outer autobahn ring road circumnavigating the city to facilitate traffic. Whyte rightly compares this emphasis on modern transport to modernist blueprints for urban design, such as Le Corbusier's "Contemporary City for Three Million People" (1922).[47] Speer's granite buildings, when compared with the exposed concrete, steel, and glass structures of Rimpl, appear poles apart in "purely constructional terms," yet "in terms of emotional response," monumental architecture and "the power of industry and technology are linked by the aesthetics of the sublime." "Both," Whyte remarks, "offer images that overwhelm our perceptual and imaginative powers," thus serving as mythic symbols for the political and industrial might of the Third Reich.[48] The Nazis were not alone in mythologizing modern technology as a metaphor for national regeneration. As we shall see, Georges Valois, the leader of the French Faisceau (1925–1928), and Philippe Lamour, founder of the Parti Fasciste Révolutionnaire (1928), both wished to incorporate Le Corbusier's architectural plans into their vision of a fascist corporative order of industrial producers, modeled after Sorel's mythic constructs.[49]

This simultaneous relation with past and future also pertained to Italian fascism. Historian Emilio Gentile has concluded that in Italian fascist discourse and in Mussolini's personal identification with Emperor Augustus, the "cult of Romanness was reconciled, without notable contradiction, with other

elements of fascism, such as its activism, its cult of youth and sport, the heroic ideal of adventure, and above all the will to experience the new continuity in action projected towards the future, without reactionary nostalgia for an ideal past perfection to be restored."[50] One finds a striking example of this thinking in Mussolini's interwar renovations of Rome, which stripped venerable edifices such as the Colosseum and the Pantheon of all later architectural excrescences and removed surrounding buildings, so that these ancient structures could exist as monumental exemplars of the new Fascist Italy.[51] Mussolini drove home the regenerative theme in a 1925 speech, claiming that comparisons between Fascist Italy and "the first Augustan Empire" would only occur if the "great Oak" of Roman building were liberated "from everything which still smothers it." "Everything which has grown up in the centuries of decadence must be swept away," Mussolini concluded.[52] This palingenetic link between Fascist Italy and Imperial Rome had its most dramatic manifestation in the stark juxtaposition of the antique and the modern created in 1938, when the Fascists enclosed the newly restored Ara Pacis in a Bauhaus-inspired structure designed by Vittorio Ballio Morpurgo.[53]

The ramifications of such thinking for the study of modern art are cogently examined in Emily Braun's book on the former futurist and fascist ideologue, Mario Sironi (1885–1961).[54] Braun's monograph is something of a milestone in the study of fascist art and politics, not only because Sironi played a seminal role in the development of fascist aesthetics but also because of the theoretical sophistication she brings to her analysis of fascism's cultural politics. Braun frames Sironi's production in terms of Emilio Gentile's and Roger Griffin's concept of fascism, noting that the palingenetic nature of the myth allowed fascists to disavow "the modernity of enlightenment reason for another modernity of activism, instinct and irrationalism."[55] Since fascist politics were premised on myth making, artists had an important role to play in the development of myths capable of sustaining a revolutionary spirit once the Fascists gained power. The myth Sironi fabricated for the masses was built on the primacy of the Italian people. As Braun states, "it was the projection of a future destiny grounded in a remote past that defined the temporal dynamic and political modernism of fascism: the power of its myth lay precisely in an imaginary national essence of origins to be recovered and created anew."[56] Since Sironi associated naturalist verisimilitude and didactic imagery with

an appeal to reason and conscious reflection, he rejected such stylistic features, relying instead on pictorial fragmentation and disjunction, expressive brushstroke, and figural deformation to operate subliminally to inspire an emotional rather than a purely intellectual reaction to his art.[57] Such imagery was intended to evoke a spiritual transformation in viewers, leading them to draw comparisons between their own actions and the epic events portrayed in Sironi's canvases and murals. The work of art functioned thus as the catalyst for the internalization of fascism's regenerative values, and thanks to Braun's comprehensive study we can now fully appreciate Sironi's seminal role as Italian fascism's foremost myth maker in the visual arts.

In her analysis of Sironi's aesthetic, Braun first turns her attention to his urban landscapes of 1920–1921 to consider how his conflation of fascist ideals with the pictorial language of Giorgio de Chirico's "metaphysical" painting lent mythic import to his unsettling images.[58] Using pictorial techniques developed by de Chirico, Sironi shrouded the urban scene in silence and immobility, thus denuding it of the vibrancy and energy so evident in futurist images of the city. The stagelike appearance and monumentality of the humble buildings and dormant factories purposely echoed the compositional clarity of quattrocento painting in order to lend epic significance to the urban environment. The only objects animating these stilled images are the trams and trucks, which crisscross streets devoid of any other activity, whether industrial or pedestrian. Most important, the trucks lent historical specificity to Sironi's subject matter for, as Braun demonstrates, they are the Fiat 18 BL trucks employed by fascist squads, and the urban landscapes they patrol are the proletarian suburbs of Milan, where Sironi had taken up residence following World War I. Like the futurists, Sironi lauded the revolutionary potential of those proletarians who had rejected both communism and parliamentary socialism in favor of the punitive politics of the fascist *squadristi*, and his urban landscapes celebrated their activity during a period of social insurrection. Over the course of 1920, labor unrest in Milan had culminated in a series of strikes and factory occupations; the fascist squads had initially supported the strikes as harbingers of a fascist revolution, but they turned against the workers when the labor unions adopted Soviet-style tactics. Sironi considered those factions of the working class who endorsed the revolutionary, antibourgeois import of Mussolini's movement and attacked Bolshevism to be engaged in a heroic

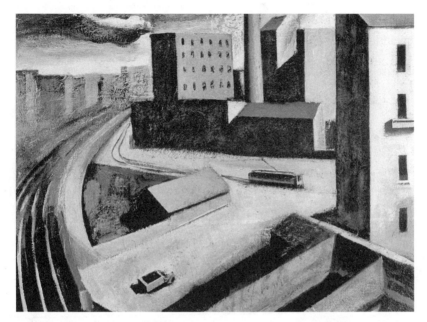

Fig. 3. Mario Sironi, *Urban Landscape*, 1920–1921. Oil on canvas, dimensions unknown. Private collection. © 2006 ARTISTS RIGHTS SOCIETY (ARS), NEW YORK/ADAGAP, PARIS/SIAE, ROME.

conflict. In this light the empty streets, uncanny perspectives, and stilled factories evoke the moment of general strike, while the fascist trucks are a portent of the impending violence needed to usher in a national revolution. As Braun states, "Sironi's urban landscapes betray that contradictory mix of proletarian sympathies and strident nationalism held uneasily together by their revolt against the values of parliamentary democracy."[59] Here, stylistic features of Quattrocento painting are combined with a contemporary event—the fascist insurrection in Milan—to render epic significance to this early moment in the history of fascism.

Literary historian Jeffrey Schnapp has underscored the mythic importance of the Fiat truck in a study of one of the first mass spectacles staged in Italy under Mussolini.[60] Titled the *18 BL*, this theatrical extravaganza took place on the bank of the Arno River in Florence in 1934. Twenty thousand spectators witnessed a series of "acts" involving two thousand amateur actors, an air squadron, ground troops, fifty 18 BL trucks, gun batteries, and ten radio stations. Composed of three parts, the theatrical presentation opened with an evocation of the cataclysm of World War I, then turned to the heroic struggle

of the "fascist revolution" before culminating in the fascists' productivist re-building of the nation. As Hal Foster notes in his introduction to Schnapp's book, the performance's tripartite format enacted a narrative of "trial and tri-umph, death and resurrection." The truck's role as principal protagonist in both the revolutionary violence and its productivist aftermath confirmed its mythic significance in this overtly palingenetic narrative.[61] Sironi's pioneering images of over a decade earlier thus set the stage for a mass reenactment of the heroic struggles associated with the Milanese insurrection. Art, in short, was an agent for social transformation, a form of mythic activism marshaled by fascists to retool consciousness and society. Through its recourse to myth, fas-cism could address both the past and the future in its ideology. Implicit in the myth is the judgment of a decadent present in need of regenerative cultural renewal.

Avant-Gardism

The concept of palingenesis is particularly germane to the study of the fas-cist debt to avant-garde aesthetics, as Matthew Affron and I have shown in our review of critical reassessments of Walter Benjamin's analysis of the cul-tural politics of fascism, as expounded in his influential essay "The Work of Art in the Age of Mechanical Reproduction" (1936).[62] In this essay the Marx-ist Benjamin claims that the fascists championed the retrograde aesthetics of "art for art's sake," and contrasts that aestheticist model with the emancipa-tory role signaled by new aesthetic forms such as cinema and montage. In Benjamin's theory, the montage aesthetic forms alone were adapted to the collective consciousness of the emerging proletariat; as a result montage and cinema were divorced from the auratic properties of older art forms, whose organic completeness, Benjamin argued, was designed for passive contempla-tion. By cloaking politics in auratic rituals and aestheticized rhetoric, fascism sought to impose passivity on the working class and simultaneously uphold the bourgeois order threatened by the class-based politics of this newly cre-ated urban proletariat.[63] Aesthetic notions of an unchanging, organic unity, whose self-referential value transcends the historical circumstances from which it emerged, were transferred to the political realm to justify fascism. Thus, in Benjamin's view, fascism seeks to overcome the sociopolitical dissen-sion caused by capitalism by imposing an aestheticized ideology on the frag-mented and pluralistic flux of contemporary society.

Part and parcel of this transferral is a denial of historical change, and the replacement of the ever-changing, dynamic condition of human history with a closed, unified, and static model of organic completion, wherein existing socioeconomic hierarchies would become ossified and forever fixed. To quote Russell Berman, Benjamin regards "the closed order of the organic work of art" as "a deception that imposes an enervated passivity on the bourgeois recipient"; in contrast, Benjamin valorizes "fragmentary, open genres: the German Trauerspiel of the baroque as well as the avant-gardist valorization of montage," whose negation of aesthetic closure precludes any passive response on the part of what is invariably a collective audience.[64] "In place of the auratic art work, with its isolated and pacified recipient lost in contemplation," asserts Berman, "Benjamin proposes a postauratic model that would convene a collective recipient (the 'masses') endowed with an active and critical character."[65] As the carrier of new cultural forms and new modes of aesthetic reception, the proletariat is the class best adapted to the new collectivist economy; the bourgeoisie and its fascist apologists, on the other hand, marshal the auratic aesthetic of an earlier era to defend the outmoded politics of private ownership. To Benjamin's mind, this model is confirmed by Italian fascism's relation to futurism; having quoted extensively from a futurist text extolling the beauty of the war in Ethiopia, Benjamin correlates the aestheticism of l'art pour l'art with Marinetti's futurist defense of fascist violence.[66] Thus, the battle between fascism and communism has an aesthetic correlate in the closed order of organic form and the fragmentary dynamism of collage, and only the latter is attuned to the socio-economics of the twentieth century. Benjamin valorizes those art movements—Dada and surrealism—that consciously attack bourgeois notions of artistic autonomy, while aligning futurism with the aestheticized discourse of the latter.

Benjamin's analysis inspired contemporary historians to explore the implications of his model for an analysis of literary texts written by fascism's apologists.[67] It also provoked scholars to counter that the aestheticization of politics can serve a variety of political positions[68] and to question Benjamin's restriction of fascist aestheticization to nostalgic models of organic unity and completion. In this regard fascism's relation to futurism has undergone extensive revision, for a number of historians have argued that futurist aesthetics utilized the very fragmentary, dynamic, and collage-based aesthetic that Benjamin would associate with antifascism and proletarian emancipation.[69]

Literary historian Andrew Hewitt claims that Benjamin's relation of fascism's politics to "falsified principles of harmony, organic totality, and unity," serving to mask a society typified by class conflict and social fragmentation, cannot explain the fascist acceptance of futurism, because that movement trumpeted the very conflict fascism supposedly sought to cover up.[70] Turning Benjamin's construct on its head, Hewitt argues that futurist proponents of fascism thought contemporary society to be in a condition of ossification, organic closure, and stasis, and thus in need of rejuvenation through violence. By calling for "the ontologization of struggle as both an aesthetic and a political principle,"[71] the futurists wished to reinvigorate a culture subsumed in the very organicist metaphors Benjamin would identify with the fascist project. Instead of following Benjamin in stressing the occultation and aesthetic resolution of class struggle under fascism, Hewitt refers us to fascism's "generation of depotentialized areas of struggle within the aesthetic," that is, the transference of the dynamism of class conflict to a realm of avant-gardism.[72]

Hewitt's critique of those who, like Benjamin, would relate fascist aesthetics and futurism to "the classical aesthetic of harmonization" and "the false reconciliation of social conflict"[73] finds an echo in Emily Braun's assessment of the use of photomontage, typography, and what the fascists termed "photomosaic" in the didactic installations for the 1932 Mostra della Rivoluzione Fascista (Exhibition of the Fascist Revolution) in Rome.[74] Designed by such artists as Sironi, Esodo Pratelli, Giuseppi Terragni, and Arnaldo Carpanetti, the cacophonous montage elements had a clear precedent in the Soviet installations of El Lissitzky and those of the German Dadaists, yet as part of an exhibition recapitulating the Italian Fascists' historical rise to power, montage served ends antithetical to those eulogized by Benjamin. Braun concludes that the medium of montage "simultaneously overstimulated and distracted the senses" so that both images and didactic texts could operate at the level of "subliminal suggestion."[75] Braun argues that montage in fascist hands, rather than serving the emancipatory ends envisioned by Benjamin, served to stifle the critical capacities of the spectator, and that the use of such techniques in the Mostra ultimately "did not alter the one-way direction of communication." By incorporating montage into the politics of the spectacle, this exhibition underscored "the potentially totalitarian powers of the media."[76] As we shall see, it also subsumed auratic and avant-garde aesthetic forms within

Fig. 4. Esoda Pratelli, with Luigi Freddi, Room A, "From the Beginning of World War I (July–August 1914) to the Founding of Il Popolo d'Italia and the Creation of the Fasci d'Azione Rivoluzionaria (December 1914)," Exhibition of the Fascist Revolution. Reproduced in Dino Alfieri and Luigi Freddi, eds., *Mostra della rivoluzione fascista, guida storica* (Rome: Partito Nazionale Fascista, 1933).

the parameters of a mythological narrative that charted fascism's redemptive impact on Italian society.

Secular Religion

Recourse to regenerative myths had its roots in the attempt, in both Nazi Germany and Fascist Italy, to create a form of mass politics based on ritual and public pageantry meant to foster a spiritual unity supposedly unattainable under parliamentary systems of governance. Emilio Gentile, concurring with George Mosse, has described this new politics as a form of "secular religion," wherein fascist regimes "adapted religious rituals to political ends, elaborating their own system of beliefs, myths, rites, and symbols" with the aim "not only to govern human beings but to regenerate them in order to create a new humanity."[77] Gentile, in his publications on Fascist Italy, and George Mosse, in his pioneering work on Nazi Germany, have both traced the origins of fascist symbology to the perceived crisis of national values following the French Revolution and Italian Risorgimento.[78] As Mosse notes, what we call "the fas-

cist style was in reality the climax of a new politics based on the emerging eighteenth-century idea of popular sovereignty."[79] Key to this transition was Jean-Jacques Rousseau's idea of the "general will," which held that citizenship is born out of moments of mass assemblage wherein individuals act in consort. During the French Revolution the general will "became a secular religion, the people worshiping themselves, and the new politics sought to guide and formalize this worship" through public forms of self-veneration. Not surprisingly, allegiance to the revolution became a matter of faith; the "cult of reason" was imposed to replace Catholic worship, and, as Mosse contends, "this cult of reason abandoned rationalism; it tended to substitute the Goddess of Reason for the Virgin Mary and infuse its cults with hymns, prayers, and response modeled on Christian liturgy."[80] In effect, the French Revolution had two offspring: democratic institutions premised on Enlightenment precepts, and the irrationalism of mass politics. "The new politics," Mosse concludes, "was, from the beginning, part of the anti-parliamentary movement in Europe, advocating a secular religion as the political cement of the nation."[81]

This alternative response to the French Revolution proved inspirational to German nationalists throughout the period before the Nazis' rise to power in 1933. Mosse has documented the development of mass rituals and the creation of national monuments designed to foster German unity by commemorating the "wars of liberation" against Napoleon (1813–1814) and other significant events expressive of German military might.[82] Through comparative analyses Mosse reveals the profound debt owed by architects such as Albert Speer, and Hitler himself, to past architects who had envisioned the construction of national shrines as sacred spaces and sites of "public worship"—whether in the form of monuments to Frederick the Great or memorials to military victory, such as the Tannenberg Memorial (completed in 1927). The latter shrine—dedicated to General Paul von Hindenburg's defeat of Russia in the First World War—had a special appeal to the Nazis, since it could accommodate 100,000 people in public festivals. Mosse rightly compares the function of the Tannenberg Memorial to the use of space at the Nazis' Nuremberg party rallies, where the architecture also served as a theatrical framework for the participants.[83] Party rallies in turn took on all the trappings of religious ceremonies. "The Introitus, the hymn sung or spoken at the beginning of the church service, became the words of the Führer; the 'Credo' a confession of faith pledging

loyalty to Nazi ideology; while the sacrifice of the Mass was transformed into a memorial for the martyrs of the movement."[84]

Secular religion was also a motivating concept during the Italian Risorgimento, and it served as the basis for subsequent critiques of Italy's unification after 1861. Gentile, in his groundbreaking study *The Sacralization of Politics in Fascist Italy* charted the seminal role of Giuseppe Mazzini in propagating the myth of national regeneration through the creation of a spiritual unity, a discourse that would be appropriated by subsequent nationalists, including avant-gardists and the major players in the fascist movement.[85] Although Italy lacked the national monuments that served as nodal points for secular religion in Germany, nationalists like Mazzini were quick to point to Italy's Catholic heritage as the basis on which to build a secular religion. As Gentile notes, "Mazzini envisioned an Italy regenerated and united through a political revolution based on faith in freedom and on the religion of the fatherland"; the fascists in turn appropriated his notion of secular religion while jettisoning Mazzini's republican ideals.[86] Mazzini thought Italy's unity could be fostered only through "a collective palingenetic experience," by undergoing a process of "struggle, sacrifice, and martyrdom" comparable to a religious transformation.[87] After 1861, Mazzini argued that while Italy was unified politically, the national revolution remained incomplete because no form of secular religion had developed as a result of the Risorgimento. In the period leading up to World War I nationalists repeatedly claimed allegiance to Mazzini while decrying the decadence of the Italian political system and calling for the spiritual rejuvenation of the body politic.

Fascists thought World War I had such mythic significance, for in their view citizens who had fought in the trenches had undergone a moral transformation as a result of their heroic defense of the nation. Mussolini and his followers then drew a dramatic contrast between these valiant soldiers and the corrupt politicians who had retained power throughout the conflict.[88] In Italy and France fascists such as Mussolini and Georges Valois followed Sorel in condemning the Enlightenment precepts underpinning the parliamentary system as antithetical to the spiritual and collective values they wished to instill.[89] Fascists throughout Europe therefore claimed to embody the heroic militancy of the wartime combatant, attracted war veterans to their ranks, and nurtured this revolution of the spirit in the interwar period by bestowing

mythic status on both fallen soldiers who had made the "supreme sacrifice" and those fascists who had been "martyrs" during the fascist struggle to gain power.

Scholars concur with Gentile when he concludes that the "new politics" advocated by fascists was indebted to wartime propaganda, because the cult of the fallen soldier was an essential ingredient in fascism's own secular religion.[90] In 1919 Mussolini drew together nationalists, futurists, and war veterans to form the Fasci di Combattimento; in 1921 the Fascists' main organ *Il fascio* underscored the palingenetic dimension of the war experience by proclaiming "the Holy Communion of war has molded us all with the same mettle of generous sacrifice."[91] After the Fascists rose to power in 1922, the punitive battles of Fascist *squadristi* against urban workers and Socialists during the so-called Red Biennium (1919–1920), and related struggles in the countryside, took on a mythic dimension as another manifestation of the zealous heroism forged during the war effort. During their incursions into Socialist-dominated areas, Fascist squads engaged in acts of symbolic iconoclasm, destroying red flags and other socialist and communist symbols and imposing public respect for the national flag and acquiescence to Fascist insignia.[92] In 1926 the future deputy secretary of the Partito Nazionale Fascista, Salvatore Gatto, even compared "the heroes of the Fascist revolution" to "Christian Martyrs," whose wholly spiritual motivations were divorced from "earthly" concerns.[93] Such findings affirm Griffin's contention that adherence to fascism was widely regarded as a form of spiritual redemption. The Fascist rank and file conceived of themselves not as servile followers of a totalitarian leader but as converts to a cause who had undergone a spiritual and palingenetic transformation.

Formalized admission to the Italian Partito Nazionale Fascista—the *leva fascista* instituted in 1927—bore all the trapping of a Catholic religious rite; as Gentile documents, the initiation ceremony imitated an act of confirmation, wherein members of Fascist youth organizations became "consecrated Fascists" by officially joining the party. This confirmation ritual was carried out in public squares throughout Italy, with Mussolini himself presiding over the ceremony in Rome.[94] Even the local public headquarters of the Fascist Party, the Case del Fascio, were referred to as "churches of our faith" or "altars of the Fatherland's religion," and during the 1930s the party specified that each casa should have a "lictorial tower" equipped with bells that would ring dur-

ing every party ceremony.[95] The "call to worship" signaled by the Fascist clarion was in direct imitation of the function of churches in local communities. These buildings were also places of veneration for the cult of Fascist martyrs, once again underscoring the primacy given to heroic violence as a galvanizing myth in the fascist lexicon. In analyses of the liturgical elements of Giuseppi Terragni's Casa del Fascio at Como (1933–1936), built in the rationalist style, both Gentile and architectural historian Richard Etlin have noted Terragni's "quasi-mystical" use of glass: glass not only allowed Terragni to integrate the building with the surrounding environment; it also served as a metaphoric reference to Mussolini's declaration that fascism be "a house of glass" open to all.[96] Terragni's *casa di vetro*, states Gentile, gave the public "an immediate sense of the full integration of the Party into the lives of the people and of the direct communication between the masses and their leaders."[97] Etlin in turn has noted the primacy Terragni accorded to the casa's Sacrario (sacrarium), dedicated to the "Fallen for the Revolution":

> To Terragni, the Sacrario was designed to convey "the spiritual elements that constitute the basis of the entire Fascist Mysticism." The ceiling of the entrance foyer was covered with black marble to "prepare the visitor for a religious attention to the Sacrario," which was formed as an "open cella" created by three monolithic walls of red granite. Terragni explained that the slabs of red granite defining the space of the Sacrario ... would suggest "primitive religious or royal constructions of ancient Mycenae or Egypt."[98]

The mythic function of fascist martyrdom also formed the centerpiece of the Exhibition of the Fascist Revolution, which opened in Rome on 28 October 1932 (the tenth anniversary of the Fascist rise to power) and closed two years later. Numerous scholars have analyzed the dual function of the exhibition as a presentation of the history of fascism and as a votive shrine for national worship.[99] Designed by modernist architects and painters, including Giuseppi Terragni and former futurist Mario Sironi, the exhibit was housed in a series of fifteen rooms in the converted Palazzo delle Esposizioni in Rome. Emily Braun, in her study of Sironi, notes that the exhibition amounted to a rite of passage wherein the public was immersed, through "ritual reenactment and engulfing spectacle," in the history of Mussolini's movement before

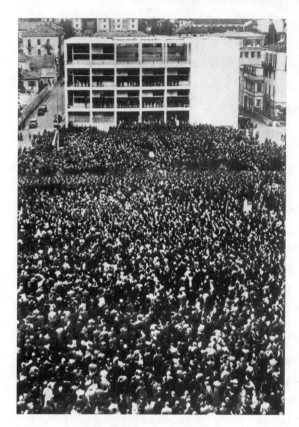

Fig. 5. Giuseppi Terragni, Casa del Fascio, Como, 5 May 1936. Reproduced in *Quadrante*, no. 35/36 (October 1936).

confronting installations "devoted to the cult and apotheosis of a triumphant Fascism."[100] The rectangular shape of the early rooms (recounting fascism's birth from the cataclysm of World War I) was masked behind an unpredictable progression of asymmetrical spaces that made use of collage elements, irregular proportions, and strong diagonals to evoke a sense of dynamism as well as sensations of dislocation, rupture, and shock (fig. 4). Braun has astutely labeled this stylistic feature a mode of "modernist defamiliarization" indebted to the collage techniques of the Soviet artist El Lissitzky.[101] Having passed through the exhibition's historical section, visitors were then confronted with a central series of rooms dedicated to the Fascists' "glorious" activities between 1919 and 1922 (designed by Sironi), and to Mussolini's role as Il Duce before entering a cylindrical crypt: the "Sacrarium of the Martyrs" of the Fascist revolution, created by rationalist architects Adalberto Libera and Antonio Valente. Bathed in a red light and dominated by a huge cross, centrally placed, to com-

Fig. 6. Adalberto Libera and Antonio Valente, Room U, "The Sacrarium of the Martyrs," Exhibition of the Fascist Revolution. Reproduced in Dino Alfieri and Luigi Freddi, eds., *Mostra della rivoluzione fascista, guida storica* (Rome: Partito Nazionale Fascista, 1933).

memorate the fallen, the space echoed with the recorded disembodied voices of Fascists uttering the word "Presente!," a declarative phrase emblazoned on the surrounding walls. The metallic cross bore the inscription "For the Fatherland," and the surrounding walls were lined with the pennants of the action squads that had engaged in the heroic struggle. Such symbolism had a real-life counterpart in early funerals for members of the Fascist squads; during their burial rites Fascists would reaffirm their comrades' immortality by responding "Presente!" when the names of the dead were read aloud. The use of the Latin term *sacrarium* to describe this sanctified space served to connect fascism's martyrs with what Romke Visser calls the fascist doctrine of "the cult of the Romanità,"[102] thereby conflating ritual symbols from Roman antiquity and Christendom.[103] As literary historian Jeffrey Schnapp concludes, the transition from the spatial dynamism of the earlier rooms to the auratic stasis of the sacrarium effectively "transformed the narrative of fascism's triumph

[into] an allegory in which the emotions of awe and terror associated with the revolutionary violence of fascism-as-movement are transmuted into feelings of order and solemn elation associated with fascism-as-regime."[104] Moreover, the extension of this civic religion in the realm of public life was underscored in the exhibition's opening and closing ceremonies, which involved the public in a full gamut of rites related to the exhibition's votive function.[105] Once again the visual syntax of modern art and that of past eras were combined within the ideological framework of mythic activism.

Primitivism

The Fascists' new politics had its roots not only in state-sanctioned cults and religious institutions but also in the cultural politics of avant-garde primitivism. Historian Walter Adamson was among the first to probe this issue in his examination of notions of secular religion propagated by such major Italian modernists as the writers Giuseppi Prezzolini and Giovanni Papini and the artist-critic Ardengo Soffici.[106] Writing in the journals *Leonardo* (1903–1907), *La voce* (1908–1916), and the futurist-oriented *Lacerba* (1913–1915), they combined antirepublican politics and admiration for Georges Sorel with calls for spiritual renewal in a manner that appealed to Mussolini, who contributed to *La voce* and later praised the journal's effort to create "spiritual unity" among Italians. "Like new-politics movements," writes Adamson, "cultural avant-gardes in the European pre-war period grew out of a perceived need for a spiritual renewal in modern culture that would involve the masses in society's political rituals."[107] In the case of the *La voce* group their quest for national regeneration led "in volkish directions as well as more cosmopolitan or 'high cultural' ones." Ardengo Soffici exemplified such thinking, and, as Adamson demonstrates, Soffici's prewar cultural politics anticipated views he held following his conversion to fascism in the early 1920s.

Soffici's synthesis of nationalism, modernism, and "völkish" regionalism before 1914 led him to celebrate the idea of *toscanità*, or "Tuscanness," as a sign of his own spiritual regeneration.[108] According to Soffici, the religiosity of Tuscan peasants, combined with deep love of the land, constituted a "folk essence" antithetical to the perceived materialism and corrupt values held by Italy's leading parliamentarians such as Giovanni Giolitti. Rooted in the land and attuned to nature's seasonal cycles, modern-day peasants symbolized all

that was enduring in Italian culture. In the realm of visual representation, Soffici signaled this continuity between past and present in terms of pictorial form and content. He rejected single-vanishing-point perspective as overly scientific, claiming that the perspectival and proportional distortions in his Tuscan landscapes and genre scenes expressed an emotive response to the humble subjects and an avant-gardist endorsement of philosopher Henri Bergson's concept of intuition.[109] Melding his politicized regionalism with modernist aesthetics, Soffici compared his decision to leave Paris for Tuscany in 1907 to Paul Cézanne's own regionalist retreat from Paris to his native Aix-en-Provence; appropriately, Soffici used Cézanne's pictorial techniques in his depictions of the local peasantry, and Fiesole's Monte Ceceri became Soffici's Mont Ste. Victoire.[110] Soffici's avant-garde style also had an Italian genealogy: he drew comparisons between Cézanne's spatial distortions and those of the Trecento "primitive" Giotto—both artists, wrote Soffici, rejected "scientific" perspective for plastic forms based on "spiritual" and emotive values. Indebted to both Giotto and Cézanne, Soffici situated his regionalist aesthetic in terms of palingenesis; circumnavigating the "decadence" of state-sanctioned academic art, Soffici simultaneously adopted Italian primitivism and French modernism in the name of those antimaterialist and spiritual values he associated with national regeneration. Following his conversion to fascism, Soffici applied this paradigm to the movement's cultural politics. In a November 1922 article titled "Religiosity and Art" published in Mussolini's *Il popolo d'Italia*, Soffici praised fascist rites and ceremonies for their ability to nurture spiritual unity among the masses and in the fascist journal *Gerarchia* he proclaimed fascism to be "neither reactionary nor revolutionary, since it unifies the experience of the past and the promise of the future."[111]

This politicized regionalism reached full fruition in the interwar period, when Soffici joined forces with such artists as Carlo Carrà and Giorgio Morandi in supporting a fascist cultural movement known as Strapaese (Supercountry), whose artistic and political trajectory has been analyzed by Adamson and Braun. Centered in the regions of Tuscany and Emilia-Romagna, the movement's proponents self-consciously allied themselves to the "revolutionary" phase of fascism (1919–1922), when the Fascist squads brought their punitive campaign to rural Italy, thus facilitating Mussolini's rise to power in 1922.[112] On the other hand, Strapaese's adherents rejected the fascist myth of

romanità intended to further Mussolini's centralization of power in Rome and the concomitant undermining of regional identity, both cultural and political. Likewise they condemned the futurist cult of the machine, rationalist architecture, and the internationalist aesthetics of the Novecento, considering these Stracittà (Supercity) movements seeking to impose foreign culture, decadent cosmopolitanism, and bourgeois values on the indigenous, "authentic" culture of rural Italy. Artists affiliated with the Strapaese identified the essence of fascism with the unsophisticated, rustic life of the peasantry; moreover, like Soffici, they looked to Cézanne's regionalist aesthetic as a model for their own interwar "return to the soil." Like other palingenetic movements Strapaese did not condemn modernism and modernity outright but, as Braun argues, wished to reconcile aspects of modern technology and avant-gardism with adherence to tradition.[113] In this manner Strapaese's allies hoped to maintain regional difference as a bulwark against the homogenizing effects of state-sanctioned centralization and mass culture on the tenacious independence of the rural populace.

This form of fascist populism was propagated in two major journals—*Il Selvaggio* (1924–1943), or *The Primitive*, founded by the critic, caricaturist, and former squad member Mino Maccari, and the Bolognese journal *L'Italiano* (1926–1942), *The Italian*, created by writer Leo Longanesi. Braun, in her exemplary study of Morandi's role in the movement, notes that the artist's still-life images of lowly handmade objects, painted in earthen colors or painstakingly inscribed in intaglio, were celebrated as expressions of Strapaese's fascist primitivism.[114] The humbleness of the depicted pitchers, bowls, and lamps underscored the primacy of their use value as opposed to the ostentatious frivolity of bourgeois display with its emphasis on exchange value. Additionally *Il Selvaggio*'s critics associated Morandi's rose and ocher palette with the muted coloration and dusty light found in Italian hillside villages and lauded his frequent recourse to etching as a venerable technique steeped in the Italian tradition. Soffici in turn fulfilled similar ideals by using fresco technique in his depictions of contemporary peasants engaged in time-honoured agrarian tasks and religious rituals to highlight the continuity and cyclical nature of a rural life attuned to nature's seasons and Catholic dogma.[115] For Maccari and his colleagues such imagery and artistic methods demonstrated Morandi's and Soffici's status as fascist "primitives," whose art synthesized the endur-

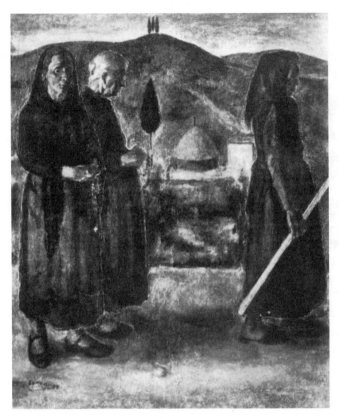

Fig. 7. Ardengo Soffici, *Procession*, 1933. Fresco on wood panel, 153 × 172 cm.
Galleria d'Arte Moderna, Palazzo Pitti, Florence.

ing values of a rural folk culture with the modernism of Cézanne and the
artistic heritage of the Trecento. In this manner, writes Braun, "Italy would be
renewed from the bottom up, so to speak, from the vital roots of the earthy
peasantry, or *Italia barbara*."[116]

The Italian fascists' primitivist synthesis of "traditionalist" and "modern-
ist" artistic forms had a French complement in the cultural politics of the
well-known art critic Waldemar George, whose conversion to fascism in the
early 1930s led to his dramatic rejection of machine aesthetics in favor of his
doctrine of "Neo-Humanism." As Matthew Affron has demonstrated, George
championed those artists who depicted contemporary agrarian subject matter
using venerable painterly techniques culled from the Franco-Italian tradition.
George was particularly enamored of a group of landscape painters known as

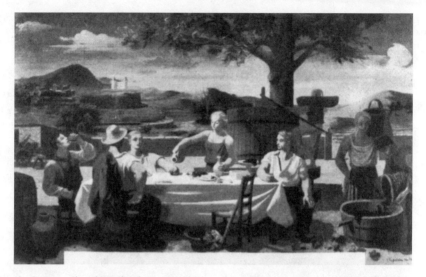

Fig. 8. Roger Chapelin-Midy, *The Grape Harvest*, 1938.Reproduced in *La renaissance* (April 1938), Institut National Agronomique Paris-Grignon. © 2006 ARTISTS RIGHTS SOCIETY (ARS), NEW YORK/ ADAGAP, PARIS.

"les Peintres de la Réalité en France poétique," describing the French peasants portrayed in Roger Chapelin-Midy's *The Grape Harvest* of 1938 as modeled after those painted by Nicholas Poussin and celebrated by the classical poets. Art historian Romy Golan in turn has charted the prevalence of such thinking in interwar France, noting that George was joined by other conservative critics who frequently associated the landscape painting of the former fauves with the cultural politics of ultranationalists such as the monarchist Maurras, who regarded rustic regionalism and exaltation of France's "Greco-Latin" roots, as "synonymous with anti-republicanism, anti-parliamentarianism, and anti-urbanism."[117]

While fascist avant-gardists in France and Italy treated the European peasantry and their rural setting as mythic ciphers for primitivist aesthetics, their colleagues in Germany wrestled with a more problematic relation to primitivism, primarily due to the debate over what constituted a regenerative form of art. For Hitler and his followers, the term "primitive" had positive and negative valences depending on its racial import. Nazis argued that the essence of the German folk resided in an Aryan genealogy with roots in classical art and culture and that of the Gothic and Renaissance eras. Historians have noted Hitler's and Nazi ideologue Alfred Rosenberg's literal association of Greek

sculpture with their own eugenic program to create a fascist "new man," untainted by the degenerative effects of racial "mixing."[118] As a result they circumscribed their notion of regenerative primitivism within the geopolitical boundaries of Europe and subsumed German society in the "organicist" politics of corporativism and racial collectivism.

Proponents of this geopolitical and racial paradigm could not countenance forms of primitivism that appropriated the art of non-European cultures as sources for European regeneration.[119] Russell Berman has touched on this very issue in his analysis of the complex relation of Emil Nolde's primitivist expressionism to the primitivism of Nazis such as Rosenberg.[120] Noting Nolde's association of the Nazi contempt for Enlightenment precepts with his own rejection of what he regarded as "bourgeois" culture and the "enervating" aesthetics of academic painting and French impressionism, Berman explicates the conflict that arose in Nazi circles over Nolde's turn to African and Oceanic sculpture as a regenerative source for his expressionist art. Unlike his Italian counterparts, Nolde looked to the art of non-Europeans as repositories for an authentic mysticism and vitalism that had been lost in industrial Europe. To resuscitate this aspect of experience he looked for correspondences between the stylistic features of African and Oceanic art and his own elemental expressionism, aligning both with the mystical and antirationalist revolt against liberalism that were the basis of his own attachment to National Socialism. As Berman notes, "primitivism here ceases to be inimical to European identity and instead turns out to be congruent with the German nationalist rejection of the Impressionist canon, and the Nietzschean call for a new barbarism."[121] Ultimately, however, as the Nazis' concept of primitivism was grounded in the regenerative potential of eugenics, Nolde's correlation of his own primitivist self-fashioning with non-European art was anathema to such ideologues as Rosenberg. This paradigm accounts for Rosenberg's mixed assessment of Nolde's painting in the July 7, 1933 issue of *Völkischer Beobachter*. While acknowledging that Nolde's expressionist depictions of the German north were "strong and weighty" he quickly dismissed his figural work as "negroid, impious, raw, and lacking in genuine inner power."[122] Although Nolde himself would identify both genres as indicative of his primitivism, the inclusion of stylistic features derived from Oceanic art in his portraiture met with Rosenberg's condemnation as evidence of artistic miscegenation. In Nolde's

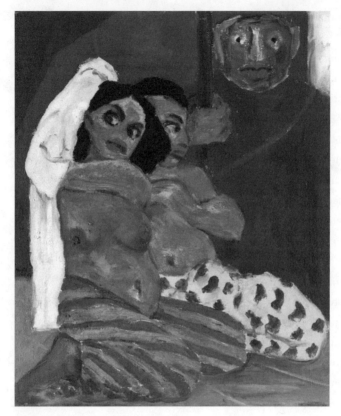

Fig. 9. Emil Nolde, *Nudes and Eunuch*, 1912. Oil on canvas, 34 ³/₈ × 28 ³/₈ in. Bloomington, Indiana University Art Museum: Jane and Roger Wolcott Memorial, Gift of Thomas T. Solley.

estimation, cultures foreign to Europe provided the Enlightenment's adversaries with an aesthetic language conducive to their own regenerative aims; for Rosenberg and Hitler, the stark contrast between the art of ancient Greece and that of "negroid" cultures constituted an absolute division between regenerative primitivism and a degenerative, atavistic "other" to be eradicated.

Fascist Space and Time

Fascist aesthetics has broader implications for our understanding of modernism when cast in terms of the dichotomy between regenerative and capitalist approaches to space and time.[123] The geographer David Harvey, for instance, has related modernist and fascist spatial-temporal configurations to resistance to the pervasive rationalization of time under capitalism and the sub-

sequent breakdown of older cultural patterns as the capitalist system of time became universalized.[124] According to Harvey the eighteenth-century clocks and bells that came to regulate the labor of workers and merchants separated the populace from the natural rhythms of agrarian life, as well as those of the Christian calendar.[125] By the twentieth century this "chronological net" had expanded to encompass the whole globe, and the spatial and temporal bases for the creation of a worldwide capitalist order were set. Space and time were now socially constructed as quantifiable commodities to be bought and sold. As social structures they were wholly absorbed into the homogenizing powers of money and commodity exchange.[126] Both subjective, "felt" experiences of time and our historical identification with a particular locale were rendered irrelevant under the cultural logic of capitalism.

Since space and time had a quantifiable and normative value, each parcel of land was like any other, and each measured hour was interchangeable with the next. The realm of industrial production became subject to similar quantification when a fin-de-siècle system of factory organization known as Taylorism became widely disseminated in Europe and the United States. Named after the American efficiency expert Frederick Winslow Taylor (1856–1915), Taylorism maximized the ratio of output to input by devising wage scales based on piecework. Proponents of scientific management not only fragmented the production process into a separate series of repetitive tasks; they also analyzed worker movements by means of chronophotography, thereby measuring the speed of human labor against the stopwatch in order to eliminate all "extraneous" movements in the name of labor "efficiency." As Marxist Georg Lukács cogently observed, this fragmentation of production destroyed "the organic manufacture of whole objects," and at the same time the "subjects of labour" were likewise "rationally fragmented." In effect, modern industrialism simultaneously declared "war on the organic manufacturer of whole products" and robbed workers of their own "qualitative" craft skills by reducing their labor to simple repetitive tasks and preventing them from producing a wholly finished object.[127] Laborers themselves became interchangeable and their labor-time quantified and measured according to the homogenizing dictates of capitalist production. The infiltration of capitalist rationalization to every corner of the globe created an awareness of the uniformity and internationalism implicit in capitalist processes of standardization. Thus, in the early 1920s, modern-

ists such as Le Corbusier saw industrialization and Taylorist techniques as a means of liberating human society from the parochialism of local culture.[128]

As Harvey notes, the shared conception of standardized time and space promoted by capitalism also precipitated a countermovement on the part of those modernists who wished to maintain a sense of local difference.[129] "By enhancing links between place and social identity," states Harvey, "this facet of modernism was bound, to some degree, to entail the aestheticization of local, regional or national politics."[130] Since the standardization of time and space "implied a loss of identity with place" or "any sense of historical continuity," architects such as Louis Sullivan in Chicago "searched for new and local vernacular structures that could satisfy the new functional needs but also celebrate the distinctive qualities of the place they occupied."[131] The Taylorist quantification of time in the service of mass production was countered by organic modes of manufacture, exemplified by the proliferation of arts and crafts movements throughout Europe and America.[132] By the 1930s even Le Corbusier had abandoned the internationalism of his Taylorist vision in favor of the corporativist and regionalist theories found in the syndicalist journals *Plans* (1931–1932) and *Préludes* (1933–1935).[133] As a result Le Corbusier developed "site-specific" modes of architecture, as exemplified in his use of rusticated Provençal stone for the construction of the Villa de Mandrot (1929–1932) on the Mediterranean coast.[134]

This geographic model gained rhetorical power with the emergence of fascism, where it played an important role in the development of aesthetic doctrines based on regional and ethnic difference, and in the subsuming of technocratic forms of industrial organization under the umbrella of organicist social and temporal orders. Soffici's and *Il Selvaggio's* primitivizing notion of toscanità, Mussolini's cult of romanità, and the Nazis' Eurocentric racial aesthetics all constitute examples of resistance to the leveling effects of capitalism. The fascists' concomitant assimilation of technocratic industrialism under the rubric of corporativism or productivist ethics in turn underscored the "qualitative" and "spiritual" aspect of this new spatial-temporal order. In the latter process an underlying tension arose as proponents of fascism sought to contain technocratic methods and industrial class relations within the framework of corporative, regional, and racial forms of social organization. In France, Italy, and Germany, fascists developed corporative theories in

an attempt to establish "organic" and thus "natural" relations between workers and their industrial overseers.

In Germany the Bureau of the Beauty of Labor proclaimed corporativism a means of emulating the supposed class harmony and organic unity of medieval society, even while it promoted mass-production methods in the workplace. In Nazi propaganda, the rationalization of the labor process was thereby "organicized" as an aesthetic metaphor for the unified discipline and productivist ethics of workers within the corporative structure.[135] In France, Georges Valois hoped to alleviate class conflict by emulating Mussolini's corporativism. Valois therefore wanted to organize industry according to trade and regional identity, claiming that this corporate structure united workers and employers in their common cause as ethical "producers." Thus, industrial methods—including Taylorism—were to be delimited within the organic structure of the corporative system to protect French society against the homogenizing forces of industrial capitalism.[136] As Diane Ghirardo and Richard Etlin have demonstrated, Italy's rationalists achieved a similar conflation of technocracy and organic regionalism by merging Le Corbusier's theories with their own allegiance to Italian fascism's nationalist, regionalist, and corporativist agenda.[137] Etlin convincingly relates the façade of Terragni's Casa del Fascio to the open loggia of rural farmhouses in Italy, noting that rationalist critics cited such agrarian loggias as historical confirmation of Le Corbusier's theories concerning the selective evolution of an architectural type, as detailed in *Vers une architecture* (1923).[138] Concurrently Ghirardo observes the rationalists' assimilation of Le Corbusier's authoritarian pronouncements in *Vers une architecture* to the fascist imposition of a corporative hierarchy (*gerarchia*) on Italian society, while Etlin has charted the rationalists' relation of Le Corbusier's classical aesthetic to the fascist doctrine of *mediterraneità*.[139] By arguing that Le Corbusier was a modernist wedded to Mediterranean culture, the rationalists effectively countered claims that they favored internationalism over an indigenous Italian tradition, reflective of a Latin and imperial past. In this manner these architects could take their place alongside fascist advocates of rural regionalism and romanità in supporting an ideology that laid claim to the cultural legacy of imperial Rome as a spring-board to colonial conquest in Africa.

This historical and spatial resistance to capitalism was augmented by the

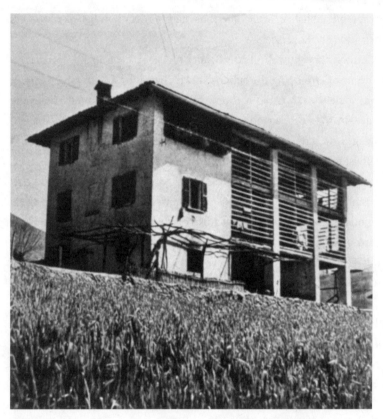

Fig. 10. Farmhouse with loggia, near Gandino, Val Seriana. Reproduced in Giuseppi Pagano and Guarniero Daniel, *Architettura rurale italiana*, Quaderni della Triennale (Milan: Ultrico Hoepli, 1936)

fascist advocacy of qualitative as opposed to quantitative notions of time. Fascists condemned the "clock time" of capitalism, claiming that it emptied temporality of meaning and thereby denied that human actions could have a "spiritual" or "epic" significance that transcended mundane materialism. For instance, fascists embraced Sorel because his theory of myth was premised on Henri Bergson's critique of rationalized clock time and promotion of "intuitive" consciousness as a means of discerning the "creative" aspects of human temporality. For Sorel, "mythic images" provoked such an intuitive consciousness, infusing human action with the life-affirming energy of an epic struggle between the forces of decadence (capitalist rationalism and plutocracy) and those of regeneration (syndicalist revolution).[140] After World War I, those fascists claiming allegiance to Sorel countered the universality implied by capitalism's normative sense of time with temporal models that identified the "eth-

ical state" as the mythic end point of teleological history.[141] This conversion of teleological history into spatial form, states Harvey, was synonymous with the "place-bound sense of geopolitics and destiny" adopted by fascism.[142] Thus while ideologues such as Sorel or fascists such as Hitler, Mussolini, and Valois did not believe in "logical, discursive thought," they "did believe in energy, in force, in unthinking passions" evoked in the name of the mythic "purification and revival of a class, a nation, or a 'race' that had a task to perform" or "a destiny to fulfill."[143]

The Nazis' foregrounding of the *chronotrope* of racial nationalism as a counterweight to capitalist homogenization led them to invest temporal experience with a spiritual and regenerative significance premised on anti-Semitism. As Robert Sayre and Michael Löwry suggest, fascists regarded the human experience of temporality as one among "an aggregate of *qualitative* values—ethical, social, and cultural—in opposition to the mercantile rationality of exchange value."[144] For fascists, stock market speculation epitomized this mercantile reduction of time to a commercial asset, for the stock market implicated both the principle of interest and that of credit as economic possibilities. These perceptions were key to the development of anticapitalist anti-Semitism among European thinkers on both the right and left who identified Jewish financiers as the nonproductive exploiters of bourgeois and working-class producers.[145] As a result, international bankers such as the Rothschilds were condemned as modern-day usurers who amassed wealth by speculating on the labor of others, and who bore no allegiance to any class or country. This viewpoint extended to the realm of art; proponents of anticapitalist anti-Semitism in France and Germany frequently contrasted the creative capacities of the artist, the folk, the Sorelian producer, or of the fascist leadership itself, with the artistic "impotence" of Jewish entrepreneurs, who saw art as a commodifiable object for fiscal speculation rather than an agent of spiritual edification.[146] The qualitative experience of time that went into the production of a work of art or the finely crafted product of a workshop reportedly had no meaning for the Jew, who saw everything in terms of exchange value. This capitalist "disenchantment" of time reduced all products of the creative process to a quantifiable commodity, subject to monetary speculation; fascism by contrast sought to infuse time with qualitative value as an expression of its ability to transform human consciousness and society.

Such notions have led Roger Griffin to speak of the fascist "social engineer-

ing" of time itself.[147] Noting that concepts of sacred, cyclical, or revolutionary time persisted into the modern era despite capitalist rationalization, Griffin joins a number of recent scholars in relating the cultural rebellion against the Enlightenment project to such alternative temporal frames, the most significant of which was the fascist quest to regenerate time through the mythic politics of palingenesis. Citing Walter Benjamin's "Theses on the Philosophy of History" (1940), Griffin concludes that revolutionary events fall under the rubric of an "alternative" time, since "a revolution is a moment when a mythically charged 'now' creates a qualitative change in the continuum of history, which is to be distinguished from undifferentiated 'clock time.'"[148] Drawing on a wide range of sources, both primary and secondary, Griffin documents Mussolini's attempt to manipulate time in order to assert the revolutionary import of fascism and instill fascism's epic sense of time among the masses. The most dramatic instance of such social engineering was the "superimposition over the Gregorian calendar" of a fascist time frame in which 1922 became "Year 1" of the Fascist era, signaling a regenerative break from the plutocratic decadence of the immediate past. The new calendar was then punctuated with certain days of national celebration, each with "a two fold mythic significance": "Thus March 23, Youth Day, commemorated the founding of the Fasci; April 21, Labour Day, the founding of Rome; May 24, Empire Day, the entry of Italy into the First World War; September 20, Italian Unity, the incorporation of Rome into the Kingdom of Italy; October 28, the Fascist Revolution, the March on Rome. . . . In this way ordinary Italians were encouraged to experience the unfolding of time as a phenomenon with a transcendental core on a par with the metaphysical reality which underlay Christianity."[149] As Griffin points out, fascism's attempt to usurp the role of Christianity as the principal custodian of qualitative time is fully confirmed by Emilio Gentile's analysis of the proliferation of secular religious rituals under Italian fascism, all organized around epic moments in the history of the movement and the cult of fascism's martyrs. For fascists the heroic actions of the World War I combatants and the Fascist squads on behalf of the nation assured their "immortal" transcendence of mundane human time; moreover, their votive enshrinement, states Griffin, was meant to lift ordinary Italians "out of the anomic experience of time [by] reconnecting them with the epic life of the nation."[150] "Immortality" through martyrdom was not the only way of marking

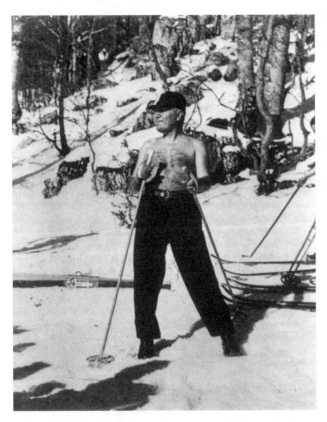

Fig. 11. Mussolini as skier at Terminillo, near Rome, n.d. Reproduced in Renzo De Felice and Luigi Goglia, *Mussolini: il mito* (Rome and Bari: Laterza, 1983).

qualitative time; numerous scholars have likewise noted that the Italian Fascist and Nazi cult of youth—exemplified in art by a predilection for sculpted nude athletes and images of female fecundity—signaled the perpetual energy and regenerative capacities of both regimes.[151] Mussolini himself took on the mythic aura of perpetual youth; journalists were forbidden to publicize his birthdays; his status as grandfather was suppressed, as well as any evidence of illnesses; his hair was shaved when it showed signs of graying; and he was frequently photographed in such virile roles as mountaineer, lion tamer, and skier.[152]

As Mabel Berezin demonstrates, this attempt to "colonize time" invaded every aspect of ordinary life in Italy. Citing Berezin's analysis of Fascist events staged for the citizens of Verona over a twenty-year period, Griffin concludes

that the ideal citizen would have attended "727 such events, an average of 36 per year, or one every 10 days."[153] Italians were asked to participate in the full-filment of the Risorgimento, to realize the imminent destiny of Fascist Italy as an empire comparable to Augustan Rome, whose creative fecundity rivaled that of the Italian Renaissance. This "cult of remembering," states Griffin, was practiced in a revolutionary spirit, for the past was commemorated "in order to regenerate the present and transform the future: a paradox expressed in the slogan of the *Movimento Sociale Italiano* 'Nostalgia for the Future.'"[154] Simi-lar thinking pervaded Nazi cultural politics, where the redemptive theme of palingenesis was promoted through a variety of media, including mass rallies, commemorative events, radio addresses, cinema, and literature.

In his important book *The Cult of Art in Nazi Germany*, art historian Eric Michaud has also addressed the import of qualitative time for Nazism through an analysis of how the Nazis' secular religious ideology relates to their Sore-lian use of mythic images in order to "accelerate" time.[155] In a section titled "Images and Anticipation" Michaud explicates the Nazis' secular religious as-sociation of their rise to power with the "salvation" of the German people, and the Nazis' subsequent transformation of German society through progress to-ward final deliverance, signified by the "eternal" establishment of the Third Reich.[156] Modeled after the christological narrative of the First and Second Coming of Christ—Christ Redeemer and Christ Pantocrator—Nazi ideology incorporated a period of "transition" into its anticipated historical narrative to account for an era when Nazi values would be inculcated among the masses as a prelude to the consolidation of the Reich. The Nazis held that progress toward the eternal Reich could be "accelerated" if the masses could be more quickly converted to the cause; this has led Michaud to consider the applica-bility of Sorel's notion of mythic images to an analysis of the agitational func-tion of Nazi propaganda, both oratorical and visual. Having outlined Sorel's claim that mythic imagery was wholly divorced from intellectual reflection and served to agitate the masses by a direct appeal to their creative intuition, Michaud analyzes the function of Nazi visual and oratory imagery in assert-ing the German people's mythic status as "a unique race" incarnating "'creative genius.'"[157]

The Nazis propagated a "myth-image" intended to awaken the people's desire for salvation, a condition to be realized through the material and ethical

transformation of Germany. This led to the proliferation of imagery devoted to "the sanctification of creative work" as "the instrument and guarantee of the future salvation." Through an analysis of the writings of such Nazi ideologues and writers as Hitler, Robert Ley, Goebbels, Gottfried Benn, and Ernst Jünger, Michaud documents the pervasive association of all forms of labor—cultural and industrial—with the Nazis' instigation of a "vast process of autoredemption for the race," which absorbed the individual in a collective effort (*Arbeitsgemeinchaft*) to establish the eternal Reich.[158] This sanctification bestowed on "ennobled labor" a degree of creativity and high moral purpose usually reserved for the fine arts; moreover, it resulted in a profusion of images devoted to collective labor, such as Ria Picco-Rückert's *Unified Force* (1944), or the monumentalizing of the building process itself, as in Carl Winckler's undated Piranesian lithograph of an ocean-going vessel under construction. This secular religious association of labor with redemption is best exemplified by Ferdinand Staeger's portrait of German Work Front laborers, titled *We Are the Work Soldiers*, marching in unison against a dramatic backdrop of cumulus clouds.[159] The Work Front recruits form an unbroken (and seemingly unending) column; armed with shovels rather than rifles, they ascend heavenward as a pictorial metaphor for their "sacred" effort to create "the eternal Germany." These "work soldiers" are completely absorbed in an epic and spiritual struggle for redemption, and their actions will transcend their own life span to play a role in the salvation of the German race. As Michaud cogently argues, by converting the worker into a heroic type and monumentalizing the scale of their sculptures, Nazi artists Fritz Koelle and Josef Thorak effaced the individuality of the laborer in order to glorify the epic significance of "Work" itself. Just as the "unknown soldier" gave his life to assure the survival of Germany, so, too, the "unknown worker" would be the custodian of the Third Reich, and his holy labor the means of achieving salvation.[160]

While images of labor inspired the German people to participate in this spiritual journey, Hitler's monumental building projects asserted Nazi Germany's status as a millennial regime not unlike ancient Rome. As Alex Scobie has demonstrated, Hitler and his principal architects pointedly modeled their architectural plans after Roman precedents. Ludwig Ruff's proposed Kongresshalle in Nuremberg (1934–1935) was to resemble the Roman Colosseum; Speer's and Hitler's Volkshalle in Berlin (1937–1940) imitated Hadrian's Pan-

Fig. 12. Ferdinand Staeger, *We Are the Work Soldiers*, 1938. Oil on canvas, dimensions unknown. Location unknown. Reproduced in Berthold Hinz, *Art in the Third Reich* (New York: Pantheon Books, 1979).

theon; and Cäsar Pinnau's Public Bath planned for the capital (1940–1941) was based on ancient Roman *thermae*.[161] Hitler and Speer pushed these conceptions further in their infamous "theory of ruin value," which, in Speer's words "called for the use of special materials and engineering techniques" so that monumental buildings "even in a state of decay, after hundreds or (such was our reckoning) thousands of years would more or less resemble Roman models."[162] The role of the German people as a sanctified race and the custodians of culture was most dramatically asserted in architect Wilhelm Kreis's wartime plan to construct a series of necropolises circumscribing the limits of the new Nazi Europe, from the Atlantic coast to the Urals.[163] These monuments to the dead, claimed Kreis, to symbolize "the meaning of a great historical turning point" would serve as "an eternal reminder . . . of the unification of Europe as carried out by the German people." The buildings, moreover, would be "surrounded by tombs of the generation of German warriors who defended

Fig. 13. Hans Liska, *In the Largest Studio in the World*. Drawing of Josef Thorak's studio. Reproduced in *Berliner Illustrierte Zeitung*, no. 51 (1938), 2103.

the existence of the Western World, as they have done for the last two thousand years."[164] Michaud argues that such edifices enabled each German to not only anticipate the "eternal" Reich, but also to envision the eventual demise of the German people themselves as part of Hitler's millennial narrative. "The paradox of the National Socialist movement," Michaud concludes, "is that it is supposed to lead the authentic German back to his primal dream by imposing itself as that prophesy already realized. It is supposed to define a space in which the end is the beginning, in which the community at last purified of the *other's* dream [namely, the Jewish dream of being the chosen people], remains eternally present to itself."[165]

A New Look at Fascism and Modernity

The consideration of fascism and modernism from the perspective of modernity underscores the permeability of the two former categories and the need

for art historians and historians to treat fascism not as an isolated political phenomenon or as an aesthetic aberration in the modernist march toward abstraction, but as a form of cultural politics in dialectic (or dialogic) relation to other anti-Enlightenment movements, both left and right. By adopting this approach we need no longer think of fascism as a fixed, stable entity but may instead conceive of it as a movement full of internal contradictions, with an unstable "base" composed of individuals and constituencies who endorsed fascism for a variety of reasons, and whose allegiance to the cause may have been transitory. The ramifications of such an approach for art history are clearly demonstrated, for example, by Matthew Affron in his analysis of French critic Waldemar George's move from a wartime endorsement of anarchism to the forging of a Franco-Italian aesthetic in the name of fascist "neohumanism" after 1930; or by Nancy Goldberg in her study of the art critic and modernist poet Henri Guilbeaux, who underwent a similar shift from syndicalism to an allegiance to Italian fascism's corporativist cultural politics following World War I.[166] In both instances the antirationalist politics of the Left acted as a catalyst for these critics' endorsement of fascism. Such anti-Enlightenment politics could also lead to disillusionment with the fascist cause if not with modernism. Philippe Lamour, who promoted Le Corbusier's architecture as exemplary of the fascist ethics of productivism, continued to do so after he had abandoned fascism for regional syndicalism in the 1930s.[167] Georges Valois, who championed modern art throughout his political career, began as an ally of Maurras's Action Française, left that movement to found the French Faisceau in 1925, but then renounced fascism in the 1930s for a notion of "libertarian communism." Valois's intransigent allegiance to communism ultimately resulted in his incarceration and death in a Nazi concentration camp in 1945.[168] Clearly, fascism could serve as a way station on the road to other forms of anticapitalism; we need to be sensitive to such choices if we are to do justice to the complex nexus of fascism and modernism. In like fashion rather than considering fascism as a monolithic term, we should speak of competing fascisms as evidenced in the cultural debates between Italian proponents of Strapaese and Stracittà, or the Nazi defenders of German expressionism and their eugenicist-oriented adversaries.

Perhaps most complex challenge facing historians, including art historians, is the need to take seriously the fascist usage of the mythic politics of

palingenesis to win over the public through a process of spiritual conversion and psychological transformation. Too often fascism's cultural politics are cast in terms of a cynical manipulation of the docile masses, with no allowance made for the *appeal* of fascism for the individual, or the internal point of view of the fascist rank and file. Concepts of secular religion were more than ideological tools for thought control; for the fascist believer they were agents for the spiritual uplifting and psychic conversion of individuals, who could then experience fascism's redemptive value as a counter to the socioeconomic upheavals of interwar Europe. Similarly, the Nazis' evocation of the "sublime" beyond its description in terms of sensations of awe, terror, or mythic symbols for political and industrial might, merits understanding with reference to its etymological roots in edifying notions of "self-transcendence."[169] Iain Boyd Whyte has touched on this very issue by linking the monumentality of Nazi architecture to the Kantian notion of the "dynamic sublime" to account for the impact of such building on the human psyche. To citizens of the Third Reich, identification with Albert Speer's monumental structures entailed the ascription of the power and might these buildings evoked to themselves. Infused with "sublime inspiration" under the impact of Nazi art and architecture, citizens could further enhance the power of the Reich through their own Promethean actions.[170] Eric Michaud in turn notes that the huge rallies staged in Nazi Germany were meant to produce "the reciprocal shaping of the masses and their leader" and "the auto-formation of a single political-religious body." The sublimity integral to such interaction was affirmed by Hitler himself in the pages of *Mein Kampf* (1925). For a rally to be successful, Hitler declared, "the will, the longing, and also the power of thousands are accumulated in every individual."[171] In Italy Fascists deployed the iconography of secular religion to achieve similar results, most notably in the 1932 Sacrarium to the Martyrs (fig. 6) and the primitivist aesthetic of Soffici (fig. 7). Hitler and Mussolini were not the only creators able to mold society according to their "sublime" vision; the people themselves were to take on such creative agency under the impact of fascism's mythic constructs.[172]

Such thinking was not confined to interwar fascism: Sorel in fact claimed in his *Reflections on Violence* that mythic images infused workers with a sense of the "sublime," since their revolt against the state was inspired by an anticipated cataclysmic revolution designed to regenerate society. Sorel argued

that the "lofty moral convictions" native to sublimity were most prevalent in "a state of war in which men voluntarily participate and which finds expression in well-defined myths."[173] If we lend credence to the fascists' allegiance to Sorel's notion of mythic images, we should therefore recognize that the impact of such constructs on the public entailed more than the oppressive politics of Guy Debord's concept of the spectacle.[174] As we have seen, Sorelian myths were meant to enhance an individual's creative capacities and instill a sense of collective purpose—even if the "holy labor" of such individuals had catastrophic results under fascism. Only by examining the dual nature of mythic politics as a belief system that can transform the initiate and as a potential tool for cynical (or sublime) manipulation by political elites will we gain an understanding of fascism's widespread attraction to modernists and ideologues alike.

The present study considers such issues in detail, beginning with a chapter devoted to Sorel's own political trajectory before 1914 and his equivocation over the relative merits of the national socialist synthesis initiated by his allies associated with the Cercle Proudhon (1911–1914) and the journal founded in his honor, *L'Indépendance* (1911–1913). Ironically it is Sorel himself who first questioned the sincerity of his reactionary followers and eventually declared their embrace of his mythic paradigms a cynical betrayal of his own revolutionary ideals. However, between 1910 and 1913, Sorel actively participated in the collusion between monarchists and syndicalists that resulted in the national socialist synthesis, and the deployment of a new Sorelian myth: the Jew as antiartist. This mythic construction had a firm basis in the anti-Enlightenment project charted above, and therefore constitutes our first excursion into the troubled relation of Sorelian ideology, avant-garde art, and theories of secular religion to the development of fascism under the Third Republic.

THE JEW AS ANTI-ARTIST

Georges Sorel and the Aesthetics of the Anti-Enlightenment

In the history of France, political theorist Georges Sorel (1847–1922) is best remembered for his controversial role in facilitating an alliance between the antidemocratic right and left before 1914.[1] However, scholars have not fully grasped the importance of aesthetics to Sorel's revolutionary doctrine, and, therefore, the relevance of art and culture to his impact on political and intellectual history.[2] As the author of the *Reflections on Violence* and *Illusions of Progress*, both published in 1908, Sorel initially critiqued the Enlightenment underpinnings of republican ideology in order to promote an antirationalist and decidedly aestheticized concept of revolution, premised on the agitational role of myths in transforming the consciousness of working-class syndicalists engaged in strike activity.[3] Before 1909 Sorel disseminated his views in the syndicalist journal *Le mouvement socialiste* (1899–1914), which also published the writings of Sorel's anarchosyndicalist ally, Edouard Berth.

Sorel aligned the heroic virtues and esprit de corps arising from proletarian class consciousness and the "myth" of the general strike to the vitalist notion of creative intuition developed by the philosopher Henri Bergson, a figure championed by Sorel as the harbinger of a spiritual revolution opposed to the rationalist and materialist premises undergirding democratic ideology. According to Sorel, the mythic vision of a cataclysmic general strike would infuse individual workers with a sense of the sublime, thereby transforming mundane strike activity into an epic struggle against capitalism. In Sorel's view, such violence would also reawaken the combative energy of the bourgeoisie, whose decadent condition was the product of their adherence to the Enlightenment ideals promoted by democratic demagogues. Ironically, Sorel's books on syndicalist revolution and republican decadence appeared just as the syndicalist strategy of *l'action directe* went into decline, which precipitated his disillusionment with the myth of the general strike. In response, Sorel and Berth abandoned the labor movement after 1909 and turned to factions within the royalist Action Française to forge a new ideological alliance, premised on a mythic divide between a rationalist Republic crippled by cultural and political decadence, and the regenerative power of religious faith and classical culture as forces for national renewal.[4] Sorel and his newfound Catholic and royalist allies promoted this agenda in the journal *L'Indépendance* (March 1911–August 1913), while Berth published his own version of Sorelian anti-Semitism in his royalist-syndicalist tract, *Les Méfaits des intellectuels* (1914) (The Misdeeds of Intellectuals).

This chapter examines the function of Sorel's cultural critique of the Enlightenment in his shift from anarchosyndicalism to an alliance with dissident neo-Catholics and royalists affiliated with *L'Indépendance*, its role in his relation of aesthetics to class consciousness, and the image of the Jew fabricated by Sorel and his followers. More specifically, the Sorelian distinction between the revolutionary consciousness arising from Bergsonian intuition, and the decadence resulting from rationalism was deployed against the Jew, whom Sorel and Berth condemned as the very epitome of the intellectual, who swore allegiance to Enlightenment precepts. Sorel and Berth drew on Bergson's theory of qualitative differences to arrive at a theory of class consciousness fundamental to their conception of proletarian and bourgeois regeneration: by declaring the Jew devoid of such consciousness they effectively labeled Jews the

déclassé allies of rationalism, democratic demagogues, and cultural decadence in all its forms.[5] Qualitative differences galvanized the intuitive capacities of a given class, a condition reflected in its revolutionary *esprit*, artistic capabilities, and industrial productivity; as one divorced from this consciousness the Jew came to symbolize the sterile intellectual whose inability to create had its social counterpart in the unproductive economics of the financier, who speculates on the productive labor of others without producing anything himself. Art, therefore, was subsumed within the parameters of class consciousness. By relating the art promoted in *L'Indépendance* to the role of aesthetics in Sorel's theory of class, Sorel and his colleagues underscored the function of visual culture within this anti-Semitic discourse, and their mythic conception of the Jew as anti-artist. This synthesis was crucial to Sorel's condemnation, in *L'Indépendance*, of the Jewish defenders of republicanism affiliated with the symbolist journal *La revue blanche* (1890–1903). To Sorel's mind, the success of *La revue blanche* evidenced the corrosive impact of Enlightenment ideals on French society; thus he drew comparisons between the cultural views of assimilated Jews associated with the journal and the decadence of the so-called moderns in their infamous battle with the "ancients" during the late seventeenth and early eighteenth centuries.

L'Indépendance, between "politique" and "mystique"

To understand this aspect of Sorel's thinking properly we must first consider the historical circumstances behind his decision to join a group of royalists in founding *L'Indépendance*. Financed by Sorel's ally, Jean Variot, the creation of *L'Indépendance* was the culmination of a series of attempts to win Sorel and Berth over to the royalist camp. Jean Variot (1881–1962) had a complicated career as an artist, dramatist, journalist, and interpreter of Sorel. Having studied literature at the Lycée Louis le Grand in Paris, Variot took up theater set design and journalism during the prewar period. In 1900 he encountered Sorel in the offices of Charles Péguy's *Les cahiers de la quinzaine*, and in 1910 he published his first book, *Très véridique histoire de deux gredins*, a critical examination of the Dreyfusard milieu. That same year he joined Sorel and royalist Georges Valois in the failed attempt to launch the journal *La Cité française* (1910). By 1911 Variot had moved into the royalist camp of Charles Maurras, but under the banner of Sorelian royalism.[6] Relations between Sorel,

Berth, Variot, and the Action Française were initially mediated by the former anarchist-turned-royalist Georges Valois (1878–1945).[7] Born in Paris the son of a butcher, Valois began to frequent anarchist circles in 1897 in the Latin Quarter, and in 1898 he met Sorel. In 1900 he undertook his military service and spent time as a tutor in Russia: these experiences sowed the seeds for his conversion to nationalism and his embrace of anticapitalist antisemitism. From 1903 onward Valois made a living as a secretary in the publishing house A. Colin. In 1905 he returned to Catholicism, and a year later he became a confirmed monarchist, publishing a book on his own political theory titled *L'homme qui vient* (1906). From 1908 to 1914 Valois was the Action Française's point man, seeking to bring about a rapprochement between the radical Left and radical Right. His efforts were chiefly directed toward Sorel and his syndicalist followers. In 1907 Valois had published his own attempt to reconcile royalism and Sorelian syndicalism titled *La révolution sociale, ou le roi*; in 1908 he launched an enquiry "on monarchy and the working class" in the monarchist journal *La revue critique des idées et des livres* (1908–1924).[8] With the sanction of the doyen of royalism, Charles Maurras, Valois set out to explore the possible merger of antidemocrats on the left and right; however, Sorel's published response to Valois's query was categorically negative, and Berth failed to reply at all.[9] Despite this setback, contributors to the *Revue critique* continued to discuss Sorel's theories, which may have inspired Sorel to republish his essay "Modernism in Religion and in Socialism" in the August 1908 edition of the journal.[10] The essay chastised socialists for not heeding the mythic dimension of Marxism and condemned contemporary proponents of Catholic modernism for abandoning the mystique of orthodox faith in an attempt to reconcile rationalism with religion, and, by inference, republican ideology with Catholicism. In the fall of 1908 Sorel befriended Jean Variot, another leftist soon to turn royalist, who published a record of his *avant-guerre* conversations with Sorel in 1935.[11] By mid-1909 Sorel's letters to his Italian friend Benedetto Croce made frequent mention of the writings of Valois and Maurras, and in July of that year he wrote a letter to Maurras himself, praising the second edition of Maurras's *Enquête sur la monarchie*.[12] In August 1909 Sorel republished an essay condemning the government-sanctioned attack on striking workers at Villeneuve-St. Georges, but this time in the main organ of the royalist movement, *L'Action française*.[13] In September *Action française*

published an interview with Sorel, wherein he professed admiration for the royalists' struggle against decadence, while finding the possibility of a monarchist restoration highly improbable.[14] By April 1910, Sorel placed another article in *Action française*, this time on the resurgence of French patriotism heralded by the appearance of Charles Péguy's epic poem *Le mystère de la charité de Jeanne d'Arc* (1910).[15] Péguy's text cast Joan in the role of the defender of France and of Christianity per se, a synthesis that Sorel interpreted primarily as a mythic tool for regeneration, rather than as an expression of religious faith. Sorel praised the poem for initiating a "renaissance of French patriotism" through its appeal to heroic commitment, self-sacrifice, and concerted action, all of which exemplified Péguy's notion of mystique. According to Sorel, Péguy's lyrical prose was able to incite emotions comparable to those created by Aeschylean drama and "the Catholic liturgy"; moreover, not only did Péguy's text evoke the myth of Joan, it instilled the myth of patriotism in its readers.[16] What has gone unnoticed is the extent to which Sorel associated Péguy's poetic imagery with his own conception of revolutionary myth as composed of a body of images immune to rationalist critique. I will be returning to this subject, but for now will simply note that scholars have concluded that Sorel fully endorsed Péguy's distinction between *mystique* and *politique*.[17] To Sorel's mind, danger arose whenever the values associated with mystique were couched in terms of a political program, for such values were then vulnerable to self-serving manipulation on the part of political operatives and corrupt institutions. By September 1910 Sorel chastised royalism in just these terms, citing Maurras's slogan of "politics first" as evidence of the subordination of monarchist mystique to venal political ends.[18] However, Sorel still hoped that religious belief and classical culture could spur regenerative renewal, a point emphasized in his essay "Grandeur and Decadence," written in July 1910 for the second edition of *Les illusions du progrès* (*The Illusions of Progress*) (1910). As we shall see, he continued to advocate war between nations as a catalyst for resurgence, a position first developed in conjunction with his theory of class war in *Reflections on Violence*.

It was in this context that Sorel first collaborated in the creation of two journals that joined the antidemocratic Right and Left in the propagation of such values. During the summer of 1910 Sorel joined his syndicalist ally Berth, the politically undeclared Variot, and the monarchists Valois and *Revue critique*'s

Pierre Gilbert in planning a journal titled *La Cité française.*[19] Scheduled to appear on 1 November 1910, the prospectus for the journal contained a "Déclaration" outlining the editors' concerted opposition to democratic ideology and their desire to defend France's "producers" against a plutocratic republic.[20] Although the declaration acknowledged the "various forms of general opinion" held by the editorial board, Sorel's friends and associates on the left were quick to infer his conversion to monarchism.[21] When the announcement of *La Cité française's* imminent appearance caused a public scandal Sorel soured on the project, fearing the taint of royalism. Valois then attempted to remove Variot from the board, which led to Sorel's resignation and the journal's demise. After Variot and Sorel's withdrawal, Berth and Valois continued their discussions, which resulted in the founding of a study group, the Cercle Proudhon, in late 1911. In 1912 the Cercle launched the *Cahiers du Cercle Proudhon* (January 1912–February 1914) to theorize the fusion of Sorelian thought and Maurrassian monarchism into a "nationalist" doctrine of royalist syndicalism.[22] Although the *Cahiers du Cercle Proudhon* claimed allegiance to Maurras and Sorel, neither endorsed the project. However, Sorel maintained close relations with Berth and wrote a laudatory preface for his apologia of national syndicalism, *Les Méfaits des intellectuels* (1914).[23]

These were the circumstances that gave rise to *L'Indépendance* (March 1911–August 1913). Variot and Sorel had begun planning the journal shortly after the failure of *La Cité française,* to provide Sorel with an outlet more suited to his ideals. Whereas the *Cité francaise* "Declaration" had focused on plutocratic democracy, and the *Cercle Proudhon's* opening proclamation declared its members to be "nationalists,"[24] the "statement" in the first issue of *L'Indépendance* pointedly banished any allusions to "politique" by focusing exclusively on the regenerative power of culture:

> *L'Indépendance* will not be the instrument of a political party or of a literary group. All the periods of history have had their errors. If, however, France has been able to transmit to us the classical heritage of Greece and Rome by enriching it, it is because, over the centuries, its thinkers, poets, all the artists, have protected themselves from confusing disorder with liberty, originality with lack of taste. It is possible that evildoers and buffoons are no more numerous today than they were in other eras; but, through fear, ignorance, or through an illusory desire for novelty,

people have let them take on an importance that they had never previously obtained.

L'Indépendance thus makes an appeal to all men, wise and of good culture, capable of battling against one such abberation. It will ask of them neither sacrifice nor concession which diminishes their personality. Negation and regret of the past are equally sterile, but tradition, far from being a hindrance, is the necessary bulwark which steadies the most hardy wills [*élans*].[25]

To defend these values, Sorel and Variot put together an editorial board of artistic luminaries, most of whom were neo-Catholic or royalist sympathizers.[26] The initial slate comprised the Catholic novelists Emile Baumann and René Benjamin, writer Emily Moselly (who resigned in October 1912), the neo-Catholic composer Vincent d'Indy (1851–1931), artist Ernest Laurent (1859–1925), and the art historian and critic Paul Jamot (1863–1939). Laurent was a former associate of Georges Seurat, whose devout Catholicism drew him into the orbit of the symbolist Puvis de Chavannes in the mid-1880s. Laurent's conversion to symbolism was supplemented by an enthusiasm for Italian religious painting, which he studied while in Rome in the early 1890s.[27] Paul Jamot was a curator at the Louvre and an early champion of the Catholic symbolist painter Maurice Denis.[28] Besides Sorel and Variot, the board also included the brothers Jérôme and Jean Tharaud, two adherents of Action Française, who had first encountered Sorel at Péguy's editorial office for *Les cahiers de la quinzaine* on the rue de la Sorbonne. Although Laurent and Jamot were nominal members, they published little in *L'Indépendance*, left the journal in September 1911, and were replaced in February 1912 by the novelist Elemir Bourges (1852–1925) and writer René-Marc Ferry.[29] Bourges was a longtime supporter of the symbolist painter and self-styled artisan Armand Point (1860–1932), whose work was promoted in *L'Indépendance*.[30] The editorial group was further enlarged in October 1912 to include a literary "who's who" among the neo-Catholic and anti-Republican Right. The board now included Maurice Barrès, neo-Catholic novelist Paul Bourget, and dramatist Maurice Donnay; all were members of the Académie Française. Bourget had popularized Sorel's theory of class warfare in his play *La barricade* (1910), which highlighted the regenerative effect of proletarian violence on the bourgeoisie. The Tharaud brothers, in an article of August 1910, celebrated the play as testimony to the salutory impact of

class war and mythic consciousness—as theorized in Sorel's *Reflections on Violence*—on the modern bourgeoisie.[31] Sorel met Bourget shortly after *La barricade* opened in Paris in January 1910, and he first met Barrès in May 1911, after Barrès had told Variot of his desire to meet Sorel.[32] Another triumvirate to sign onto the project were *Revue critique*'s editorial secretary Henri Clouard, the Catholic symbolist Maurice Denis (1870–1943), and the fervent Catholic and regionalist writer Francis Jammes (1868–1938). The Catholic playwright Paul Claudel (1868–1955) also contributed poetry to the journal, and under Jammes's influence the April–May 1913 edition of *L'Indépendance* published sketches of Jammes's native Gascony by his close friend, the symbolist Charles Lacoste (1870–1959).[33] Another contributer was André Fergan, who drew on Sorel's theories in his writings on art and theater.

Sorel's own involvement ceased after the March 1913 issue, and with his resignation that Easter *L'Indépendance* lost its raison d'être, underwent another transformation in June 1913, and folded in August. Historians have attributed Sorel's withdrawal to his renewed concern that royalist "politics" were eclipsing the journal's cultural agenda.[34] Sorel's worries first emerged after the October 1912 change of editorship: in November, he confided to Croce that he found "the spirit of the majority of the young editors very compromising for an old man such as I am."[35] Between December 1912 and March 1913 he began expressing doubts concerning the rebirth of religious and patriotic sentiments among his neo-Catholic colleagues. In a series of letters written in January 1913 to Joseph Lotte—a close friend of Péguy, and himself a recent convert— Sorel called into question the sincerity of Claudel, Jammes, and of Lotte himself.[36] Having decided that the Catholic literary renaissance was a sham, Sorel no longer regarded *L'Indépendance* as a vehicle for cultural regeneration. That Easter he conveyed his negative appraisal to Variot, who was understandably devastated.

My analysis will focus on the artistic dimension of *L'Indépendance* to elucidate the impact of Sorel's views on creativity, classicism, and religious belief on the cultural politics of neo-Catholics and royalists during the period of Sorel's own involvement. To date, historians examining Sorel's contributions to *L'Indépendance* have done so to underscore his imperviousness to the "national syndicalism" or monarchism of his newfound allies and of Berth. Scholars have rightly argued that Sorel's pronouncements on tradition and

classicism were rooted in his past writings, rather than the royalist ideology of Charles Maurras.[37] However, this has led some historians to claim that Sorel rejected nationalism altogether in favor of a more benign allegiance to the mythic power of patriotism.[38] That nationalism still held "mystique" for Sorel is clear from his articles celebrating the Italian Risorgimento and war between nations published in *L'Indépendance*. In an article titled "La Rivolta Ideale" Sorel cited Mazzini's vision of a united Italy as a regenerative myth that had spiritually transformed the Italian populace; he also judged Italy's imperialist campaign in Libya in 1911 to have had a comparable effect on the masses.[39] The war in Libya reportedly had consequences unimagined by Italy's parliamentary elite: the battle had instilled "high military virtues" in the military rank and file, and the public, despite the "harangues" of the socialists, followed "the adventures of its soldiers with passion." Not since "the most beautiful days of the Risorgimento" had "the sentiment of the grandeur of la patrie" been so strongly felt.[40] Clearly Sorel's notion of the mythic power of "la patrie" encompassed more than simple love of country; it included nationalism within its purview. Other writers for *L'Indépendance* voiced similar concerns: for instance, an article on Italian nationalism—written by the Sorelian Mario Missiroli, and translated by Berth—reiterated Sorel's views regarding the regenerative impact of the Risorgimento and of war in Libya before lamenting that Italy lacked the "great historical and monarchical tradition" that galvanized "French nationalists" in their fight against plutocratic democracy.[41] Berth also joined the chorus, praising the regenerative impact of Italy's Libyan campaign in the *Cahiers du Cercle Proudhon* while admonishing France—"the most plutocratic of modern nations"—for failing to avenge "the shame of Sedan."[42] Such statements underscore Sorel's continued faith in the mythic power of nationalism, the assertion of a nationalist agenda in *L'Indépendance*, and the role of that paradigm in Berth's national syndicalist writings.

In like fashion, the possible impact of Sorel's views on the contributors to *L'Indépendance*, or the role of art in that discourse, has received scant attention. For instance, in her detailed study of the journal, Marie Laurence Netter concludes that the common agenda shared by Sorel and his colleagues amounted to nothing more than an attempt to reconcile creativity and tradition. They defended creative freedom, but not "freedom to break the rules," and the *Indépendance* group thought art should safeguard "certain values." Netter

concludes that Sorel and his allies shared little besides an interest in "classical intelligibility and universal form."[43] Thomas Roman has gone even further, asserting that Sorel's thought had no impact on the journal's contributors, despite the fact that Variot had specifically founded *L'Indépendance* to promote Sorel's views.[44] Acknowledging that Sorel contributed fully 37 percent of the articles published in the journal, he nevertheless concludes that it could not be considered a Sorelian review because 63 percent of the essays were neither written by Sorel "nor influenced by his thought."[45] On this basis Roman concludes that *L'Indépendance* was "traditionalist" in the conservative sense, and in no way an expression of Sorel's "revolutionary" agenda.[46] As for the cultural dimension, Roman argues that the journal was "against romanticism, symbolism, or naturalism" while it developed "a classical discourse and a nationalist and religious conception of art."[47] Despite such claims neither Netter nor Roman actually analyzes the art reproduced or promoted in *L'Indépendance* or the art criticism that Sorel himself, or Variot, Fergan, and others published in the journal. Even when attention has been paid to Sorel's impact on those seeking to combine Sorelian thought and integral nationalism, culture has been categorically marginalized in favor of a focus on ideology. Thus historians who examine this issue have concentrated almost exclusively on the Cercle Proudhon, while the aesthetics highlighted in *L'Indépendance* have been virtually ignored.[48]

As a result scholars have failed to grasp the integral relation of Sorel's syndicalist thought to a key tenet permeating his writings for *L'Indépendance*: his endorsement of an extreme form of anticapitalist anti-Semitism as a counterpoint to his theory of creativity. Sorel's anti-Semitism was continuous with his theory of art, a direct outgrowth of his earlier critique of the Enlightenment, and a motivating force behind his interest in the regenerative power of neo-Catholic aesthetics. *L'Indépendance* provided Sorel with a platform to express these views and to win over converts to his revolutionary agenda, which was quite distinct from that of Charles Maurras. Thus writers for *L'Indépendance* identified Catholic faith as an agent for the creation of antidemocratic values and championed a religious version of symbolism in literature and the fine arts. As we have seen, *L'Indépendance* numbered the painter Maurice Denis, writers René Benjamin and Paul Bourget, composer Vincent d'Indy, and playwright Paul Claudel among its contributors: all were prominent figures in the

neo-Catholic revival that swept France following the separation of church and state in 1905.[49] Sorel had already signaled his own interest in militant Catholicism in his review of Charles Péguy's *Mystère de la charité de Jeanne d'Arc* (1910), published in *Action française*. Richard Griffiths, in his comprehensive study of the Catholic revival in French literature, has argued that the doctrine of vicarious suffering held special significance for writers such as Benjamin, Bourget, Claudel, and Péguy, because of its mystical import and symbolic value as a sign of "hard" Catholicism;[50] as we shall see Sorel and his followers endorsed the concept by relating vicarious suffering to Sorel's theory of myth and its manifestations in the sublime heroism native to Greek tragedy, proletarian violence, and Christian acts of martyrdom and self-abnegation. In many respects Sorel's 1910 review of Péguy's *Mystère de la charité de Jeanne d'Arc* had set the stage for this formula, by comparing the regenerative force of Péguy's homage to Joan of Arc to Aeschylean drama, Sorelian myth, and the rhythmic incantations of Catholic liturgy. To understand that synthesis we must begin by examining Sorel's initial revolt against the democratic tradition, and its relation to issues of class.

The Abstract Citizen

The creation of the Third Republic produced a conflict between those favorable to the doctrine of universal suffrage and those opposed to it. As Pierre Birnbaum has detailed, political dissidents such as Charles Maurras and Maurice Barrès condemned the republican principle of "one man, one vote" for falsely positing political equality among all citizens on the basis of Enlightenment ideals; they campaigned instead in favor of older forms of communal solidarity native to France, such as Catholic faith, regional identity, or the system of guilds that united workers according to their profession.[51] Study of Sorel's writings reveals that his theory of syndicalist revolution was based on antirationalist paradigms conducive to such rightist antidemocratic thought. Sorel drew a strong contrast between vital and degenerative social forces, premised on a Bergsonian division between social structures emanating from intellectual modes of thought and those tied to intuition, and thus expressive of a creative force opposed to intellectualism. In Sorel's view republican ideology subsumed all classes into its atomized concept of citizenship; he countered this homogenization by asserting the heterogeneity of class difference

and identifying vital qualities unique to each class.[52] In *Le mouvement socia-liste*, Sorel critiqued the deterministic, mechanistic, and materialist aspects of both capitalism and parliamentary democracy, which in turn inspired him to posit a spiritualist road to revolution meant to galvanize both the bourgeoisie and the proletariat. His primary concern was with the decadence of French society, for Sorel viewed class conflict as the means by which bourgeois and proletarian alike could be rejuvenated and the corrupting effects of parlia-mentary democracy successfully resisted.[53]

Fundamental to Sorel's distinction between vital and degenerative social forces was a division derived from Bergson between those social structures arising from intellectual modes of thought and those tied to intuition, and thus expressive of the vital *durée* animating life. "Duration," Bergson's term for temporality, was synonymous with creativity, and each material manifesta-tion of duration reportedly contained within it an *élan vital*, or vital impulse. According to Bergson, intuition was the faculty of thought most adapted to this life force and thus able both to discern duration and contribute to its creative evolution, its production of material form. Ultimately Bergson hoped that intuition would give us not only insight into life but also knowledge of one another, and that social forms based on intuition would create a society open to its own creative evolution. Since intuition was a form of empathic consciousness, a disinterested type of instinct, the social order arising from this state would be the product of a sympathetic communion of free wills, an order expressive of the consciousness of each citizen rather than one imposed mechanically from without by some external authority. Intuition then was a state of mind able to reflect on its own nature and externalize or express that nature in the form of creative acts. The nature of those acts necessarily mir-rored the creative process from which they sprang; thus intuitive acts had all the attributes of creative duration itself: they were indivisible, heterogeneous, and qualitative processes.[54]

For Sorel, Bergson's insights had profound consequences, both for his vision of society and the means by which he sought to change it. In his interpretation of Bergson, intellectualized conceptions described by Bergson as antithetical to intuition had their political equivalent in republican and Enlightenment ideology.[55] Sorel and his colleague Berth sought to identify the qualitative dif-ferences within the body politic ignored by democratic apologists, the most

significant of these differences being that of class. In Sorel's theory each class had its unique *élan*; the error of democracy was that it subsumed all classes into its abstract conception of citizenship, thereby denying the heterogeneity of class difference and the vital qualities intrinsic to each class.

In his *Reflections on Violence* Sorel applied this theory of qualitative differences to his conception of collectivity, claiming that individuals chose to join a *syndicat* as an expression of their free will, and their intuitive sympathy with one another. The spiritual transformation of each individual assured that all action undertaken by an individual was in harmonious relation to that of his peers. In a chapter titled "The Morality of the Producers," Sorel related such harmonious actions to an internal discipline "founded on the deepest feelings of the soul," rather than a discipline that was "merely external constraint." He concluded that syndicalist action was the product of "a qualitative and individualistic point of view," before adding that "anarchists have entered the syndicats in great numbers, and have done much to develop tendencies favorable to the general strike."[56] To Sorel's mind, anarchism and the intuitive consciousness animating syndicalism were utterly compatible, as long as creative individuals acted in consort, in response to a class consciousness premised on intuitive sympathy.

Berth, in a May 1905 article published in *Le mouvement socialiste*—later reedited for *Les Méfaits des intellectuels*—defined the role of revolutionary syndicalism in promoting that intuitive state and the manner in which anarchists hostile to collectivity, along with orthodox Marxists and parliamentary socialists, set out to impede it.[57] According to Berth the epistomological roots of these last three ideologies resided in an intellectualized and atomized conception of the individual, whereas revolutionary syndicalism was allied to "a new philosophy of life" charted by Berth's heroes, Friedrich Nietszche and Bergson. Anarchoindividualism purportedly advocated "extreme social automatism" derived from intellectualism in the sciences and akin to the concept of "abstract citizenship" posited under "democratism." Likewise orthodox Marxism, by virtue of its rationalism, did not escape what Berth called "the law of intellectualism," for the collectivity promoted by Marxists amounted to a "totally mechanical" form of cooperation among workers, a cooperation, stated Berth, "where the will of the cooperators counts for nothing, a cooperation whose directing idea is exterior to the cooperators themselves."[58] Whether social

order took the form of the collection of atomized individuals as conceived by anarchoindividualists or a mechanical order external to its component parts, as developed by orthodox Marxists, it still amounted to an abstract conception of citizenship, no different from that posited under democracy.[59] In his *Illusions of Progress* Sorel endorsed Berth's thesis, adding that the democratic concept of the "abstract citizen" stemmed from "theories of natural law," and "atomistic theories" of physics; consequently the ideal citizen was divorced from "real people" and "real ideas."[60] "Like physics," Sorel asserted, "society can be simplified, and [take on] an atomistic clarity if national tradition [and] the organisation of production are disregarded in order to consider nothing but the people who come to the market to exchange their products." The democratic idea of citizenship was therefore modeled on that of commercial exchange, rather than on "national tradition" or "the organisation of production," crucial to class consciousness.[61]

In *The Illusions of Progress* Sorel traced the emergence of abstract notions of citizenship back to the seventeenth and eighteenth centuries, when a leisured aristocracy embraced the philosophy of René Descartes and theories of "natural law" that set the stage for the democratic "doctrine of progress."[62] According to Sorel, Enlightenment theories were based on Cartesian notions of endless progress, as evidenced by the continual growth of human knowledge.[63] Optimistic in outlook, the Enlightenment's allies were hostile to concepts of original sin; indeed, the Cartesian universe was that of a mathematical machine set in motion by a divine being who had little relevance in the realm of human affairs. According to Sorel, the decline in religious faith, signaled by the defeat of Jansenism under Louis XIV, was a function of the rise of Cartesian ideology among the aristocracy. "Cartesianism was resolutely optimistic," stated Sorel, "a fact which greatly pleased a society desirous of amusing itself freely and irritated by the harshness of Jansenism." Devoid of morality and rendered useless by Louis XIV, the aristocracy now exploited Cartesianism to justify its "frivolity," since that ideology was "very amenable to Parisian intellectual circles."[64] By preaching moral laxity to the idle rich, advocates of Cartesian ideology permitted "the enjoyment of the good things of today in good conscience without worrying about tomorrow's difficulties."[65]

To Sorel's mind Cartesianism was tailor-made for the political oligarchy that arose in the wake of the French Revolution of 1789.[66] Cartesianism suited

not only "the old, idle aristocracy" but also a later generation of "politicians elevated to power by democracy, who, menaced by possible downfall, wish to make their friends profit from all the advantages to be reaped by the state."[67] "Nothing is more aristocratic than the aspirations of democracy," Sorel asserted, for "the latter tries to continue the exploitation of the producing masses by an oligarchy of intellectual and political professionals."[68] Divorced from the forces of production, the idea of progress developed by "our democrats" consisted "neither in the accumulation of technical methods nor even of scientific knowledge," and instead took the form of a pure "logic," ensuring "the happiness of all who possess the means of living well."[69] Like the aristocracy of the previous generation, these plutocratic advocates of abstract logic and moral laxity had their adversaries in the defenders of Christian belief, moral rectitude, and intuition.[70] In the seventeenth century the followers of Descartes were challenged by Pascal, while in the twentieth century, democratic ideology was threatened by the rising tide of Bergsonism.[71] One should compare Pascal and Bergson, added Sorel, since both were opposed to "the illusions of rationalism."[72] Democratic thought, like Cartesianism, had no role to play in human affairs other than to justify the existence of unproductive elements in society, whether they be the landed aristocrats and their intellectual courtiers, or large-scale financiers and their democratic apologists.

The rise of the "productive bourgeoisie" after 1789, therefore, spawned the creation of an unproductive *haute bourgeoisie* within its midst.[73] It was this haute bourgeoisie that undermined class consciousness by aping the aristocracy. The bourgeois assumption of power was accompanied by efforts to emulate the aristocratic delight in theoretical reasoning. Ironically this latter-day enthusiasm for the trappings of aristocratic culture had been preceded, in the eighteenth century, by the aristocracy's equally disastrous assimilation of bourgeois ideology into the cultivated world of the literary salon. When the philosopher Jean-Jacques Rousseau developed an abstract theory of "general will," the aristocracy, states Sorel, "borrowed subjects for discourse from the Third Estate and amused itself with projects for social reform, which it considered on a par with accounts of marvelous voyages in the land of milk and honey."[74] For these aristocrats Rousseau's abstract ideas were first and foremost a form of salon entertainment, not a call to revolution.

In *The Illusions of Progress* Sorel defined an alternative aesthetic to this leisure culture, based on adherence to aesthetic traditions grounded in productive labor and class consciousness. In his view, the proponents of progress were not only hostile to religious belief; they also thought their own culture superior to the art of past eras, including that of classical antiquity. The most important manifestation of this was the quarrel between "ancients" and "moderns" in the seventeenth and eighteenth centuries, a time when new philosophical precepts came into conflict with the long-unchallenged belief in the superiority of the culture of the ancient world.[75]

Cartesianism, stated Sorel, had influenced literary debates between the defenders of the ancients, most notably Nicholas Boileau, and promoters of the moderns, such as Charles Perrault. In Sorel's words, Perrault "systematically ranked his contemporaries above the great men of antiquity or the Renaissance [and] preferred Lebrun to Raphael."[76] Not surprisingly Sorel claimed that Boileau had allies in those "men of the Renaissance" who had "studied Greek customs," and religious reformers such as the Jansenists, who had defended the "classical tradition," and exalted Saint Augustine as the Christian exemplar of classical values. By contrast the moderns valued novelty and viewed art as a mere "diversion."[77] "Almost all the women sided with Perrault's party," asserted Sorel, so that the cause of the moderns, like Cartesianism, was taken up in the literary salons; moreover Perrault's flattery of his contemporaries won him advocates in "the great literary gazettes" and among "the great mass of men who had pretensions to literary taste." As a result of Perrault's defense of progress in the arts the "philosophico-scientific poetry" of writers such as Lamotte won widespread approval. Concurrently, Descartes's teachers, the Jesuits, defended "literary mediocrity against Boileau" and "moral mediocrity against the Jansenists," in order to gain influence over "the greatest number of people."[78] "Boileau's defeat was thus complete," lamented Sorel, for "all around him he could see a rebirth of literary affectation, while in the coteries, transformed into literary salons," the "Fontenelles and Lamottes" were in ascendance.[79] Although the nineteenth-century romantics were to renew the attack on Boileau, he had a defender in the anarchist Pierre-Joseph Proudhon, whose mixture of leftist politics and cultural conservatism appealed to Sorel

(and to the Cercle Proudhon group). Thus Sorel cited Proudhon's claim that "Boileau's glory reappears 'in proportion as the new generation rids itself of the romanticist mantle.'"[80] The quarrel between ancients and moderns had a nineteenth-century correlate in the battle between romantics and classicists, and more importantly, defenders of the decadent Republic and the followers of Proudhon.

Having sided with the ancients, Sorel incorporated concepts of classicism and tradition into his theory of class consciousness. In Sorel's schema, traditionalists respected past techniques of artistic *production* and consciously adopted these methods in emulation of past artistic achievements. There are "two groups of writers," wrote Sorel; "one prides itself on having become 'good literary craftsmen'; its members have trained themselves by a long apprenticeship," while "the other group has continued to churn out works according to the tastes of the day." Like the ancients, these craftsmen reportedly "felt the value of form in poetry"; they recognized that such production required "patient labor," and, as a result, addressed "a limited public." By contrast their adversaries shared the moderns' obsession with literary novelty, and compromised artistic standards for commercial success by writing "for café-concerts and newspapers."[81] Decline in craftsmanship had accelerated in the eighteenth century, for proponents of Enlightenment philosophy such as Condorcet condemned not only religious art but also the Medieval guild structure associated with it. Sorel thus speculated whether "the influence of the friends of the Enlightenment was not fatal to art during the end of the eighteenth century," for they "helped to ruin professional traditions and to set art on an artificial path with a view to expressing philosophical fantasies."[82]

If French society were to be saved, artisanal traditions and productivist ethics should guide all creative endeavors. Sorel, in the *Illusions of Progress*, found evidence of such resurgence in the time-honored, aesthetic sensibility of independent, rural winegrowers as well as in the inventiveness of the industrial worker.[83] In his *Reflections on Violence* Sorel related the esprit de corps generated by the syndicats to "the morality of the producers" and the creativity workers brought to production processes.[84] Drawing on the anarchist aesthetics of Proudhon, Sorel declared art to be "an anticipation of the kind of work that ought to be carried on in a highly productive state of society."[85] He then defined the conditions under which the modern worker could develop an

aesthetic sensibility.[86] As "an experimental field which continually incites the worker to scientific research," the modern workshop required workers to be forever open "to the difficulties the current method of production present." "We are thus led to invention," and through that to the realization that "art should be regarded as being an anticipation of the highest form of production as it tends to be manifested more and more in society."[87] Sorel's correlation between creativity and a productivist ethic also inspired Berth, in an article of 1905 published in *Le mouvement socialiste,* to analyze the creative rather than routine nature of the work undertaken by syndicalists. According to Berth, production methods in the progressive unions required "an incessant adaptation to techniques always more delicate, whose rhythm is perpetually new, and to state it clearly, more revolutionary." Creativity in the workplace ensured that "the worker understands and loves his work," that it becomes "the center of his existence," a source of "pride," "dignity," and a feeling of "justice."[88] Given the agitational role of industrial syndicats in Paris it is not surprising that Sorel and Berth would praise the urban worker in the modern workshop; what has gone unnoticed is that his eulogy to the rural *vigneron* was equally politicized, for winegrowers in the Midi had embraced revolutionary syndicalism and initiated a massive strike wave that engulfed the entire south between 1903 and 1911.[89] As one attuned to the condition of his fields, every winegrower had a "feeling of attachment" toward "the productive forces entrusted to him"; in like fashion, the proletarian was acutely aware of changes in industrial technology. "It has long been pointed out," Sorel continued, "how much the winegrower is an observer, a thinker, and is curious about new phenomena; he resembles the worker of progressive workshops much more than the laborer," since "it is impossible for him to be content with routine, for each year brings a burden of new difficulties." Devoid of routine, such skill had been "celebrated" by poets, "because they perceive its aesthetic character."[90] Like the ancients, the winegrower or industrial worker took pride in the craft of production: it was this relation of art to labor that distinguished classical and artisanal culture from those art forms designed to entertain a leisured class, whether aristocratic or bourgeois.

In his *Reflections on Violence* Sorel went further by comparing the ethos animating the male warrior of classical Greece to that of striking workers, whether agrarian or industrial.[91] Sorel claimed that not only did the myth of

the general strike, in producing an epic consciousness, galvanize the worker's creative capacities, but such myth making potentially regenerated the bourgeoisie by leading that class to abandon the politics of appeasement espoused by parliamentary socialists. Worker agitation would thus cause industrialists to foment the cataclysmic class war predicted by Marx.[92] The fundamental aim of the proletariat, argued Sorel, was to reinvigorate the bourgeoisie through class conflict, thereby making the middle class recover the "serious moral habits," "productive energy," and "feeling of its own dignity" that had dissipated under the impact of democratic ideals.[93] For this reason Sorel regarded labor militancy as a salutary form of violence, qualitatively distinct from the oppressive force of the state. The Enlightenment precepts undergirding the Third Republic and its institutions had encouraged reconciliation between the classes. In response Sorel lauded the antiparliamentary policies of the syndicats, and the decision of the Confédération Générale du Travail (CGT) to employ strike action as a means of maintaining labor militancy and with it, class schism. The myth of the general strike therefore produced an intuitive class consciousness, typified by heroism, moral rectitude, and sublimity, comparable to that of the citizen soldiers of classical Greece. "Proletarian violence," we are told, is "a very heroic thing" since "it is at the service of the immemorial interests of civilization": thus we should "salute the revolutionaries as the Greeks saluted the Spartan heroes who defended Thermopylae." Such epic consciousness also instilled a spirit of invention among the working class, akin to the creativity that had motivated Gothic artisans during the Middle Ages.[94]

Sorel and the Neo-Catholic Revival

Sorel's blueprint for social revolution underwent radical revision after 1909, when the CGT's strike activity faltered and the syndicalists entered into a dialogue with Jean Jaurès's parliamentary socialists. Sorel and Berth responded by turning to antirepublican advocates of militant Catholicism for potential allies in their fight against the parliamentary system and its Enlightenment underpinnings. In *L'Indépendance* Sorel further melded his ideological doctrine with a theory of culture and used notions of classicism and religious aesthetics as a bulwark against the Republic and its allies in the cultural domain. In *Reflections on Violence* Sorel had already related religious faith to revolutionary consciousness, claiming that "Bergson has taught us that it is

not only religion which occupies the profounder region of our mental life; revolutionary myths have their place there equally with religion." Christians, like revolutionaries, could possess "sublimity," provided that believers were motivated by "well-defined myths" in their epic struggle against the forces of immorality.[95] After 1909, Sorel (in conjunction with his *L'Indépendance* allies) incorporated religious belief into his program by proclaiming the battle between Dreyfusard republicans and their Catholic adversaries a momentous confrontation between decadent and regenerative forces in French society. The myth of a Catholic France, purged of destructive rationalism, would now sustain the forces of resistance. Though "the present time is not favorable to grandeur," Sorel wrote in a 1910 appendix to *The Illusions of Progress*, "History teaches us that greatness cannot be absent indefinitely in that part of mankind that possesses the incomparable treasures of classical culture and the Christian tradition."[96] That same year Sorel published his review of Péguy's *Le mystère de la charité de Jeanne d'Arc* (1910) in *L'Action française*, setting in motion his postsyndicalist approach to myth making. Sorel opened his essay by describing Péguy's text as a healthy antidote to the decline in French patriotism that had followed the Franco-Prussian war. In Sorel's estimation "the Dreyfusian revolution" was a direct product of this ebb in patriotic fervor; thus it was all the more telling that a "former Dreyfusard" such as Péguy should resuscitate patriotic sentiment.[97] Sorel lauded Péguy's choice of Joan of Arc as a literary vehicle, because the legend of her Catholic piety and patriotism had all the hallmarks of a regenerative myth in the Sorelian sense. As proof of the potency of this synthesis Sorel pointed to the "extraordinary Christian renaissance" that had occurred among the German literati during the wars for German independence and national unification. Just like Péguy, these German writers had never separated "la patrie from religion." The Germans ostensibly had French counterparts in the romantics, and still later, in Victor Hugo, a writer who recognized "the poetic utility" of theology. However, Péguy had trumped them all by turning to "ecclesiastical literature" for poetic inspiration, thus couching his patriotism in a genre that "cedes nothing to the rationalists."[98] Péguy's text was thus full of "fervent praises, lamentations, and supplications" that had a genealogy in "the predramatic genre from which developed Aeschylean drama."[99] Catholic liturgy, like ancient Greek drama, appealed to fundamental human emotions, and Péguy's synthesis of the two represented

the "triumph" of art over "false science." Sorel then described the impact of Péguy's text on the reader. The poet's ceaseless shift from "popular represen-tations" to "orthodox formulas" throughout the text provoked an "oscillation" in our imagination, and a sympathetic appeal to our own quotidian memo-ries. Péguy's prose was full of rhythmic patterns and vivid images whose basis in Greek drama and liturgical laments was antithetical to rational discourse. "Everyone knows," Sorel continued, "that ecclesiastical eloquence does not follow the same law as profane eloquence" and that religious "homilies" can never serve as models for "political discourses" or judicial arguments. When "lyricism touches the supernatural it multiples the repetitions, the progression of images, the reiteration of ideas expressed: it seems to be more inspired by musical procedures" than by the rules followed by more ordinary writers.[100] Sorel's praise of Péguy's antirationalist recourse to images and lyrical rhythms reiterated the Bergsonian tenets behind his own notion of "mythic images" developed in his *Reflections on Violence*, but he now incorporated a theory of literary form and cultural tradition into that matrix.[101] If critics were to find a painterly equivalent to Péguy's technique, states Sorel, they should study "paintings prior to Raphael." Sorel attributed Péguy's mastery of this method to his strong grasp of "classical culture" before concurring with Maurice Bar-rès that *Le mystère de la charité de Jeanne d'Arc* was destined to have an "edu-cative" effect on the French public. Through the rhythmic power of images, readers could once again perceive "the eternal soul of France." Sorel fully ex-pected the "boors" in political power to disparage Péguy's ode to Joan of Arc, but he, like Barrès, welcomed its "harshly Catholic (âprement catholique)" ap-peal to the "French tradition."[102]

I would argue that this synthesis of Sorelian myth with the aesthetics of Greek drama, Christian liturgy, and the art of the Italian "primitives" served as the blueprint for the cultural program developed in *L'Indépendance* a year later. The writers for *L'Indépendance* repeatedly identified the neo-Catholic revival with a return to the aesthetics of classical Greece, all in the service of the Sorelian sublime. In a July 1911 review of Claudel's neo-Catholic play *L'Otage* (The Hostage) of 1909, Sorel compared the drama's theme of mystical transcendence through earthly suffering to the central role given to the hero in Greek myth, noting that Claudel's play recalled the spirit of self-sacrifice evoked in the tragedies of Aeschylus.[103] As we shall see the *Indépendance*

group claimed that Christianity also encouraged heroism by celebrating the moral and physical suffering of Christ and that of the saints. The doctrine of vicarious suffering had a special appeal for Sorel's Catholic allies, since it held that good Christians could atone for the sins of others through their own suffering, in emulation of Christ's sacrifice on behalf of humanity. Like Greek myths, or the myth of the general strike, Catholic myths had a regenerative role to play in French society. Similarly, Sorel's likening of religious faith to working-class consciousness signaled his belief that Christianity, like syndicalism, could be a regenerative defense against an immoral world.

The appearance of *L'Indépendance* in 1911 made public the Sorelians' endorsement of the medieval and Pre-Raphaelite aesthetics championed by John Ruskin, whom Sorel held in the highest regard.[104] Having associated the creativity of the *vigneron* or proletarian with the revolutionary "sublime," Sorel now defended medieval workshop practices on similar grounds, substituting the sublimity of Christian faith as a mythic catalyst for social upheaval. Thus Sorel and his colleagues won over the Third Republic's Catholic adversaries by championing artists who combined religiosity with respect for the classical tradition and artisanal techniques. In an article of April 1912, André Fergan brought this thesis to bear in an assessment of the spiritualist theory of art expounded by Maurice Barrès in his 1912 text, *El Greco, or the Secret of Toledo*. Fergan cast Barrès's opposition to secularism in philosophical terms, declaring the writer's rejection of "pure intellectualism" for a literary method imbued with "love" and "sympathy" fully comparable to Bergsonian intuition. Since Sorel's *Reflections on Violence* identified Bergson's theory of intuition with revolutionary consciousness, Fergan clearly hoped to underscore the agitational potential of religious belief for the readers of *L'Indépendance*. Barrès, portrayed in a contemporaneous portrait by the Spanish artist Ignacio Zuloaga, thus joined Bergson in inspiring a religious revival in France synonymous with antirepublicanism (fig. 14). In Fergan's estimation Barrès's choice of El Greco as a subject was premised on that artist's own antirationalism. El Greco, we are told, had rejected the "science" of single-vanishing-point perspective that he had studied in Italy for a style of Byzantine abstraction expressive of fervent Catholicism.[105] The figural distortions and compressed spatial constructions in such works as El Greco's *Burial of Count Orgaz* of 1586–1588 therefore were testimony to the renewed Catholic faith that inspired his late painting, and his artistic response to the "tragic pathos" found in Byzantine

mosaics (fig. 15). It also confirmed Sorel's purported conviction that artists in old age become spiritually introspective, a theory in accord, states Fergan "with the theory of personality of Henri Bergson," who argued that "a weakening of the life force diminishes the contact of the spirit with present reality and lets it relive memories [and] emotions that appeared to be lost." El Greco's Bergsonian spirituality thus entailed a rejection of the rationalist precepts undergirding single-vanishing-point perspective for an aesthetic reflective of the antimaterialist values of an earlier Christian era. This assessment was very close to that of Barrès in *El Greco, or the Secret of Toledo*. In that book, Barrès compared El Greco's art to the religious painting of Zuloaga, proclaimed El Greco's aesthetic to be the product of spiritual antimaterialism, with Byzantine precedents, and asserted that "these paintings, thus placed at the heart of Spain, give us an intuition of the motives of this nation in its classical age." He also argued that "to the extent that he advances in age, it seems that the dreams of the artist are charged more and more with religious meditations."[106] Not surprisingly Zuloaga's portrait of Barrès—painted after his book appeared— positioned the writer on a bluff above Toledo in emulation of El Greco's *View and Map of Toledo* (1608, Museo del Greco, Toledo).[107]

Barrès's enthusiasm for Zuloaga was shared by others in the circle of *L'Indépendance*, most notably Elémir Bourges. Zuloaga's popularity stemmed in part from that artist's allegiance to the neo-Catholic symbolist Emile Bernard, whose journal *Rénovation esthétique* (1905–1910) advocated a return to Catholicism and the religious aesthetics of medieval Europe as well as of Renaissance Italy.[108] Bernard had first met Zuloaga in 1897, and in subsequent years they developed a strong friendship based on their mutual respect for the sacred art of Italy and Spain. Bernard's *Rénovation esthétique* was instrumental in promoting fellow revivalists such as Armand Point and Zuloaga among Bernard's hardline Catholic constituency. Thus *Rénovation esthétique* published articles praising the traditionalism of Point and Zuloaga in tandem with laudatory reviews of writings by Barrès and neo-Catholics such as Léon Bloy, Bourget, Claudel, and Jammes. Bernard also facilitated Zuloaga's exposure to neo-Catholic circles: for instance, he introduced Zuloaga to Bourges in 1907. Zuloaga's encounter with Bernard reinforced not only his own return to the Spanish masters but also the symbolist underpinnings of his aesthetic, as manifest in his brooding portrait of Elémir Bourges (1907).[109]

Fergan's association of Byzantine aesthetics with antirationalism and re-

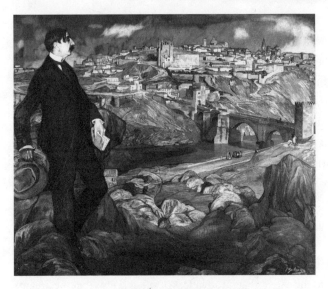

Fig. 14. Ignacio Zuloaga y Zabaleta, *Portrait of Maurice Barrès with Toledo in the Background,* 1913. Oil on canvas. Musée historique Lorrain, Nancy, France. © 2006 ARTISTS RIGHTS SOCIETY (ARS), NEW YORK/VEGAP, MADRID.

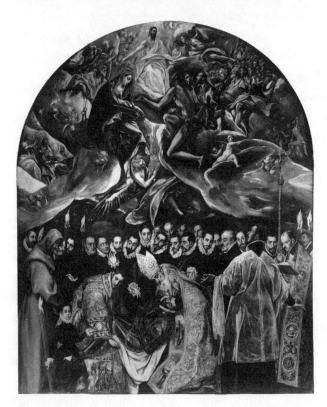

Fig. 15. El Greco, *Burial of Count Orgaz,* ca. 1586–1588. Oil on canvas. S. Tomé, Toledo.

Fig. 16. Ignazio Zuloaga y Zabaleta, *Portrait of Elémir Bourges, author,* 1907. Oil on canvas, 195 × 104 cm. Chateaux de Versailles et de Trianon, Versailles, France. Photo: G. Blot, Réunion des Musées Nationaux/Art Resource, N.Y. © 2006 ARTISTS RIGHTS SOCIETY (ARS), NEW YORK/ VEGAP, MADRID.

ligious resurgence was endorsed by Sorel himself, both in the pages of *L'Indépendance* and in Jean Variot's reminiscence of a visit, in mid-April 1911, with Sorel to the Paris studio of Zuloaga. Sorel's visit was sparked by his admiration for Zuloaga's portrait of Bourges and his hope to obtain photographs of the artist's paintings for reproduction in *L'Indépendance.* Rather than choose a portrait for reproduction, Sorel immediately gravitated toward Zuloaga's religious paintings, in particular a scene of the lamentation at Calvary, in which Zuloaga had used contemporary Basque peasants as his models for the holy entourage. Although that painting is now lost, it probably resembled Zuloaga's contemporaneous *Christ of the Blood* (1911), which depicted a Catholic order of humble penitents contemplating Christ's sacrifice. Both these paintings took the theme of vicarious suffering as their central motif, with the peas-

ant models forming a psychological bridge between the crucified Christ and the workaday world of the contemplative beholder. Variot recorded Zuloaga's comparison of the figural and spatial distortions in his depictions of the crucified Christ to El Greco's *Burial of Count Orgaz*, and Sorel's positive assessment of the "dramatic atmosphere" created by both artists. Sorel claimed that his emotive reaction to Zuloaga's religious painting stemmed from its compositional structure as well as its religious content: the contemplation of Christ's sacrifice. As a celebration of the Catholic belief in vicarious suffering, paintings such as these were exemplary of the spiritual ideals Sorel and his followers wished to promote.[110] Sorel then embarked on a long exegesis, celebrating Zuloaga's adherence to past masters as evidence that his call for artists to honor the "ancients" in his *Illusions of Progress* had not gone unheeded. According to Sorel, Zuloaga's painting possessed a "grandeur of conception" comparable to the art of Michelangelo, Velasquez, and El Greco. Sorel then condemned the impressionists as moderns who had purportedly rejected the old masters' search for compositional "form."[111]

L'Indépendance promoted painters and sculptors who adhered to Sorel's precepts. As we have seen, Maurice Denis indicated his sympathy for Sorel's and Variot's cultural program by joining the editorial board in 1913.[112] Sorel's claim that impressionist painting lacked compositional structure echoed the art criticism of Denis, who never tired of contrasting impressionist technique with his own emulation of the fresco painting of such artists as the Italian "primitive" Fra Angelico.[113] In 1913 *L'Indépendance* published a poetic eulogy to Denis, praising a painting titled *Our Lady of the Schools* of 1903 (fig. 18) as evidence of the rebirth of religious painting in France, and as a pictorial manifesto against republican attacks on Catholic education.[114] Denis's painting placed the Virgin and Christ child in a modern school room, where they are reverently greeted by a group of students, sheltered by nuns. From a compositional standpoint the painting clearly recalls the painting of Duccio and Fra Angelico; from an ideological perspective it anticipates the mixture of cultural and religious values promoted in *L'Indépendance*, as well as the tertiary theme of *revanche* (revenge) (Mary's head intersects with a map of France where the "lost" provinces of Alsace and Lorraine are painted blood red). The journal also championed the former symbolist and Pre-Raphaelite enthusiast Armand Point, who had set up an artists' colony in 1897 near Fontainebleau

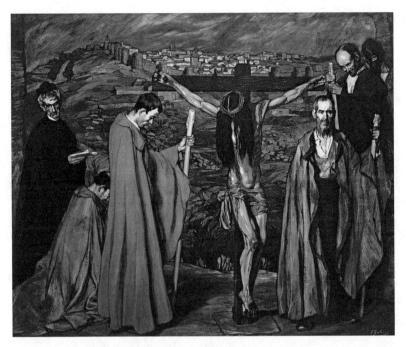

Fig. 17. Ignazio Zuloaga y Zabaleta, *The Christ of the Blood (El Cristo de la Sangre)*, 1911. Oil on canvas. Cason del Buen Retiro, Madrid, Spain. Photo: Eric Lessing/Art Resource, N.Y. © 2006 ARTISTS RIGHTS SOCIETY (ARS), NEW YORK/VEGAP, MADRID.

with the expressed aim of reviving medieval and early Renaissance workshop practices in emulation of William Morris's arts and crafts movement. This artisanal cooperative was cofounded by Sorel's literary ally Elémir Bourges, who introduced Cennino Cennini's Renaissance treatise on artisanal practices to Point's followers.[115] *L'Indépendance* publicized Point's achievements by reproducing a handcrafted casket made in Point's studio workshop, which synthesized elements of late Gothic and early Renaissance design, all serving the thoroughly symbolist theme of an arcadian "island of happiness." The July 1911 issue had an article by Jean Variot on the revived Catholic Salon de la Rose + Croix, which included Point among its original membership.[116] Members of the group also returned to medieval craft traditions for inspiration, as evidenced in the design created by a Rose + Croix adherent named Angel. Angel's image of the rose and cross was a frontispiece for the religious poetry of Paul Claudel reproduced in a November 1911 issue of *L'Indépendance*.[117] Variot drew comparisons between Angel's art and that of Maurice Denis, and

declared the Rose + Croix collective to be made up of "good workers," whose art was modeled after the Bardi Chapel frescoes created by the Florentine Trecento artist Giotto.[118] Variot then went on to praise Denis's spring 1911 exhibition of illustrations for the *Fioretti* (*Little Flowers*) of Saint Francis, which were based on sketches made during a recent trip to Umbria and Tuscany.[119] In a December 1912 article in *L'Indépendance* Sorel made public his own high estimation of Giotto, whose frescoes of the life of Saint Francis reportedly testified to the artist's fervent Christianity and interest in Byzantine aesthetics. Sorel claimed that Byzantine artists had retained a knowledge of classical form, and that Giotto's familiarity with Byzantine ivories had allowed him "to acquire a clear consciousness of his genius" by studying the Greeks.[120] Indeed, Sorel's refashioning of Giotto as the Pre-Raphaelite counterpart to El Greco had a resounding echo in Jean Variot's essay on the 1911 Rose + Croix exhibition, which praised Angel for having exhibited copies of Giotto's frescoes of Saint Francis at the Church of Santa Croce. Byzantine icons, medieval workshops, and the religious painting of Giotto and El Greco had thus set a precedent for artists like Denis, Zuloaga, Angel, and Point in their own revolt against naturalism. Hieratic form, spatial planarity, and figural distortion were the aesthetic manifestations of a new political order, divorced from the Enlightenment foundations of the Third Republic. It is equally telling that Sorel and Variot would laud artists who took Giotto's representations of the life of Saint Francis as their inspiration, for the saint's ascetic renunciation of worldly goods fitted well with the antimaterialist tenets of Sorel's cultural program.

In the realm of sculpture, the Sorelians favored Charles Despiau (1874–1946), whose *Bust of Paulette* was reproduced in an October 1911 edition of the journal (fig. 21). At the time Despiau was involved in a parallel revival of Italian "primitive" sculpture, modeled after the fifteenth-century religious works of Donatello and the Italian portrait busts of the Florentine Antonio Rossellino (as well as Greek classical sculpture).[121] Despiau's portrayal of French peasants in the manner of Rossellino confirmed the correlation, in *L'Indépendance*, of medieval revivalism with an art of the people, while the religious fervor animating this art was conducive to the aesthetics of royalists such as Denis. The relation of such work to militant Catholicism was made explicit in Emile Pompineau's design for a bust of Joan of Arc, reproduced in the June 15, 1912, issue of *L'Indépendance* (fig. 22). Following his 1910 eulogy to

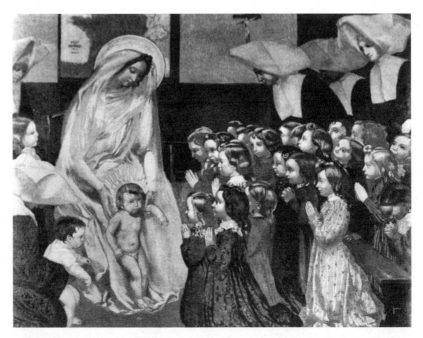

Fig. 18. Maurice Denis, *Our Lady of the Schools*, 1903. Oil on canvas, Musées Royaux des Beaux-Arts de Belgique, Brussels, Belgium. © 2006 ARTISTS RIGHTS SOCIETY (ARS), NEW YORK/ADAGAP, PARIS.

Péguy's poem honoring Joan of Arc, Sorel had unceasingly praised the saint as the very embodiment of the spirit of France, a figure whose peasant origins, mystical belief, and militant patriotism gave her an exalted place in the Sorelian pantheon. Indeed *L'Indépendance* commemorated the five hundredth anniversary of her birth by publishing a limited-edition book by Maurice Barrès, illustrated by Angel. *Le jubilé de Jeanne d'Arc* juxtaposed Barrès's regionalist tribute to Joan of Arc with woodcuts by Angel, celebrating her fervent Catholicism (fig. 23). Angel's designs were medieval in inspiration, but his perspectival settings also recalled the Pre-Raphaelite aesthetics of illustrators associated with the circle of William Morris (fig. 24). As Michel Winock has pointed out, reactionaries such as Edouard Drumont and Maurras never tired of contrasting Joan, as the embodiment of plebeian, Catholic France, with the wealthy, rootless cosmopolitanism of the Jew; thus it is appropriate that this symbol of France should find a home in the pages of *L'Indépendance*.[122]

The fusion of art and religion was also the primary aim of the Catholic composer Vincent d'Indy, who was on the editorial board of *L'Indépendance*

Fig. 19. Armand Point, *Coffret de l'Ile Heureuse*, ca. 1903. Enameled relief, cloisonné. Reproduced in *L'Indépendance*, 1 June 1912.

from the journal's inception (fig. 25).[123] In 1896 d'Indy had cofounded the self-proclaimed, antirepublican Schola Cantorum in an attempt to revive religious music in France, particularly the Gregorian chant and late medieval and Renaissance polyphony. Housed in a former Benedictine monastery on the rue St. Jacques in Paris, the Schola itself was launched as a direct challenge to the "secular" teaching promoted at the state-sanctioned Conservatoire (fig. 26).[124] The use of the name Schola Cantorum was in emulation of the first Roman schola, founded in the seventh century to sing liturgical chants in the Papal Chapel. In his book *Une école de musique répondant aux besoins moderne* (1900), d'Indy had insisted that music should bring about "the gradual elevation of humanity" by imbuing art with "a sense of the sublime."[125] In his pedagogical writings d'Indy described the self-effacing religiosity of the medieval artist as the ideal he wished to emulate through a collaborative, rather than competitive, approach to learning.[126] Most important, d'Indy structured the

Fig. 20. Angel, *Rose and Cross*, 1911. Engraving. Reproduced in *L'Indépendance*, 15 November 1911.

Schola's curriculum around an intensive study of the Western musical tradition, beginning with early liturgical chant. At the time the Conservatoire had largely ignored the history of music, and d'Indy railed against that institution for favoring technical virtuosity—defined in terms of contemporary taste—over a historical understanding of musical praxis. D'Indy's religiosity, his championing of tradition, and his appeal to the sublime, was tailor-made for Sorel, whose praise of sublimity in art and religion, and adherence to the ancients over moderns, virtually replicated the tenets of d'Indy's program. Concurrent with his involvement in *L'Indépendance*, d'Indy was in close contact with Denis, whose exposure to Sorel's ideas was likely mediated through the composer as well as Variot.[127]

The ideological alliances forged by *L'Indépendance* culminated in d'Indy, Denis, and Variot's collaboration in the staging of Paul Claudel's religious play *L'Annonce faite à Marie* (The Tidings Brought to Mary) at Lugné-Poë's

Fig. 21. Charles Despiau, *Bust of Paulette*, 1907. Reproduced in *L'Indépendance*, 15 November 1911. © 2006 ARTISTS RIGHTS SOCIETY (ARS), NEW YORK/ADAGAP, PARIS.

Fig. 22. Emile Pompineau, *Bust of Joan of Arc*, n.d. Reproduced in *L'Indépendance*, 15 June 1912.

MAURICE BARRÈS
DE L'ACADÉMIE FRANÇAISE

LE JUBILÉ
DE
JEANNE D'ARC
ORNÉ
DE SIX COMPOSITIONS
D'ANGEL

VIS ET VIRTUS

PARIS
ÉDITIONS DE « L'INDÉPENDANCE »
31, RUE JACOB, 31

M. DCCCC. XII.

Fig. 23. Maurice Barrès, *Le jubilé de Jeanne d'Arc* (Paris: Editions de "*L'Indépendance*," 1912).

Fig. 24. Angel. Illustration from Maurice Barrès, *Le jubilé de Jeanne d'Arc* (Paris: Editions de "*L'Indépendance*," 1912).

Fig. 25. Photograph of
Vincent d'Indy, 1913.
Reproduced in Leon Vallas,
Vincent d'Indy, vol. 2 (Paris:
Editions Albin Michel, 1950).

Fig. 26. Concert Hall, Schola Cantorum, rue Saint Jacques, Paris, n.d. Reproduced in Leon
Vallas, *Vincent d'Indy*, vol. 2 (Paris: Editions Albin Michel, 1950).

symbolist Théâtre de l'Oeuvre in December 1912.[128] D'Indy arranged for Schola Cantorum singers to perform the play's choral music, while Variot designed the austere stage sets. Maurice Denis's painting *Catholic Mystery* of 1891 was reproduced on the program cover for the play, thus making Claudel's drama a Sorelian *Gesamtkunstwerk*.[129] Sorel, in a 1911 edition of *L'Indépendance*, claimed Claudel's theatrical productions were modeled after the "mythological" plays of ancient Greece, and that the heroic sacrifice celebrated in Aeschylus's *Prometheus* was comparable to that found in the "religious tragedies" of Claudel.[130] From a Sorelian perspective Claudel's *L'Annonce faite à Marie* celebrated the heroism achieved through vicarious suffering, since the play's protagonist, Violaine, becomes a leper through an act of Christian charity. At the play's Christmas Eve climax, the dying Violaine brings her sister's child back to life, just as Joan of Arc is crowning the dauphin at Rheims.[131] Thus Claudel drew a parallel between Violaine's spiritual heroism and that of Joan, a symbol, in Sorelian circles, of militant Catholicism.[132] Indeed Fergan and Variot affirmed Sorel's assessment of Claudel in articles on the play and its stage sets, published in the December 1912 issue of Lugné-Poë's journal *L'Oeuvre*.[133] Echoing Sorel, Fergan described *L'Annonce faite à Marie* as a medieval "mystery play," before comparing Claudel's prose to that of Aeschylus. "Claudel does not use regular verse in his drama," wrote Fergan; instead, his verse "resembles that of Greek or Latin prose, and the iambic trimeter of Greek tragedy."[134] Variot in turn proclaimed his Sorelian allegiances in the play's epilogue, by modeling the symbolic tree of life for the theater backdrop on medieval tapestry design, and basing the proportional relation of performers to his stage sets on the paintings of the Siennese primitive, Duccio.[135] Variot later acknowledged Sorel's influence on his theater backdrops, stating that Sorel had advised him on his designs throughout their development.[136] Sorel described Claudel's play as advocating a "profoundly rigid orthodoxy," and instructed Variot to avoid realism in his designs so that the audience could transcend the material world and grasp the "sublime" message of Christianity.[137] Sorel then counseled Variot to plunge the actors into shadow, so that spectators would concentrate on the spirituality of Claudel's text, rather than on the external appearance of the actors themselves. To Sorel's mind, the vague silhouettes would evoke a spiritual realm more conducive to the religious import of the play itself.[138] Like symbolists of his era, Sorel seems to have valued shadow for

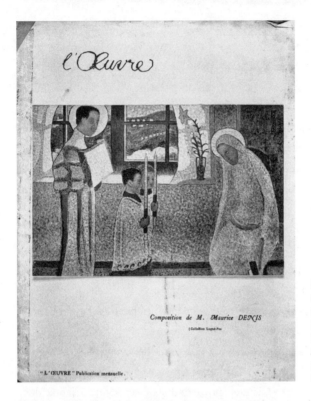

l'Oeuvre

Composition de M. Maurice DENIS

[Collection Logné-Paz]

" L'ŒUVRE " Publication mensuelle.

Fig. 27. Maurice Denis, *Catholic Mystery*, 1891. Oil on canvas. Reproduced in *L'Oeuvre*, December 1911. © 2006 ARTISTS RIGHTS SOCIETY (ARS), NEW YORK/ADAGAP, PARIS.

Fig. 28. Jean Variot, *Tree of Life*, 1912. Conté drawing on paper. Reproduced in *L'Oeuvre*, October–December 1912.

its powers of suggestion and its association with the inner realm of the soul, rather than the mundane world of outward appearances.[139] Sorel's enthusiasm for Lugné-Poë's production was such that he became, in Variot's words, an "intransigent Claudelian."[140]

Anticapitalist Anti-Semitism

While the mythic power of Catholicism served to reinvigorate France, proponents of rationalism in both art and politics actively undermined such resurgence. In Sorel's own day, Enlightenment philosophers were replaced by politicians as symbols of decadence, with the difference that parliamentary socialists such as Jean Jaurès substituted democratic ideology for the social contract, and catered to an idle bourgeoisie rather than the landed aristocracy. "Parliamentary socialism," argued Sorel in *The Illusions of Progress*, "would not recruit so many adherents among the wealthy class if Jaurès's revolutionary harangues were taken seriously in those rich bourgeois circles that seek to imitate the inanities of the old aristocracy."[141] Worse still, these socialists also campaigned among the working class. According to Sorel, the parliamentary socialists who had mounted a defense of Captain Dreyfus founded the *universités populaires* after 1899 to spread democratic ideology and bourgeois culture among the working class. "Democracy has as its object the disappearance of class feeling," wrote Sorel, and if "the movement that, for several years, propelled the most intelligent workers toward the popular universities had developed as the bourgeoisie had wished, [revolutionary] socialism would have fallen into the democratic rut.... Instead of teaching workers what they need to know to equip themselves for their life as workers," the popular universities strived "to develop in them a lively curiosity for things found only in books written to amuse the bourgeoisie." As a result "the public universities were a vast advertisement for reading the books of the Dreyfusards."[142] In *The Illusions of Progress*, Sorel also attacked the writer Anatole France, describing him as a Dreyfusard who frequented the literary salons of wealthy Parisians. "Following the Dreyfus Affair," wrote Sorel, France became "a refined boudoir entertainer of the Monceau Quarter," whose "little drolleries to the fine ladies and gentlemen of high finance" eventually transformed him into "an oracle of socialism."[143] Woven into this latter description were the threads of anticapitalist anti-Semitism, for the correlation of Dreyfus's defenders with figures

of "high finance" was a theme that would reappear in Sorel's writings on culture for *L'Indépendance*. By contrasting "financiers" with the truly productive members of French society, Sorel wished to underscore the classless, unproductive, and rationalist nature of financial speculators, whom he stereotyped as Jews. For Sorel, these Jewish capitalists were instrumental in promoting the Republic's abstract concept of citizenship, thereby suppressing the class identity and the productivist ethics Sorel wished to develop. The social corollary to this anti-Semitic anticapitalism was decadence in the realm of art. "It is often asked why rich Jews are so sympathetic to utopian ideas and sometime give themselves socialist airs," wrote Sorel in *The Illusions of Progress*, and in response he attributed the phenomenon to their economic condition. "These men live on the margins of production," Sorel proclaimed; "literature, music, and financial speculation are their interests," and their "outspoken boldness [thus resembles] that of eighteenth-century gentlemen." [144]

In an article of October 1912 published in *L'Indépendance*, Sorel took this thesis to its logical conclusion in a diatribe against the symbolist and pro-Dreyfusard journal *La revue blanche* (1890–1903). [145] As Venita Datta has demonstrated, *La revue blanche* was a major target for the anti-Dreyfusard camp because of the high number of Jewish intellectuals on its editorial staff, its alliance with Dreyfusards in the universities, and the journal's defense of the concept of "abstract" citizenship that regionalists, Catholics, and royalists found so abhorrent. [146] Sorel added his own voice to this chorus by vilifying *La revue blanche* as an unholy alliance between a fully secularized Jewish intelligentsia and their anarchist counterparts among the Nabis and neoimpressionist painters. Having condemned Dreyfus's supporters for rejecting the French tradition and propagating a concept of nationhood premised on a faith in "the dialectic of absolute reason," Sorel described the "fanatical" idealism of the *Revue blanche* circle as the logical outcome of such thinking. Quoting liberally from Henry de Bruchard's anti-Semitic *Petites mémoires du temps de la ligue* (1912), Sorel referred to the journal's founders, the Natanson brothers, as "two Jews come from Poland in order to regenerate our poor country, so unhappily still contaminated by the Christian civilization of the seventeenth century." [147] These foreigners reportedly set out to corrupt French literature, and in so doing enlisted the anarchist Félix Fénéon in their cause, making him the journal's editor-in-chief. [148] Sorel, like his close ally Edouard Berth,

equated the anarchist defence of individual freedom with the atomized ratio-nalism stemming from parliamentary politics, and both doctrines served the Jewish intelligentsia's desire to merge classes under an abstract concept of citizenship.[149] "The paradoxical collaboration of classes which arose with the Dreyfus Affair," stated Sorel, "was only an imitation of that which took place in the Natanson academy." Thus *La revue blanche*, which numbered the anar-chists Fénéon, Félix Vallotton, Maximilien Luce, and Paul Signac among its contributors, was condemned by Sorel as "a salon of cosmopolitan anarchy, where esthetes rubbed shoulders with usurers and impressionist painters . . . or more to the point, those who had provoked bomb throwing."[150] For art-ists such as Maurice Denis, Sorel's anti-Semitic polemic against those sym-bolists associated with *La revue blanche* would have served to confirm his own previous attacks on the journal, and his division, in 1899, of symbolism into "Semite" and "Latin" camps, with the *La revue blanche* adherents Edouard Vuillard, Pierre Bonnard, and Vallotton numbered among the former, and the neo-Catholics Paul Sérusier, Paul Ranson, and Denis himself among the latter.[151]

Berth lent theoretical weight to this thesis in his book *Les Méfaits des intellectuels* (The Misdeeds of Intellectuals), which outlined his synthesis of Sorelian syndicalism and royalism. In his book Berth claims that democ-racy, as an ideology, wants to deny qualitative differences and subsume "all life in the flat transparency of an antimetaphysical, antipoetic, and antivital rationalism."[152] The virtue of both the Action Française and the syndicalist movements, states Berth, is that they recognize such differences in the form of bourgeois and aristocratic values in the case of the royalists and proletarian consciousness among the syndicalists. In a chapter titled "Tradition and Revo-lution" Berth singles out the intellectual as the chief spokesperson for democ-racy, antithetical, he adds, to the "ancient values, heroic, religious, warlike, na-tional," that would constitute a regenerated France.[153] It is these intellectual advocates of pacifism and enlightenment rationalism who hold republican ideals; as "stockholders on the market of ideas" they "are like their accomplices the stockholders of the Bourse, completely devoid of all sentiment of honor and eternally dedicated to trickery, that weapon of the weak." Berth claims that these intellectual and economic stockholders, divorced from the ethics of production, reject the "ideal of virile dignity" that would exist under a Sorelian

"warrior state."[154] It is "their essential feminine nature and impotence" that makes them incapable "of having or acquiring the force, loyalty, the duty, the feeling of honor of the soldier."[155] Berth's anti-Semitic diatribe reached a crescendo in a section that singled out Julien Benda as "the Jew of metaphysics," "the Ghetto intellectual," "the quintessence and the extreme end of modern intellectualism."[156] Here we are told that Benda, the Cartesian adversary of Bergson, is as dead as his antivital ideas: he purportedly practiced "a philosophy of transcendental immobility" that left him enclosed in a darkened study, "stiffened in contemplation of his unchanging concepts." Most damning of all, Benda "wants to make us believe that in defending intellectualism he defends aristocratic conceptions" when in fact the "warrior" and "heroic" spirit of the true aristocrat is "anti-intellectual." In truth, declares Berth, Julien Benda is a Jew whose class allegiances are a sham, and his intellectualism is the philosophy of the uprooted and rootless, fully compatible with the universalist pretensions of democratic rationalism. Benda's rationalism, we are told "is antitraditional, antiphysical . . . [and] only wants to know 'pure spirits,' detached from all historical time and place." For this reason Jewish intellectuals are divorced from the peasantry and proletariat, the bourgeoisie and the aristocracy, for "the people, like the aristocracy, are a historical reality, a carnal reality; it is not the Pure Idea that constitutes them, but blood, traditions, race, all physical and nonintellectual things."[157] With Berth, Bergsonian intuition and qualitative differences have at last become essentialized as a racial and corporeal essence, and intellectualism reified into the disembodied, racial other, the Wandering Jew, foreign to the esprit de corps of the French folk.[158]

Perhaps the most public presentation of such views is found in d'Indy's opera *Légende de Saint Christophe* (Legend of Saint Christopher), written between 1908 and 1915. Based on the medieval Golden Legend and a local myth from the Ardèche region, the opera had stage sets designed by Maurice Denis and was performed to great acclaim at the Paris Opera in June 1920. Denis's depiction on the curtain of Saint Christopher carrying the Christ child showcased the religious import of the opera's narrative, in which the saint is locked in mortal combat with the corrupt King of Gold, symbolized by a Jew. In Denis's maquette for the palace of the King of Gold, the image of a goat at the center portal signaled the appearance of the king's ally, the Prince du Mal, as a symbol of universal evil. D'Indy's operatic score described the royal reti-

Fig. 29. Photograph of Julien Benda, 1930. Reproduced in Julien Benda, *Un régulier dans le siècle* (Paris: Gallimard, 1938).

nue as made up of so-called false artists carrying shapeless blocks of stone and canvases dotted with spots of bright color, and gold-spectacled "intellectuals," who join "false thinkers" in denouncing Catholicism and Christian charity while praising science and secularism.[159] The incorporation of Solomonic columns, the most ornate of the orders, into the palace façade heralds the excessive opulence and sexual depravity found in the interior as well as the Judaic origins of the reigning monarch.[160] D'Indy and Denis further emphasized the decadence and evil of these protagonists by basing the Prince du Mal and King of Gold on the grotesques carved into the capitals of medieval cathedrals.[161] D'Indy declared his opera an attack on the "Judeo-Dreyfusard" conspiracy that had supposedly poisoned French culture,[162] and the success of his 1920 production unfortunately illustrates the extent to which d'Indy could count on popular anti-Semitism to disseminate the concept, developed in the pages of *L'Independance* before 1914, of the Jew as anti-artist.

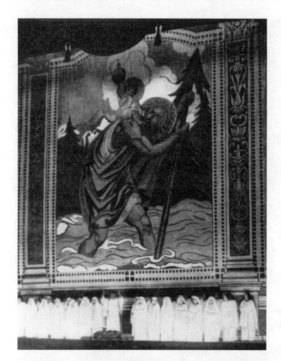

Fig. 30. Maurice Denis, *Curtain, Decor for the Prologue, La Légende de Saint Christophe,* 1925. Reproduced in *Cinquante ans de musique française, de 1874 à 1925,* ed. L. Rohozinski (Paris: Editions Musicales de la Librairie de France, 1926), 113. © 2006 ARTISTS RIGHTS SOCIETY (ARS), NEW YORK/ADAGAP, PARIS.

Fig. 31. Maurice Denis, *The King of Gold,* maquette for *La Légende de Saint Christophe,* 1920. Gouache on cardboard. Musée départmental du Prieuré, Saint-Germaine-en-Laye, France. © 2006 ARTISTS RIGHTS SOCIETY (ARS), NEW YORK/ADAGAP, PARIS.

Sorelian anti-Semitism by virtue of its déclassé conception of the Jew bears close resemblance to the model of anticapitalist anti-Semitism outlined by Pierre Birnbaum, who has charted the conflation, in French political discourse, of the Jew with *les gros*, a small group of international, cosmopolitan bankers.[163] According to this myth such bankers were prepared to exploit all classes; thus Edouard Drumont's *La libre parole* could picture the modern day Wandering Jew as an international financier without class allegiances, whose monetary dealing potentially placed the French state in jeopardy. Drumont's anti-Semitism was by no means fully conducive to Sorel's, for unlike Sorel, Drumont's economic anti-Semitism did not include a developed critique of the state and of Republican ideology. Yet Sorel's contrast between productive classes and the unproductive Jew would have found a sympathetic audience among Drumont's followers, who had already been exposed to images propagating this myth. For example, the cover of a December 1893 edition of Drumont's journal portrays three burly workers invading the office of a Jew, with the memorable caption "He doesn't work. He transacts!"[164]

On the left, anti-Semitism was also operative within syndicalist circles, and the prominent anarchosyndicalist artist Jules-Félix Grandjouan propagated that ideology in a series of drawings designed for a special issue of *L'Assiette au buerre* (29 December 1906), devoted to anticlericalism. In these drawings Grandjouan equated Christ with a Jewish usurer and insinuated that the clergy, like the stockbroker, exploited the productivity of others. Unlike the Sorelians, who would equate revolutionary consciousness with religious faith, the anti-Semitic syndicalists associated with such journals as *Le mouvement socialiste* followed Grandjouan's example in lumping Catholic prelates and Jewish bankers together in a wider conspiracy.[165] Thus Robert Louzon, in a 1906 article titled "The Bankruptcy of Dreyfusism or the Triumph of the Jewish Party," could inform readers of *Le mouvement socialiste* that "Semitism and clericalism constitute the two poles of the vast bourgeois alliance,"[166] while the Sorelian journal *La terre libre* avoided any critique of Catholicism and instead identified Freemasons together with Jews and politicians as the tripartite enemy of the working class.[167]

In sum the role of aesthetics in Sorel's anti-Semitic theory of class con-

Fig. 32. "Le juif errant."
La libre parole, 28
October 1893.

sciousness serves to underscore the integral relation of palingenesis to aesthetic discourse, for at the heart of Sorel's theory of national regeneration is a theory of art, and a racist discourse concerning art's antithesis. Not only did Sorel's Bergsonism lead him to condemn the Jew as the agent of corruption within the French body politic; the same thinking inspired his follower Berth to label Jews the very epitome of the "intellectual," the abstract, disembodied symbol of the "pure idea," divorced from all qualitative and corporative entities. As one without allegiance to any class or country, and as one affiliated with the economics of usury rather than production, the Jew exemplified all that served to stultify creativity. The Jew's transgression of qualitative differences broke other boundaries as well: thus Sorel's conception of a virile, masculine "warrior state" was anathema to the "femininized" male Jew, whose support of the politics of pacifist internationalism was testimony to his degenerative condition.[168] In Sorelian thought, the Jew exemplified a degenerative present

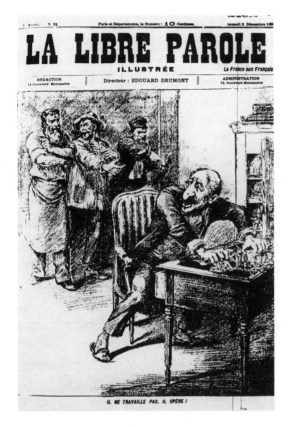

LA LIBRE PAROLE
ILLUSTRÉE
La France aux Français

RÉDACTION Directeur : EDOUARD DRUMONT ADMINISTRATION

IL NE TRAVAILLE PAS. IL OPÈRE !

Fig. 33. "Il ne travaille pas.
Il opère!" *La libre parole*,
2 December 1893.

to be overcome by a palingenetic turn to models of social renewal that would allow French society as a whole to reenter time's durational flux and realize its creative potential.

The theme of temporality is also central to Sorel's highly original interpretation of the classical sublime, which stood in stark contrast to rationalist interpretations of the concept developed in the Enlightenment era. For eighteenth-century philosophers and aestheticians the classical ideal was frequently premised on a sublime transcendence of materiality through the cognitive grasp of universal absolutes, discernable by way of rational reflection. As historian Harold Mah has argued, the ideal notion of the classical self developed during the Enlightenment defined subjectivity in terms of "its sense of self-sufficient rational plenitude, the feeling of rational self-possession, of being in control of oneself because one's physical responses to external circumstances have been rationally mastered."[169] The attainment of this classicist rational

subjectivity was premised not only on an overcoming of material physicality, as registered in one's sensory response to stimuli, but also on a related transcendence of "the vicissitudes of time" through rational apprehension of "the eternal principles of beauty," and of unchanging, universal concepts.[170] In moving from the particular to the general and from the sensate to the realm of pure ideas, the individual was able to master emotions and experience a rational concept of beauty unclouded by any "base" and thus morally suspect response. By the eighteenth century, aestheticians identified the attainment of such consciousness as an agon, or spiritual struggle against the physicality of the human body.[171] Johann Joachim Winckelmann (1717–1768) argued that the sculpture group known as the Laocoön (50 B.C.E.) realized the classical ideal through a dramatic contrast between the physical torment experienced by the central figure and the "noble simplicity and still grandeur" registered by that figure's facial countenance and bodily gestures.[172] Thus classicism was an expression of rational self-mastery, an act of will to overcome the contingency of human existence in order to grasp an edifying "eternal" beauty antithetical to the sensate.

Sorel's concept of the classical sublime overturned the rationalist assumptions of Winckelmann and his Enlightenment contemporaries. Instead of interpreting sublime transcendence in terms of a cerebral flight from temporality, Sorel argued that Bergsonian duration was at the heart of his concept of mythic consciousness, whether manifest in the heroism of the Greek citizen-soldier, the revolutionary esprit de corps of the syndicalists, or the creative urge that gave birth to art and industry, both antique and modern. Intuition, rather than rationality, was the psychological agent of willed transcendence: instead of moving beyond the "the vicissitudes of time" the Sorelian revolutionary actively transformed human history by conceiving his own actions as in sympathetic consort with his peers, whose revolt against rationalism would bring about an apocalyptic change, a qualitative break with the past. By allying such consciousness to the agon of classical Greek tragedy and neo-Catholic notions of vicarious suffering, Sorel and his *Indépendance* allies actively carried this revolutionary project forward into Sorel's postsyndicalist phase. Art was not marginal to this project but central to it, for revolutionary consciousness was synonymous with the antirationalism of classicist intuitive subjectivity.

The economic dimension of this temporal discourse underscores the historical genealogy of Sorel's anti-Semitism. During the Middle Ages Catholics followed Saint Augustine in regarding time as sacred, and thus something not to be bought and sold by a Christian. Since time necessarily belongs to all God's creatures it could not be possessed by any one individual, which meant that the profit derived from a mortgage on time amounted to a form of sin. As Jacques Le Goff has pointed out, "the whole economic life at the dawn of commercial capitalism is here called into question," for the medieval correlation of earnings on time with usury implicated both the principle of interest and that of credit as economic possibilities. As a result the selling of time was left to those outside the Christian community, namely the Jews, and the division between redemptive *kairos* and sinful *chronos*, sacred time as opposed to its commodified counterpart in human affairs, was embedded in the economic relation of Christians to Jews.[173] Sorel's simultaneous association of the homogenized treatment of time as a commodity with fiscal speculation on the part of Jewish financiers, and relation of the regenerative force of durational creativity in the workplace to religious faith, constituted a revival of this Augustinian view on temporality for a twentieth-century audience.

Indeed it is this discourse that gives us insight into Sorel's attack on one of the most celebrated Jewish intellectuals of his era: Henri Bergson. Sorel's post-syndicalist correlation of Bergsonian intuition with religious faith ironically undergirded his criticism of Bergson himself, whose status as a Jew allegedly crippled his ability to fully discern the religious implications of his own philosophy.[174] Thus in an article of 1910, Sorel claimed that Bergson was unable to fully comprehend religious life because Western Judaism had been emptied of all religious substance. Religious faith in France, stated Sorel, "had taken refuge in Catholicism" and "being Jewish Bergson was hardly able to approach those who in our country practice religious life."[175] Sorel, in a November 1912 issue of *L'Indépendance*, even claimed that the Jewish community rejected Bergsonism because "it realized that the lessons of the celebrated philosopher could be utilized to justify Christianity."[176] This reprimand had graver consequences, for in Sorel's theory any diminishing of religious faith was accompanied by a decline into decadence, with political and economic implications. Sorel never tired of pointing out that the secularization of the Jewish community went hand in hand with its increased involvement in international

finance.[177] In his *Reflections on Violence*, Sorel praised the Jewish religion for instilling collective consciousness among the faithful during the earlier eras of religious persecution, even as he condemned the modern-day assimilated Jew as one devoid of any mystical belief, and thus wedded to mercantile interest and intellectualist ideology.[178] Though Bergson remained exempt from such criticism up until World War I, his support of the French war effort led Sorel to chastize him for caving into democratic ideology. Thus Sorel's declaration in a letter of 1918 that Bergson's wartime writings encapsulated "the opinions of the house of Rothschild" serves to remind us that no ally of the French Republic could escape Sorel's condemnation, even one whose own philosophy held the key to social regeneration.[179]

For Sorel, eighteenth- and nineteenth-century doctrines of progress facilitated the loss of class consciousness, religious faith, and productivist ethics, and at the nexus of this transformation was the artistic salon, an arena where rationalist discourse reigned supreme. Ultimately it was the Jewish intellectual, the figure who benefited most from Enlightenment concepts of citizenship,[180] who bore the brunt of Sorel and Berth's antidemocratic diatribe against the Third Republic. Far from being opposed to modernity, Sorel's revolution embraced classical antiquity and medieval culture, not with nostalgia, but with an eye to a future society of agrarian and industrial producers, in a France purged of both capitalism and democracy. Sorel thus takes his place alongside other proponents of palingenesis, the sublime, classicism, and concepts of secular religion, whose recourse to myth making facilitated a "cultural" revolution against Enlightenment precepts and democracy itself. This heady synthesis should have proven inspirational to Sorel's fascist disciples after World War I; that the cultural politics of *L'Indépendance* were appropriated in piecemeal fashion, rather than as a coherent doctrine, is very much due to the profound impact of the war on Europe as a whole. In the wake of the carnage of war, French fascists looked as often to Mussolini's regime as to Sorel and Berth's avant-guerre thought for sources of inspiration. This "dialogue" between Fascist Italy and fascists in France is the topic of my subsequent chapters, which examine the advent of Sorelian fascism in interwar France.

LA CITÉ FRANÇAISE

Georges Valois, Le Corbusier, and Fascist Theories of Urbanism

For some time now art historians have recognized that Le Corbusier's participation after 1925 in Ernest Mercier's organization Redressement Français, and subsequent endorsement of the regional syndicalism of Hubert Lagardelle during the 1930s, allied him in both cases to reactionary tendencies within French culture. In the early 1920s Le Corbusier adapted his modernist aesthetic, exemplified by his 1922 plans for the rebuilding of Paris publicized in the book *Urbanisme* (1925), to Mercier's promotion of a Taylorist, capitalist order. His later shift from the politics of Mercier to regional syndicalism led him to repudiate his rationalist modernism in favor of architectural forms whose curvilinear structure exemplified Lagardelle's "corporativist" and "organic" definition of the nation state.[1] Here I consider another reactionary aspect of Le Corbusier's career: the enthusiastic reception of his work within Georges Valois's fascist movement in the late 1920s and his

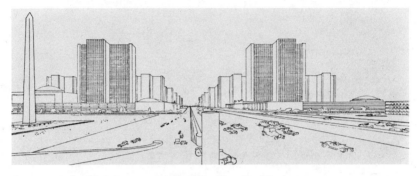

Fig. 34. Le Corbusier, "A Contemporary City." Reproduced in *Urbanisme*, 1925.

understudied impact on the aesthetics of that movement. To date, analyses of Le Corbusier's relations to French fascism have focused on his equivocations over the merits of the Faisceau, with little attention being given to the fascists' own theories or to their evaluation of Le Corbusier.[2] In taking up the latter theme I examine fascist theories of urbanism and the ways in which French fascism adapted Le Corbusier's modernist aesthetics to what Zeev Sternhell has termed fascism's "antimaterialist" ideology.[3] By analyzing the fascists' Sorelian and secular religious conception of a "productivist" ethic I reveal the profound gulf that separated fascists like Georges Valois from Le Corbusier and his technocratic allies in the Redressement Français. Whereas the former conceived Le Corbusier's plans in terms of the historically grounded, socio-economic public space the French refer to as *la cité*, Le Corbusier combined cultural references to urban designs of the Roman, monarchical, and imperial eras with a more abstract conception of urban planning, defining the city as a sociotechnical environment. Paul Rabinow has argued that Le Corbusier's technocratic orientation served to separate him from more traditional town planners, who adhered more closely to the idea of la cité; I will argue that this view of urbanism also separated Le Corbusier from Valois, who from 1910 onward upheld the concept of la cité developed by his mentor, the anarcho-syndicalist Georges Sorel.[4]

Founded on Armistice Day, 11 November 1925, the fascist movement was the vehicle of Georges Valois (1878–1945), an interesting figure whose career ranged from anarchism to royalism before World War I, and from fascism in the 1920s to libertarian communism in the 1930s (fig. 35).[5] Up to November 1925, Valois remained a disciple of Maurras and framed his theory of revolu-

Chapter 3

tion in terms of the restoration of the monarchy; with the creation of his independent fascist movement, Valois and his followers now hoped to ally former royalists and dissident leftists in a new movement that would resuscitate the right-left synthesis initially forged under the auspices of the Cercle Proudhon.[6] For Valois, fascism was a volatile combination of progressive and reactionary positions, and in the late 1920s Valois's doctrine of national socialism was designed to rid France of what he saw as the decadent effects of parliamentary democracy. Valois's break with Maurras resulted in open warfare with his former mentor, which probably played a role in Valois's decision to define his fascist corporativism along Sorelian lines from 1926 onward.[7] This shift in emphasis was most evident in his 1927 book *Le fascisme*, which declared fascism a doctrine of "national socialism" steeped in Sorelian precepts. By the time of the demise of Valois's organization in 1928, his plans for a fascist state called for the rebuilding of Paris to facilitate the corporativist and syndicalist structure informing his vision of a new society. This interest in urbanism emerged shortly after the Faisceau's founding in a series of articles in Valois's journal *Nouveau siècle* by Georges Oudard on the "new face of France," detailing the reconstruction of French cities and the modernization of industry in the wake of World War I.[8] In March of 1926 *Nouveau siècle* supplemented Oudard's analyses with an article by Yvan Noé on modern architecture in New York and two lengthy tracts by Valois calling for the administrative and economic reorganization of "Greater Paris." Noé's article chronicled the spirited defense of modern skyscrapers by two architects: the American Paul Theodore Frankl and the French architect Auguste Perret.[9] Both architects were praised for their support of new building materials such as reinforced concrete, and their endorsement of lack of ornamentation in modern skyscaper design. Valois's articles, published 12 May 1926, decried the bureaucratic fragmentation of "Greater Paris" into separate jurisdictions, so that urban planning for central Paris bore no relation to that for the burgeoning suburbs, despite the fact that France's "producers" inhabited both regions, working in the city center while residing in the suburbs. Under the fascist corporative and syndicalist order the myriad suburban municipalities beyond the city would be consolidated to reflect this socioeconomic reality. To achieve this, Valois called for the creation of a "unique assembly with a syndical, corporative and familial base" made up of delegates drawn from all classes. The assembly in turn would appoint a

Fig. 35. Photograph of Georges Valois, ca. 1925. Reproduced in *Nouveau siècle*, 17 July 1927, 3.

group of commissioners who would work together with local syndicats and corporations to coordinate urban development. Under their direction Greater Paris would be reorganized through the creation of highways connecting newly created industrial sectors to those reserved for garden cities. "Our city," Valois wrote, "must be the most beautiful city in the world, the best organized city, equipped with the most modern means of transportation, the city where an immense population of workers, of sales clerks, and of bourgeoisie, should be able to find the most beautiful, the most healthy habitations."[10]

Thanks to the work of Mary McLeod we now know that Le Corbusier was attracted to this fascist orbit in 1927.[11] As early as 16 May 1926, Le Corbusier's friend and Faisceau convert Pierre Winter cited the architect's 1925 book *Urbanisme* in an article in *Nouveau siècle* devoted to the hygienic dimension of fascist town planning. The prominent role given to war veterans in Valois's Faisceau probably won over Winter, who had served in the medical auxil-

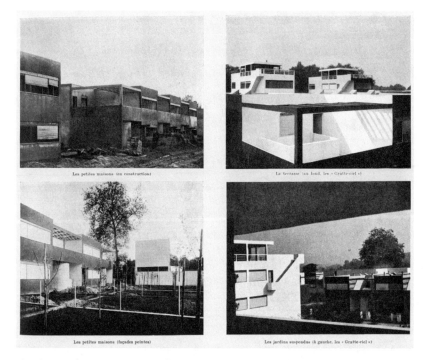

Fig. 36. Le Corbusier, *Le quartier moderne, Frugès,* Pessac, near Bordeaux, France, 1924–1926. Reproduced in *Le Corbusier et Pierre Jeanneret: oeuvre complète de 1910–1929* (Zurich: Les Editions d'Architecture Erlenbach, 1946), 81. © 2006 ARTISTS RIGHTS SOCIETY (ARS), NEW YORK/ADAGAP PARIS/FLC.

iary during World War I and had received the Légion d'Honneur in 1921.[12] In September 1926 Winter wrote another article on Le Corbusier, highlighting the architect's construction of worker housing at Pessac, near Bordeaux, for the millionaire businessman Henri Frugès.[13] By January 1927, Le Corbusier's ideas had become so popular among the fascists that he made the *Nouveau siècle*'s front page as one of the "organizers" (*animateurs*) of the French Faisceau. On March 20 the fascist Charles Biver published an article praising Le Corbusier's "Plan Voisin" for the rebuilding of Paris and urged his colleagues to study Le Corbusier's model for the city of Paris.[14] Biver's article recounted a slide show of the Plan Voisin Le Corbusier had presented to workers at a Parisian *bourse du travail*, thus attesting to the architect's popularity among the proletariat. Like Winter, Biver was a decorated war veteran, but he was also an engineer who had risen to become vice president of the Faisceau's Metallurgi-

Le Corbusier

Le Corbusier (Edouard-Jeanneret), né à la Chaux-de-Fonds en 1887, fondateur et directeur de l'Esprit Nouveau est l'un de nos architectes les plus remarquables.

Travailleur acharné et clairvoyant, ennemi de toute routine, ses idées, incomprises pendant quinze ans, le placent maintenant à la tête du mouvement urbaniste.

En collaboration avec Pierre Jeanneret, dans le domaine de l'habitation, qu'il s'agisse de villas, de villes entières ou de son plan du centre de Paris, Le Corbusier a fait beaucoup pour la standardisation du bâtiment.

Allez un jour à Pessac, près de Bordeaux, et visitez le quartier Fruges, vous y verrez : sobre de lignes, admirable de confort, éblouissante de lumière la cité future enfin réalisée par le génie d'un homme enthousiaste, sûr de sa science, qui a su rompre avec les procédés traditionnels.

Fig. 37. Photograph of Le Corbusier.
Reproduced in *Nouveau siècle*,
9 January 1927, 1.

cal Corporation by 1927.[15] By the end of March, Biver and fellow fascist René de la Porte-Lussignac were corresponding with Le Corbusier, who expressed a general interest in the Faisceau, without endorsing the movement.[16] René de la Porte was a war veteran and former member of the French Socialist Party who published under the name "Lussigne" to mask his fascist identity from his former colleagues.[17] Thus the fascists' attempts to recruit Le Corbusier were undertaken by figures representative of the Faisceau's military, technocratic, and leftist credentials at a time when Valois declared his renewed allegiance to the productivist and class-based dimension of Sorel's theory of national regeneration.

That effort apparently met with success, for the paper celebrated May Day with the inclusion of a drawing and extracts from the architect's own 1925

commentary in *Urbanisme* on the Plan Voisin (fig. 38). On May 8 fascist Marcel Delagrange—the former communist mayor of Périgueux—published an article calling for the rejection of outmoded concepts of urban development in conjunction with another piece by Winter containing extracts from Le Corbusier's *Urbanisme*.[18] Le Corbusier's association with the fascists was solidified on 20 May, when he gave a slide presentation of his urban designs at a fascist rally, valiantly inaugurating the Faisceau's move from sumptuous headquarters on the rue d'Aguesseau to a modest location at 63 rue du faubourg Poissonnière, near the Gare du Nord.[19] The move followed Valois's loss of financial backing for *Nouveau siècle* from perfume manufacturer François Coty. Coty severed his fiscal support for *Nouveau siècle* in the fall of 1926, concurrent with Valois's heated campaign against the Action Francaise and his reframing of the Faisceau along Sorelian lines.[20] The difficulties were compounded by the reappointment of the conservative Raymond Poincaré to head a government of "national union" in July 1926: this signaled the fall of the so-called Cartel des Gauches, a grouping of parliamentary radicals and socialists who had ruled from May 1924 to 1926. For Valois's right-wing supporters, Poincaré's rehabilitation provided the socioeconomic stability they desired, while Valois's public war with Maurras and his newfound enthusiasm for Sorel were considered increasingly alarming.[21] Thus Le Corbusier's involvement with the Faisceau occurred in the wake of this leftward turn, when the architect's own sympathies with syndicalism would have been welcomed by Valois. From May to July 1927, Valois published a series of essays in *Nouveau siècle* in which he allied his conception of the fascist "New Order" with Le Corbusier's "New City."[22] Valois declared Le Corbusier's architectural ideas an expression "in forceful images" of "the profoundest tendencies of the Faisceau," before admitting that Le Corbusier's own professed sympathy for the communist-oriented Confédération Générale du Travail Unifiée still served to separate him from the fascist creed.[23] Thus while Valois openly acknowledged his political differences with the architect, he clearly identified Le Corbusier as a potential convert with left-leaning credentials. An exploration of the political dimension of Le Corbusier's and Valois's views on urbanism should help us to understand why.

As Mary McLeod has noted, Le Corbusier endorsed American models of industrial rationalization and managerial reform throughout the 1920s, and only became hostile to American-style capitalism following the market crash of

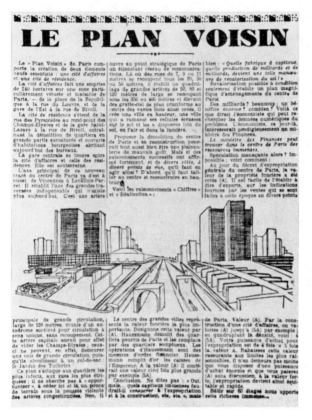

Fig. 38. Le Corbusier, "Le Plan Voisin." Reproduced in *Nouveau siècle*, 1 May 1925, 1.

1929. Among the models Le Corbusier had found most compelling was Taylorism, a developing system of scientific management in America, the stated aim of which was to increase efficiency in the workplace by means of the rational organization of factory production and worker movements in the production process. For Le Corbusier (and, as we shall see, for Valois) the sociopolitical implications of Taylorism were of primary importance, for the movement's founder, Frederick Taylor, thought that class divisions between management and workers could be overcome once both groups recognized their mutual interest in increasing production. The ultimate result of rationalization, argued Taylor, would be the creation of goods for all at affordable prices; thus Taylorist social engineering would serve to unite classes in the pursuit of material well-being. Taylor's French advocates came to admire the American Taylorist Henry Ford for his self-proclaimed aim to lower the cost of goods through increased production, thus democratizing purchasing power. For Le Corbusier, the

government-sponsored application of Taylorist and Fordist methods during World War I was proof of the constructive role of both systems in unifying the nation behind the productive dimension of the war effort. Under the auspices of a new journal, *L'Esprit nouveau* (1920–1925), Le Corbusier and his ally Amadée Ozenfant propagandized Taylorist social engineering in the postwar period, so as to ensure continued prosperity and social cohesion.[24]

Thus Le Corbusier opted for the politics of reform, putting his faith in an improved capitalist structure, premised on efficiency and economy, as a vehicle for social change. For the architect, productivism was a value-neutral form of social engineering, a technocratic tool that would bolster the republican status quo by alleviating the material needs of all classes.[25] In fact Le Corbusier extended this paradigm beyond France's borders when, in the 1925 book *Urbanisme*, he called for the reconstruction, with foreign capital, of Paris and its environs. Foreign investment in the French infrastructure, he reasoned, would ensure that the city would not be subject to attack by a foreign power; and on a global scale Le Corbusier hoped that the extension of capitalist rationalization worldwide would result in the creation of a world federation able to guarantee political stability.[26] In short, while Le Corbusier envisioned no political change within France, his theories had international implications that potentially put him at odds with his erstwhile allies in the Redressement Français and in the Faisceau. Both these groups were ardently nationalist and saw industrial rationalization as a means of bolstering French industry in the face of foreign competition.[27] However, whereas the Redressement Français, like Le Corbusier, thought rationalization could be enacted within the framework of the Republic, the Faisceau incorporated Fordism and Taylorization into a blueprint for total revolution, subsuming Ford and Taylor's industrial innovations within a Sorelian "productivist" ethic that contradicted any strict adherence to rationalism. Not surprisingly, Le Corbusier found Mercier's program more conducive to his own less radical agenda, with the result that he published two brochures promoting his Taylorist plans under the auspices of the Redressement Français in 1928.[28] Since Le Corbusier's differences with the fascists were primarily ideological, analysis of the philosophical roots of Valois's fascism are in order, so that we may better understand the fascist leader's urbanism.

Valois's embrace of Le Corbusier's technocratic modernism cannot be un-

derstood apart from the spiritual values and palingenetic precepts animating his fascist politics. Valois's fascist theory of urbanism was indebted to Sorel's concept of la cité, but he was discerning in his reading of Sorel, emphasizing some aspects of Sorel's theory while ignoring others. Sorel himself had definitively codified his notion of la cité in *De l'utilité du pragmatisme* (On the Utility of Pragmatism), first published in 1921, but with roots going back to the prewar era, as manifest in the anti-Enlightenment theory of class consciousness enshrined in the *Cité française* declaration of 1910 and in the related division between mystique and politique that informed his theory of myth and revolution. For Sorel the cité constituted an elite grouping of individuals who safeguarded and propagated regenerative values, whether manifest in the ethics of class consciousness, creativity in industry and the arts, religious faith, labor militancy, or heroism on the battlefield. As we have seen, Sorel incorporated syndicalism, patriotism, nationalism, and militant Catholicism into this framework by arguing for the regenerative power of class war, war between nations, and ardent religious belief. He also included creativity in this purview, collapsing distinctions between the fine arts, artisanal production, and the skilled labor demanded of factory workers and rural peasants. Proponents of these values, whether syndicalists, Catholics, or royalists, guaranteed the integrity of their particular cité by maintaining their autonomy and exclusionary identity; however, if the group succumbed to material greed or embraced a political agenda, then a cité fell prey to moral corruption. Thus Sorel endorsed a particular constituency—regardless of ideological orientation—only to the extent that it successfully resisted commercialism, manipulation for purely political ends, and the Enlightenment precepts of parliamentary democracy. The instant a cité betrayed the values that had inspired its formation, it lost its raison d'être: for instance, Sorel dismissed the syndicalist cité once that movement abandoned the myth of the general strike for the reformist politics of parliamentary socialism and a singular focus on the material welfare of the rank and file. In like fashion Sorel became disillusioned with the militant Catholicism of his *L'Indépendance* allies once he thought the antidemocratic mystique of their cultural cité became political fodder for Maurras's Action Française. Since the societal vision propagated by these two cités were myths, they acted to define regenerative values for the French community as a whole, la cité française. In his summary thoughts on la cité

in *De l'utilité de pragmatisme*, Sorel had defined this concept in terms of the pragmatism of William James, but before World War I Henri Bergson's philosophy of intuition was the guiding principle for this theory of palingenesis. I would argue that the concept of la cité promoted by Valois's Faisceau at the moment when he championed Le Corbusier was premised on the theory of class regeneration undergirding the *Cité française* declaration and Sorel and Berth's avant-guerre comments on the salutary effect of war between nations on the French citizen-soldier. Valois thought the proletariat and bourgeoisie would institute a new industrial revolution, provided the fascist state channeled the competitive relation between these two classes to serve the interests of the French people. Like Sorel, Valois maintained that each class, once it had rejected democratic ideology, would rediscover its creative capacity in the realm of art and industry; moreover, when that energy was combined with the sense of national purpose animating French war veterans, France could prolong the wartime "spirit of victory" into the postwar era. As an alliance of combatants and producers, the Faisceau would achieve a Sorelian synthesis not envisaged by Sorel himself. Indeed, study of Sorel's pronouncements on the French cité makes plain the uniqueness of Valois's adaptation of Sorelian ideas.

Sorel's Cité Française: An Alliance of Citizen-Soldiers and Producers

Sorel's overarching vision before 1914 of la cité française was premised on military virtue, productivist ethics, and the maintenance of those values through adherence to cultural traditions, especially in their mythic form. Sorel's concept of military virtue was modeled after the citizen-soldier of ancient Athens, while his productivism combined an antique concept of the dignity of labor with a nineteenth-century definition of "industriousness" encompassing managerial, productive, and inventive skills, especially in modern industry. Historian Richard Vernon has examined the historical geneology of Sorel's theory, drawing attention to Sorel and Berth's contrast between military virtue and industriousness and the degenerative impact of mercantilism and rationalism on the body politic.[29] Sorel and Berth followed such luminaries as Montesquieu, Hume, and Tocqueville in noting "the contradiction between the classical ideal of the self-repression and self-forgetfulness of the citizen

and a social order in which the predominant motive is profit seeking."[30] Sorel and others contrasted the military virtues operative in the ancient Greek polis with the pacifist values encouraged by mercantilism. Whereas military values extolled heroism and self-sacrifice in the name of the community, commercialism promoted individual self-interest at the expense of the collective good. Sorel's 1889 study of Athenian society, *Le procès de Socrate* (The Trial of Socrates), examined the class-based dimension of this paradigm to the detriment of the contemporary bourgeoisie. The ancient Athenians, wrote Sorel, "were much superior to our envious, ignorant and greedy bourgeoisie. . . . The citizens were not merchants, demanding guarantees for their transactions and protection for their industry, or seeking favors from government. They were soldiers whose very life was linked to the greatness of the city."[31] As Vernon demonstrates, Sorel identified contemporary syndicalists as the inheritors of this military ethic, declaring that "socialism returns to ancient thinking" and that "the warrior of the city" had a modern counterpart in "the worker of advanced industry."[32] Thus the ethical violence of class war had a historical precedent in the heroism of citizen-soldiers in ancient Greece: this accounts for Sorel's comparison, in *The Reflections on Violence*, of striking proletarians to the "Spartan heroes who defended Thermopylae."[33] Sorel's faith in this warrior esprit led him to praise the citizen-soldiers of the revolutionary era in France as modern-day Athenians: thus Sorel concluded that, with the early Republic's recreation of citizen armies, "a quite new notion of the Cité was born, with strong analogies to that of antiquity, and patriotism became a force of hitherto unsuspected importance."[34] Unfortunately this robust concept of citizenship quickly ceded to the "abstract citizen" vilified in *The Illusions of Progress*, which ushered in the loss not only of military virtue but also of class consciousness and productivist ethics. This change had cultural consequences as well, and once again Athens set a precedent. In *Le procès de Socrate*, Sorel concluded that Athens's citizen-soldiers studied the epic poetry of Homer and tragic dramas of Aeschylus in hopes of emulating the heroic deeds of their ancestors.[35] "The Homeric epic," wrote Sorel, "which inspires heroic feelings and the passion for lofty ideas . . . expressed with striking clarity everything that a brave citizen of Athens should know and attempt!"[36] Thus Socrates' crime lay precisely in his disdain for the Greek tradition, exemplified by "the old poets" and the moral virtues they had nurtured. As Vernon notes, Sorel's

eulogy to the educative role of civic poetry and drama in ancient Greece had a telling echo in his praise of the "social poetry" of Marx's vision of class war and the "drama" of the general strike, for both these "myths" instilled militancy and heroism in the proletariat.[37] Likewise, Sorel's postsyndicalist comparison of Péguy's *Mystère de la charité de Jeanne d'Arc* and the neo-Catholic plays of Claudel to the tragedies of Aeschylus indicated the palingenetic and pedagogical function of the myth of Joan of Arc and of Christian sacrifice in French society. For Sorel's allies associated with *L'Indépendance*, militant Catholicism and its cultural correlates had the same regenerative force as labor militancy or the heroism of the citizen soldier, and all three forms of consciousness were firmly rooted in the classical tradition.

Sorel's merger of labor militancy with the marshal valor found in ancient Athens also had consequences for the moribund bourgeoisie. Proletarian violence proved beneficial to the cité française as a whole by virtue of its effect on the bourgeoisie's own dormant potential for industriousness and militancy. The special mission of the proletariat in Sorel's theory was to awaken the bourgeoisie from its intellectual stupor and make that class recover the "serious moral habits," "productive energy," and "feeling of its own dignity" that had been lost under the impact of democatic ideals.[38] Before the advent of democracy those bourgeois involved in industry had adhered to their own sense of values. Animated by a "conquering, insatiable and pitiless spirit," that made business competition "a battlefield," there was a similarity "between the capitalist type and the warrior type."[39] It was this militant bourgeoisie, solely concerned with "the great problem of the organisation of labour," that inspired Marx to declare revolution inevitable, for militant capitalism according to Sorel throws "the working class into revolutionary organisations by the pressure it exercises on wages."[40] "The more ardently capitalist the middle class is," declared Sorel, "the more the proletariat is full of a warlike spirit and confident of its revolutionary strength."[41] Thus the intuitive nature of each class was subject to mutual reinforcement, which culminated in revolution—as long as the "productive energy" of the bourgeoisie inspired the "revolutionary energy" of the proletariat. However, with the disappearance of bourgeois militancy under the impact of parliamentary democracy, the working class alone possessed the necessary "energy" to bring about the cataclysm envisioned by Marx. The pressure exerted on the bourgeoisie by a revolutionary proletariat,

fully conscious of its class interests, was the only means by which the bourgeoisie could regain its class consciousness, and, with that, its productive energy. As Sorel put it in his concluding remarks in the chapter in *Reflections on Violence* entitled "Violence and the Decadence of the Middle Class":

> The dangers which threaten the future of the world may be avoided, if the proletariat, by their use of violence, manages to re-establish the division into classes, and so restore to the middle class something of its former energy; that is the great aim towards which the whole thought of men . . . must be directed. Proletarian violence, carried on as a pure and simple manifestation of the sentiment of the class war, appears thus as a very fine and heroic thing; it is at the service of the immemorial interests of civilisation. . . . Let us salute the revolutionaries as the Greeks saluted the Spartan heroes who defended Thermopylae and helped to preserve the civilisation of the ancient world.[42]

This class-inclusive vision was the cornerstone for the agenda mapped out in the prospectus of 1910 for the journal *La Cité française*. *La Cité française* united royalists Georges Valois and Pierre Gilbert, syndicalists Edouard Berth and Georges Sorel, and the Sorelian Jean Variot in promoting this particular version of the cité, as evidenced in the journal's official "Déclaration" of intent:

> The founders of this journal are united in order to participate in the free organization of the French cité. . . . The founders of *Cité française* represent various forms of public judgment but are in perfect accord on this point: that if one wants to resolve in a favorable sense for civilization the questions that are posed in the modern world, it is absolutely necessary to destroy democratic institutions. Contemporary experience teaches that democracy constitutes the greatest social peril for all classes of the cité, principally for the working class. Democracy confuses classes, in order to allow a band of politicians, associated with financiers or dominated by them, to exploit producers.
>
> It is therefore necessary to organize the cité apart from democratic ideas, it is necessary to organize classes apart from democracy, in spite of democracy and against it. It is necessary to revive the consciousness that classes must possess of themselves and which are actually suffo-

cated by democratic ideas. It is necessary to revive the virtues unique to each class, without which neither can accomplish its historical mission.[43]

Clearly for Valois, Sorel, and their allies the term *la cité française* stood not only for the physical borders that defined France but, more important, for the spiritual values held by citizens within those borders and the ideological systems expressive of those values. Above all else the constitution of la cité française was accomplished through the destruction of democratic precepts and institutions, and the substitution of values "unique to each class," intuitive values necessary for the moral revival of the nation. Thus Berth, in *Les Méfaits des intellectuels*, carried forward this agenda by claiming that democratic "intellectualization" had created "a social space, where each individual is pronounced to be an isolated and closed monad, an atom," without "any spiritual unity, any cité." By contrast "the myth of the general strike" expressed "the resurrection of a people" who "had formed themselves around workshops, into syndicats" and so created "a spiritual unity, a new cité, a new justice, a new civilization."[44]

A comparable revolt had occurred among the middle class. In the preface for his book Berth noted that "the young bourgeoisie who, fifteen years ago called themselves [parliamentary] socialists, and adhered to collectivist student groups, are going today to the Action Française where they rejoin their class." "The degenerative bourgeoisie seems to be finished," proclaimed Berth, before adding that "it is necessary that the revival of heroic values which seems to animate the young bourgeoisie also be instilled in young workers."[45] With the decline of the syndicalist movement Sorel and his allies associated with Action Française sought alternative means to regenerate class consciousness, and with it, productivism and militant opposition to democracy. This accounted for the cultural agenda promoted in *L'Indépendance*, which combined the celebration of Christian myths with a defense of cultural traditions rooted in the "productivist values" of antique art and culture. Christianity and Catholicism were now added to proletarian strike action as agents for social regeneration.

Yet another regenerative option was proposed by Sorel himself: war between nations. In his *Reflections on Violence* Sorel had already speculated that "two accidents" were capable of combating the unproductive decadence and

pacifist lethargy resulting from the democratic betrayal of France's classical legacy. The alternatives he offered were

> a great foreign war, which might renew lost energies, and which in any case would doubtless bring into power men with a will to govern; or a great extension of proletarian violence, which would make the revolutionary reality evident to the middle class, and would disgust them with the humanitarian platitudes with which Jaurès lulls them to sleep. It is in view of these two dangers that the latter displays all his resources as a popular orator. European peace must be maintained at all costs; some limit must be put to proletarian violence.[46]

For Sorel then, a war in the name of the appropriate values could reinvigorate the nation; examples included "the wars of Revolution and the Empire" which, by virtue of their success, were also a stimulus to "industrial production."[47] One had only to turn to the classical era to find a historical precedent for this paradigm. In *Reflections on Violence* Sorel described ancient Greece as a society "dominated by the idea of war conceived heroically," asserting that classical institutions "had as their basis the organisation of armies of citizens," that "Greek art reached its apex in the citadels," and that philosophers before Socrates "conceived of no other possible form of education than that which fostered in youth the heroic tradition."[48] Thus proletarian producers and the regenerated bourgeoisie could find their palingenetic raison d'être in the heroism of militant nationalism. This thinking accounts for Sorel's postsyndicalist praise of Italy's military campaign in Libya in the pages of *Indépendance*, and his eulogy, in the journal *Action française*, to the resurgence of patriotism in France signaled by Péguy's ode to Joan of Arc. In each case nationalism had proved inspirational for the populace at large and restored a warrior spirit to the cité. In the final chapter of *Les Méfaits des intellectuels*, Berth referred to Sorel's comments on the benefits of ethical violence before concluding that "war nourishes patriotism like the general strike nourishes socialism." In Berth's estimation "the double German and syndicalist threat" had produced "a revival of the contemporary bourgeoisie; the warrior and religious spirit have the upper hand over the humanitarian and pacifist spirit; today's youth . . . is totally penetrated by patriotic and Catholic aspirations." As proof Berth referred his readers to Sorel's claim that Péguy's *Mystère de la charité de Jeanne*

d'Arc heralded "the awakening of the French soul and the synchronism of religious and patriotic aspirations."[49]

In "Bourgeois capitaliste," his essay of 1912 for *Les Cahiers du Cercle Proudhon*, Valois added his own royalist variation on this theme by proclaiming bourgeois regeneration the result of the dual threat of economic competition with German industry and syndicalist agitation by a robust "Sorelian" proletariat.[50] Thus Valois argued that the bourgeoisie had regained its "patriotic values" and "warlike qualities" as a result of economic rather than military competition. Unlike Berth, Valois referred his readers to Sorel's analysis of the regenerative effects of class war, rather than war between nations, on the French body politic.[51] Like Sorel and Berth, Valois claimed that the rejuvenated bourgeoisie had recovered its allegiance to "the traditional values of French culture," including classicism, but Valois considered these values a stimulus to renewed productivity in the workplace as opposed to heroism on the battlefield.[52] As we shall see it was World War I that caused Valois to fully embrace Sorel's pronouncements on the regenerative effects of war, despite Sorel (and Berth's) condemnation of the war effort.

With the outbreak of World War I Sorel fell into a deep depression, noting that every cité capable of regenerating France had caved into the plutocratic Republic's call for a "union sacrée." To Sorel's mind, World War I had none of the sublimity of an "ethical" war; instead it signaled the victory of munitions profiteers and politicians over those movements previously dedicated to the overthrow of parliamentary democracy and those individuals formally opposed to the Enlightenment agenda. Claudel and Péguy were now renounced as "empty spirits," Bergson catered to the "Parisian haute bourgeoisie" and "grands Juifs," the syndicalist leadership had betrayed the movement "in order to avoid military employment and to obtain good positions," and royalism had demonstrated its impotence even before the war began.[53] In September 1914 Sorel wrote to Croce that "the Jacobin politicians, the financiers, and the 'big city high-livers'" had embarked on a massacre of unparalleled proportions.[54]

It was in March 1917, in the midst of the carnage, that Sorel wrote the preface to *De l'utilité de pragmatisme*, which finally appeared in 1921.[55] The book has been described as "purely philosophic," but the centrality of Sorel's concept of cité in the text suggests otherwise.[56] In *De l'utilité de pragmatisme* Sorel considered the concept of la cité from a historical perspective, avoiding any

mention of the European conflagration or the possible role of these various cités in resuscitating postwar Europe. Most significant, Sorel made no mention of the citizen-soldier or syndicalist as agents for renewal, in sharp contrast to the prewar years, when the combatant and proletarian producer were given pride of place in Sorel's blueprint for la cité française. Instead Sorel restricted his analysis to four distinct cités native to France: the *cité savante*, the *cité esthétique*, the *cité morale*, and what Sorel referred to as a "secondary cité," the *cité catholique*.[57] The first three of these groupings safeguarded regenerative values, but were subject to varying degrees of political corruption over the course of their historical evolution. The cité savante constituted the community of scholars, whose modern scientific practitioners wielded great authority: their ideal role in the nineteenth century had been to nurture a spirit of invention crucial to industrial productivity. Having risen to social prominence as a result of their discoveries, the leaders of this cité frequently tried to prolong their influence to the detriment of younger scholars, whose subsequent innovations challenged the status quo. This led to internal corruption, as the "barons" of the cité savante consolidated their power by awarding faithful disciples with top scholarly appointments, encouraged the popularization of their ideas by "hack writers," and catered to the vanity of "progressive politicians," who augmented their own standing by bestowing symbolic honors on "representative scientific personalities." In short, the creative impulse that was the very raison d'être for this community survived despite "a frightful triumph of moral materialism, artistic vulgarity, and stupidity in all its forms."[58] Sorel next turned his attention to the cité esthétique, which had "produced so many admirable monuments from the twelfth to the fifteenth century." As if to recall his prewar writings, Sorel claimed that the Gothic edifices constructed by this artistic community attested to their familiarity with "Greek science" and "Greek customs." Citing Viollet-le-Duc, Sorel maintained that the medieval corporation resembled a classical "aristocracy of professionals," that its artisans knowingly adopted the methods used "in composing the metopes of the Parthenon," and that Gothic architects designed church naves in accordance with classical laws of proportion.[59] These classical references even had a military component, for "the façade of Notre Dame in Paris" allegedly owed its beauty "to its military symbolism, which connects it closely to the gates of Roman fortresses."[60] For this reason the cité esthétique constituted an ideal

"art of producers" governed by an inventive impulse that caused its member-
ship to reevaluate classical monuments and building methods in a "critical
spirit." It was the nurturing of this "extraordinarily strong tradition" that acted
to protect the cité esthétique from external influences, including the tastes of
"sovereigns, the bourgeoisie, and the clergy."[61]

In Sorel's estimation the cité esthétique went into sharp decline once its
artists "abandoned the community of artisans to mix with courtiers, human-
ists and rich bourgeois." Thus the fragmentation of the cité's membership into
various specialities, and the societal elevation of artists and architects over
artisans, led to material corruption and artistic decadence, as adherence to
the classical tradition faded. The artists, having mixed with the "plutocratic
oligarchies" previously mentioned, were now called upon to produce "forms
of art" reflective of the frivolity of their clientele.[62] Painters satisfied the
plutocrats by composing "erotic mythologies," while the architects, "instead
of trying to construct well-planned buildings, painted vast decors" in pala-
tial interiors.[63] This decline had its beginnings during the Renaissance, but it
continued into the present. Speaking of his contemporaries, Sorel noted that
"men of the stock market support painters whose interests greatly resemble
their own," so that "landscapes that resemble sexual revels" fetch high prices,
as well as "vulgar scenes of the races, of the backstage, and café life."[64] Having
condemned the standard imagery of the impressionists, Sorel then embarked
on a wholesale dismissal of "so-called avant-garde painters," describing them
as "bourgeois"and untouched by the spirit of "poetry" so fundamental to clas-
sical culture. Architects suffered a similar fate: having been asked to ignore
tradition, they confined themselves to "designing pretentious decorations,
which are capable of emphasizing the glorification of money."[65] Once again
Sorel blamed the pernicious influence of the Enlightenment for this artistic
decline. Having completely rescinded its autonomy by the eighteenth century,
the cité esthétique's fate was sealed when its members endorsed the Enlight-
enment's attack on the ancients and championing of the moderns. The pro-
motion of "rational education" during the Enlightenment era was premised on
the assumption that all men were "naturally artistic" and therefore required no
exposure to past artistic traditions.[66] This pedagogical dismissal of classical
culture and the guild traditions uprooted aspiring artisans "from their class"
as well as from any knowledge of the artistic practices formally preserved by

the cité esthétique.[67] In sum this cité had become a historical relic, and in 1921 Sorel drew no parallels between these Gothic artisans and the contemporary syndicalists.

The third category, the cité morale, was composed of so-called captains of industry, whose self-proclaimed mission was the improvement of society as a whole. Here Sorel drew a comparison between the American and French cité morale, drawing more favorable conclusions about the former. Both groups aimed to instill a sense of industriousness, but the French had fallen victim to parliamentary democracy. In France members of the cité morale had placed false hope in democratic institutions as a vehicle for moral improvement.[68] In America "the evils caused in the United States by politicians" were counterbalanced by the philanthropic activities of the prosperous elite.[69] The cité morale in America had founded educational institutions and administered philanthropic trusts free of any government interference. Moreover, these prominent citizens "achieved exceptional positions in the economic life of the country as a result of severe selectivity." By contrast the French cité morale—though also a "bourgeois intellectual aristocracy"—had "little taste for industrial struggles" and thought "republican progress" would sweep away political corruption. Thus the ethics of the French cité morale was organized around "theories of French liberalism," which, in Sorel's words, were now "in full decomposition."[70] To Sorel's mind the French cité morale could only be resuscitated if it followed the American example by placing less faith in the political sphere and more in the ethics of production.

In the prewar era, Sorel regarded Catholicism as a source for regenerative ethics and a guardian of classical culture; by 1921 he was referring dismissively to the French cité catholique as upholding an outmoded belief system incapable of resuscitating French society. Sorel drove the point home by making an unflattering comparison between religious practice in the United States and that in his native France. In America the plurality of religious sects and their competing worldviews had not only inspired James's pragmatic approach to truth; it had proven salutory for society as a whole as well. In France, on the other hand, the Catholic adherence to an older metaphysical system based on universal truth led Catholic theologians "to attack pragmatism frantically" as a threat to the one "True Religion."[71] For this reason Sorel regarded Catholicism as a tertiary cité, whose belief system was as ossified as that of

the positivist Auguste Comte.[72] Gone were the days when Sorel drew a simple correlation between the regenerative capacity of religious faith and the militant Catholicism of Péguy or Claudel.

The Cité of Georges Valois: Secular Religion and the Society of Producers

After founding the Faisceau, Valois rejected Sorel's postwar assessment of the French cité, even while he asserted that fascism had its origins in Sorel's thought. In the opening pages of *Le fascisme* (1927) Valois boldly proclaimed the French origins of the movement, citing Mussolini's declaration that "it is neither to Nietzsche, nor to William James that I owe a debt, it is to Georges Sorel."[73] In this manner Valois not only underscored the French genealogy of Italian fascism but also implied that Sorelian thought and American pragmatism were mutually exclusive, despite Sorel's published claims to the contrary. Indeed Sorel's *Utility of Pragmatism* is never mentioned in Valois's *Le fascisme* (or any other fascist publication); instead, "le père intellectuel de fascisme" is identified solely as the author of *The Reflections on Violence*. Valois was also eager to distance himself from his royalist roots in *Le fascisme*, arguing that "Sorelian socialism," rather than "intellectualist and Maurrassian nationalism," had given birth to fascism and the "national sentiment" that had emerged out of the war effort.[74] This anti-intellectual synthesis of nationalism and socialism necessitated the overthrow of the parliamentary state. Such was the goal of Lenin's bolshevism and Mussolini's fascism. But in Valois's estimation fascism was superior by virtue of its realization of Sorel's conjecture that an "ardent proletariat" could, through its revolutionary actions, rekindle the "creative energy" of the bourgeoisie.[75] To bolster this claim Valois referred his readers to Sorel's analysis of the regenerative effect of proletarian class war on the bourgeoisie in *The Reflections on Violence*. In *Le fascisme* Valois cited the concluding remarks in Sorel's chapter "Violence and the Decadence of the Middle Class," thus making explicit the role of the proletariat in bourgeois regeneration under a fascist regime.[76] In effect Valois updated a Sorelian formula he first deployed in his 1912 essay, "Bourgeois capitaliste." Once again French citizens were instructed to "salute the revolutionaries as the Greeks saluted the Spartan heroes who defended Thermopylae." However, in Valois's new schema, it is the fascist state, rather than the monarchy, that would act in

tandem with an energized proletariat to ensure that the bourgeoisie fulfilled its regenerative mission and did not overstep its mandate.

In Valois's opinion World War I had reinvigorated the French citizen-soldier in just the manner predicted by Sorel in his seminal text; moreover, Valois asserted that the sense of collective purpose and national pride animating the combatants had a Sorelian corollary in the productivist ethic fascism sought to develop in the postwar era.[77] In *Le fascisme* Valois defined the role of Sorelian thought in nurturing the "spirit of victory" animating French fascists.[78] This spirit had its origins in familial obligations, the heroism of the citizen soldier, Christian values, and the morality of the producers celebrated by Sorel. In a chapter of the book devoted to "spiritual life" Valois declared the joy experienced by mothers and fathers when they labor on behalf of their children comparable to the "exaltation" and "superhuman vision" felt by combatants willing to give their lives for the benefit of the nation.[79] Filial bonds, like those uniting the combatants, caused each individual to look beyond his or her own self-interest and to act in the interest of France's future generations. Valois claimed that Christianity also played a crucial role in augmenting this sense of collective responsibility. He called on Catholic fascists to utilize the sense of "truth," "justice," and "love" nurtured by their faith to achieve "justice in economic and social life." Under the auspices of fascism, Christians could become "the great artisans of the reintegration of justice into the modern world."[80] However, the French spirit of victory would only fully develop if class solidarity could be established: this was the task of the Faisceau. To achieve this Valois called for the overthrow of democratic institutions and the creation of a syndicalist and corporative structure designed to encourage a collaborative but competitive relation among the proletariat and bourgeoisie. "It is in this regard," wrote Valois, "that Sorelian ideas will play a role of fundamental importance."[81] Democracy upheld an ideology of ultraindividualism, which, in conjunction with unbridled capitalism, destroyed all sense of community—whether familial, national, or class-based—among the French. Whereas Sorel had condemned parliamentary democracy for promoting the mixture of classes, Valois's fascists disparaged the Third Republic for instilling "artificial" divisions between classes harmful to the regenerative class consciousness that fascism sought to resuscitate. The melding of classes in Sorelian theory was a result of the creation of an abstract, universal concept of

citizenship that failed to recognize the ethical values of various classes; Valois claimed that abstract citizenship also precipitated divisions unrelated to class, premised on false criteria such as party affiliation, greed, and self-interest.[82] These "artificial" divisions were the product of democratic decadence rather than any qualitative consciousness on the part of the bourgeois or working class, and Valois sought to rekindle the regenerative values native to class consciousness. Valois reminded his readers of Sorel's claim that "proletarian strength" was "destined to restore the creative bourgeoisie to its energy" before concluding that an invigorated proletariat would "thrust the leaders of the national economy toward the future, toward the new world that they will have to conquer and organize." "Thus in the twentieth century, confronted with a workers' movement that wants to work according to new methods, that desires higher salaries," the bourgeoisie would recover its productivist ethic and once again be the "constructors of trains, highways, canals, and factories."[83] In the nineteenth century "Saint-Simonian thought" had been a stimulus for such productivist thinking; in Valois's own era "Sorelian thought" would preside over "the organization, the action, of a new great team which will take in hand the destiny of the century of electricity."[84] Under the paternal guidance of a fascist corporative and syndicalist order, and in response to the pressure of an energized proletariat, the bourgeoisie would once again focus its attention solely on production. Valois envisaged a future world in which workers responded creatively to new technology, and industrialists utilized new tools and managerial techniques to increase output. Surprisingly, he also declared this Sorelian "society of producers" a form of secular religion: "Fascism owes its worker conceptions to Christianity and to socialism and especially Sorelian socialism. But Georges Sorel owes his ideas to living Christianity. His conception of a robust working class, which, through its ardor, its audacity, its demands even, obliges the bourgeoisie to rectify itself, to grow, to provide great leaders, to love work, and to no longer be slaves to their riches: this is the complete doctrine that is inscribed in the verses of the Magnificat."[85] Valois alludes here to Mary's response to the angel at the Annunciation ("My soul doth magnify the Lord," Luke 1.46–55), an ecstatic celebration of the Immaculate Conception as a favor bestowed by God on her and on the people of Israel. The Latin text of that response was recited daily at the vesper services of the Catholic Church, so the significance of Valois's reference would have been

readily discernable to his readers. In Valois's opinion adherence to Sorelian fascism amounted to a spiritual calling, which actively transformed the soul of those willing to embrace fascist precepts. Elsewhere in *Le fascisme* Valois even struck a vitalist and Bergsonian note by claiming that the spiritual changes realizable under fascism amounted to a "force" akin to the "vital flux" that is "life itself."[86] In short, Sorelian productivism was more than a value-neutral instrument for social transformation; it was an integral part of a fascist mentality deeply rooted in the religious, familial, and heroic values of la cité française.

Valois underscored the secular religious dimension of his revolution from the Faisceau's inception. When he announced the founding of the fascist movement at its first rally on Armistice Day, Valois was joined by 250 legionaires who later marched with him to the Arc de Triomphe and the tomb of the unknown soldier. An image commemorating the event pictured a fascist dressed in blue shirt and with cane in hand, a suited bourgeois, and a blue-bloused worker, united by what the fascist Philippe Barrès called the "élan of victory," the Bergsonian élan vital identified with the ethics produced through heroic warfare, and signified in the poster by the ghostly shadow of a fallen soldier.[87] Over the intervening years fascist rallies were held at battlefields such as Verdun (21 February 1926) and sites of massive reconstruction such as Reims (27 June 1926), to affirm Valois's contention that his productivist vision was a continuation of the sublime "spirit of victory" that led so many French soldiers to make the supreme sacrifice. The date chosen for the Verdun rally was that of the tenth anniversary of the German main assault, and included a pilgrimage to battlefield sites and the massive ossuary at Douaumont.[88] Following the publication of *Le fascisme*, Valois also exploited the mythic value of Joan of Arc by scheduling another meeting-pilgrimage on 22 May at Domrémy to honor the newly canonized warrior saint.[89] This intermingling of secular religion, military valor, and productivist ethics encapsulated the "Spirit of Victory" that would transform postwar France.

Fascist Urbanism for the New Century

Valois actively propagated this vision in the movement's newspaper, appropriately titled *Nouveau siècle* (New Century). Thus the newspaper's masthead declared it an "organ of the fasces of combatants, producers, and heads of families,"[90] designed to promote the productive and combative esprit native to each collective group, and to construct a social vision of la cité française

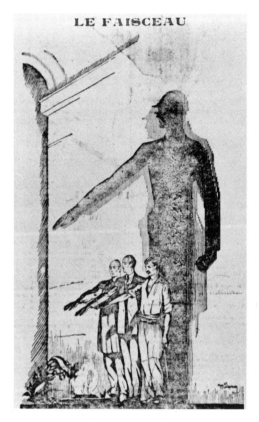

Fig. 39. "Le Faisceau." Reproduced in *Nouveau siècle*, 12 November 1925, 1.

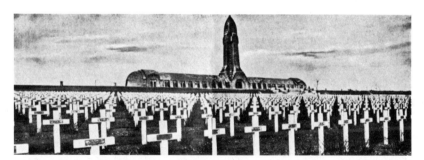

Fig. 40. Mortuary at Douaumont. Reproduced in *Verdun: An Illustrated Historical Guide* (Verdun: Editions Lorraines, n.d.), 82–83.

conducive to Sorelian values. In this regard Valois's decision to ally his movement to fascism was no accident, for Mussolini too joined the Sorelian combatant with the producer in his conception of fascism: thus by 1919 his paper *Il popolo d'Italia* dropped all references to socialism from its masthead and became "the journal of combatants and producers."[91] As we have seen Valois was fully cognizant of Mussolini's own admiration for the author of *The Reflections on Violence*.[92] The shared ideals animating Valois and Mussolini were dutifully noted by Valois, Valois's writings were quickly translated into Italian, and articles in Valois's journal praised the Italian Fascists for having harnessed the bourgeoisie's productive capacity.[93] Industrial progress in Italy was cited as evidence of the renewed vigor of this class, and it was the fusion of construction with the productivist esprit of fascism that Valois consciously emulated in his own urban vision. Evidence that fascism had "awakened" the "energies" of the Italian mercantile class was the subject of an article of May 1926 charting the proliferation of private enterprise road construction under Mussolini.[94] At the same time Valois claimed that "French problems" demanded "French solutions," for French fascism could only encompass the French cité. Thus while *Nouveau siècle* praised the fascist spirit motivating Italian technological advances, the newspaper did not eulogize Italian fascist architecture, but instead cited the work of the "French" Le Corbusier—who was actually Swiss—as the proper model for la cité française.[95] To drive home the interrelation of French technological development, and bourgeois and proletarian élan, *Nouveau siècle* had a running column titled "L'Atelier et la cité," which defined the role of both classes in a fascist, corporate society. The column's stated aim was to demonstrate "to the French the physiognomy of each social class which constitutes the nation . . . thus preparing for the reconciliation of people artificially separated by an abominable regime."[96] Recognition on the part of each class of their own productive and combative esprit, and the role of that spirit in the defence and reconstruction of France, would lead, in the fascist paradigm, to mutual respect between classes for their roles in this collective effort. Thus Sorel and Valois were in agreement that the renewal of class consciousness in both classes would ultimately reinvigorate France through a warlike and productive élan vital.[97] What made Valois's version of the revived cité française unique was the relation he posited between the fascist spirit and the physical reconstruction of France in the wake of World War I.

LA POLITIQUE
DE LA VICTOIRE

Fig. 41. André de Székely, frontispiece for Georges Valois, *La politique de la victoire*
(Paris: Nouvelle Librairie Nationale, 1925).

Valois emulated Mussolini by including town planning in the orbit of fas-
cist values.[98] At the heart of Valois's approach to urban renewal is an associa-
tion of technological development with the capacity for creative invention he
identified with "the spirit of victory." Valois's first book devoted to fascism,
The Politics of Victory (1925), contained a frontispiece by the former anarchist
André de Székely highlighting the technological advances that would give
birth to the modern city.[99] Székely's urban panorama celebrates a new tech-
nological civilization in which all historical references have been banished in
favor of railway viaducts, electrical cables, cranes, searchlights, skyscrapers,
and airplanes. Gone were any associations between productivist ethics and
the classical, medieval, or symbolist aesthetics promoted in *L'Indépendance*
or Sorel's *De l'utilité de pragmatisme*. Valois reinforced this enthusiasm for all
things modern by inviting F. T. Marinetti to speak at a pan-European fascist
reunion held in Paris on 2 November 1926. Marinetti's participation was an-
nounced in a 30 October article, which described futurism's chief as an ardent
follower of Mussolini who exemplified "the new Italy."[100] The following year

Valois evoked the spirit of futurism to condemn Maurras's Action Française as an archaic organization fixated on France's past.[101] According to Valois, Maurras "serves the France of yesterday," whereas he himself "serves the France of tomorrow, with automobiles, airplanes, and peasants working with machines." Maurras advocated a "rational nationalism" that made him an "archivist rat," whereas Valois was "an organizer of factories, a road builder, and constructor of a new world." "According to the vocabulary of Marinetti," Valois proclaimed, "Maurras is a *passéiste*, and I am a futurist."[102] This singular focus on the modernist dimension of fascist productivism was repeated on the illustrated cover of *Le fascisme*, which depicted a frieze of male fascists saluting in front of an industrialized landscape. Thus what Valois termed a "spirit of defeat," a spirit typified by excessive individualism and the postwar revival of divisive party politics, would once more give way to the wartime spirit of victory, now exemplified by modern industriousness.[103] Valois's fascist revolution was premised on the combative and productive esprit innate to all classes, who would identify the maintenance of their class consciousness with the reconstruction of French values and institutions, and the assurance of the nation's health in times of peace as well as war.[104]

Valois, like Sorel before him, claimed that the spirit of battle should also animate industrial production, thereby fusing the ethics of the combatant and those of the producer, whether bourgeois or proletarian. In addition, Sorel's own association of productivist energy and the *esprit guerrier* with the regenerated "captains of industry" was not lost on Valois. In his June 1926 address to the Associations of Combatants gathered at the Reims Assembly, Valois noted that the "esprit de la victoire" had not only saved France but allowed the combatants to take their place "in the country in order to fulfill their role as producers."[105] As we have seen, fascism sought to promote that effort under the auspices of syndical and corporative stuctures destined to reinforce the productivist ethics of all classes. Once again, Valois lauded Fascist Italy for having achieved the Sorelian revolution he hoped to institute in France. "In Rome," declared Valois in an article of April 1926, "a national state, presiding firmly over the bourgeoisie, having the strong support of peasants and workers, limits and directs toward greatness the economic and social activity of the bourgeoisie." Valois then contrasted fascism's successful usage of proletarian and bourgeois energies with Soviet communism, which "suppressed the

bourgeois" and proclaimed a "proletarian state." Lenin's support of one class to the detriment of another failed to realize a fundamental tenet of Sorelianism, namely that "an ardent, energetic proletariat" returns the bourgeoisie to "its creative energy."[106] In an article titled "Pour reconstituer la cité," Valois proclaimed fascism to be hostile to the divisiveness of party politics and the domination of one class by another. Instead the fascist "national state" was "above parties and classes," and thus able to protect and preserve the "heroic values" intrinsic to each class that served as building blocks for "national values." By being *ni droite ni gauche*, neither right nor left, fascism would unite all classes in the construction of *la cité française*.[107]

Under fascism a strong working class would assure that the industrialist put production at the top of the agenda. The proletariat's passion for technological innovation would thus be complemented by a community of engineers and industrialists eager to increase production by developing new technology and organizational techniques. Valois argued that an energized bourgeoisie, by prioritizing production, would no longer suppress worker's wages but instead increase employee salaries while simultaneously augmenting company profits. Thus "the elite leaders of industry, the technicians, and the strongest faction of the working class" would bring about an economic miracle.[108] To Valois's mind, one had only to look to American industry to see the productivist spirit in action. Valois regarded Henry Ford as exemplary of this collaborative spirit, for he had managed to increase production, lower the cost of goods, and simultaneously increase the wages of his workers.[109] In *Le fascisme* Valois cited a recently translated book by two British engineers, *The Secret of Higher Wages*, as a guide to the industriousness of America's "captains of industry." Innovators such as Ford were reportedly "perfecting without cease the tools and methods of work": in industry this resulted in the invention of increasingly efficient machines, while on the managerial side new organizational methods were developed to eliminate waste.[110] "Georges Sorel," wrote Valois, "had proven that proletarian demands would reawaken the energy and faculty of invention in leaders of industry."[111] Valois regarded this spirit of "invention" as crucial to the productivist rapprochement between classes. Ford had discovered that the source of the greatest profits resided "in invention, in economic creation, in technical progress." As a result the productivist esprit of the working class could be harnessed along with that of their technocratic

partners in industry.[112] Valois even concluded that, under a fascist version of Fordism, the proletariat would take pride in "good work" for its own sake, independent of any monetary benefits.[113]

In 1927 this faith in productivist ethics was stretched to the limit in two contiguous articles published in the May Day issue of *Nouveau siècle* alongside a photograph of "le maître" Georges Sorel. In an article titled "Le travail et l'artisan" Gäetan Bernoville posed a fundamental question: how could the modern-day worker continue to value his role in industry when the labor involved had been denuded of its creative dimension?[114] To cast the question in the starkest light, Bernoville contrasted the era of the artisan, when an individual worker was involved in all phases of production, with that of the contemporary factory worker, whose work was regulated by "machinism" and "Taylorization." For the artisan, love of work arose spontaneously due to the skill involved in the production process itself. Vestiges of such "professional pride" still survived, we are told, in small workshops, and "in the corporation of typographers where the machine had not yet rendered useless manual skill." One could also find such pride in "the intellectual worker who must draw totally from his own resources." However, these workers were the exception to the rule, which led Bernoville to ask how a modern worker could "love a métier in which his function is indefinitely to repeat the same gesture." The solution resided in fascism's corporative approach to productivism:

> The remedy? I see it for my part in the feeling that the worker can safeguard or recover the grandeur of work, as mechanistic and automatic as it is. I see it again in an organization of the profession increasingly rational, balanced, shaped by justice. If the worker, in the majority of cases, can no longer have the creative pride that animated the artisan, he continues to love his profession, to feel profoundly the ties of solidarity that unite him with other members of his corporation, he knows to what essential degree production relies on him. It is necessary to awaken and to translate into acts, into interests, the feeling of collaboration which unites the leader of an enterprise to his subordinates.[115]

In effect Gäetan conflated Sorel's early pronouncements concerning the role of machine technology in stimulating workers' creative capacities with a more general enthusiasm for their role in a corporative enterprise. Thus the Sorelian artisanal or "intellectual" worker and his "Taylorized" counterpart

could feel the same sense of purpose and pride in production, provided there was a fascist syndicalist and corporative order to nurture social justice and communal responsibility. Valois himself had put forth a similar thesis in his book *L'Économie nouvelle* (1924 edition), arguing that Taylorism in industry could be a positive force if industry itself was organized along corporative and syndicalist lines, to instill a spirit of collaboration and common purpose among all classes engaged in the production process.[116] Bernoville's conclusions were bolstered in a second article, by Hubert Bourgin, "The Literature of Work."[117] Bourgin—a former member of the Proudhonian wing of the French Socialist Party[118]—cast this productivist spirit in literary and historical terms, tracing its development from the classical era to that of fascism. Having favorably mentioned the Greek poet Hesiod's *Works and Days* and Virgil's ode to the Roman "soldier-laborers" in his *Georgics*, Bourgin turned his attention to the nineteenth century, to chart the literary creation of "new images of human labor" during the industrial revolution. Such images, we are told, initially emerged "in the utopias of the first French socialists": for instance "Saint-Simonian productivism" substituted ecstatic images of "the exploitation of the globe by industry" for discordant images of "the exploitation of man by man." Saint-Simonian thought was later supplemented by "Fourierist cooperatism or phalansterism," which proclaimed "the happy benefits of passionately attractive labor." However, a new image of labor emerged in the writings of Proudhon:

> If Proudhon reveals the profound contradictions of the economic world and violently clashes with the tendencies that account for them, he remains steadfast in his glorification of the free worker, the creator of rights, founder of moral and material well-being, guardian and breadwinner of the family. Work demands justice and the right to realize it. Work leads to political ability, and in the workshop itself, it forms the organic cell of the cité. Proudhon engenders Sorel, and Sorel, Georges Valois; the mutualism of the first gives rise to the revolutionary syndicalism of the second, which calls forth the new economy and fascism of the third. But these new conceptions can only blossom in the atmosphere of victory.[119]

Proudhon's new vision of the worker—full of moral rectitude, familial duty, and revolutionary esprit—differed profoundly from the Epicurean sensuality

of his Fourierist predecessors. According to Bourgin, the laborers described by Proudhon and Sorel could only flourish "if the Faisceau of workers and producers realizes its program of national restoration." With the advent of fascism, the values dear to Proudhon, Sorel, and Valois would transform the body politic, "productive energies" would be unleashed, and "the literature of labor" would become "infinitely richer." Under fascism, the worker would rediscover his "love of life, of creation, of grandeur; an imperious wish for justice and fraternity . . . the taste for effort, but effort organized, methodical, always heading toward a goal, economizing forces, opening up in thought, in spiritual flowering: matter in the service of spirit." Thus the mythic image of the ideal worker posed by Proudhon and Sorel would become a lived reality under fascism. Thanks to the fascists' corporative order such consciousness would be shared by all who contributed to the production process, from the Taylorized worker, to the industrial engineer, to the Fordist "captains of industry."

In *Le fascisme*, Valois used these precepts to assess France's industrialists, with mixed results. Valois praised the Michelin firm and the organization Redressement Français, founded by the industrialist Ernest Mercier, for attempting to import Fordist methods into France.[120] However, in an article published on 1 May 1927, he criticized Mercier's group for adopting Ford's organizational methods—including Taylorism—while ignoring the inventive potential and interests of the working class. Valois acknowledged his admiration for the "high discipline" entailed in Redressement Français's focus on planned technological innovation, but condemned the group for failing to give workers a say in organizational planning.[121] "Rational capitalism," Valois complained, "wants to make the boss the sole arbiter of change," while fascism alone "wants to realize change through the collaboration of producers issuing from all classes, and tending to form a single entity." "Fascism," Valois continued, "wants to organize worker pressure on the bosses to ensure that the bourgeoisie accomplishes its historical mission, which is to help create a society of producers." Valois asserted that the very existence of Mercier's group was a healthy reaction to the success of socialism in France and the Russian Revolution abroad, which served to vindicate Sorel's claim in *Reflections on Violence* "that capitalist productivity only exists as long as worker pressure remains, and is consciously organized."[122] Valois reiterated these criticisms in November 1927, voicing the fascists' approval of Redressement's endorsement

of rationalism in industry, but admonishing Mercier for leaving decision-making powers in the hands of industrialists.[123]

The true fascist organizer or "animateur" would take the worker's perspective into account in planning, a position in keeping with the unification of classes through the collective ethic animating all producers. Ideally the fascist technocrat should combine the worker's love of new technology with the industrialist's penchant for rational organization. By designating Le Corbusier an "organizer" in the fascist sense, Valois wished to indicate that a balance should be struck between proletarian interests and those of industrialists and of the technocratic elite of which Le Corbusier was a representative. When Valois asserted that the fascist rank and file "saw their own thought materialized" on viewing Le Corbusier's urban plans, he claimed for the architect a profound understanding of the wishes of the proletariat, as well as the captains of industry.[124] As producers endowed with their own organizational skills and inventive capabilities, the proletariat had already imagined the modern city; Le Corbusier's plans merely confirmed that vision. In celebrating the agitational power of Le Corbusier's urban plans, Valois and his colleagues affirmed Saint-Simon's own pronouncements concerning the central role of aesthetic images as a catalyst for social transformation. As Eric Michaud has demonstrated, this exaltation of the image as an agent of historical change was endorsed by a cross-section of avant-garde critics, artists and political theorists in France, from the Saint-Simonians, to Sorel, to the Neo-Impressionists and Fernand Léger.[125] Thus Valois, in exalting Le Corbusier, takes his place among practitioners and supporters of avant-gardism who celebrated the revolutionary potential of visionary art.

Le Corbusier among the Fascists

For Valois and his colleagues associated with *Nouveau siècle* the "inventive spirit" so dear to Sorel had inspired Le Corbusier's innovative architecture. Evidence of that spirit resided in the architect's bold use of new materials, his endorsement of Taylorism in construction, and his plan to organize urban development around new modes of transport, such as the automobile and airplane. In a September 1926 article Pierre Winter applied this synthesis in an evaluation of the architecture of Le Corbusier and Pierre Jeanneret (Le Corbusier's cousin) in the Quartier Frugès at Pessac (fig. 36).[126] Having des-

ignated Le Corbusier's and Jeanneret's architectural ideas the blueprint for "a national politics of construction," he described their use of "reinforced concrete" as evidence of their status as members of the regenerated fascist elite. This new material required them to "innovate" and "forget the traditional expenses imposed by the outdated means of the old materials, old prejudices, old sentiments"; indeed, the use of concrete amounted to "a veritable act of belief." The disavowal of ornament in favor of "pure line" at Frugès constituted "a victory," a groundbreaking "rediscovery under light, of planes and simple volumes." Winter singled out their use of standardized materials as further evidence of the innovation that heralded the fascist revolution. Having compared the "constructions of Le Corbusier and Jeanneret" to "a beautiful auto, an ocean liner, a bridge, a factory," he labeled the architects "poets." Under fascism "poetry" was manifest in all forms of industrial production, since the labor involved expressed the collective "spirit of victory" of the new corporative society.

The fascists, however, were very selective in their reading of Le Corbusier, emphasizing his compatibility with their conception of a society of producers and remaining silent about aspects of his plan that contradicted Valois's socioeconomic politics. Given the fact that the fascists had studied the economic implications of Le Corbusier's ideas, it is significant that the excerpts on the "Voisin" plan in *Nouveau siècle* did not include Le Corbusier's own complex stipulations concerning social structures and class relations. Instead, the extracts from *Urbanisme* quoted in *Nouveau siècle* were those most compatible with the fascists' own doctrine. Pierre Winter cited Le Corbusier's statements concerning the hygienic problems arising from urban congestion, which reveal further racist views by evoking a "zone of odors, [a] terrible and suffocating zone comparable to a field of gypsies crammed in their caravans amid disorder and improvization." The section quoted, taken from a chapter of *Urbanisme* titled "The Great City," was related to a larger thesis concerning humankind's progress from nomadism, exemplified by the "disorder" of gypsy encampments, to the creation of order in the form of sedentary rural and urban development: hence Le Corbusier's comparison of urban chaos to a regressive return to a nomadic condition, foreign to the "Cartesian" order native to the French populace. Here as well as elsewhere in his book Le Corbusier cast himself in the role of a doctor who would "cure" the ills created by

urban congestion through the "radical surgery" of his Plan Voisin.[127] Winter approved of the metaphor, which resonated well with the fascists' palingenetic aim to resuscitate an ailing France through the institutional and social changes prescribed by the Faisceau. Most important, such surgical terminology had already been deployed by Mussolini to characterize the Fascist revolution to the south. For instance, in 1922, Il Duce described the existing state administration as requiring a "scalpel" that could "take away everything parasitic, harmful and suffocating that has latched on to the various offices."[128] Throughout the 1920s Mussolini repeatedly referred to Italian society as a sick organism whose health was contingent on fascism's "radical transformations." By drawing attention to Le Corbusier's language of social hygiene Winter emphasized that aspect of the architect's program most conducive to the metaphorical vocabulary of Italian fascism. In that way he made Le Corbusier's urban designs more palatable to those steeped in a fascist mentality.

In highlighting such themes Winter also had in mind Valois's own contrast between the nomadic eastern "hordes" who constantly threatened France with invasion, and the sedentary French "Latins," the descendants of the Roman "legions" who had brought civilization and urban development to Gaul. This division between nomadic foreigners and civilized Latins ultimately took ideological form in the guise of the "Asian" embrace of rootless communism and the "Latin" peoples' turn to fascism. A perennial theme in Valois's writing was his condemnation of nomadism, illustrated with references to endless steppes. In an essay titled "Fascisme ou communisme?" (3 December 1925), Valois claimed that these two alternatives to parliamentary democracy "have the same origin," namely, their reaction "against the liberal and individualist regime"; where they differed was in their means of defeating liberalism, for "communism suppresses the great resource of human activity, the personal interest attached to property." Fascism on the other hand subjected "personal interest" and "private property" to "the discipline and economic, social, and national obligations from which they escape in the individualist regime." Rather than suppress bourgeois entrepreneurship, fascism disengaged that group from individualist ideology and harnessed its productive force for the collective good of the nation. The Soviet Union's decision to allow a limited amount of private enterprise indicated that communism was "now evolving toward the institutions of the fascist economy." There was hope therefore

that fascism would yet succeed in Russia, provided the communists learnt to respect the productive ethic of the bourgeoisie and abandon an ideology that left all classes in the unpropertied and rootless condition of the "horde."[129] In *Le fascisme* Valois even argued that the nomadic tendency within communism mirrored that of its adversary, international capitalism. Capitalism, by fragmenting families and forcing workers to constantly uproot themselves in their endless search for employment, had destroyed all sense of regional or geopolitical identity among the working class. "The country," Valois lamented, "ceased to be a living reality for all the workers reduced to the condition of isolated individuals." Torn from their communities, both rural and urban, they were "nomads," the hapless victims of "economic forces." Alienated from any sense of national allegiance, workers then took refuge in a communist movement that was as indifferent to national borders as international capitalism. "It is one of the greatest tasks of fascism to give his country back to the French worker nomadized by an inhuman economy."[130] Tellingly Valois looked to the Christian corporativist doctrine of Marquis René de La Tour du Pin, rather than to Sorelian thought, for an ideological curative to the twin threats of capitalist and communist nomadism. La Tour du Pin was a theorist promoted in royalist circles, who had been celebrated by Valois and his colleagues in the Cercle Proudhon.[131] Thus Valois's theory of nomadism had a genealogy in right-wing Christian corporativism, whereas his "productivism" emanated from the left. Allen Douglas notes that, for Valois, "the foremost value of property was that, along with the family, it fixed man geographically and broke the spirit of nomadism." Valois argued that the communists' attack on private property was evidence of their nomadic impulse, an instinctive drive native to Asian cultures.[132] Thus in the pages of *Nouveau siècle* the communists are presented as "la horde," the nomadic, restless masses who attack the propertied "combattant," the farmer rooted in the soil of France. Appropriately, when Winter wished to defend Le Corbusier's urban designs, the architect's implicitly racist condemnation of "nomadism" was falsely highlighted as proof of the fascistic dimension of his town planning.[133]

That correlation also affected the fascist evaluation of modern art, for the movement's art critic, Jean-Loup Forain (son of the royalist sympathizer Jean-Louis Forain), condemned abstract art as a foreign incursion akin to bolshevism, while promoting the rural landscapes of Maurice Vlaminck as the sin-

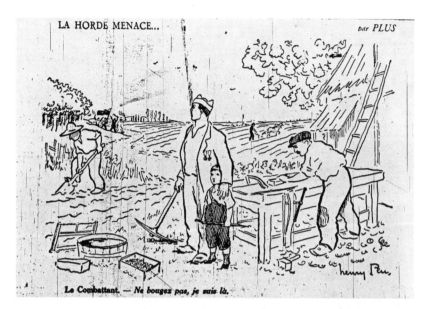

Fig. 42. Henry Plu (Plus), "La horde menace. . . ." Reproduced in *Nouveau siècle*, 30 April 1925, 1.

cere expression of a French "sauvage rudesse."[134] Forain's criticism echoed a widespread racist distinction between an *École de Paris*, supposedly made up of urban artists of foreign extraction, and an *École française*, whose chief representatives were Vlaminck, André Derain, Dunoyer de Segonzac, and Othon Friesz. Like other conservative critics Forain thought Vlaminck's rural landscapes, devoid of abstraction or machine-age imagery, reflected his sincere desire to "return to the soil," to rediscover the simplicity of French peasant culture.[135] Such sentiments approximated the views of Vlaminck himself, who in his 1929 autobiography decried the pernicious impact of rural immigration to urban centers on the economic and social viability of agrarian life.[136] Having declared himself a "man of the north" in 1923, Vlaminck lent credence to his convictions by taking up residence in the French countryside near Normandy in 1925.[137] During the same period he categorically abandoned the bright palette and radical experimentation that typified his early fauve style for a more staid technique that adhered to the traditional laws of perspective. His fauve paintings of the Midi, bathed in garish colors and vibrant hues, were now replaced by gloomy images of run-down country villages shrouded under the ink-blue sky of northern France in the heart of winter. As Golan notes,

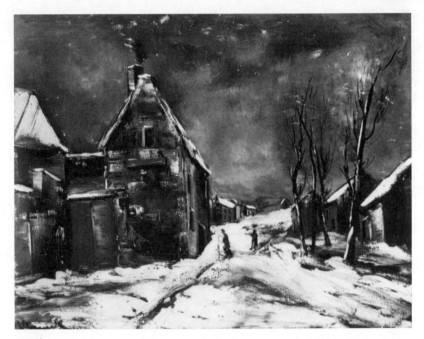

Fig. 43. Maurice de Vlaminck, *Neige à Auvers-sur-Oise*, ca. 1925. © 2006 ARTISTS RIGHTS SOCIETY (ARS), NEW YORK/ADAGAP, PARIS.

Vlaminck, like former fauves Dunoyer de Segonzac and André Derain, set out to "rusticate" the modern, and in so doing won the praise of xenophobic nationalists who, like Forain, attacked machine aesthetics as a sign of the industrial metropolis.[138]

Such criticism points to a paradox within fascist discourse, namely, *Nouveau siècle*'s simultaneous defense of machine-age modernism in architecture and condemnation of modernism in painting. While Le Corbusier's architecture reportedly expressed the antimaterialist and productive élan of the French combattant, its stylistic equivalent in the realm of painting was deemed a nomadic incursion, divorced from the cité française, and as a result Le Corbusier's Purist aesthetic never won acceptance within fascist circles.

Fascist ideological precepts also permeated the response, in *Nouveau siècle*, to Le Corbusier's statements on class relations. Although the architect's social blueprint predicated social advancement on creative ability and expertise alone, Le Corbusier not only assumed that not all workers could become managers; he also created a geographical division between these groups. In a

section of *Urbanisme* not reproduced in *Nouveau siècle*, he stipulated that the managerial and technocratic elite—made up of engineers, industrialists, financiers, and artists—would work and live in buildings constructed in the city center, while workers would be dispersed in surrounding garden cities, far removed from the epicenter of organizational planning.[139] This scheme contradicted a fundamental tenet of fascism, namely that theory and praxis were to be merged in the guise of the producer, and that corporatism encouraged the commingling of all classes involved in production. Under fascism, all classes would reside throughout the city, where their constant contact would encourage a collaborative spirit. A year before Le Corbusier was invited to present his Plan Voisin to the Faisceau, Valois had already developed his own plan for the reorganization of "Greater Paris" along corporative and syndicalist lines. This corporative frame constituted the socioeconomic glue that would create cohesion between various sectors in industry, and, more crucially, in the body politic. The grand "Assembly" overseeing urban development throughout the region would be composed of "delegates from syndicats and corporations of producers" encompassing "worker syndicats," "property owners" and "tenants," as well as delegates for each region and district. This assembly would then appoint a directory, composed of representatives from each constituency, which would administer the development of "Greater Paris." The directory would in turn create a high commission, which would work in tandem with various regional authorities and "worker and employee syndicats" to develop the Parisian infrastructure along corporative lines. The commissioners would be those most expert in "the modern organization of cities." Under their guidance, industries belonging to a single corporative entity would be clustered together, and serviced by distribution centers, able to transport goods en masse through a newly constructed system of freeways. This reorganization of industry had a corporative counterpart in residential development. Valois stipulated that housing should be separated from industry, but unlike Le Corbusier he did not call for the division of residential districts along class lines. To Valois's mind the economic and social stability of the working class could only be guaranteed "through a constant collaboration of employee syndicats, worker syndicats, and the commission for the Parisian region and the state." To facilitate such exchange Valois called for the creation of "an economic and social bureau" in each sector of Greater Paris, where "the producers—bosses,

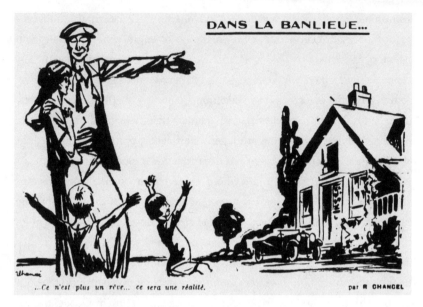

DANS LA BANLIEUE...

...Ce n'est plus un rêve... ce sera une réalité.

par R CHANCEL

Fig. 44. "Dans la banlieue. . . ." Reproduced in *Nouveau siècle*, 12 May 1926, 1.

technicians, and workers—will be able to hold local meetings, regulate their intersyndical affairs, and organize the social life of the sector." Since the organization of social life involved the creation of housing, each sector would likewise possess a "bureau of housing" where "construction societies" in tandem with "syndicats and communes" would plan urban development.[140] Even before their exposure to Le Corbusier's theories, the readers of *Nouveau siècle* had encountered images of suburban utopia and familial joy meant to signal the worker's pride in his own handiwork. Far from isolating an urban technocratic elite from a general populace of manual laborers relegated to garden cities, Valois called for the merger of both groups in the formation of decentralized bureaus that would oversee the construction of Greater Paris. In this manner the modern city would be "nothing other than the fasces of all energies, all the wills behind technical, social and national progress."[141]

Such distinctions permeate Valois's own evaluation of Le Corbusier. In his May 1927 essay, "The New Stage of Fascism," Valois outlined the fascists' response to Le Corbusier's presentation of his urban plans for Paris in a slide lecture inaugurating the opening of the movement's new headquarters on the rue du faubourg Poissonnière:

Chapter 3

It is with a very clear intention that we asked Le Corbusier for this lecture. I am still totally ignorant of the political ideas of Le Corbusier, who speaks to the CGT [Confédération Générale du Travail] as well as to us. What I know is that his work expresses magnificently, in forceful images, the profound tendency of the Faisceau. From the Faisceau's inception, there was misunderstanding. Even in terms of image. The Arc de Triomphe on the large poster for *Nouveau siècle* made some people think that we were a group whose object would be to march once a year before a monument of the past. Well, we are constructors, the constructors of new cities. The conceptions of Le Corbusier express our profoundest thoughts.... Our comrades had, at first, a moment of shock upon seeing his projections. Then they understood. And they entered into a state of enthusiasm. I say it: enthusiasm. Confronted with the City of Tomorrow, grand, beautiful, rational, and full of faith, they saw their own thought materialized.[142]

Rather than fixating nostalgically on the era of World War I, the Faisceau looked to the future, when a new corporative society would construct cities designed to maximize production. Valois wished to remind his readers that fascism had converted the combatant into the producer, and that Sorelian productivism instigated a spiritual awakening among all classes. Thus the fascists' oath of allegiance to France's war dead at the Arc de Triomphe (fig. 39) on 11 November 1925, could only be fulfilled if they turned their attention to a Sorelian image of the future, wherein every aspect of modernity would be harnessed (fig. 44). For Valois, Le Corbusier's image of the new city functioned just like Sorel's mythic image of the general strike: to paraphrase Sorel, the Plan Voisin constituted a "body of images" able to galvanize the productivist spirit within each fascist, and to group their aspirations into a "coordinated picture" of the coming revolution.[143] Since Le Corbusier's plans were premised on new modes of transportation, Taylorist techniques, and the use of standardized materials to speed construction, they seemed imminently adaptable to Valois's corporative vision. Valois claimed that Le Corbusier's designs could be appropriated to his own ends because "fascism is exactly that, a rational organization of all aspects of national life, conceived in such a manner that individual initiative is multiplied by ten."[144] By thinking in terms of the collective rather than the individual, Le Corbusier had allegedly created an architectural

program ideally suited to a corporative society, and a productivist ethic. Thus Valois lauded Le Corbusier's architecture for its use of rationalism and new materials, while claiming a willful ignorance of the architect's own political views. To Valois's mind the fascist rank and file "saw their own thought materialized" on viewing Le Corbusier's modern city because it expressed their own spirit of invention, a spirit in fact denied to the proletariat in Le Corbusier's own technocratic hierarchy.

Le Corbusier's elitism caused him to draw a sharp distinction between the mass of producers and the select few who possessed an artistic sensibility. In *Urbanisme* he stipulated that the architect's role was to go beyond the engineer by infusing aesthetic criteria into industrial design. "Mechanical beauty" would not exist were it not for the fact that "man's sensibilities intervene in the midst of the most rigorous calculation." Design must be "lifted outside the realm of mere calculation" by virtue of "the intervention of an individual taste, sensibility, and passion" conducive to "the state of mind of an epoch." "An engineer should stay fixed and remain a calculator," for he is concerned with the "utilitarian"; only "architecture" can go "beyond calculation." The beauty of such marvels of engineering as the Eiffel Tower or Pont du Gard stemmed from the "individual taste" of an architect, rather than the productivist ethics and inventive capacities of the workers and engineers who built these structures.[145]

Since the architect's elitist vision had more in common with the politics of the Redressement Français, by 1928 Le Corbusier chose to promote his urban plans in that movement's journal, concurrent with the demise of Valois's Faisceau.[146] Valois's reading of Le Corbusier placed more emphasis on the spirit behind his designs than the social implications of his plans for the modern city, declaring the architect's structures to be an expression of productive esprit rather than technocratic elitism. Far from abandoning his faith in class conflict as an agent of national regeneration, or denying the bourgeoisie a regenerative role in la cité française, Valois wanted to utilize the *esprit guerrier* and *esprit producteur* of all classes in his fascist revolution.[147] For Valois combatants of all classes were also producers, and as such possessed the creative capacities Le Corbusier reserved for himself and his select peers. Despite Valois's seeming embrace of Le Corbusier's rationalized conception of town planning, he claimed that all architectural ideas were the product of a vital-

ist "spirit of production," fully compatible with Sorel's conception of Bergsonian intuition. Valois's vitalism led him to declare the fascist city an organic and corporative expression of the collective will of la cité française; Le Corbusier by contrast, likened the home to a monastic cell, ideally created for the single individual.[148] Thus Valois combined technological modernism and vitalism within the logic of what the Faisceau termed the "mystique of the producer,"[149] a spiritual and collective dimension to urban planning that Le Corbusier never entirely embraced.

MACHINE PRIMITIVES

Philippe Lamour and the Fascist Cult of Youth

A s examples of the primitive, the sculpted athletes lining the "Stadium of the Marbles" in the Foro Mussolini in Rome do not usually come to mind, but that is because art historians have largely ignored the related temporal and mythic dimension shared by primitivism and fascism's cultural politics.[1] We customarily analyze primitivism in terms of a binary contrast between "civilized" Europe and societies at a supposed earlier stage of development: for example, the symbolist Paul Gauguin cast his move from industrialized Paris to Brittany and then Tahiti in terms of a redemptive return to a primeval condition, akin to the childhood of Western civilization. By entering into a foreign culture—whether rural Brittany or the south seas—Gauguin and others like him hoped to leave the decadent West behind and undergo a form of psychosexual rejuvenation through contact with so-called primitive societies. Decadence and regeneration served to define the differ-

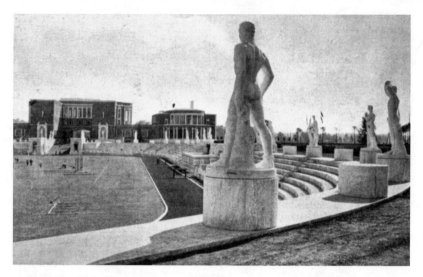

Fig. 45. Enrico del Debbio, Stadio dei Marmi, Foro Mussolini, 1928–1932. Reproduced in
L'Illustrazione italiana, 13 November 1932, 698–699.

ence between industrial Europe and cultures viewed as still rooted in a distant
past, whether the medievalism of agrarian Brittany or the primeval eden of
Tahiti.[2]

Art historian Romy Golan has recently examined the political (and fascist)
dimension of this primitivist flight with reference to the widespread repudia-
tion of machine aesthetics in interwar France and under the Vichy regime. As
Golan demonstrates, critics such as Camille Mauclair and Louis Vauxcelles
couched the contrast between decadent cosmopolitanism and regenerative
agrarianism in terms of a racial confrontation between the urban-based École
de Paris—supposedly dominated by Jewish artists of foreign extraction—and
an indigenous École française, made up of former fauves who had "returned
to the soil" to rediscover their own French roots.[3] They found evidence of
such regeneration in the work of André de Segonzac, whose rural imagery
now served to confirm his status as a member of the rural gentry, and in the
landscape painting of Maurice Vlaminck and André Derain, who emulated de
Segonzac by purchasing large estates in the French countryside. Golan relates
this primitivizing quest to an embrace of the reactionary cultural politics of
Maurice Barrès, who pitted regional identity against the homogenized, repub-
lican concept of citizenship, and to the ideology of royalist Charles Maur-

ras, for whom regionalism became synonymous with opposition to republi-
canism, the parliamentary system, and the cosmopolitanism of cities.[4] Such
thinking culminated in the anti-Semitic "soft-fascism" of the Vichy regime,
whose call for a revival of folklore, tapestry making, and other forms of arti-
sanal production was indicative of an anti-industrial nostalgia for an agrarian
and medieval France.[5]

This orientation even affected the "machine aesthetic" of self-styled leftists
such as Fernand Léger and the architect Le Corbusier, who both underwent a
crisis of confidence following the stock market crash of 1929 and the ensuing
Great Depression. Repudiating rationalism in industrial design and machine
forms as metaphors for international capitalism, Léger and Le Corbusier now
turned to natural or biomorphic imagery to signal their newfound interest
in "organicist" ideologies such as corporatism or regional syndicalism.[6] In Le
Corbusier's case, such thinking resulted in site-specific architecture incorpo-
rating local materials, and in biomorphic paintings of rural subjects, such as
his *Woodcutter* of 1931.[7] Though opposed to the reactionary cultural politics
of the fauves, they too were led "in critically analogous directions" toward "an
infatuation with the French countryside and its denizens" and "a new atten-
tion in their work to manual craft, site-specificity, texture, and local color."[8]

Italian fascists likewise conjured with themes of urban decay and rural re-
demption,[9] but, more significant, cast the degenerate/regenerative trope in
terms of a *generational* contrast between elder statemen, who defended de-
mocracy in the name of Enlightenment ideals, and a generation of World War
I combatants, whose valor and sacrifice served to transform Italy and give it
a spiritual mission.[10] Youthful virility became the most visible hallmark of
fascist ideology; thus the warrior athletes in the Foro Mussolini symbolized
fascism's perpetual adolescence and the regime's regenerative effect on Italian
society. Historians now concur that the concept of youth played a key role in
Italian fascist ideology under Mussolini, but scholars have yet to consider the
impact of that ideological myth on theories of visual culture promoted by fas-
cist groups in France.[11] This chapter will address the latter theme by analyzing
the appropriation of the fascist cult of youth by an important, but understud-
ied proponent of French fascism: the lawyer and fascist ideologue Philippe
Lamour (1903–1991).[12]

Unlike his Italian colleagues Lamour described machine aesthetics, rather

Fig. 46. Photograph of Philippe Lamour, 1924. Reproduced in *Le cadran solaire* (Paris: Robert Laffont, 1980).

than male athleticism, as the primary embodiment of fascism's youth cult. Instead of associating "the primitive" with a turn away from machine-age imagery, Lamour claimed that modern industrialism, in producing a new consciousness, had also resuscitated a primeval, poetic imagination, integral to the fascist *mentalité*. Like the futurists before him Lamour was the self-styled "primitive" of a new consciousness attuned to the dynamism of technology;[13] moreover, he thought this attitude signaled the death knell of republican France, since democratic ideals were based on Enlightenment rationalism. As we shall see this association of the fascist spirit with a "poetic" and irrational revolt against democracy was derived from Lamour's reading of political theorist Georges Sorel, whose theory of revolution called for the resuscitation of such "primitive" consciousness through the emotive impact of mythic images on our imagination. For Lamour, a poetic response to machine dynamism constituted one such mythic image, and served to define the new conscious-

ness of a younger generation opposed to the Third Republic. To support his claim Lamour referred to a surprising array of left-leaning modernists, including the filmmaker Sergei Eisenstein, architects André Lurçat and Le Corbusier, and the "new vision" photographer Germaine Krull. Lamour's machine primitivism thus stands in striking contrast to the avant-garde repudiation of machine aesthetics sketched out above and runs counter to any singular correlation of interwar primitivism with an agrarian or organicist retreat from "the modern" in its urban and technological forms.

I begin by examining Philippe Lamour's involvement in fascist movements between 1925 and 1928 before considering the ideological precepts undergirding his machine aesthetics. Lamour regarded the fascist cult of youth as a Sorelian myth able to provoke a generational revolution and create a collective work ethic that would result in a new social order, organized around industrial production. This "society of producers" was premised on a new revolutionary dynamism, which Lamour associated with a Sorelian activation of mythopoetic consciousness. Machine aesthetics—manifest in montage techniques in film and photography, modern architecture, and automotive design—constituted so many "mythic images" able to sustain this fascist state of mind. Study of Lamour's theory of machine primitivism, therefore, sheds new light on the cultural interchange between Fascist Italy and ideologues in interwar France, as well as the role of generational ideology in this aestheticized form of politics.

Fascist Nonconformism

Born in 1903, Lamour was very much a part of a postwar generation who rejected the Third Republic. In his autobiography, *Le cadran solaire* (1980), Lamour described himself as a "lawyer and journalist" during the interwar years, who advocated a variety of political causes before becoming an agrarian syndicalist, based in the Languedoc-Rousillon region, after World War II. Lamour recalled reading Bergson while completing his baccalaureate during the war; when he pursued a law degree in 1920 that interest was supplemented with study of everything "from Émile Zola to Georges Sorel."[14] His postwar disillusionment with republican politics first took the form of "a weakness for the group *Clarté*," a group he described as "hostile to the *embourgeoisement* of the social democrats" and "seduced by the example of the Russian Soviet

revolution."[15] Lamour's enthusiasm was reinforced by his friendship with a self-declared Christian socialist, Philippe André, who, like Lamour, wished to conjoin politics and ethics to ensure social cohesion. His support for André's dissident socialism was relatively short lived, chiefly due to the latter's engagement in parliamentary politics. Thus while André celebrated the election of the *cartel des gauches* in 1924, the twenty-one-year-old Lamour thought the very involvement of the socialists in the parliamentary system an indication of their moral bankruptcy.[16] Lamour's enthusiasms lay with Fascist Italy and Soviet Russia, though his assessment of their relative merits varied over the interwar years. Writing of the period before 1923, Lamour recalled his view that the Russian revolution attempted to create "a society founded on work, merit, and solidarity between men" that "would enrich the whole nation and not just some privileged portion."[17] Fascism on the other hand was reportedly not meant to "defend the established order" but to create "a new order" that was both "popular and social, agnostic if not anticlerical," and "opposed to egoistic capitalism." What these two ideologies shared, declared Lamour, was "a contempt for the bourgeois tradition and the impotence of parliamentary regimes"; thus in "calling for a dictatorship resting on a patriotic elite or on the proletariat," both movements advocated "recourse to violence" rather than the ballot box to achieve their ends. Lamour states that he was one among many who saw communism and fascism as "two aspects of a single ethic," an ethic "expressed in the work of Georges Sorel." "We read with passion the *Reflections on Violence* and *Illusions of Progress*," he states, singling out those volumes that were key to his own developing ideas on ideology.[18] Fusing Sorelian thought with communist aspirations, Lamour claimed that the "myth of the general strike" would, at the appropriate time, "paralyze the economic machine, ruin the propertied classes, and permit the dictatorship of the proletariat."[19] However, following his military service from 1921 to 1924, he turned away from this communist-oriented vision in search of a doctrine that was at once "social and national." The result was his decision, in the winter of 1925, to join Valois's Faisceau in an attempt to realize his Sorelian ideals. With the fall of the *cartel des gauches* in the summer of 1926, the fascist Lamour expected revolution; instead the return of the conservative Poincaré to power signaled the slow demise of Valois's movement in the midst of internal dissension.[20]

Lamour, in *Le cadran solaire*, claimed that 1926 was a turning point for

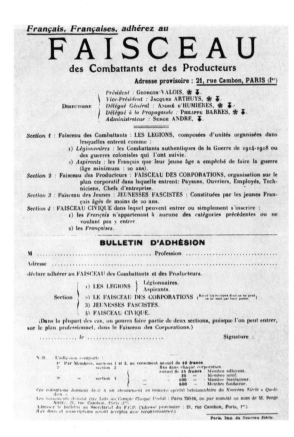

Fig. 47. *Bulletin d'adhésion au Faisceau des combattants et des producteurs, 1925.*

him, and that Valois's Sorelian ideology subsequently lost its appeal. Writing in 1980 he condemned national socialism as an "old dream" that had led Sorel to "the antechambers of the Action Française" and Lagardelle to a position as "minister of labor at Vichy, charged with the deportation of French workers to Germany."[21] In the immediate aftermath of the Faisceau's demise, Lamour states that he abandoned fascist ideology for a youth-oriented cultural protest against "the ethic and aesthetic of bourgeois society."[22] Though the moral corruption of the bourgeoisie remained a concern, Lamour now reportedly turned to generational politics as the force for change and founded the journal *Grand'Route* to promote those young writers and artists whom he thought to be a new elite, able to renew French culture and society. Lamour's exaltation of youthful exuberance, supposedly devoid of any fascist or communist valences, was codified in his 1929 book, *Entretiens sous la tour Eiffel* (Conversations beneath the Eiffel Tower).[23] In 1931, Lamour's politics underwent further evo-

lution, culminating in his self-declared return to the syndicalist doctrine of *Le mouvement socialiste* and an alliance with Lagardelle's regional syndicalism; this political shift resulted in the founding of the journal *Plans*.[24]

Lamour would have us believe that the decline of Valois's Faisceau after 1926 signaled his disenchantment with fascism, when, in fact the historical record tells a different story. As Robert Soucy and Allen Douglas have demonstrated, Lamour was more disappointed with Valois's leadership than with fascism per se, with the result that he became involved in attempts to usurp Valois when the fascist movement waned in the wake of Poincaré's reelection.[25] In the process Lamour was caught up in the struggle between left and right forces within the movement, and attempted to satisfy both constituencies. When he first entered the Faisceau he was numbered among dissident leftists and joined fellow fascist Henri Bourgin, a former member of the Proudhonian wing of the Le Parti Socialiste Section Française de l'International Ouvrière (French Socialist Party), in founding the Corporation des Etudiants and Section Universitaire des Jeunesses Fascistes.[26] In May 1926 Lamour coauthored an important appeal to French workers to join the movement; in October of that year he was elected secretary general of the Faisceau in the Parisian outskirts, and in April 1927 he published an article on Sorel that labeled fascists "syndicalists and revolutionaries."[27] At a July 1927 dinner organized by fascists in honor of Hubert Lagardelle, Lamour could describe Sorelian thought as a "philosophy exalting the producer" that was embraced by "Lenin and Mussolini." Between 1926 and 1928 Lamour published three works on fascism, including his major doctrinal statement, *La république des producteurs* (1926), a text indebted to Sorel's thought.[28] Throughout his Faisceau period Lamour paraded his left-wing credentials and adhered to the antiparliamentary aspects of Sorel's doctrine.

Lamour's leftist principles were most clearly articulated in his pamphlet *La république des producteurs*, which anticipated many of the themes broached in Valois's *Le fascisme* (1927).[29] The pamphlet opened with a critique of the parliamentary system's divisive party politics and its total indifference to matters of production, even when it concerned such strategic goods as wheat, coal, iron, and electricity. The purpose of political choice under the democratic system, we are told, was to ensure the reelection of the elected, not the social and material welfare of French producers.[30] Lamour concurred with Valois on the need for a new fascist state modeled along corporative, syndical-

ist, and regionalist lines to rectify the situation. This new "Republic of Producers" would reject the individualist ideology of democracy and substitute a new order designed to guarantee "familial, regional, corporative, and religious freedoms under the direction of a strong state." Thus Lamour defined the nation as "the assembly of social groups from which arises the prosperity and future of the country: families, regions, professions."[31] Like Valois he viewed the extended family as a bulwark against rampant individualism and "nomadism." The Third Republic's centralized government reportedly ignored all regional distinctions, and Lamour called for the creation of decentralized, regional administrations, modeled along corporative lines. Each regional entity would represent family groupings and federated syndicats that would unite all the workers, technicians, and employers associated with a particular industry. Finally, an overarching state council, headed by a benevolent leader, would work in consultation with these federated structures to guarantee peace within France and to safeguard the country's national interests abroad.[32]

Lamour also shared Valois's conviction that the fascist regime should unite producers of all classes through the creation of a postwar "spirit of victory." To emphasize the point, he criticized the Soviet Union for initially espousing an internationalism that ignored regional differences, and for its suppression of bourgeois industriousness and the confiscation of private property in the name of the dictatorship of the proletariat. Thus he noted with approval the Soviet Union's recent retreat from "Marxist principles" as evidenced by the "new economic policy" and the return of land to peasant ownership. This valorization of the producer, coupled with Soviet Russia's resurgent nationalism, constituted "the principles of a veritable fascist revolution."[33] Thus Lamour regarded the Soviet system as a fluid social "experiment" which might yet undergo a conversion to fascism.

In fact Lamour was not alone in adopting a leftist interpretation of fascism in the later 1920s, for Valois himself was simultaneously moving to the left, having first emerged from monarchist circles. In contrast to Valois, however, Lamour continued to advocate an alliance of left and right antiparliamentarians long after Valois had abandoned this strategy. According to Allen Douglas, Valois's shift to the left was reflected in his move away from defining fascism as "eternal resistance to the Barbarian," exemplified by communism's Asiatic "hordes," to his proclamation in Le fascisme (1927), that "nationalism + social-

ism = fascism." "Fascism was now described as the culmination of a process, begun by the French Revolution, that was creating the modern state," a shift, states Douglas, based on the Italian fascist Enrico Corradini's characterization of fascism "as surpassing, but not negating, democracy, liberalism, and socialism."[34] By the fall of 1926 Valois's leftward turn had alienated his major financial backer, the perfume manufacturer François Coty, and a year later Valois's syndicalist-oriented supporters also had risen in revolt against his leadership, though for radically different reasons. In the winter of 1926, Valois softened his opposition to parliamentary politics, and at the January 1927 meeting of the First Fascist Congress, he asked the assembled to consider discussing elections. For Sorelian fascists, whether syndicalist or dissident Maurrasians, such a suggestion was anathema, and those attending the congress successfully moved to counter any attempt to debate a strategic alliance with parliamentarians. Shortly before the congress Lamour and the decorated war veteran Marcel Bucard were already attempting to revive the antiparliamentary, left-right synthesis by entering into negotiations with Coty to overthrow Valois. Valois's subsequent rejection of the right-wing component of that synthesis, combined with his announcement, in the late spring and summer of 1927, that the fascists could support larger groups that ran parliamentary candidates, indicated a fundamental shift in his views.[35] Valois's evolution culminated in the dissolution of the Faisceau and creation of the Parti Républicain Syndicaliste in June 1928. Over the period from January to March of that year Lamour and his allies attempted to undermine Valois leadership, but the only result was Lamour's expulsion from the Faisceau following a meeting of the Valois-controlled fascist Supreme Council in March 1928. After the March meeting Lamour, ex-communist Henri Lauridan, and Guéguen, a former member of the conservative veterans Légion of Antoine Rédier, gathered together those fascists opposed to Valois, to form the Parti Fasciste Révolutionnaire. Although the newly formed party won the support of Coty, and succeeded in publishing a newspaper, *La révolution fasciste* (1928–1929), it quickly disappeared. However, the centrality of Lamour's *République des producteurs* to his new fascist program was underscored by its republication, in extract form, in *La révolution fasciste.*[36]

Following the demise of the Parti Fasciste, Lamour formed a new profascist team under the auspices of the journals *Grand'Route* (March 1930–July 1930)

and *Plans* (January 1931–May 1933), a regional syndicalist organ founded in 1931 with the financial backing of Jeanne Walter. Throughout 1930 *Grand'Route* contributors Lamour and his literary allies André Cayatte and Eric Hurel also wrote for Senator Henri de Jouvenel's "Organe des Générations de la Guerre," *La revue des vivants* (1927–35).[37] Eager to involve the younger generation in the journal and open to all political tendencies, including fascism, Jouvenel invited Lamour to write a regular column on "La Pensée des Jeunes," with the first installment appearing in September 1929. Sometime that fall Lamour joined forces with Jouvenel's son, Renaud de Jouvenel, in launching *Grand'Route*; between the appearance of *Grand'Route* in March 1930 and its demise in July of the same year, Lamour, Cayatte and Hurel contributed regularly to "La Pensée des Jeunes." The close relation of the *Grand'Route* group to Jouvenel's journal indicates that the allegiance the fascist Lamour posited between his own generation, the "generation of 1909," and that of the combatants, the *générations de la guerre*, continued to preoccupy him after the failure of the Parti Fasciste Révolutionnaire.

Between 1928 and 1932 Lamour continued to contemplate the relative merits of fascism and bolshevism as models for a Sorelian "Republic of Producers" untethered from parliamentary democracy. Once again, however, fascism trumped bolshevism for Lamour. In a section of *Entretiens sous la tour Eiffel* (1929) subtitled "Lenin and Mussolini," Lamour argued that both figures "profited from the catalyser of energies that was the war to create a new order," a "Republic of Producers," but that "the superiority of Mussolini" stemmed from the fact that he avoided favoring one class over another and sought to organize producers from all classes.[38] The Soviet Union, on the other hand, had begun by "pitting one group of producers against another," but since the creation of a "Republic of Producers" required the organization of "all production," bolshevism had to rely on producers emanating from all classes. Mussolini had correctly avoided such a schism, "for the battle of classes, if it is an undeniable fact, is a fact to eliminate and not one to organize."[39] Clearly Lamour still endorsed Valois's fascist theory of class collaboration, with its basis in Sorelian productivism. Though "bolshevism and fascism are founded on the industrial collectivities that are the source of the prosperity of the nation" the Soviet Union only survived by abandoning "the self-proclaimed principles that served as slogans for the revolution." "Directed against property, it only

survived by creating peasant property"; "directed against industry, it only survived by organizing it"; "directed against the nation, it had for a principal result the creation of the Russian nation and a sense of its grandeur."[40] The Soviet Union, Lamour continued, was destined to become "a modern nation, reorganized, strong, imperialist, open to progress" that would destroy "the Third International in the greater interests of Russia.'"[41] By avoiding the class conflict precipitated under Lenin's dictatorship, Mussolini succeeded where bolshevism had initially failed; it was now up to the Soviet Union to shed its class biases and follow the Italian Fascists in creating the Republic of Producers.

"Mussolini has observed the battle of classes," Lamour confidently states, so that unlike "communism" he will not make it "the basis of a new order."[42] Instead, Mussolini only used class conflict, in the guise of anticommunism, to dupe the bourgeoisie into thinking a Fascist regime would defend "their interests," but having used the bourgeoisie to gain power, he then subsumed their interests within "the interests of the nation." This nationalist agenda made Italian fascism "European" whereas bolshevism was less European by virtue of its internationalist rhetoric. Additionally the bloody nature of the Russian Revolution was evidence of "a cruelty of the race," whereas the relatively benign Fascist coup in Italy reflected the "discipline" of the Italian "Roman spirit." Since "the second fascist revolution will be French" one could assume that France will follow its Latin confrère in establishing a Republic of Producers modeled along fascist lines.[43]

In 1930 Lamour supplemented this Valois-inspired defense of Italian fascism with a more pragmatic interpretation of fascism's merits. Writing in *Grand'Route* (June 1930) he claimed that only "two movements" in Europe—bolshevism and fascism—had embraced the "new order" by overturning the "old principles" that resulted in "war, inflation, democracy" and "a general mediocrity in public spirit and the arts."[44] The Bolshevik revolution had for its basis "a general theory of the organization of collective society which would sacrifice the personality to the collectivity." Since the Sorelian Lamour claimed that "the organization of societies must have for a goal the liberation of personalities," the Soviet Union made "a means" into "an end," thereby suppressing "the necessary end for all civilization: permitting the personality its full development." The "fascist revolution," on the other hand, "issues not

from a theory but from a sentiment, from a reflex of the offended personality."
"Whereas bolshevism sacrifices the individual in order to organize society,"
Lamour continued, "fascism, in wanting to liberate the individual, discovers
the urgency of giving him an appropriate social frame." In yet another article
(March 1930) he argued that fascism's method of "organizational empiricism"
accounted for its "flexibility and its permanence."[45] Unlike the Soviet system,
Italian fascism was able to adapt its corporative structures to new economic
circumstances and to rely on the productivist spirit of its citizens to meet un-
foreseen challenges. Although Lamour claimed that "it is necessary to con-
sider with equal sympathy these two attempts [at] rejuvenating old Europe
through the adaptation of institutions to a new economic civilization," he
clearly favored fascist empiricism over the Soviet version of collectivism.[46]
Thus, while counseling Italy and the Soviet Union to safeguard their produc-
tivist ethic, Lamour also reviled international "antifascists," describing them as
retrograde protesters opposed to the new order of Sorelian producteurs.[47]

This profascist agenda resurfaced with the founding of the journal *Plans*
(January 1930), which aimed to reorganize French society on the basis of Hu-
bert Lagardelle's doctrine of regional syndicalism. *Plans* brought together not
only Faisceau sympathizers Lamour, Le Corbusier, Winter, Aldo Dani (for-
mer secretary for Valois's Librairie Nationale), and Hubert Lagardelle, but also
the polemicists Alexandre Marc, Denis de Rougement, and René Dupuis, who
were members of the newly created Ordre Nouveau group.[48] In fact, the evolv-
ing relationship between Lamour and proponents of Ordre Nouveau charts
Lamour's gradual disenchantment with fascism, which reached a head in the
spring of 1932, shortly before the appearance of the second series of the jour-
nal *Plans*. As Loubet del Bayle and John Hellman have noted, the politics ad-
vocated by Lamour in *Plans* were part of the broader political phenomenon
of "nonconformism" developed by the Ordre Nouveau, whose name derived
from a 1930 manifesto written by future *Plans* contributer Alexandre Marc.[49]
Created at the time of the demise of *Grand'Route* the group's precepts were
codified by the cultural theorists Robert Aron, Arnaud Dandieu, and Henri
Daniel-Rops, all of whom contributed to either *Grand'Route* or *Plans*. Indeed,
the November 1931 edition of *Plans* welcomed the arrival "parmi nous en for-
mation parfaite du jeune group de l'Ordre Nouveau" and the formation of a
"Comité d'action *Plans*–Ordre Nouveau" made up of Jeanne Walter, Robert

Aron, Arnaud Dandieu, Jean-Marie Gabriel, Philippe Lamour, and Alexandre Marc.[50] Like Lamour, Aron and Dandieu combined a Sorelian disdain for the "materialism" of the Third Republic with an attraction for the "spiritual" values propagated by fascism and communism; but unlike Lamour's group they condemned American productivism as a sign of moral decay.[51] This contrast is exemplified by the cultural views advocated by Aron and Dandieu in *Décadence de la nation française* (1931) and *Le cancer américain* (1931), when compared to the cultural politics of *Plans*. According to Loubet del Bayle, Aron and Dandieu laid out the "fundamental positions of the Ordre Nouveau," namely, "mistrust of everything that was suspected of capitulating to rationalism and the spirit of abstraction," "rejection of productivist materialism both capitalist and communist," and a belief in the "idea of a spiritual revolution."[52] Echoing the language of the Sorelians, they called for a renewal of national energies through a return to the revolutionary tradition and a collectivism founded on a concept of "real man," as opposed to the abstract and disembodied individualism promoted by liberal and idealist thought. *Le cancer américain* (1931) in turn related this "tyranny of abstraction," all in the name of "the hegemony of rational mechanicism over concrete and emotional realities," to the "Yankee spirit" and its doctrine of "homo economicus."[53] Although excerpts from *Le cancer américain* were published in the October 1931 issue of *Plans*, they were preceded by an open letter written by Lamour defending the technocratic views expounded in the journal.[54] Despite their shared disdain for capitalism, Lamour, Lagardelle, and Le Corbusier included organizational systems such as Taylorism in their regional syndicalist blueprint; Aron and Dandieu, on the other hand, claimed that Taylorism could not be separated from the capitalist ideology that created it.

These theoretical differences were soon compounded by political disagreements over possible reconciliation with dissident German National Socialists. Members of *Plans*, like the Ordre Nouveau group, wished to overcome national barriers by creating a European federation; moreover, Lamour believed that Lagardelle's regional syndicalism held the key to achieving this goal. To further these ends Marc had established ties with like-minded Germans, and in 1930 he attended meetings at the Solhberg camp with young Germans such as Otto Abetz, a German design teacher who would later become ambassador for the Third Reich to France between 1940 and 1945.[55] The following year the *Plans*–Ordre Nouveau action committee organized the French section of

the Front Unique de la Jeunesse Européenne, to overcome national barriers and further the cause of reconciliation between France and Germany. Proponents Marc and René Dupuis wrote a manifesto laying out the group's principles. Claiming that "a radical crisis" necessitated "radical solutions" and lamenting "the tragic misunderstanding that separates Germany from France," they proposed that both peoples embark on a "revolutionary battle" for the "return to real man," "federalism," and "elaboration of a European plan."[56] This "real European federalism," founded on the destruction of older conceptions of the nation state, would result in a "logical and free Europe" unburdened of "social injustice" and warmongering. German allies of the Front Unique program included Otto Abetz and Harro Schulze-Boysen, the director of *Planen*, the German equivalent of *Plans*. Abetz was among the founders of the centrist Reichbanner, an organization that attempted to reconcile communist and National Socialist currents. To further these ends the December 1931 issue of *Plans* published the founding "Manifeste du Front Noir," written by the dissident National Socialist Otto Strasser, who defended the leftist elements of Nazi doctrine when they came under attack within the party. Strasser, who had joined the National Socialist German Workers' Party (NSDAP) in 1925, broke with Hitler in 1930 in order to found the Black Front, an organization, states Roger Griffin, "based on a blend of Volkish nationalism, anti-semitism, national socialism, and Europeanism."[57] Thus *Plans*, though opposed to Hitler, nevertheless supported left-leaning National Socialists disillusioned with Hitler's authoritarianism. To consolidate the relationship Marc, Lamour, and their Ordre Nouveau friends met Abetz, former Reichbanner founder Baldur von Shirach, and Strasser—dressed in his Black Front uniform—in August 1931 at Rethel, in the Ardennes. The Front Unique movement culminated in a Congrès de la Jeunesse Franco-Allemande organized under the auspices of the Front in February 1932 at Frankfurt am Main; but shortly after that date the movement fell into internal disarray.[58]

This decline was primarily the result of a schism between the Ordre Nouveau group and *Plans* contributors Lamour and Marc. Having visited Germany in the summer and autumn of 1931, Lamour and Marc had become increasingly alarmed by the rise of Hitler's National Socialists, and upon their return to France they called for the clandestine shipment of arms into Germany in an effort to counter the Nazi threat.[59] In response the Ordre Nouveau group rejected Lamour's activism, tried to gain more control over the editor-

ship of *Plans*, and in an article published in *Plans* titled "Précisions sur L'Ordre nouveau," counseled caution as an appropriate response to recent events in Europe. After January 1932 only Marc, Dupuis, and Denis de Rougement continued to publish in *Plans*, and by the summer of 1932, Lamour had even parted ways with these three members of Ordre Nouveau. Concurrently *Plans* evolved from a journal equally open to fascist, national socialist, and communist currents, to an organ sympathetic to the Soviet Union. Whereas Lamour had allied the first edition of *Plans* to the Sorelianism of Lagardelle's *Mouvement Socialiste*, the second series (beginning in April 1932) evoked Henri Barbusse's procommunist journal *Clarté* as a model. Following the demise of *Plans* in May 1933, Lamour became an ardent antifascist, contributing to the communist-oriented journal *Mondes*.[60]

Thus, far from becoming less interested in fascism's prospects after 1926, Lamour was a diehard member of the Faisceau who attempted to keep French fascism afloat even after Valois was prepared to abandon the project. As for Lamour's claim that the publication of *Entretiens sous la tour Eiffel* (1929) signaled a new phase of his political development, that too deserves closer scrutiny, for the volume was first advertised in the June 1927 issue of *Nouveau siècle* as part of a new series of publications titled *Les Écrivains du nouveau siècle*. As we have seen, Lamour's defense of Mussolini in that volume was a reprise of arguments for fascism made by Valois under the auspices of the Faisceau. In fact, the themes found in Lamour's volume form a continuum with ideas first broached in the pages of *Nouveau siècle* penned by none other than Philippe Lamour himself. When that literature is then compared to the writings in *Grand'Route*, it becomes clear that the politics of *jeunesse* advanced in the latter journal affirmed, rather than displaced, the fascist themes upheld by Lamour during the late 1920s. Lamour's generational politics—which saw French youth as the vehicle of national renewal—were not only predicated on his contacts with the Ordre Nouveau group, but, I would argue, on his familiarity with the cult of youth propagated by Mussolini.

The Fascist Cult of Youth

Lamour's main contribution to French fascism was to cast Georges Valois's Sorelian confrontation between parliamentarians and combatants and producers in terms of a generational divide. In various texts published in *Nou-*

veau siècle Lamour argued that the postwar government amounted to a gerontocracy whose members had been unaffected by the ethical transformation initiated by the war effort. By contrast, the generation of wartime combatants and postwar youth had been profoundly affected by the war, with the result that they possessed the productivist consciousness celebrated by Sorel and his fascist followers Mussolini and Valois. Having equated valor in combat with national "health," Lamour gave his own generation a role in this national renewal. This theme was first broached in an essay titled "Sous le signe de la victoire" (3 December 1925), in which Lamour described France as a "gérontocratie" composed of "elders who made war" but did not inhabit the trenches, and a youth who now suffered from "the economic difficulties of peace."[61] Referring to his generation as the "generation of victory," and the "daughters, the sons, the friends of the combatants," he contrasted them with "the generation of defeat" who continued to dominate politics throughout the wartime and postwar era. For that older generation, states Lamour, the war did not herald "the renaissance of all national virtues" but was "an unpleasant and provisional interruption of the profitable little parliamentary game."[62] Unable to grasp the significance of the transformation of the producer into the heroic, Sorelian combatant, the older generation continued to adhere to the individualist ideology of parliamentary democracy and the divisiveness of party politics.

In Lamour's writings for *Nouveau siècle* the relation posited between the fascist youth and the Sorelian combatant became more and more pronounced as he developed his credentials as head of the student contingent of the Faisceau. In the process the palingenetic theme of rejuvenation through heroic violence was transformed into a Sorelian version of generational revolt. In an article titled "A ceux qui n'ont pas vingt-six ans" (21 February 1926), Lamour wrote a eulogy to the fallen soldiers at Verdun, suggesting that the "energy" and "productive force" of the combatants should be instilled in those under the age of twenty-six.[63] "Now it is necessary to be men," proclaimed Lamour," there is no longer the right to lack energy, there is no longer the right to doubt oneself, no longer the right to live by chance. Their memory must inspire our acts, accompany our joys, make our hearts more manly [viriliser]."[64] In his June address to the twelve thousand fascists who gathered at Rheims for the "Assemblée nationale," Lamour gave a speech in which he proclaimed himself a "representative of the younger generation who did not participate in the

war but who want to remain worthy of the victory that we received from our elders." "The politicians of the generation of defeat are only capable of ruining us," declared Lamour, "we want to realize the work of the combatants."[65] In the fall of 1926 Lamour even went to Italy to experience the Fascist revolution firsthand, a trip recorded in a series of articles in *Nouveau siècle* titled "Visite à l'Italie vivante." In an article of 20 September he reported the enthusiastic response of a crowd, composed predominantly of workers, to three films titled *March on Rome, Voyage of the Norge,* and *Italian Empire*; in an article dated 14 October he wrote of his experience of a Fascist parade in Venice that was dominated by "young volunteers," led by "young leaders," all marching to the hymn of the Fascist Arditi, "Giovinezza, Giovinezza" (Youth, Youth). Fascism had reportedly inculcated Italy's leaders with a taste for "action" and a horror for the "vain eloquence" of political rhetoric. "L'Italie," we are told, "a un peuple jeune, fervent, enthousiaste."[66] By claiming that the "spirit of youth" was intrinsic to fascist ideology, Lamour separated the politics of "youth" from simple demographics, and proclaimed fascism a metaphysical force for national "regeneration."

That very correlation was actively propagated by Mussolini, who repeatedly demonstrated his own youthful vigor in staged photographs taken throughout his career as Italy's Il Duce.[67] Beginning in 1919 Mussolini contrasted the "combattentismo" of the Italian officers returning from the war with the timidity of their elders, who continued to control the government. Thus arose the fascist myth of two Italies, a defeatist Italy made up of parliamentary bureaucrats who did not participate in the heroic struggle and the new Italy of an emerging "trenchocracy" of reserve officers, whose heroic valor had saved the nation. In the words of historian Robert Wohl, Mussolini was able to give disillusioned soldiers like Italo Balbo and Giuseppi Bottai "the program of radical negation they sought; and beyond the overthrow of the existing system, he offered them a positive vision: the regime of the young, a nation of victors, the Fascist State."[68] In July 1919 Mussolini attributed the attraction fascism had for young veterans to the fact that "in the *fasci* there is not mildew of old ideas, the venerable beard of the old men, the hierarchy of conventional values, but there is youth, there is impetuousness and faith." By 1920 Mussolini was cloaking fascism in the myth of "youth" to overcome class differences and to broaden the appeal of the doctrine beyond the core constituency of war

Fig. 48. Fascist *gerarchi* demonstrating their vigor by running to their assignments, n.d. Reproduced in Renzo De Felice and Luigi Goglia, eds., *Mussolini: il mito* (Rome and Bari: Laterza, 1983).

veterans. "After October 1922 when the Fascists came to power," states Wohl, "'youth' became a prominent and distinguishing characteristic of the regime's style, an element of its political program, and an essential aspect of its myth."[69] As Wohl demonstrates, Mussolini's deployment of the generational myth was premised on his knowledge of Sorel's theory, for he believed that the role of myth in his ascent to power "verified Sorel's affirmation that men act not out of reason, but out of faith."[70]

Italian Fascists also claimed to speak for a generation of students and young intellectuals who had called for Italian intervention in World War I, as well as for the combatants who had participated in the war effort after 1915. The war played a large role in uniting Italians along generational lines, since those who served were between the ages of eighteen and forty during the war (1915–1918), and in these same years the Fascists expanded their constituency to include an emerging youthful intelligentsia composed of writers and students who had not participated in the actual fighting. Mussolini consolidated this alliance of students, literary groups, and combatants in the postwar period by founding the Fasci di Combattimento (Combat Units) and Avanguardisti (Avant-garde

Students) in 1919, thereby uniting students and war veterans in the punitive battle against the socialists launched by the Fascist squads. Concurrently Fascist groups were founded for university students between the ages of eighteen and twenty-eight to inculcate a new generation in fascist ideals.[71] Bruno Wanrooij attributes Mussolini's postwar success in recruiting students to the violence of fascism's political actions which "offered these young people, who, for reasons of age, had not participated in the war, the opportunity to show their courage."[72] Indeed, statistics reinforced the Fascist claim to embody the ideals of the wartime generation: in November 1921 students accounted for 13.1 percent of the movement's membership, while youths under the age of twenty-one made up 15 percent of the rank and file. The identity with youth was reflected in the leadership, for when the Fascists ascended to power in 1922, Mussolini was thirty-nine, Italo Balbo twenty-six, and Guiseppe Bottai twenty-seven; moreover in the 1924 parliamentary elections 82.3 percent of the Fascist candidates had no parliamentary experience and 35.9 percent were less than thirty years old. As Luisa Passerini notes, the wartime experience united "the three determinants (youth, male, and warrior) which would also be the basis of the image of Il Duce, who was idealised to the point of preserving an eternal youth."[73]

Thus fascism not only claimed to represent the wartime generation, it also embodied the *spirit* of youth intrinsic to the warrior mentality, quite apart from the issue of demographics. Indeed in the postwar period this distinction between the qualities of youth favored by Italian fascism and the biological condition of being young was played out in the political arena in the guise of "the debate on youth." In fact, the regime underwent an ideological crisis in the late 1920s as a new generation who came of age under fascism claimed the mantle of youth from the generation now in charge, namely, those who had participated in the Fascist rise to power in 1922. The refusal of this wartime generation to transfer institutional power to Fascists who had just come of age led the regime to reconfigure the myth of youth. As Bruno Wanrooij notes, "the leaders in power reacted to this threat by pointing out that the concept of youth could not be restricted to a certain age group, but applied to all possessing a number of spiritual qualities, such as enthusiasm, optimism and faith."[74] In addition, Fascist ideologues such as Giuseppe Bottai claimed that the spiritual qualities forged out of the war experience supposedly endowed

the generation of combatants with leadership qualities many of the younger generation lacked.[75]

Between 1928 and 1930—the very years when Lamour was continuing the fascist project in France—there was an ongoing debate published in Bottai's journal *Critica fascista* over the so-called problem of the young, and the relationship between the mythic discourse of the regime and the reality of which generation held institutional power. In 1930 Mussolini boldly ended the debate with the publication of his "Punti fermi sui giovani" (Firm Ideas on Youth) in Bottai's journal. Writers for *Critica fascista* saw in Mussolini's declaration a confirmation of their claim that biological age was not a measure of merit, and that the youthful "qualities" valued by the regime could be untethered from demographics.[76] However, while Il Duce confirmed that "youth" was as much a state of mind as a physical condition, he also committed the regime to the promotion of men of thirty over those of forty or more years. Thus Mussolini's ambiguous defense of his own mythic ideology conveniently thwarted any attempts by his fellow ex-combatants to establish firm positions of power within the Fascist hierarchy.[77] While Mussolini's aging colleagues were subject to criticism, the Duce's own youthful vigor continued to be celebrated in the popular press as a symbol of the vitality of fascist ideals.

The Eternal Youth of Georges Sorel

Indeed, Lamour incorporated Sorel himself into this cult of youth in a 1927 article devoted to the "éternelle jeunesse de Georges Sorel."[78] In Lamour's estimation Sorel's theory of national regeneration not only galvanized the energies of his own postwar generation, it was testament to the eternal youthfulness of Sorel himself. Having outlined the ideological trajectory of Sorel and his followers, which culminated in the founding of the Cercle Proudhon before 1914, Lamour concluded that Sorel's doctrine "does not create a party," it "expresses a spontaneous movement." These youthful qualities were even inherent in Sorel's writing style, which Lamour describes as typified by a "perpetual dynamism," a form of thought "liberated" from the "rigid formulas" that typify the ordered rationality of parliamentary discourse.[79] In a book of 1924 the Fascist Camillo Pellizzi had already described the fascist state "not as a fixed reality" but as "a dynamic process," "a social instrument for the realization of a myth."[80] Evidently "youthfulness" itself was such a myth, since it

embodied the perpetual dynamism Lamour identified with the thought of *le maître,* Georges Sorel.

In *Reflections on Violence* Sorel himself related his style of writing to the spirit of activism he hoped to instill in the reader. Sorel described his text as composed of "happy intuitions," an "untidy arrangement" devoid of the "magnificent formulas" or the "clear-cut and symmetrical" arguments that were the product of rational modes of thought.[81] Citing Bergson's condemnation of logic and rational discourse as a mode of conveying knowledge, Sorel claimed that his technique of expressing his thought through a disjunctive series of images instilled an "inventive spirit" in the reader, who would have to make the "individual effort" Bergson identified with intuitive insight. "I put before my readers the working of a mental effort which is continually endeavouring to break through the bonds of what has been previously constructed for common use. . . . I skip the transitions between these things, because they nearly always come under the heading of commonplaces."[82] Having followed Bergson in identifying intuition as a form of sympathetic attention akin to creative thinking, Sorel described the galvanizing myths that were central to his theory of revolution as composed of a series of images, comparable to poetry in their ability to conjure up a sympathetic response in the listener or reader. According to Sorel, revolutionary change was only possible "when the popular soul returns to a primitive state, when everything is instinctive, creative, poetic."[83] Sorel contrasted this poetic mode of understanding with rational thought, claiming that the latter actively hindered our imaginative capacities. By awakening the creative intuition of the reader, such mythic images could inspire revolutionary activity, the overthrow of rationalism, and the demise of its ideological bedfellow: parliamentary democracy.

Sorel's recourse to "primitive" consciousness derived from his reading of the anti-Enlightenment philosophy of Giambattista Vico (1688–1744), whose own theory of social regeneration was premised on the recovery of "the mythopoetic wellsprings of our emotions and inner drives."[84] Such thinking led Sorel to lament the inability of the general populace to appreciate the mythopoetic power of African art: writing in 1896 of the "primitive" sculpture housed in the Musée d'Ethnographie (now the Trocadéro), Sorel noted that our contemporary interest in these objects "derives from an intellectual process without any emotional or religious attachments."[85] Sorel even extended

this paradigm to include technology, claiming that all forms of invention, whether in the guise of art or industrial innovation, had their origins in our poetic imagination. Thus Sorel's theory of mythic consciousness was not only revolutionary, it encompassed what John Stanley has termed "a poetic and aesthetic understanding of the productive process."[86] "I have sometimes succeeded in liberating the spirit of invention in my readers," Sorel asserted in his *Reflections on Violence*, "and it is the spirit of invention which it is above all necessary to stir up in the world."[87]

Machine Primitives

In the interwar years Lamour sought to instill such Sorelian mythopoetic thinking in his own readers, first by means of literary eulogies to industrial technology and then through the promotion of machine-age aesthetics in the journal *Grand'Route*. Lamour's assimilation of machine-age imagery into his Sorelian myth of youth first emerged in his fascist tract *La république des producteurs*, but reached full development only in his book of 1929, *Entretiens sous la tour Eiffel*.[88] In the closing section of his fascist pamphlet, Lamour called for an accord between the followers of Proudhon and Saint-Simon, for both groups were well aware of "the inadequacy, of the senility of the outmoded institutions of the parliamentary regime and bourgeois hegemony." Most important, these two constituencies each possessed an "enthusiastic élan [impulse] toward the future." "The same youthfulness animates the two orientations, which unites the new elites whose hour has come and who march toward the conquest of power." Fascism would join them, thus allowing the postwar generation of combatants and producers to "create the new beauty, that of the bright century of electricity." The followers of Proudhon recognized the role of morality, familial duty, and productivity in assuring the nation's health; those allied to Saint-Simon valued technical innovation, the beauty of modern industrialism, and new forms of urban planning. Sorel's concept of the producer served to synthesize these two streams, and fascism provided these groups with the ideological framework for a Republic of Producers. Not surprisingly, Lamour cited Le Corbusier's Plan Voisin as the urban fulfillment of his fascist vision of the future. Thanks to Le Corbusier, society would at last be organized to facilitate the "rhythm" of modern industry, and the creation of a "new beauty" in the form of "large highways," skyscrapers "isolated in im-

mense gardens," and an environment structured around the "right angle." The French, we are told, would now follow the example of the Italians, whose Fascist regime had constructed a vast system of highways by marshaling the economic resources of private companies. Le Corbusier's Plan Voisin could also be realized, if the power of bourgeois and proletarian producers was properly coordinated to serve the national interest.

Lamour's *Entretiens sous la tour Eiffel* developed these precepts into a full-blown paean to machine aesthetics, defined along Sorelian lines. His new book contained chapters on Sorel's theory of revolution, on urban design, the role of fascism in heralding the creation of a Sorelian republic of producers, a series of aphorisms outlining his regional syndicalist vision of the future, and a final section on the rejuvenating energy of youth. Having charted the role of modern technology and syndicalism in creating a new collective consciousness among the postwar generation, Lamour called for the establishment of political institutions geared to this new society. Democracy only recognized "the state and the individual" but not "the collective interests of citizens, manifest in their shared regional identity, class, or profession." Elsewhere in the book Lamour called for the replacement of democratic institutions by professional or regional syndicats that would unite all producers under fascism. "The individual," we are told, "must be left to the philosophical and private domain." "The syndicat is the organ of national sovereignty in the modern state governed by collective life." Once again Lamour called for the creation of decentralized regional institutions, answerable to "delegates from districts and regional corporative organizations." [89] The national symbol for this new order was the Eiffel Tower. Lamour claimed that the structure stood for "the generation of 1909," by virtue of its utilitarian function and appearance. As a radio transmitter the tower instilled collective consciousness among the citizenry; as a feat of modern engineering it reflected the industriousness of the French, who admired Eiffel's use of raw industrial materials, stripped of all embellishments. Collective consciousness, love of precision, and the worship of functional form: these characteristics mirrored the values of the "generation of 1909" and had their architectural embodiment in the tower's machine aesthetic. The younger generation, we are told, possessed a new aesthetic sensibility, geared to the collectivism born of the industrial revolution. [90]

The most innovative feature of the volume lay in its format, for Lamour ap-

plied Sorel's theory of myths to the book's narrative structure. Like his mentor, he hoped to stifle logic and rekindle a revolutionary state of mind by appealing to his reader's poetic imagination. Instead of providing the reader with an orderly sequence of interconnected chapters, Lamour divided the book into four parts, and then punctuated the critical dialogue with a series of poetic "images," the mythic counterpart to his social blueprint. The first section, titled "la révolution est faite" opened up with a poetic "Invocation luminaire à la tour Eiffel," followed by an exposition of Sorel's revolutionary doctrine, before terminating in an "Image": Lamour's description of his experience of a speeding automobile. The second and third sections, titled "Aspects du monde" and "Ordre du monde" contained chapters on the modern city and the republic of producers in tandem with "images" of flight, a speeding train, a bardic "Hymne à la cité," a syndicalist demonstration in Paris and a Fascist parade in Venice, and a synesthetic description of the "primitive dance" elicited by the rhythms of jazz. The book concluded with an "Invocation Finale" celebrating the youthful "barbarity" of a machine age in its infancy. In his *Reflections on Violence* Sorel claimed that revolutionary consciousness could be instilled through myths, "a body of images capable of evoking instinctively all the sentiments which correspond to the different manifestations of the war undertaken by Socialism against modern society."[91] When Sorel wrote these lines, the myth he deemed most appropriate was that of the general strike; in 1929 Lamour interspersed images of syndicalist agitation and a Fascist rally with images of the modern machine, reflective of the productive esprit and technological dynamism to be generated under a Sorelian republic of producers.

Having trumpeted fascism as the best alternative to democracy, Lamour, like Valois before him, praised Le Corbusier's Plan Voisin for the rebuilding of Paris as the material manifestation of his Sorelian vision.[92] Lamour declared Le Corbusier's use of mass production methods to construct roadways, airports, and glass and steel skyscrapers to be the urban counterpart to his technocratic ideals. Echoing the productivism codified by Valois, Lamour described the modern city as "an instrument of work" that "must be conceived, executed, built for work and according to precise values"; likewise he lamented the absence of such productivist values in the construction of cities under the Third Republic.[93] Instead, urban development had occurred haphazardly,

and city centers had become congested and disease-ridden. Under democracy individual rights took precedent over the collective needs of the community as a whole, and urban expansion bore no relation to the public good.

When Lamour looked to the past for urban planners who had acheived his ideals he cited Le Corbusier's praise in his book *Urbanisme* (1925) for Louis XIV and Baron Haussmann, for their creation of "ordered" public spaces, free of congestion.[94] The "moral" and "public order" sought by Lamour could not be achieved within the framework of democratic institutions; indeed, attempts to realize such order had only occurred under autocratic regimes. Thus, according to Lamour, the ideology of abstract individualism promoted under democracy was ill suited to meet the needs of industrial society. Productivist ethics and collective consciousness had their institutional counterpart in the creation of a fascist state to oversee city planning.

Lamour, like Valois, identified Le Corbusier as a modern technocrat whose ideas encapsulated the productivist values crucial to the Sorelian "revolution." "What is a city, asks Le Corbusier? A place of residence? No. An instrument of work. It is a center where the producers congregate for work, negotiation, exchange."[95] Le Corbusier's urban designs, enshrined in the Plan Voisin, reportedly facilitated the "organization of work," and his *Urbanisme* was "the most important book to appear since the war." By clearing central Paris of areas of congestion, and making the city accessible through modern transport, Le Corbusier used the products of the industrial revolution—the car, the airplane—to further coordinate production in a manner unrealizable under the democratic system. "The time of the producers will come," wrote Lamour, and with it would come not only Le Corbusier's architecture but an era of "perpetual rejuvenation," free of democratic ideology, and governed by a theory of "collective life."[96] In a manner reminiscent of Valois, but also indebted to Lagardelle's regional syndicalism, Lamour allied Le Corbusier's urban planning to the creation of a decentralized government composed of syndicats and regional organizations, with an overarching corporative body to oversee matters of national import.[97]

This theory was further developed in articles on collectivism and montage published in Henri de Jouvenel's *Revue des vivants* (1927–1936), a self-proclaimed "Voice of the war generation" that called for closer ties between Fascist Italy and France.[98] Lamour initially formulated the terms for his col-

lectivist aesthetic in a September 1929 article in *La revue des vivants* titled "Sur une prétendue crise de l'esprit."[99] "Individualist civilization" was again declared to be dead, "killed by the industrial revolution that precipitated the necessity for a civilization with an essentially social and collective character." Under the Third Republic individualism had taken "bourgeois and capitalist form," and by opposing republicanism and its bourgeois and capitalist apologists, proponents of the "new order" constituted a "revolutionary force" able to orient individual initiative to collectivist ends. Those who decried the decline of the existing system expressed "old ideas in the old style of a bygone era and for old people." The mythic divide between new and old orders was once again sharply defined from a generational point of view. Lamour lauded the creation of a postwar collectivist aesthetic, expressive of "a general spirit, a logical and total construction, a universal viewpoint, a synthetic spirit." The medium of film reportedly spoke the "new language," Le Corbusier had succeeded in "revolutionizing architecture," jazz captured the spirit "of a youth born in the fracas of the war," and finally industrial lithography had been superceded by the "photographic art" of Man Ray and Germaine Krull. Le Corbusier, through his use of ferroconcrete, and Krull, in her 1927 photographs of the Eiffel Tower (fig. 49), had responded to the industrial forces of their day; they therefore were part of "the new elite of the new civilization" that would produce "grandeur."[100]

That December Lamour published a detailed account of how the technique of montage in film augmented this collectivist aesthetic.[101] Referring to Buñuel's and Dali's 1929 surrealist film *Un chien andalou*, Lamour claimed that montage was able to transform unconscious drives into an aesthetic experience by conjoining the audience's emotional response with an ability to consciously reflect on experience. "No longer exterior to those that it addresses, reader or spectator," this "suggestive art . . . calls for participation up to the point of complicity." "The author furnishes a theme, a frame, a departure, a dynamic value suitable to each, adequate for all." "Artistic emotion" therefore "becomes the product of a collaboration," only able to achieve "perfect expression" in "the collective mode." With the "mechanical art" of film "it is we who must animate the machine that others have constructed." Our aesthetic experience of montage is necessarily dynamic by virtue of the temporal dimension of film itself, and as *Un chien andalou* unfolds the unconscious desires of

filmmaker and audience alike take the aesthetic form of a "logical construction," addressed to our creative consciousness. The creative act thus becomes a matter of "collective effort, constant communion, continual creation."[102] This new technology adapted psychosexual desire to artistic ends, fully compatible with the "mythopoetic" consciousness of the Sorelian producer. For Lamour the artistic medium of oil on canvas therefore took second place to the "mechanical arts" of photography, film, and design engineering, all attuned to the sensibility of the masses.

Car Culture

These art forms were given pride of place with the appearance of *Grand'Route* in March 1930. Lamour's inaugural essay, "L'Art mécanique: naissance d'un art collectif" (Mechanical Art: The Birth of a Collective Art), claimed that the "rhythm" of industrial production had inspired an aesthetic appreciation for the dynamism of modern technology. Having previously exalted mechanical "rhythm" and the "hymn of production," he now defined the aesthetic dimension of this productivist aesthetic, born from the labor of Sorelian "artist-engineers."[103] In doing so he contrasted an art made by individuals for individual delectation with the aesthetic response provoked by the automobile. Whereas a painting in a gallery was made by a single artist for the "passive contemplation" of an individual buyer, a car was the product of the collective endeavor of anonymous "artist-engineers," who designed a standardized object for mass consumption. Aesthetic experience of "mechanical art" did not arise from contemplation of its "external form" alone, but instead from the experience of dynamism produced by the actual "physical handling" of the automobile in motion. Although "the exterior contemplation of a machine can inspire feelings of plastic aesthetics" comparable to those provoked by architecture, sculpture, or literature, the "sensation of mechanical art can only be attained through participation, the integration of the subject with the machine."[104] Thus the aesthetic experience of the machine object will vary "according to the manner in which it is driven." The "aesthetic feeling, the beauty, not only depends on the creator of the work of art but on the artistic quality of the individual who utilizes it." Mechanical art therefore produces "new aesthetic pleasures; speed, productive rhythm, statistical drunkenness," as well as a penchant for "precise organization." This "dynamic art" is "a collective art,"

for "it is not made by an individual but by the collaboration of individual constructors and of individual utilizers."[105]

In "L'art mécanique" Lamour drove home the latter point by announcing the acendancy of the "salon de l'auto" over the "salon d'automne" as the forum most expressive of "the artistic tastes of the new world."[106] The very title of Lamour's journal, *Grand'Route* heralded the creation of this new dynamic aesthetic. *Grand'Route* signified the road to Sorelian revolution, the emerging collectivist aesthetic, and the productivist and mythopoetic consciousness associated with the new order. In an article titled "Première étape" (The First Stage) Lamour claimed this rhythmic dynamism could be captured through another mechanical device, the camera. Modern photography, we are told, was attuned to a new "[productivist] ethic, diametrically opposed to the bourgeois individualist ethic." This new ethic had created "a totally new art form, both in terms of its themes as well as in its instruments of expression."[107] That point was reinforced in a poetic tribute to Krull's photographs of the Eiffel Tower and of railways published in the May issue of *Grand'Route*:[108]

> Thus we cast our eyes, and also cast the eye of the lens, oh Germaine Krull!, on these long iron routes: the rail; on these cables suspended at length, in this secret domain of waves. We gaze upon our tower, the Eiffel Tower, new constructive Babel, youthful clarity of languages, esperanto of iron, bridges in braided mesh, of trapezoids. We see the play, the fire of factories, the daily rotation of turbines, and we lend our ears to the imperious sounds, royal, alternating, of currents, of waves. The enormous rotation of the heavens finally awakens the forces of the earth. And man astonished, rushes from one source to another bursting with new and rare energies; inexhaustible.[109]

The Eiffel Tower's "exact perfection of parts adjusted to one another" encapsulates "the new beauty of the times," and moves beyond the "confusion" and "disorder" of a society in "transition."[110] As a symbol of the collaborative effort of artist-engineers, the Eiffel Tower, the structure lauded in Lamour's *Entretiens sous la tour Eiffel*, anticipated the future society of producers. Krull's photographs affirm for him that productivist vision by concentrating on the tower's complex mesh of iron rods, rails, and spiral staircases, all seen from a vertiginous viewpoint high above the earth. Germaine Krull used the camera,

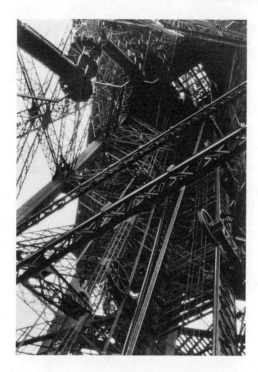

Fig. 49. Germaine Krull, Eiffel Tower, ca. 1928. Photograph, reproduced in Germaine Krull, *Métal* (Paris: Librairie des arts décoratifs, 1929), plate 2.

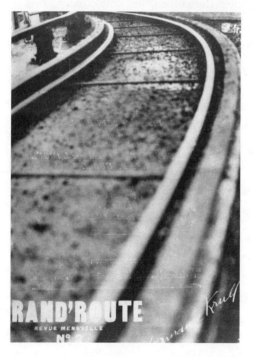

Fig. 50. Germaine Krull, photograph for the cover of *Grand'Route: revue mensuelle*, Paris, no. 2 (April 1930).

itself a machine-age product of *l'art mécanique*, to glorify the forces of industrial production and a new mode of mass communication, exemplified by the tower's function as a radio transmitter.

Art and the "Spirit of Collectivity"

While Lamour restricted his artistic preferences to those art forms most closely allied to modern technology, other contributors to *Grand'Route* were prepared to defend painting as a medium potentially compatible with the new order. In an essay titled "L'Art de mentir" (The Art of Lying) critic Georges Herbiet cast Lamour's vilification of the fine arts in terms of the "commercial" rather than "moral" prerogative of contemporary modernists. Herbiet asserted that commercial gain alone was behind the "crafty aestheticism" of Matisse and Picasso, whose readily consumable art was out of step with the modern sensibility: "The precisions of today's mechanical life have given birth to the demand for things much more complex and much more exact. There has arisen for the arts principles of utility, of economy, of efficacy ... that conclude in a concentration of means. Disorder, the effect of art of pythian inspiration, of local titillation, cannot give birth to a generous emotion that raises us to the sentiment of plenitude, which serves to define the power of a civilization."[111] According to Herbiet the "static still lives," found in the annual salons stood for the old order, now couched in terms of a "renewed romanticism"; whereas forms reflective of the modern sensibility—"our buildings, our machinery, posters, furniture"—captured the "enveloping rhythm" of mechanical life. Rather than inspiring a "contemplative stupor," art should provoke dynamism, a life-affirming "jouissance," in tune with the industrial rhythms of modern culture.[112] Likewise, the expression of "sentimental values" and "respect for traditions" in the arts should cede to "the precise expression of emotions" and forms suited to "our houses of cement and plywood."[113] When Herbiet described those art forms most expressive of this new sensibility he not only praised cinema, but also the art of Paul Cézanne, the cubists, and paintings by a new group of "mythological surrealists." Herbiet claimed that the rhythmic patterning and distortion of form in Cézanne's late paintings constituted "la recherche de l'exactitude."[114] Cézanne's canvases therefore "concealed a learned craftsmanship under a perfect orchestration of form and of color in such a way that the tableau stands out in its unity," its "harmony of

conception." In a world dominated by industry, the sense of exactitude, crafts-manship, and unified harmony found in Cézanne's paintings exemplified the "concentration of means" and "precise expression of emotions" that should typify art of the modern era.[115] Herbiet also followed Lamour in claiming that surrealism appealed to our desire for the clarity and order intrinsic to the mythopoetic consciousness of the modern producer. Herbiet called for the creation of "mythological surreality" in painting, wherein sensations of "erotic" desire and "free association" would be subjected to "cerebral specula-tion" resulting in "sensations of harmony and order." To illustrate the doctrine, Herbiet's article was preceded by Robert Jourdain's *Dormeuse*, a drawing of a sleeping woman surrounded by spatially ambiguous images of a village and a disembodied hand reaching to caress her hair. Presumably sensations of order and harmony could be culled from this dream image of domestic quietude.

For this reason the painting of Cézanne, the cubists, and "mythological" surrealists could find a place in the domestic interior, provided it conformed to the modern sensibility outlined by Herbiet and Lamour. The "incontestable hygienic virtues" of such art could only be fully appreciated in interiors com-parable to those advertized by Léonce Rosenberg in his cubist journal, *Bul-letin de l'effort moderne* (1924–1927) (fig. 53). In these spaces monochromatic walls were lit by electric light, decorated with modern art and machine-age furnishings. Such interiors were in stark contrast to those that situated "des panneaux surcubistes dans des arrangements post-Réstaurés." To combine cubist painting with furniture in the "Louis-Philippe" style was to confuse genres, concluded Herbiet, and to imitate the decadent ideals of "bourgeois" and "Jewish upstarts."[116] The hygienic virtues and precision of cubist painting were declared antithetical to the decadence of the *parvenu juif*.

These hygienic interiors required the creation of machine-age building. Lamour claimed that "collective civilization" should have its "material tools," and noted that an article by André Lurçat, titled "Esprit collectif et architec-ture" (The Collective Spirit and Architecture), and another by Le Corbusier and Pierre Jeanneret, "La maison minimum," outlined the changes needed in order to achieve "the first stage" of the Sorelian revolution.[117] It seemed appro-priate that Lamour should turn to Lurçat and Le Corbusier, for like him these architects had adapted their ideas to a variety of political agendas. Lamour had already acknowledged his debt to Le Corbusier by dedicating *Entretiens*

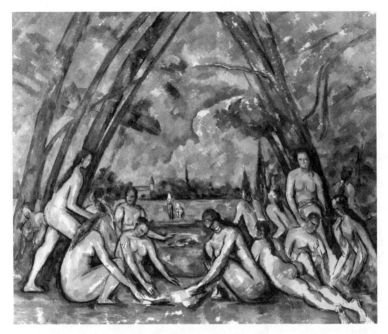

Fig. 51. Paul Cézanne, *Large Bathers*, 1906. Philadelphia Museum of Art; Purchased with the W. P. Wistach Fund, 1937.

Fig. 52. Robert Jourdain, *Dormeuse*, n.d. Reproduced in *Grand'Route: revue mensuelle*, Paris, no. 2 (April 1930).

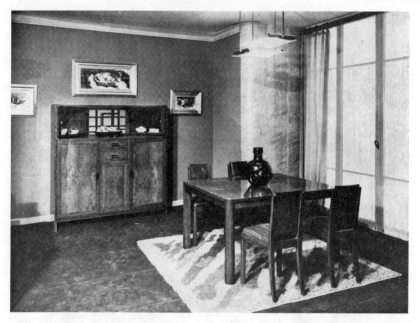

Fig. 53. "Ateliers Primavera, salle à manger," Salons d'Automne, 1926. Reproduced *Bulletin de l'effort moderne*, no. 31 (January 1927).

sous la tour Eiffel to him; Lurçat, like Lamour, had nurtured contacts with the *Clarté* group, and the communist affiliations of both architects would have resonated with Lamour's own self-styled leftism.[118] The essays by Lurçat and Le Corbusier published in *Grand'Route* indicate why Lamour saw them as allies, for they affirmed his faith in collectivism and modern methods of production, even if they lacked the fascist inflection of Lamour's theory.

In his essay for *Grand'Route* Lurçat described architecture as the primary means through which the new "spirit of collectivity" could be ordered. As an expression of modern industrial society, architecture should convey "sentiments of order, measure, of harmony"; however, since social development follows "an unequal rhythm," some aspects of culture will inevitably lag behind others. In "certain epochs" this disjunction is magnified because "new energies" result in "a more intense production." Such was the case with the nineteenth century, for the Revolution of 1789 had "destroyed ancient society as well as the economic order," thereby unleashing the industrial revolution in France. "Machinism," we are told, "subtly transforms all the rules established up until then of human industry, and gives a new form to all social relations."

This resulted in "the development of great cities," the "rapidity" of "means of transportation," and a "profound" transformation of Europe as a whole. Lurçat's claim that economic development and the institutions designed to service it could evolve in an "unequal rhythm" iterates the paradigms operative in Lamour's account of the conflict between preexisting political structures and the new social order arising from industrialization.[119]

In Lurçat's opinion contemporary architecture reflected the "absence of social equilibrium" resulting from such disjunction and did not meet the "spiritual and material needs" consonant with "technical progress."[120] He hoped that the postwar generation would become conscious of "its progression toward a new moral order" and forge a "new general organization" based on "social collectivism." In industrial society, we are told, "the feeling of the collective becomes more and more dominant" and pervades the "economic, moral, and spiritual domains." Echoing Lamour's diatribe against individualism Lurçat asserted that architecture must no longer be "at the service of the isolated individual" but instead "at the service of society, of collectivity."[121] An architecture adapted to the "modern qualities of rapidity and precision" would be adapted to new modes of transportation, such as the automobile, and facilitate the construction of garden cities, removed from the "noise and deleterious fumes" of industry.[122] Similarly the economics of private ownership should cede to the new collective order. "In all domains," asserted Lurçat, "men are now forced to regroup, to be organized in order to live; and the economic forces must also be regrouped, and no longer this time for the profit of isolated individuals, but in the service of groups of individuals, of the collective in its entirety." Just as industrialists had organized into "powerful trusts for the production and distribution of manufactured products," so too architecture could no longer be built to serve the "speculative" interests of "private enterprise"; instead "the prosperity of the community" should take precedence.[123] Rather than construct individual homes, architects would now build for "powerful organisms," whether they be large corporate conglomerates or the state. "Urbanism" as defined by Lurçat encompassed the cultural geography of whole cities, "the partitioning of terrain," "the collective life of inhabitants," the "circulation, transport, refueling, even services for the redistribution of all the service networks." "Modern urbanism becomes, in sum, the complete organization of the world," a world that "now follows a single

rhythm," a "general harmony."[124] Architecture will therefore express "morality, calm, and well being," by means of "the geometry, rhythm, beautiful proportions that regulate a vast ensemble." Since the transformation of "social and moral life" necessarily affects "plastic life," "personal sentiment" would be replaced by a desire for "general order."[125]

In his essay "Première étape" Lamour related the writings of Lurçat, Le Corbusier, and Pierre Jeanneret to the precepts of Sorelian ideology.[126] He lauded these architects for their theory of "collectivism" in architecture and announced that "research for a doctrine of the collective state" founded on "real man" was to be outlined in a series of articles by Hubert Lagardelle, who saw real man as a part "of an organized social body." This redefinition of man in terms of "his region and his métier" and "federalism and syndicalism," would result in "the revision of ideas at the base of individualist institutions."[127] Lurçat and Lamour both argued that existing institutions inhibited the development of industrial production and the new collective consciousness arising from it. Le Corbusier and Jeanneret, in the 1929 report of the Congrès Internationaux d'Architecture Moderne on the "maison minimum," reproduced in *Grand'Route*, lent credence to Lamour's claim that the conflict between old institutions and the new industrial order could be overcome in part through architecture adapted to the collectivism and the production methods of industrial society. Anticipating Lamour's language of aestheticized dynamism, these architects cast the conflict between old and new social orders in terms of the static as opposed to dynamic elements of urban design conducive to "an organized social body." To Lamour's mind, Lagardelle's theories were fully adaptable to the machine aesthetic of Le Corbusier's "maison minimum," which represented an intermediate stage in Le Corbusier's shift from the geometricity and capitalist underpinnings of the Plan Voisin to the organic forms and Lagardelle-inspired precepts undergirding his Plan Obus (1932–1942) for the city of Algiers.[128]

In their essay Jeanneret and Le Corbusier claimed that "the poverty, the insufficiency of traditional [building] techniques" had resulted from the "forced mixture" of two functions, the "biological event" and the "static event."[129] The biological dimension of housing reflected its role as "a system organized for circulation," while the static encapsulated its function as "a system of structure," that is, as a material object. Since contemporary building methods were

still those "codified by the écoles and academies," modern techniques of industrial production had had no impact on building design. Divorced from "the rigorous conditions of the general economy" such building traditions could not resolve the contemporary housing crisis. "It is necessary to discover and apply new clear methods, which permit the composition of useful means of habitation and which, for their realization, offer themselves naturally to standardization, to industrialization, to Taylorization." An architect who cannot "make plans adapted to the modern economy and society in a full state of social reformation and undergoing a dangerous crisis of housing, will not prepare the way for the "maison minimum.'"[130]

Jeanneret and Le Corbusier prepared the way by adapting their architecture to the mass production techniques found in industry, in order to facilitate the integration of modern housing into industrial society. Exactitude, economic efficiency, and rapid circulation were the elements to be incorporated into modern design.[131] "The sequence of these functions is established following a logic which is more of a biological order than geometric"; moreover, the use of standardized materials allowed architects to produce housing on a mass scale at low cost. Composed of moveable partitions, floors of reinforced concrete, and curtain wall façades, the maison minimum's "static function, that is the frame," was to be "rationalized" to accommodate the dynamics of maximum "circulation."[132] Construction on pillars would in turn allow for traffic underneath buildings. "Rational installation (response to the biological function) results in an enormous economy of surface habitation," and by integrating "architecture, planning, and industry," the modern architect "will be able to create biological groupings in a static, standard frame." Since industrial methods "can conform to all social conditions" and are "utilizable under all climates" construction of the maison miminum would occur around the globe; to facilitate this Le Corbusier and Jeanneret called for the creation of a "world convention" to standardize systems of measurement. Having "definitely left the terrain of tradition," the architects announced that they had "cemented new alliances with the scientific world of large-scale production." In keeping with Lamour's program Le Corbusier and Jeanneret allied themselves with an aestheticized notion of "revolution," premised on the dynamism of production. By breaking with the past and embracing industrial methods the two architects would create "a new harmony, in which all relations will be new, but where their coher-

ence, their unity of principle, will bring about ease, a good functioning, an increase in output."[133] By employing "methods harmonizing with contemporary labor," the maison minimum served "the harmonization of everything" into a single "unity."[134] "Unity is that to which every revolution tends," for "everything can be in motion, everything can change from one day to the next, but unity alone contributes efficiency." For Le Corbusier and Jeanneret, evidence of such revolutionary productivism was not found in democratic France, nor in Fascist Italy, but instead in the Soviet Union and the plans for "Greater Moscow" then under development at the "Soviet du travail."[135] That correlation was, however, compatible with the nonconformist politics of Lamour, who, as we have seen, was not averse to the Soviet Union, provided its all-important theory of "collectivism" evolved along fascist lines. In effect human society as a whole had to be aestheticized if it was to adhere to the rhythm of production and the values arising from collective consciousness. The "harmony of conception" of Cézanne's canvases so admired by Herbiet, the "mechanical art" Eric Hurel associated with Krull's photographic techniques, and the "general harmony" and "unity" sought by Lurçat and Le Corbusier constituted a new aesthetic that, ideally, should pervade every aspect of society.

Montage, Photography, and Fascism

Of the art reproduced in *Grand'Route*, that of Germaine Krull was most prominent. Photographs by Krull were published in all but one issue of the journal, and her photographs—the only such contributions published in *Grand'Route*—were on the cover of the first three issues, a clear indication of her close relations to the Lamour group. Krull's previous affiliation with anarchist circles, and her status as a "new Woman," appealed to Lamour, who, to a lesser degree, shared her doubts about Soviet bolshevism as well as her admiration for leftist alternatives to Leninist statism.[136] Before coming to Paris in 1926 Krull had participated in the failed 1919 Sparticist revolution in Munich and was forced to flee Germany for the Soviet Union in 1921. Krull arrived in the Soviet Union only to be caught up in Lenin's suppression of anarchosyndicalists and anarchocommunists, which led to her incarceration in 1922. When Lenin decided to release and expel anarchists with no record of violent opposition to his regime, Krull was among those forcefully exiled to Germany.[137] In Berlin Krull befriended the anarchist Arthur Lehning, who

introduced her to the Dutch filmmaker Joris Ivens; in 1925 Krull and Ivens moved to Amsterdam, where they collaborated on a series of innovative films celebrating the industrial bridges, rails, and factories of modern Holland.[138] The following year Krull settled in Paris, where she won the critical support of photography and art critic Florent Fels, editor of the avant-garde magazines *L'Art vivant* (1925–1939) and *Vu* (1928–1940).[139] As Theresa Papanikolas has demonstrated, Fels was a longtime proponent of anarchoindividualism, whose early art criticism celebrated aesthetic innovation as a corollary to his political ideals.[140] Clearly Krull's own anarchist pedigree won Fels's approval, which could account for his collaboration with Krull in articles for *Vu*, and in writing the introduction to her 1928 book, *Métal*, which reproduced her Eiffel Tower photographs.

Before her arrival in France, Krull and Ivens experimented with montage techniques and studied the work of filmmakers such as the Russians Sergei Eisenstein and Vsevolod Pudovkin; this collaboration culminated in Ivens's filming of *The Bridge* in 1928 and Krull's publication of the photo album *Métal* in 1928 or early 1929. In January 1930 Ivens took up Pudovkin's invitation to travel to Russia, and Krull in her memoirs recalled her dismay at his decision to visit the "counterrevolutionary" Soviet Union.[141] However, Krull's hostility to bolshevism did not extend to a condemnation of artists who worked under the Soviet regime; thus she welcomed Sergei Eisenstein's visit to France in February 1930, photographed the filmmaker, and protested when the French government threatened Eisenstein with expulsion.[142] Despite her anarchist sympathies, Krull was willing to enter into a dialogue with artists from a variety of political positions, including self-styled "leftists" such as Lamour.

Krull's contacts with Lamour's circle occurred in 1929, when she befriended Renaud de Jouvenel (son of Henri de Jouvenel).[143] Sometime in early 1930, her new friend, the publisher Jacques Jaumont, proposed that she collaborate with Paul Morand on a book titled *Route de Paris à la Méditerranée*. Published in 1931, the photographs made for the volume were taken during a spring 1930 automobile trip from Paris to the Côte d'Azur. In her memoirs Krull recalled choosing Philippe Lamour as a traveling companion, describing him as "a young Parisian lawyer" who was "full of enthusiasm" for the project.[144] Having planned the route together, Lamour drove while Krull made photographs, one of which graced the cover of the May 1930 issue of *Grand'Route* (fig. 55).

The same issue included a Krull photograph of Eisenstein made that winter (fig. 57) and a montage image titled "Machinerie du théâtre, Pigalle" discussed below (fig. 56). Given Krull's interest in film, it seems likely that she helped facilitate the publication of Eisenstein's "La quatrième dimension au cinéma" in the May edition of *Grand'Route*.[145] The previous year Lamour had praised her photography in the pages of *La revue des vivants* as exemplary of the new "collectivist" art emerging from the industrial revolution, and Krull's artistic presence in *Grand'Route* clearly confirmed that assessment.[146] Lamour's own synthesis of art and politics in *Grand'Route* was heavily indebted to montage theory, and could indicate the influence of Krull—and of film theory in general—on his evolving ideas.

Krull's most notable contributions to *Grand'Route* appeared on the covers of the first three issues. Her cover for *Grand'Route*'s inaugural issue conveyed the technological dynamism Lamour celebrated by photographing an industrial landscape from a moving vehicle or train. In this photograph, the blur of the passing scenery, dominated by factory chimneys, is captured at an oblique angle, devoid of the horizontal or vertical lines that would convey stasis. Instead the viewer is suspended in a nebulous space, untethered from any fixed locale or physical relation to the earth. Krull captured the intoxicating speed of the motor car in the third issue of *Grand'Route* with a nocturnal photograph made en route during her sojourn with Lamour. In this case the blur of the road and approaching headlights evoke that experience of "physical handling" and "dynamism" Lamour associated with the new sensibility. As for the industrial rhythm of the workplace, that too was celebrated by Krull in her image of stage machinery at a theater. In this photograph Krull drew on montage technique to portray stage set machinery for a theater in Pigalle, a plebeian section of Paris. Here the theater stage and the performance itself take second place to the hidden machinery that makes the staging possible. By printing from more than one negative, Krull juxtaposes the whirl of gears and banks of electrical circuits with an image replete with floodlights, metal ladders, platforms, and scaffolding.

Indeed, montage was the subject of the May 1930 essay in *Grand'Route* on cinema written by Eisenstein, whose portrait by Krull accompanied the article.[147] Although neither Krull nor Lamour fully endorsed bolshevism, they admired Eisenstein's politicized association of montage with collectivism. Speak-

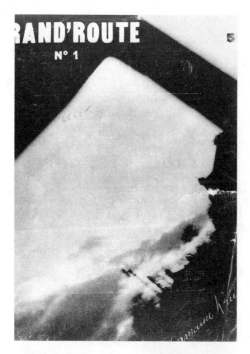

Fig. 54. Germaine Krull, photograph for the cover of *Grand'Route: revue mensuelle*, Paris, no. 1 (March 1930).

Fig. 55. Germaine Krull, photograph for the cover of *Grand'Route: revue mensuelle*, Paris, no. 3 (May 1930).

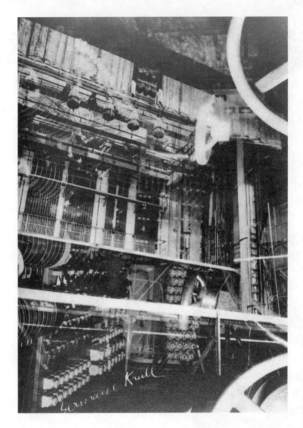

Fig. 56. Germaine Krull, "Machinerie du théâtre, Pigalle." Photograph, reproduced in *Grand'Route: revue mensuelle*, Paris, no. 3 (May 1930).

ing of his use of montage in the article for *Grand'Route*, Eisenstein claimed to have purged his films of "individual, aristocratic dominants" by establishing "the method of 'democratic' equal rights for all stimulants, viewed together as a complex." Rather than reject optical "aberrations and distortions" through lens adjustments, Eisenstein utilized such elements to produce "a whole series of compositional effects" that he labeled "the visual overtonal complex of the shot," borrowing a term from modernist music.[148] Further, his theory of montage held that a film should proceed "by a series of shocks": "If montage is to be compared with something," Eisenstein wrote in 1929, "then a phalanx of montage pieces, of shots, should be compared to the series of explosions of an internal combustion engine, driving forward its automobile or tractor."[149]

By introducing similar techniques into the artistic process, Krull's photographs conveyed Eisenstein's theory of collectivism to the readers of *Grand'Route*. Krull's images for the journal consistently highlight what Eisen-

Fig. 57 Germaine Krull, photograph of Sergei Eisenstein. Reproduced in *Grand'Route: revue mensuelle*, Paris, no. 3 (May 1930).

stein would call the montage elements of her medium, proceeding by a series of visual shocks comparably rooted in a celebration of the machine both as image and as tool. Eisenstein's portrait shocks the viewer through its abstraction, both by presenting the face as a fragment and by bringing the camera closer than the focal capacity of her lens, which necessarily results in extreme blur. This abstract approach to the photographic process reminds us of the sitter's own role as a visual artist who manipulates the film medium. In her image of the theater, printing from more than one negative literalizes the application of montage principles to photography. These manipulative techniques—lighting, camera angle, blur resulting from slow film speed or lens focal length, and combination printing—are themselves subjects in her work for *Grand'Route*, and combine to evoke the dynamism of travel and of the modern world.

At the same time we should also recognize that Lamour and his colleagues did not embrace every dimension of Krull's aesthetic. As Kim Sichel has noted,

Krull in her Eiffel Tower images followed the example of Bauhaus photographer Lázlo Moholy-Nagy in eliminating all evidence of human presence to focus our attention on the structure itself.[150] In a text accompanying photographs of the tower reproduced in the magazine *Vu*, Krull's close friend Florent Fels argued that the photographer's images of "girders and rivets" were comparable to "verse, words, rhyme." Krull's tower photographs reportedly conspired to make us contemplate the "incomparable poet: Eiffel," for one "no longer thinks of the mechanical marvel," "of the forge, of the mine," or of "the engineer, the worker, the laborer."[151] This separation of the poetic or artistic import of the tower from the collective efforts of its manufacturers in effect denies that the processes of industrialism could have any aesthetic significance, or that the tower itself could embody the collective sensibility of l'art mécanique. By contrast, for *Grand'Route*'s readers, the same images of the tower conjured up visions of "the fire of factories" and "the daily rotation of turbines."[152] By claiming that the Eiffel Tower represented the poetic sensibility of one man—Gustave Eiffel—rather than of the engineers and workers who participated in the tower's construction, Fels celebrated the very individualism that was anathema to Lamour. Yet in keeping with the productivism of *Grand'Route*, Krull's images for the journal conveyed the technological dynamism of speeding automobiles, while her montage techniques were subsumed within Lamour's theory of collectivism. *Grand'Route* celebrated Krull because for Lamour her photographs expressed more than her own poetic sensibility or that of Eiffel: they expressed the dynamism of collective consciousness and the industrial revolution.

Lamour's judicious appreciation of Krull also led him to ignore her photographs of the Parisian homeless (*clochards*), published in two portfolios in 1928 (fig. 59).[153] Krull's focus on the defiant individualism of her subjects effectively fullfilled the popular myth that these victims of urban poverty were poor and itinerant by choice, and thus symbols of resistance to the socioeconomic status quo. One such image, published in a 1928 edition of *Vu* magazine, was accompanied by a caption by writer Henri Danjou identifying the clochard holding a sack as "un philosophe de la place Maubert," and Krull in her autobiography claimed that the clochards had "a special view of liberty" and consciously chose "to live freely as clochards."[154] Kim Sichel rightly associates the *clochard-philosophe* reproduced in *Vu* with another urban "philoso-

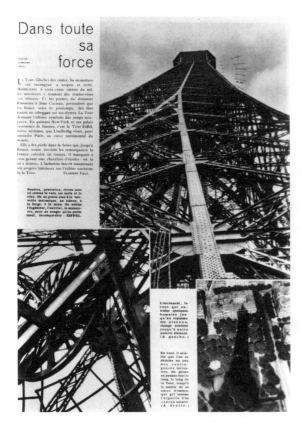

Fig. 58. Florent Fels, "Dans toute sa force." Reproduced in *Vu*, no. 11 (31 May 1928), 284. Photographs by Germaine Krull.

pher" eulogized in both painting and poetry, the nineteenth-century *chiffonnier*, or rag picker, but Krull may also be alluding to the anarchist *trimardeur*, or wandering proselytizer.[155] Krull's images celebrated the individual tenacity of these social outcasts, and nothing could be further from the spirit of collectivism and modern productivism promoted in *Grand'Route*. Clochards and other marginal figures had no place in a technological society structured around the cult of industrial labor, and such imagery was appropriately absent from the pages of Lamour's journal.

In sum, Philippe Lamour was unique among the Sorelians in allying a machine aesthetic to a call for generational renewal. Drawing on Sorel's theory, Lamour not only posited a mythic divide between generations, he developed a theory of art premised on Sorel's precepts. To inspire revolution, the Sorelian did not appeal to our rational faculties, but instead utilized the power of mythic images to activate a "dynamic" or poetic state of mind. Mythic

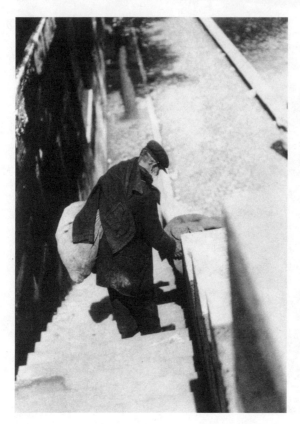

Fig. 59. Germaine Krull. A clochard in the place Maubert. Photograph, reproduced in Henri Danjou, "Les clochards dans les Bas-Fonds de Paris—ceux de la 'Maubert,'" *Vu*, no. 31 (17 October 1928), 688.

images returned our consciousness to a primitive condition, akin to that of the citizen-soldier or industrial worker. Lamour conjoined this theory of creativity to Sorel's analysis of the aesthetics of industrial production. Creativity in the realm of production, argued Sorel, also activated a spirit of revolt against those institutions and individuals that undervalued the industrial worker. According to Lamour, an aesthetic born of this productivist ethic should share in its revolutionary characteristics: it should convey the dynamism, energy, and discipline so highly valued by the Sorelian producer. In fact Lamour's claim that modern technology had produced a "collectivist" sensibility, attuned to fascism rather than republican individualism, anticipated a discourse operative among youth groups in Italy during the 1930s. As Ruth Ben-Ghiat has demonstrated, fascist youth journals such as *Orpheus* (1932–1934) signaled their radicalism by rejecting the idea that Italian culture under fascism could accommodate past traditions, arguing instead that the "dynamic

multiplicity of modern life had rendered obsolete all absolute values and past legacies."[156] Similarly *Orpheus*'s authors celebrated fascism for inculcating a "dynamic" state of mind attuned to the collectivism and industrial rhythms of modern society, but unlike Lamour they turned to the phenomenology of Edmund Husserl rather than the Bergsonism of Georges Sorel for a philosophical corollary to fascist dynamism. Not surprisingly the *Orpheus* group celebrated rationalist architecture—the Italian counterpart to Le Corbusier's Plan Voisin—as properly rooted in the modern sensibility, an orientation fully conducive to Lamour's ideological vision.[157]

Indeed, for Lamour modes of artistic production themselves should spring from industrial innovation, and for this reason he lauded the photograph and film as the two art forms best able to express the sensations of technological dynamism experienced by this postwar generation. The photographs produced by Krull, the urban designs of Le Corbusier, or the automobiles developed by artist-engineers were the true artistic forerunners of an emerging society of producers. A revolutionary cadre of postwar youth, rather than aging combatants, would now transform society through the primitivizing power of mythic images. As historian Robert Wohl has argued, generational theory was "one of the side effects of the coming of mass society," but "unlike concepts of class or other forms of determinism" generational collectivism "emphasized temporal rather than socioeconomic location." Lamour's fascist doctrine of l'art mécanique gave an aesthetic as well as temporal dimension to that generational revolt.

CLASSICAL VIOLENCE

Thierry Maulnier and the Legacy of the Cercle Proudhon

Shortly after the founding of the journal *Combat* in January 1936, literary critic and royalist Thierry Maulnier (1909–1988) endorsed a radical claim: fascism's origins resided in the avant-guerre alliance between the followers of Charles Maurras and Georges Sorel that had given birth to the Cercle Proudhon late in 1911. Maulnier made this assertion in a February 1936 essay, titled "Les deux violences" (The Two Violences), in which he referred *Combat*'s readers to a contiguous article by the Sorelian Pierre Andreu as proof. Andreu's provocative article, titled "Fascisme 1913," quoted polemicist and novelist Pierre Drieu La Rochelle to the effect that the founding of the Cercle Proudhon constituted "a marriage of nationalism and socialism" that amounted to "the nebula of a kind of fascism."[1] Andreu then outlined the aesthetic implications of the thesis. Drawing on Berth's *Méfaits des intellectuels* (1914), he argued that the Cercle successfully melded the classical "beauty" and

Apollonian spirit promoted by Charles Maurras with the Dionysian notion of the revolutionary "sublime" as defined by Georges Sorel: in this way Sorelian violence took on "a spirit of order and discipline." "Violence calls for order like the sublime calls for beauty," asserted Andreu. He lamented that the Cercle Proudhon's regenerative merger between the radical Left and Right was artificially cut short by World War I, and Maulnier in "Les deux violences" upheld that view. Andreu's thesis was shared by others: for instance, in an October 1936 article titled "Fascisme et syndicalisme," Jean Saillenfest could confidently inform *Combat*'s readers that "the essence of fascism" resided in "the social nationalism and French syndicalism of the prewar period." In response Maulnier called for the resuscitation of the Cercle's antidemocratic alliance between elite factions among the bourgeoisie and working class, in hopes that the violence of both constituencies could be turned against an emerging enemy: the antifascist Popular Front, which would govern France from May 1936 to April 1938.[2] Over the period leading up to the French declaration of war against Germany in September 1939, Maulnier and his colleagues carried out this campaign in the pages of *Combat* (January 1936–July 1939) and in a short-lived newspaper appropriately titled *Insurgé* (January–October 1937).

Despite his professed sympathy for fascism, Maulnier never explicitly declared himself fascist; nor did he join his associates Drieu La Rochelle, Lucien Rebatet, or Robert Brasillach in openly supporting the Nazis following the fall of France in May–June 1940.[3] It is this tentative posture, combined with Maulnier's theoretical intransigence, which led historian David Carroll to describe Maulnier's fascism as "literary" in orientation.[4] Thus Maulnier, like the Sorelians Valois and Lamour, went through a fascist phase, but at a greater remove than his predecessors. Indeed, over the course of *Combat*'s existence Maulnier remained critical of Europe's fascist regimes, even as he and his colleagues attempted to define a fascist agenda suitable for French consumption. As a result Maulnier could still proclaim his allegiance to Sorelian ideology in the spring of 1939 while calling for the French to adopt a "minimum fascism" to counter the threat of Nazi Germany.[5]

Combat's proclamation that fascism's genealogy could be traced to the Cercle Proudhon has received ongoing attention in the scholarship on French fascism. Jack Roth has noted that Mussolini's claim, in 1932, that fascism's origins derived from the thought of Sorel, Péguy, and Lagardelle, likely embold-

ened Il Duce's apologists in France to make similar assertions.[6] In addition to Andreu, Maulnier, and Drieu La Rochelle, Roth cites Hubert Lagardelle, Jean Variot, and René Johannet in this regard.[7] Zeev Sternhell contends that Maulnier's antimaterialist ideology, with its Sorelian rejection of democracy, capitalism, and Marxism, was a virtual reprise of the "pre-1914 fascism" of the Cercle Proudhon.[8] Although I disagree with Sternhell's assertion that the Cercle Proudhon constituted a form of fascism *avant la lettre*, his analysis of Maulnier's debt to Sorelian thought is nevertheless convincing.[9] Paul Mazgaj has argued that the creation of *Combat* was part of a broader response among the "jeune droite" (young Right) to the *engagé* position of leftist writers associated with the Popular Front and the journal *Nouvelle revue française*.[10] Over the course of the early 1930s prominent *Nouvelle revue française* contributors such as André Gide and Julien Benda had abandoned their political neutrality in favor of a leftist, pro-Soviet agenda. As Mazgaj demonstrates, Maulnier's profascist writings during the same period constituted "a kind of running argument against those on the centre and Left," especially Gide and the *Nouvelle revue française*.[11] As we shall see, *Combat* endorsed the Cercle Proudhon as an early prototype for the "militancy" they wished in inculcate among the contemporary French proletariat and bourgeoisie.

Indeed, I would argue that Maulnier's embrace of the Cercle Proudhon was an instance of selective appropriation designed to augment *Combat*'s own unique interpretation of the cultural legacy of Sorelian ideology. Rather than refer their readers to *Grand'Route*'s machine aesthetics, *Nouveau siècle*'s Le Corbusier–inspired urbanism, or the Catholic and symbolist precepts endorsed in *L'Indépendance*, Andreu and Maulnier turned to the Cercle and in particular to Berth's *Méfaits des intellectuels* (1914) to define their version of Sorelian aesthetics. Thus the *Combat* group, though modeling itself after the Cercle Proudhon's union of Maurrassians and Sorelians, did so in the name of "classical violence," which they identified as an "embryonic fascism" native to France.[12] Rather than constituting an act of nostalgia for the prewar era, their appeal to the spirit of classical violence was a veritable call to arms, designed to revolutionize French society. To facilitate this the journal's contributors not only followed Sorel in lamenting the decadence of Socratic Greece and the decline of revolutionary syndicalism before World War I, they also identified the cultural politics of the Popular Front as ripe for Sorelian deconstruction.

The latter discourse played out most prominently in the writings of Maulnier and fellow *Combat* contributor Jean Loisy, who, in conjunction with others, took aim at the 1937 Paris World's Fair as well as the "Marxist" aesthetics of the "Maison de la Culture," founded in 1935 by the communist-led artists' league known as the Association des Ecrivains et Artistes Révolutionnaires. Art policy under the Popular Front was deemed to be decadent by virtue of its promotion of "pompierism," whether in the guise of extreme abstraction, slavish academicism, or the communist doctrine of socialist realism. *Pompier* was a derogatory term developed by nineteenth-century critics to describe overblown paintings by artists affiliated with the Ecole des Beaux-Arts; the *Combat* group extended the original meaning to include artists and critics whose art and art criticism fulfilled the mandate of political organizations. The writers for *Combat* linked their own revolt against the Third Republic to the classicizing aesthetics of sculptor Aristide Maillol (1861–1944) and architect Auguste Perret (1874–1954), whom they lauded as the true harbingers of a national renewal. In this manner the revolutionary sublime could once again give birth to a spirit of order and discipline expressed through a proper balance between aesthetic innovation and respect for tradition and métier. Palingenesis, in short, was the hallmark of *Combat*'s cultural program and integral to the journal's Sorelian aims. Thus Maulnier's Janus-faced agenda appropriated the discourse of fascism's prewar French "origins" in Sorelian royalism to create a postdemocratic order superior to that found in Fascist Italy or Nazi Germany. Maulnier's distillation of this ideological agenda to its cultural essence also enabled him to continually criticize totalitarian politics in Nazi Germany and Fascist Italy while endorsing what David Carroll, Mary Ann Frese Witt, and Zeev Sternhell have termed a "spiritualistic" or "aesthetic" fascism, one that gave primacy to art, ethics, and a theory of revolution rather than the muddy actualities of the Fascist regimes then in power.[13]

The fascist valences informing the cultural program developed in *Combat* and *Insurgé* cannot be properly understood without first analyzing the writings of Sorel's principal apologists, Maulnier and Andreu. By examining Andreu's Sorelian commentaries and Maulnier's evaluation of Sorel, Maurras, and fascism in the Maurrassian journal *Revue universelle* (1920–1944) we gain a fuller understanding of why Maulnier was so sympathetic to Andreu's fascist interpretation of the Cercle Proudhon in *Combat*. Having outlined this

ideological trajectory, we will then turn to its cultural implications. The *Combat* group's critique of art policy under the Popular Front demonstrates the degree to which their ideology defined the terms of discourse operative in their writings on culture. This is especially evident in *Combat*'s and *Insurgé*'s promotion of the classicizing and traditionalist aesthetics of architect Auguste Perret, and of sculptors Aristide Maillol and Charles Despiau, as palingenetic alternatives to the "decadence" of Popular Front aesthetics. The case of Perret is especially interesting because of his contacts with the *Combat* group: for instance, when *Combat* organized a symposium on tradition and revolution on 29 June 1936, Perret was a participant, along with the writer Abel Bonnard, Brasillach, Loisy, and the Paris city councilor René Gillouin. Gillouin was an adamant critic of the Popular Front who would soon gain notoriety for his racist diatribes against the influx of "foreign" artists into Paris.[14] Over the course of 1936 and into 1937, Maulnier and his colleagues repeatedly attacked the organizers of the Paris World's Fair for canceling Perret's architectural plan for the creation of the Palais de Chaillot, to be constructed on the site of the old Palais Trocadéro. Perret's edifice—which *Insurgé* christened an "acropolis" for Paris—was the ideal symbol of the *Combat* group's aesthetic aims, since it was thoroughly classicizing in design and would have included sculptures by Despiau and Maillol. Perret's project had been originally commissioned by the state in 1933, but had been rejected as too costly following the fall of the republican government of Edouard Daladier in 1934.[15] *Insurgé* showcased Perret's designs in the January 1937 inaugural issue to underscore the gap separating the *Combat* group's own classical ideals from the aesthetic tastes of their republican adversaries, whose cost-cutting efforts and uncritical defense of the proletarian syndicats had reportedly resulted in the shoddy construction and the repeated strikes that jeopardized plans for the World's Fair's opening, scheduled for 1 May 1937.[16] Although Loisy, Maulnier, and others in their circle did not espouse Gillouin's xenophobic rhetoric, they were adamant in promoting native-born artists steeped in the "French tradition," a sure indication that palingenetic regeneration was homegrown, just as their "kind of fascism" had its genealogy in the Maurrassian/Sorelian synthesis forged in 1913.

Combat (1936–1939) was coedited by Jean de Fabrèques and Maulnier, both of whom had previously contributed to the Catholic and monarchist journal *Réaction* (1930–1932) in an unsuccessful attempt at an "ouverture à gauche."[17]

Figs. 60–61. Auguste Perret, *Plans for the Palais de Chaillot*, 1933–1934. Reproduced in *L'Insurgé*, 13 January 1937.

Combat continued this program but this time in the name of a more "revo-lutionary" form of nationalism that conjoined an interest in Maurras and the Catholic corporatist La Tour du Pin, with enthusiasm for Sorel and the corporativism of Fascist Italy. Most of *Combat*'s contributors had royalist or radical right pedigrees: prominent among them were the polemicists Robert Brasillach and Jean-Pierre Maxence, the writer Abel Bonnard, art critic Jean Loisy, and poet Claude Orland (Claude Roy). Brasillach, Fabrèques, Maulnier, and Roy had all been youthful contributors to the Action Française journal *L'Étudiant français;*[18] Bonnard was a former member of Valois's Faisceau who, in the 1930s, became a Maurrassian sympathetic to Italian fascism; and Loisy was a Catholic corporatist who also wrote for the comte de Paris's *Courier*

royal (1934–1939) (along with Maulnier, Bonnard, and Fabrèques).[19] In an effort to further publicize his campaign Maulnier joined Maxence in edit-ing the "political and social weekly" *Insurgé*. Between January and October 1937, Maulnier, Maxence, Loisy, and others filled *Insurgé*'s pages with diatribes against the cultural politics of the Popular Front, calls for a Sorelian revolt by "national-syndicalists," and laudatory articles on the sculpture of Aristide Maillol and that of fellow traditionalist Charles Despiau (1874–1946).[20]

Pierre Andreu's status as a Sorelian augmented the *Combat* group's left-ist credentials. Before joining Maulnier's circle, Andreu published articles on Sorel and Italian corporativism for the dissident socialist journal *L'homme nouveau* (1934–1937). The journal's editor Georges Roditi hoped to synthe-size "the economic and social politics of the extreme Left" with "the intellec-tual and moral universe of traditionalism."[21] Andreu contributed to the cause with articles on Sorel's political and cultural views as well as commentaries on the corporativism of the Italian Ugo Spirito (1896–1979), whose leftist theory of "corporative ownership" caused a controversy in fascist circles in the early 1930s.[22] Spirito's corporativist theory was indebted to the idealist philosophy of Giovanni Gentile, who interpreted fascist ideology as a form of "human-ism" able to transform the ethical mind set of ordinary citizens. For Gentile and his followers the Italian Fascists' emphasis on morality and creative will meant that each individual's spiritual aspirations found an expression in the collective aims of the Fascist state.[23] Spirito hoped to instigate a comparable revolution in industry: under his system of corporative ownership of the means of production, distinctions between capital and labor would disappear, to be replaced by the singular category of "producers," united in a common effort. Andreu advertized Spirito's theory in the pages of *L'homme nouveau* and *Combat*,[24] unaware that, by the mid-1930s, his mentor had been effectively marginalized by members of Mussolini's Fascist hierarchy opposed to the Bol-shevik implications of Spirito's doctrine.[25] Andreu also continued to promote Sorel's writings on classical Greece and syndicalism in the pages of *Combat*,[26] where his enthusiasm for the leftist valences of fascist corporativism was sup-plemented by laudatory articles on the Italian Fascist corporative state by An-dré Monconduit.[27] In keeping with Maulnier's effort to draw Sorelian com-parisons between present and past eras of potential revolt Andreu paid special attention to Sorel's favorable evaluation of Athens in the age of Homer and the

untimely demise of the Cercle Proudhon. In both cases the sublimity of these portentous moments in the history of ancient Greece and avant-guerre France was dramatically undercut by the forces of decadence, whether in the guise of Socratic thought or a plutocratic Third Republic. Maulnier saw a similar catastrophe unfolding in his own era, and in carrying forward the cultural legacy of the Cercle Proudhon, he hoped to rekindle a revolutionary spirit among his Sorelian and Maurrassian allies. This revolutionary "mission" amounted to a galvanizing myth, premised on the claim to have located the origins of fascism not only in the cultural politics of the Cercle Proudhon, but in a classical spirit with roots going back to the era of Louis XIV, and, ultimately, to ancient Greece.

The Myth of Origins

Maulnier's careful distinction between existing Fascist regimes and the Sorelian order to be developed in France is clearly stated in a series of articles published in *Revue universelle*. The first, "Le 'fascisme' et son avenir en France," appeared in January 1936, in tandem with the initial issue of *Combat*; the second, "Le socialisme antidémocratique de Georges Sorel," was published in February—the same month as Andreu's *Combat* article "Fascisme 1913" and Maulnier's "Les deux violences." Given the rather doctrinaire Maurrassian agenda of *Revue universelle*,[28] it is not surprising that Maulnier endorsed a version of monarchism as the ideological frame best suited to France, but he then posited a close relation between the Cercle Proudhon and Italian fascism by virtue of their shared Sorelian roots. In a third article, "Charles Maurras et le socialisme" (1 January 1937), Maulnier made clear that the Cercle's synthesis of "the antidemocratic socialism of Sorel and the 'socialist' nationalism of Maurras" represented a departure from the strictures of Maurras's own monarchist program. Thus the Cercle Proudhon constituted a kind of laboratory for a new antidemocratic order that could improve upon Italian fascism by virtue of its incorporation of Maurrassian nationalism into the national socialist mix.

Maulnier's January 1936 article on the future of fascism in France chastised the French left for falsely labeling fascism the tool of capitalists, when in truth the "large financiers" and "great leaders of trusts" saw fascism as a threat to the status quo of "liberal anarchy." Fascism, stated Maulnier, threatened factions

on both the left and right by "raising the political and social interests of the nation above particular economic interests."[29] Fascism first emerged in Italy and Germany as a result of the economic and social turmoil following World War I, and if the conditions were right "this extraordinary event may occur in France tomorrow."[30] This postwar phenomenon was the offspring of the avant-guerre "birth of a new Right" in Europe that rejected the conservatives' reactionary defense of the socioeconomic status quo. "The phalanxes of the Action Française," Maulnier proudly asserted, "had been, at the beginning of the century, the harbingers of this new right, which was not content to be the party of resistance" and instead aspired to become a "movement."[31] After World War I the "movement" reportedly spread "throughout Europe." As a result the Left was now confronted with a militant Right that called for "a complete rejuvenation [and] restoration of the human social order." Unlike the old conservatives, who used authoritarian institutions to maintain the "disorder" spawned by liberal capitalism, fascism transcended "class divisions" and "political divisions" to forge a "moral unity" that transformed "the spiritual state" of individuals. Under the corporative system developed in Italy the worker was no longer "the salaried servant of an employer" but instead a "collaborator in the service of the community."[32] A comparable revolution could occur in France, if right-wing conservatives broke with "liberal capitalism" and if leftists abandoned parliamentary politics and became less wary of fascist alternatives to democracy. In fact Maulnier conjectured that the "decomposition" of existing political parties in France meant that "a fascist grouping was possible," provided the conservatives joined forces with France's "activist" youth. "The word is unpopular, agreed. But the thing can be born without the word."[33]

Maulnier then defined a kind of fascism "without the word" by describing monarchy as a structure that shared fascism's anticapitalist opposition to democracy and its call for a "moral revolution"; yet rejected the totalitarian concept of mass society purportedly promoted by Mussolini's Fascists. Under a monarchist "dualist society," collective concerns would accrue to the state, which would also guarantee individual freedom.[34] In Maulnier's estimation monarchism improved on the collectivism of Fascist Italy by giving individuals a greater degree of autonomy; however, this did not stop Maulnier from concluding that Revue universelle's readers had "much to learn from fascism."[35] Indeed, the lesson continued in Maulnier's February 1936 article "Le social-

isme antidémocratique de Georges Sorel" (The Antidemocratic Socialism of Georges Sorel). In that essay he described Sorel as a "philosopher-prophet" whose ideas had profoundly influenced "the leaders of three great revolutions on which the future of Europe depends, Lenin, Mussolini, Hitler."[36] He then cited Jean Variot's newly published memoir *Propos de Georges Sorel* (1935) to the effect that, in 1912, Sorel had already identified Mussolini as the figure who would revitalize Italy by fomenting a syndicalist revolt against democracy. To understand Sorel's acuity, we are told, one had only to consider his own ideological trajectory. Having renounced "Dreyfusard socialism and conservative patriotism" Sorel in 1910 was drawn to the Action Française as the "only serious nationalist movement" that actively embraced his concept of "violence."[37] This violence was not the "romantic violence" exemplified by "the taste for riot and spilled blood"; rather, it was founded on "the principles of a rigorous doctrine" that required "intellectual courage" and was uncompromising in its opposition to "the established order."[38] Maulnier's assertion that Sorelian violence was not "romantic" echoed Sorel's own synthesis of ethical violence with classical culture in his eulogies to the military discipline of Homeric Greece, and Berth's praise of the antidemocratic fusion of Apollonian beauty and Dionysian sublimity initiated by the Cercle Proudhon. Further, Berth, Sorel, and Maulnier all lauded the concept of tragic heroism developed in Nietzsche's *Birth of Tragedy*, as a spiritual attitude to be instilled in contemporary revolutionaries.[39] Sorel had already witnessed the dissipation of such violence among the syndicalists, because of that movement's capitulation to "the parliamentary game." The "alliance of socialism and democracy" reportedly "wounded him to the depths of his being." This caused Sorel to turn his attention to the only antidemocratic movement left in France, the Action Française, and to pin his socialist hopes on radical leftists outside of France, namely Lenin and Mussolini.[40]

It is at this point that Maulnier takes over Sorel's mantle, by claiming that his mentor's untimely death in 1922 meant that he did not witness the decline of Soviet communism into a degenerate condition reminiscent of Jean Jaurès's parliamentary socialists. "The author of the *Matériaux d'une théorie du prolétariat* did not live long enough to see communism follow the path opened by socialism, sink into political schemes, and, obedient to the instructions of this same new Russia in which Sorel placed his aspirations, enter into the Popular

Front for the defense of democracy."[41] While Maulnier was prepared to dismiss French communism and the Soviet Union on Sorel's behalf, he lionized Mussolini as the only postwar leader who remained true to Sorel's doctrine. Mussolini, we are told, was every bit Lenin's equal in his initial endorsement of Sorelian violence, but he had surpassed Lenin by creating the "national and syndicalist society of which Sorel had dreamed." Significantly, whereas Lenin's initial attack on social democracy satisfied "the revolutionary will in Sorel," Mussolini alone had engaged in the kind of societal reconstruction that might fulfill "the positive doctrine of the master."[42] In a *Revue universelle* article of August 1936 Maulnier speculated that corporativism could be "one of the principle building blocks of a renewed society," since that institutional framework reconciled "social justice with respect for liberties."[43] As we have seen, *Combat* published numerous articles on Italian corporativism as well as the French Catholic corporativism of La Tour du Pin; a sure indication that Maulnier's group regarded corporativism as a possible avenue out of the capitalist and democratic morass. Most important, a corporativism untethered from the "dictatorial statism" of Europe's "totalitarian regimes" could safeguard those "liberties" presently compromised under Italian fascism.[44] While Maulnier in his article on Sorel recognized that the Fascist "experiment" in Italy was still evolving, he was eager to subsume its Sorelian violence and corporative institutions within his preferred agenda: a French version of fascism modeled on the Cercle Proudhon. "Maurrassian analysis" showed the French how to separate "the idea of nationalism from that of bourgeois social conservatism," while "Sorelian analysis" disentangled "the idea of social revolution from democratic progress." These two orientations could not help but "complete" each other, for the followers of Sorel and Maurras shared "an intellectual courage," constituted "a breaking force" and embodied "a future promise." Before August 1914 this synthesis had become "the work of his [Sorel's] disciples," but the cataclysm of World War I had "interrupted this research." "But," concluded Maulnier," the principle of a new revolutionary force in the service of a national, political, social order would truly survive: it will appear, it has already appeared."[45] Presumably *Combat* represented such "research," and the classical violence of the Cercle Proudhon—the nebula of a kind of fascism—constituted the "revolutionary force" able to transform France.

With the publication of his article "Fascisme 1913" in the February 1936

issue of *Combat*, Andreu joined forces with Maulnier in promoting Sorelian royalism as a fascistic solution to the country's democratic woes. Andreu had paid little attention to Sorel's royalist phase in his writings for *L'homme nouveau*, but in *Combat* Sorel's alliance with the Action Française and his impact on the Cercle Proudhon were frequent topics of discussion. As we have seen, Andreu's "Fascisme 1913" showcased the Cercle Proudhon's classicizing synthesis of Sorelian "sublimity" and Maurrassian "order and discipline"; in other essays Andreu would recount the untimely demise of the Cercle Proudhon experiment in the midst of the carnage of World War I. In an article of April 1936, Andreu paid homage to the Cercle Proudhon's principle founder, Henri Lagrange, describing him as a young Sorelian royalist whose ideological "rigor" and penchant for "violence" reportedly "'terrified' Maurras."[46] Lagrange was cast as a practitioner of classical violence who became a tragic victim of World War I, and in "Fascisme 1913" Andreu described the misplaced "heroism" of the Cercle's wartime combatants as furthering "the insolent triumph of the democracies, to the ruin of all their hopes." By contrasting the ethical violence of the Cercle with the state-sanctioned barbarism of World War I, Andreu applied a fundamental tenet of Sorel's *Reflections on Violence* to a critique of the Third Republic.[47] He also drew attention to Sorel's ruminations on classicism and Catholicism. In his republication of Sorel's writings in the July 1936 issue of *Combat*, Andreu ended his selections with a prophetic excerpt from Sorel's chapter "Grandeur et décadence," which had appeared in the 1910 edition of *Les illusions du progrès*.[48] Once again we are informed that "though the present time is not favorable to grandeur . . . history teaches us that greatness cannot be absent indefinitely in that part of mankind which possesses the incomparable treasures of classical culture and the Christian tradition." Other excerpts pointed to the possible rebirth of classical violence, as exemplified by Andreu's quotation of the following line from Sorel's *Reflections on Violence*: "That very ancient type, the Achaean type celebrated by Homer, is not simply a memory; it has several times reappeared in the world." Metaphysics too could play a role in democracy's decline: Andreu quotes an excerpt from Sorel's preface to Berth's *Les Méfaits des Intellectuels* to the effect that "in ten or twenty years, a new generation" might forsake the "intellectualist philosophies" of democracy through exposure to "Bergsonism" and "Pascal." In his March 1936 review of Variot's *Propos de Sorel* (1935), Andreu not only pointed to Sorel's praise of

Mussolini (with no mention of Lenin), he highlighted Sorel's postsyndicalist "testimonials on Maurras" and his eulogy to that icon of classical and Christian tragedy, Claudel's neo-Catholic mystery play, *L'Annonce faite à Marie*.[49] In "Fascisme 1913" Andreu alerted his readers to Sorel's praise of Péguy's *Mystère de la charité de Jeanne d'Arc* in the April 1910 issue of the journal *L'Action française*, Sorel's involvement in the aborted *La Cité française* (1910), and his defense of the royalist cause (and anti-Semitism) in *L'Indépendance*. While Andreu characterized Sorel's contributions to *L'Indépendance* as "extraordinary" in scope, he faulted the journal for not laying out "a defined political and intellectual course of action." That is why the Cercle Proudhon and Berth's book *Les Méfaits des intellectuels* were the best indicators of "the astonishing possibilities" latent in Sorelian royalism.[50]

Classical Humanism from Edouard Berth to Thierry Maulnier

As we have seen, Maulnier endorsed Andreu's interpretation of the Cercle's union of Sorelian and Maurrassian ideals in the February 1936 issue of *Combat*, but what has gone unnoticed is the striking similarity between Maulnier's related call for a Dionysian and Apollonian synthesis in the guise of classical humanism and the definition of classicism developed by Edouard Berth in *Les Méfaits des intellectuels*, the book Andreu lauded as a potential blueprint for any future fascism native to France. In his opening chapter, dated March 1913, Berth took aim at what he called the "antipoetic and antivital rationalism" upheld by democratic ideologues and their apologists in the realm of literature, most notably Julien Benda.[51] The latter was among those guilty of promoting a "caricature of true classical culture, which, far from being a formalist and purely rhetorical culture" was instead profoundly "realist."[52] The classicism of Maurras and Sorel was antithetical to that of Benda, for both ideologues associated classicism with an "organizing empiricism" that Berth equated with Bergsonian intuition and a Nietzschean will-to-power.[53] By making the realm of instinct the object of the intellect's capacity for reflection, Maurras and Sorel employed empathetic consciousness to plumb life itself. Their classicism was truly vital: indeed it was this form of "classical reason" rather than the "abstraction" favored by Benda that had inspired "great classical writers" such as Montaigne and Molière.[54] The "intuitive" classicism of Sorel and Maurras had

likewise succeeded in reconciling intellect and instinct, which Berth equated with the Apollonian and the Dionysian, the two "artistic divinities" whose poetic synthesis produced Greek tragedy. If one were to define a difference between the classicism of Maurras and that of Sorel, it would be in Maurras's greater love of "beauty"—an Apollonian tendency—in contrast to Sorel's allegiance to the "sublime," which attested to his Dionysian temperament.[55] However, both were united in their opposition to antivital rationalism, whether manifest in the "formalist" classicism of Benda or the "democratic abstraction" of the Third Republic. "Syndicalist violence," stated Berth, "calls for order, as the sublime calls for the beautiful; Apollo must complete the work of Dionysus."[56]

In his book on Nietzsche of 1935, and in his 1936 study of the seventeenth-century playwright Jean Racine (1639–1699), Maulnier followed Berth's example by defining classical humanism as a synthesis of Dionysian energy and Apollonian restraint, whose artistic corollary was a classicism that subjected the creative impulse—also defined in vitalist terms—to the rigors of intellectual reflection. The result was a classical formula that combined force and form, dynamism and order. David Carroll has analyzed the Nietzchean assumptions informing Maulnier's theory in his examination of the latter's literary fascism.[57] As Carroll demonstrates, Maulnier's palingenetic notion of classical humanism looked beyond existing European nationalisms by calling for "a return to first principles, to what he considered to be the origin or essence of both true nationalism and socialism, as well as authentic 'spiritualistic' fascism."[58] In his 1935 study of Nietzsche and in his book on Racine published the following year, Maulnier argued that "the Nietzschean notion of a pure and extreme aesthetics of force can be realized as a maximum of intensity or violence only within the constraints of classical form—the Dionysian realizing itself fully only through the Apollonian."[59] Like Berth, Maulnier employed this synthesis to separate his classicism from formalist or abstract conceptions of the classical. Concurrently he defined his theory of violence as distinct from any crude equation between mythic consciousness and a direct appeal to instinct, unchecked by willed reflection. Like Berth he defined violence as ethical, and as the product of Dionysian and Apollonian forces. In a book published in early 1936—the exact moment when *Combat* endorsed Berth's synthesis of the "Dionysian" Sorel and "Apollonian" Maurras—Maul-

nier lauded Racine for forging a comparable synthesis of the Dionysian and Apollonian into a theory of classicism.[60] Thus Racine's classicism arguably prefigured that of the Cercle Proudhon, which in turn indicated the trajectory for the emergence of a "kind of fascism" inherent to French culture. By returning to the first principles of Greek classicism, Racine (like Nietzsche) had reportedly rediscovered the violence and sublimity native to a creativity whose aesthetic corollary was Greek tragedy.[61] On this basis Maulnier declared Racine's classicism to be antithetical to the "mutilated, abstract, formal classicism" endorsed by the "stupid worshipers of French clarity and order."[62] Maulnier wanted to vanquish the "legend of an Apollonian France" by promoting that of Racinian France, arguing that true classicism was born when "the greatest vital fervor [élan vital] and the supreme blossoming of energies coincide with the triumph of formal perfection."[63] In his earlier book on Nietzsche, Maulnier struck an equally vitalist note, describing the hero in Greek tragedy as driven by "the imperious élan that throws the human being into action."[64] This classicism amounted to what Carroll calls "a radical aesthetics of force," wherein the Dionysian "delirium of creative energy" achieved its full development through the Apollonian imposition of order, form, and technique on unbridled inspiration.[65] Maulnier's reference to the "élan vital" in describing this creative impulse likely signaled his awareness of Bergson, whose impact on Berth and the Cercle Proudhon was profound.[66]

In his later writings Maulnier held that his model of classical humanism would be a beacon for an emerging French elite that would successfully combat the collectivism of contemporary political regimes.[67] Thanks to this cultural orientation French society would not fall prey to the racist myths promoted by the Nazis, the Soviet Union's exaltation of the proletariat, or the populist cult of the "general will" embraced by the democracies.[68] In Maulnier's estimation such "socialist myths" resulted in forms of mass somnambulism that subordinated individual consciousness to the dictates of collectivism while simultaneously reducing art to a tool for potential manipulation by venal politicians.[69] By contrast, Sorel's theory of the revolutionary sublime made individual freedom and collective solidarity utterly compatible. Referring to the "wars of Liberty" in his *Reflections on Violence* Sorel had argued that "each soldier considered himself an *individual* having something important to do in the battle" rather than as "one part of the military mecha-

nism committed by the supreme direction of the leader." Thus the republican armies of the French revolution were composed of *"free men,"* as opposed to the *"automatons* of the royal armies." Under such conditions, the revolutionaries viewed their fellow soldiers as engaged in an epic struggle, wherein each individual act had the potential to jeopardize the success of the whole. United through their empathetic or intuitive relation to one another, these soldiers reportedly engaged in "heroic exploits" akin to the "Homeric conflicts" of classical Greece. Sorel developed this argument in *Reflections on Violence* and his Bergsonian reconciliation of individual freedom and collective action was reiterated by Berth in *Les Méfaits des intellectuels*.[70] Given Maulnier's familiarity with both texts, it is likely that he put Sorel's analysis to use in his own "individualist" definition of classical humanism. By recognizing the classical roots of ethical violence, French society and culture would transcend the arid inertia represented by pure rationalism *and* the infantile barbarism promoted by "collectivist" regimes. Referring to such rationalism in *Mythes socialistes* (1936), Maulnier singled out none other than Julien Benda as exemplary of those whose cult of the "pure idea" and "pure reason" only resulted in "disdain for life and the world," the very wellspring of the classical imagination.[71] Likewise, the individual freedom integral to Sorel's classical notion of collective violence meant that individuals would never be reduced to automatons, subject to the authoritarian whims of a supreme leader. The classicism of Racine and related cultural politics of Sorel, Berth, and the Cercle Proudhon could therefore point the way to a new order and to a new kind of fascism that rejected the collectivism of existing Fascist states while embracing the tragic sense of national destiny, self-discipline, and activism those regimes sought to promote, however imperfectly.[72] In this manner, the antidemocratic agenda synonymous with classical violence could be conjoined with what Maulnier termed, in May 1939, a "minimum fascism" that would act to protect France against the increasing threat posed by the Nazis while saving the nation from the pitfalls of another plutocratic "union sacrée."[73]

Art and Politics under the Popular Front

By drawing attention to the prophetic aspects of Sorel's thought and the revolutionary potential inherent in the Cercle Proudhon experiment Andreu and Maulnier set the stage for *Combat*'s and *Insurgé*'s Sorelian critique of the

Popular Front government of Léon Blum, whose election in May 1936 precipitated a firestorm among the radical Right. Beginning with his article "Les deux violences" (February 1936) Maulnier drew comparison's between Sorel's era and his own while calling for a return to Sorel's revolutionary principles. Having drawn readers' attention to Andreu's description of the Cercle Proudhon in "Fascisme 1913," Maulnier outlined the ongoing relevance of Sorel's theory of violence for his contemporaries.[74] The Cercle Proudhon had hoped to "restore grandeur and order" to the nation, and to "assure a better future for the oppressed and deprived classes." Sorel had rejected the syndicalist movement because its reformist leadership "no longer possessed the *violence*, that is the courage to imagine, the disrespect and independence with regard to the established order," or "the will to revolt" that animated "the Maurrassian extreme Right."[75] However, "if the French people were already deceived before the war by the betrayal of [Aristide] Briand and [Jean] Jaurès" that historical moment paled when compared to the contemporary "collusion of revolutionary leaders, politicians, and financiers." In Maulnier's era, socialist politicians whom "Sorel had so eloquently denounced" were once again exploiting the workers' anger and desire for justice to further their parliamentary careers. The "violence" that defined "the revolutionary ideal" had been betrayed by "the Popular Front"; moreover, the Soviet Union's endorsement of that movement indicated its own internal corruption. In response Maulnier called upon "disciplined and powerful elites" among the bourgeoisie and proletariat to take up the "heroic" mantle of Sorelian violence to "battle against the enemy, that is, political and economic forms of democracy." *Combat*'s mission was to "unite" these "two violences" by forging a new alliance across class lines.[76]

Maulnier furthered this agenda in articles denouncing the Right and Left's collusion in the government's reformist policies: in an essay titled "Les conservateurs" (The Conservatives) (*Combat*, May 1936) he took aim at bourgeois factions eager to maintain the political status quo; in "Le seul combat possible" (The Only Combat Possible) (*Combat*, June 1936) he condemned the Popular Front as a new "union sacrée" designed to suppress revolutionary fervor across the political spectrum, and in a July 1936 assessment of the newly elected Blum government, Maulnier once again conjured with Sorel in a damning critique of the syndicalist movement.[77] Titled "La fin d'un 'ordre'" (The End of an "Order"), this last article outlined Maulnier's Sorelian interpretation of the

Matignon Agreements signed on 6 June 1936. Between Léon Blum's electoral victory on 5 May and the installment of his government on 6 June, France had been riven by strikes, including factory occupations, and one of Blum's first acts as premier was to bring together leaders of the Confédération Générale du Travail and of the industrialists to sign an accord, known as the Matignon Agreements. The agreements were a model of reformist politics: in return for ending the strikes, workers would be guaranteed a forty-hour week, an increase in wages, and two weeks paid holiday. This economic truce won the support of the syndicalists and their communist allies, though factions within both movements accused Blum of having thwarted a revolution.[78] Maulnier evidently shared the latter position, albeit from the standpoint of the Sorelian Right. To his mind, the Matignon Agreements signaled "the decomposition of the syndicalist movement," which "had entered into the service of the plutocratic state, manipulated by politicians, corrupted, as Sorel predicted, by parliamentary democracy." The bourgeoisie was no better off, for they too had become the victims of "statist hypercapitalism" by capitulating to Blum's machinations.[79] Maulnier's Sorelian battle cry was reiterated in the pages of *Insurgé* the following year. In an article titled "Les deux trahisons" (The Two Treasons) (21 April 1937) he railed against the alliance between the French Communist Party—formed in 1921—and the parliamentary socialists, once again comparing the Popular Front to the wartime union sacrée "denounced by Sorel."[80] Jean-Pierre Maxence in turn declared *Insurgé*'s "revolutionary youth" to be the followers of "Maurras, Péguy, Sorel" in a diatribe titled "Pas de nationalisme valuable sans justice sociale" (No Valuable Nationalism without Social Justice) (14 April 1937).[81] The Sorelian royalist synthesis endorsed by *Insurgé*'s contributors was part and parcel of their resolute opposition to democracy "in all its forms; political, economic, social."[82] The newspaper's very title, "The Insurgent," made plain the *engagé* nature of their ideological agenda.

In the 1930s the *Combat* group singled out the cultural allies of the Soviet Union, the French Association des Ecrivains et Artistes Révolutionnaires (AEAR) and of the Popular Front as their principle adversaries. The AEAR was founded in 1932 as the cultural arm of the Parti Communiste Français (PCF), and early in 1934, the former surrealist-turned-orthodox-communist Louis Aragon began promoting the doctrine of socialist realism in the organiza-

tion's journal, *Commune* (1933–1939).[83] Socialist realism was the brainchild of Andrey Zhdanov, a powerful member of the Soviet Union's Central Committee who would later become Joseph Stalin's minister of culture. At an August 1934 congress of the recently created Union of Soviet Writers Zhdanov expanded on Stalin's characterization of writers as "engineers of the soul" to argue that artists should adopt a realist mode to effect "the ideological remolding and education of the toiling people in the spirit of socialism." Zhdanov called on writers to develop a form of "revolutionary romanticism" as an alternative to "bourgeois" aesthetics. At the same conference Nikolai Bukharin employed Zhdhanov's ideas to denounce Russian formalism as a bourgeois idiom that divorced art from its social context.[84] Aragon, André Malraux, Jean-Richard Bloch, and Vladimir Pozner were the French representatives at the congress; in its wake they joined communist sympathizer André Gide in seeking to define "proletarian culture" and socialist realist aesthetics from a French perspective. Their campaign filled the pages of *Commune* and the related journal *Europe* during 1934, and in 1935 Aragon summarized his views on the subject in his edited anthology *Pour un réalisme socialiste*.[85] In that book Aragon struck a difficult balance: having dismissed both propaganda art and modernist abstraction (including surrealism), he claimed that "revolutionary romanticism" could be achieved if an artist's subject matter captured the drama of societal struggles, both historical and contemporary.[86] In the visual arts, *Commune*'s contributors lauded the Le Nain brothers' seventeenth-century depictions of the French peasantry as exemplary of the aesthetic they hoped to nurture in modern-day France. In a review of an exhibition titled Les Frères Le Nain, held at the Grand Palais in 1934, *Commune* art critic Jean-Louis Garcin argued that the Le Nain's depiction of the down-trodden attested to class tensions and the polarization of rich and poor in the era of Louis XIV.[87] Three years later the Soviet Union's official brochure introducing that country's pavilion at the 1937 Paris World's Fair described Vera Mukhina's monumental sculpture *Worker and Collective Farm Woman*—which was perched on top of the Soviet pavilion—as bearing "the definite imprint of the artistic method we call socialist realism" (fig. 63).[88] Thus the Soviet pavilion itself was a cultural symbol of the united front linking French communists and their Russian counterparts.

The arrival of socialist realism into France coincided with the emergence

of two new art movements dedicated to realist aesthetics, Les Peintres de la Réalité en France Poétique and Forces Nouvelles. As Romy Golan notes, both groups called for a return to the human subject, to craftsmanship and tradition, and espoused renewed contact with nature; however, they differed in their ideological orientation. The Peintres de la Réalité Poétique—which included artists such as Roland Oudot and Roger Chapelin-Midy (fig. 8)— preferred less politically charged genres, such as the pastoral. By contrast, the subject matter of Forces Nouvelles painters such as Georges Rohner, Edouard Pignon, and Henri Jannot was decidedly leftist and *engagé*, with a focus on the impact of the Depression on the French proletariat and peasantry and the plight of rural workers during the Spanish civil war.[89] In 1935 the AEAR created the Maison de la Culture movement to further the Communist Party's artistic agenda through conferences and discussion groups. Shortly after the Popular Front victory on 5 May 1936, the AEAR sponsored a debate at the Paris Maison de la Culture, during which abstraction was roundly condemned as a form of arcane "obfuscation" designed to appeal to the educated bourgeoisie, rather than the proletariat.[90]

The same period witnessed the alliance of left-wing parties and syndicats that gave birth to the Popular Front.[91] In the wake of the February 1934 Paris riots by French paramilitary leagues—including Colonel de La Rocque's Croix-de-Feu and Action Française militants—the communists, socialists, radicals, and Confédération Générale du Travail held a series of meetings that culminated in a 14 July 1935 rally in the Buffalo Stadium at Montrouge, on the outskirts of Paris. That event concluded with a public oath "to remain united to defend democracy, to disarm and dissolve the factious leagues, to place our liberties out of reach of fascism."[92] Pressure from the newly formed Front Populaire played a role in the passing of a law in the Chamber of Deputies authorizing the dissolution of French paramilitary organizations in January 1936. The rapprochement between the communists and the parliamentary socialists was further facilitated by the Franco-Soviet pact of mutual assistance in May 1935, which the French communist leader Maurice Thorez took as a sign of Stalin's willingness to defend the Republic against the increasing threat posed by Fascist Italy and Nazi Germany. Thus the victory of the Popular Front in May 1936 was widely viewed as a public response to the political instability created by the French paramilitary leagues in early 1934, Mussolini's inva-

Fig. 62. Roland Oudot, *Travaux rustiques*, 1933. © 2006 ARTISTS RIGHTS SOCIETY (ARS), NEW YORK/ ADAGAP, PARIS.

sion of Ethiopia in 1935, and Hitler's remilitarization of Germany in 1936.[93] In July 1936—one month after Léon Blum took office—this sense of crisis was compounded by the outbreak of the Spanish civil war. In August Blum proposed an official policy of nonintervention in Spain, which met with fierce opposition within the communist movement, the Confédération Générale du Travail, and factions within Blum's own socialist party, Section Française de l'Internationale Ouvrière. Dissent within the Popular Front reached a boiling point when Communist deputies abstained from a vote supporting the government's foreign policy on 4 December 1936.[94]

The 1937 Paris World's Fair

In the midst of this political upheaval a series of governments were involved in organizing the 1937 Paris World's Fair, originally conceived in 1932 and set to open on 1 May 1937.[95] As we shall see, the *Combat* group condemned the fair as evidence of the decadence supposedly rife under the Popular Front. Extending outward from the Champ de Mars, the fairgrounds stretched across

the Seine to the newly constructed Palais de Chaillot (which replaced the old Palais du Trocadéro), and lined the river banks from the Place de la Concorde to the Ile de Cygnes. The most prominent foreign pavilions, including those of the Soviet Union, Nazi Germany, and Fascist Italy (all appearing in a June 1937 photograph of a regatta on the Seine), were clustered in front of the Palais de Chaillot, while a series of pavilions representing France's regions were situated to the west of the Eiffel Tower, and a French Colonial Center was sequestered on the Ile de Cygnes. The period between 1932 and the ascent of the Popular Front government in June, 1936, was a tumultuous one for the fair's organizers: originally conceived as a modest undertaking with minimum financial support, the World's Fair was briefly canceled in January 1934, only to be revived that February with the more ambitious mandate of showcasing French culture and industry in an expanded series of pavilions. Before the Popular Front took power the master plan had been redrawn more than twenty times, and the fair's budget had ballooned from an original estimate of 300 million francs to close to 900 million francs by the end of 1936.[96] When Blum became premier in June 1936, the building of the Palais de Chaillot and the newly created Musées d'Art Moderne—known as the Palais de Tokyo—were barely under way, while the vast majority of the French pavilions were still in the planning stages. In response, Blum's government launched an all-out attempt to remake the fair in time for the 1 May 1937 opening by expanding the budget and adding a series of new exhibitions reflective of the Popular Front's social and cultural policies. The new buildings included a "Solidarity Pavilion" and a "Hygenic Pavilion," which advertised the government's commitment to improving French health facilities; in addition the Ministry of Agriculture created a Rural Center, the Ministry of Air, an Aeronautics Palace, and the Ministry of Public Works showcased its accomplishments in a separate museum. In the period leading up to the fair's opening, Blum's government added a Work Pavilion built by the Confédération Générale du Travail, as well as a Peace Monument, situated behind the Palais de Chaillot's central plaza.[97]

After surveying the exhibition plans at the end of 1936 Blum realized that French achievements in the fine arts were conspicuously absent; thus he authorized the hasty creation of an exhibition titled "Chefs-d'oeuvre de l'Art Français," which opened in the west wing of the newly built Palais de Tokyo in June 1937.[98] This huge survey of French art, which included over thirteen hundred

Fig. 63. "Le passage des équipes aux régates internationales de l'Exposition." Reproduced in *L'Illustration*, 19 June 1937, 259.

works, went from the Gallo-Roman era to the painting of the impression-ists, Paul Cézanne, the neoimpressionist Georges Seurat, and symbolists Paul Gauguin and Toulouse-Lautrec. As James Herbert notes, the exhibition was lionized in the right-wing press as indicative of the French people's "spiritual" and "racial" superiority: for instance, *Combat* ally Abel Bonnard informed the French that "the soul" of their country was on exhibit, while Lucien Rebatet told the readers of *Revue universelle* that the magnificent art on display was the product of "instinct, of blood."[99] That same month, the Paris Municipal Council opened a "companion" exhibition of contemporary art at the Petit Palais. Titled Les Maîtres de l'Art Indépendant, the exhibition met with fierce resistance from French academicians associated with the Société des Artistes Français and Société Nationale des Beaux-arts, since it amounted to the offi-cial sanctioning of the Parisian avant-garde, including immigrant artists affili-ated with the École de Paris.[100] In response the city councilor René Gillouin

launched a public campaign against the exhibition in the January 1938 edition of *La revue hebdomadaire*, claiming that its organizers had excluded "hundreds of artists of the good French race" in order to showcase "extremist forms of modern art" fabricated by "aliens" who had "flocked to Paris from their native Lithuania, Podolsk, or Czechoslovakia."[101] The views of Bonnard, Gillouin, and Rebatet are particularly interesting since all three figures had contacts with the *Combat* group.[102] As we shall see, Jean Loisy also assessed these exhibitions for *Combat* and *Insurgé*, but he did so in the context of Maulnier's ideological program, rather than the overt racism and xenophobia espoused by Rabatet and Gillouin.

As Shanny Peer has demonstrated, the Paris World's Fair had become a symbolic outlet for competing political and economic factions even before the Popular Front came to power, but the Blum ministry's interventions from June 1936 onward led the government's opponents to christen the fair "the Popular Front's Expo." These interventions occurred in the administrative arena as well as in the public sphere. Blum's government had inherited a retired civil servant, Edmond Labbé, as the fair's general commissioner, whose assistant was François Latour, a right-wing member of the Paris Municipal Council. In November, 1936, Blum dismissed Latour and replaced him with the radical-socialist politician Pierre Mortier.[103] The personnel change proved controversial, for that same month Latour had sent a letter of support to Charles Maurras, who had been imprisoned in October for the "incitement to murder" deputies and senators favoring sanctions against Fascist Italy for its invasion of Ethiopia. Accusations of political bias blossomed in the right-wing press, which in turn provoked equally sectarian responses from the left.[104] Over the same period, the Confédération Générale du Travail spearheaded a series of strikes on the fair grounds, with the result that construction had fallen an estimated five months behind schedule by December 1936. Since the situation was further exacerbated by the Popular Front's introduction of the forty-hour work week, failure to meet the 1 May opening deadline would have proved highly embarrassing. In an effort to rally workers to the government's cause Blum visited the work site in February 1937, declaring that "the failure of the Popular Front would be a triumph for fascism. A delay in the exhibition would be its victory." Léon Jouhaux, general secretary of the Confédération Générale du Travail, joined Blum on the podium, adding that "the exposition will be the

triumph of the working class, the Popular Front, and liberty."[105] The right-wing press immediately accused the Popular Front of appropriating the exposition: in fact Maulnier had already tried to create a schism between the workers, the Confédération Générale leadership, and the Popular Front in a 7 February article in *Insurgé* titled "Syndicalisme? OUI, Démocratie? NON."[106] Maulnier argued that the striking workers had been manipulated into undermining the national interest by the Confédération Générale du Travail, which had in turn betrayed its revolutionary mission as defined by Georges Sorel. Instead of combating democracy, the Confédération Générale had risen to defend the Popular Front, even as it instituted work stoppages in hopes of winning further economic concessions. "When the CGT allies itself with parliamentary politicians," Maulnier argued, it allies itself with capitalism, for "democracy is nothing other than the system of political institutions of the liberal-bourgeois regime, the political form of the society of which liberal capitalism is the economic form." Class inequalities would only be overcome if these economic and political structures were destroyed, thus "syndicalism will only become truly constructive by first destroying democracy."[107] *Insurgé* further mocked Blum's government by pairing Maulnier's polemic with an article titled "Paris défiguré," which consisted largely of photographs of the unfinished buildings littering the fairgrounds.[108] The 7 April edition of *Insurgé* accused Léon Blum of making the World's Fair "into a project of the Popular Front" that "systematically pushed French people, belonging to any party other than his own, away from something which should have been the work of France." "The best service we can render France," the article continued, "is to warn foreigners that they're likely to visit an exposition of scaffolding and piles of crap. The decline of France is too evident to anyone who compares the Belgian, German, Italian, or Russian pavilions to the French pavilions."[109] Sadly the article proved prophetic, for the exhibition's inauguration had to be delayed until 24 May, and while the German, Italian, and Russian exhibitions were completed on time, only two of the French pavilions opened on schedule.[110]

Art and Revolution: The Apples of Cézanne

It is with such issues in mind that we should read the art criticism published in *Combat* and *Insurgé*, for I would argue that the *Combat* group's theory of "classical violence" not only aestheticized their politics, it politicized their theory

of art. The art and architecture promoted by Maulnier and his colleagues took on mythic value as a harbinger of the fascist revolution. Over the course of 1936, Maulnier, Robert Brasillach, and Jean Loisy published a series of essays on the relation of aesthetics to tradition that were the building blocks for their full-scale critique of the cultural policies of the Soviet Union, the Association des Ecrivains et Artistes Révolutionnaires, and the Popular Front, as manifest in the 1937 World's Fair.[111] In defining an aesthetic corollary to their palingenetic ideology, the *Combat* group sought to reconcile adherence to tradition with artistic innovation: this resulted in praise for the art of Paul Cézanne, the métier of sculptor Charles Despiau, and the classicizing aesthetics of sculptor Aristide Maillol and of architect Auguste Perret (who had direct ties with the *Combat* circle). By contrast, *Combat*'s ideological enemies in the art world were attacked for failing to achieve the proper balance between tradition and innovation: this latter group included the full gamut of Communist Party and Popular Front "pompiers," from abstractionists and surrealists to socialist realists. The left-wing pompiers' penchant for stylistic "extremes"—whether abstract or academic—was evidence of their societal factionalism, which privileged one class, the proletariat, over all others. In addition the writers for *Combat* accused the artistic allies of socialist realism and of the Popular Front of being opportunists who forfeited freedom of expression in the name of stylistic conventions that signified their party loyalty and class allegiances. By contrast *Combat*'s aesthetic program purportedly reconciled creative freedom with tradition to regenerate French culture for all classes, just as it merged Sorelian sublimity with Maurrassian order and discipline to bring about a national revolution. By this sleight of hand Maulnier and his allies claimed to defend freedom of expression even while they circumscribed "creativity" within the classicizing confines of a nascent fascism.

Maulnier set the stage for this campaign in an early essay titled "Inspiration et métier," which appeared in the April 1936 issue of *Revue universelle*. He argued that the truly creative artist could not help but respect tradition because the creative impulse itself entailed a desire for order, as manifest in the venerable rules governing an artist's particular métier. As a result the artificial opposition between "revolution or order, free play for the creator or severe discipline" could be transcended.[112] Classicism in the arts had achieved this synthesis—in this context Maulnier cited Charles Maurras and the poet Paul

Valéry as having plumbed "the authentic nature of poetic problems," but more surprisingly he upheld the Russian composer Igor Stravinsky as exemplary of this aesthetic ideal. Maulnier cited with approval Stravinsky's claim that order in art was a product of the creative act itself: rather than being something "imposed" from without, order was part of a work's "organic development," for "creation" was by definition an expression of "the need for order."[113] Classicism in the arts, asserted Maulnier, constituted "a will to impose regularity on the chaos of sensations and images" that gave birth to "style." Maulnier then pitted this classicizing impulse against its romantic counterpart, as exemplified by the surrealists. Like the romantics before them, the surrealists gave free rein to the senses, thus converting the artist into the "docile victim" of a sensory onslaught—both internal and external—that stretched "aesthetic creation to the limits of lunacy." This "cult of inspiration," untethered from all desire for order, converted the artist into "a sort of somnambulist" whose expressive powers were reduced to what the surrealist called "automatic writing."[114] On this basis Maulnier accused the surrealists of separating inspiration from craft, creativity from tradition, and in so doing precipitating a complete break with the art of the past. "For the classical writer, for the Renaissance painter," wrote Maulnier, inspiration and métier were integral: only eras of "technical decadence" could give rise to romanticism and its offspring, surrealism.[115] "Inspiration," we are told could only achieve its true value, "at the cost of a certain constraint" exemplified by the challenges posed by an artist's chosen medium. On the other hand, attention to métier to the exclusion of the creative imagination was equally dangerous: this orientation gave birth to the art of the "pseudo-classicists," whose slavish imitation of academic techniques was devoid of all inspiration. Maulnier also cited the use of machine tools and standardization in those areas of craft production previously reserved for artisans as yet another indicator of "technical decadence."[116] In the past, a piece of furniture was the physical embodiment of an artisanal tradition handed down through the centuries, but now "quantity" and "speed" of production had been given priority over quality and craft. Surrealism, machine-aesthetics, and academicism thus constituted an unholy trinity whose banishment required a palingenetic turn to classical precepts. The classical tradition for Maulnier was therefore antithetical to any slavish imitation of the past. As Maulnier put it in another essay, he categorically rejected tradition "if one

means by tradition the fear of change, the cult of history, the gaze toward the past of old men and declining civilizations." "In the history of civilizations," Maulnier asserts," tradition only expresses the continuity of life, it demands to be, without cease, surpassed."[117] In an essay published in the October 1936 issue of *Combat*, Maulnier condemned the Marxist doctrine of "proletarian culture" on similar grounds, arguing that the communists broke the palingenetic link between the classical past and contemporary civilization.[118] By designating the proletariat the arbiters of culture, the communists wanted to make the least educated and most disenfranchised group the catalyst for an artistic renaissance. In a reductive fashion French communists had dismissed France's "classical writers" such as Jean Racine as bourgeois, when in fact classicism should be regarded as the heritage of all French people rather than that of a single class. Maulnier noted that, under the Third Republic, this cultural legacy had been appropriated as a form of salon entertainment by the wealthy bourgeoisie: *Combat*'s aim was to restore that classical heritage to the people, so the French could regain their sense of "dignity."[119]

Jean Loisy brought Maulnier's thesis to bear on contemporary art in a major aesthetic statement for a special number of *Combat* titled "Points of Departure" (August–September 1936).[120] Loisy not only followed Maulnier in lauding Stravinsky, he praised Paul Cézanne and *Combat*'s favorite son, architect Auguste Perret, for joining Stravinsky in "a heroic battle to integrate modern discoveries into the classical tradition." Loisy claimed that artistic patronage under the Third Republic had fallen into disarray, for the art and architecture sponsored by the Republic had no sense of "grandeur" or "beauty"—traits native to the sublime power of classicism. Moreover, artists had themselves become increasingly isolated due to lack of the sort of large-scale commissions that brought together architects, sculptors, and painters. In recent years French art and classicism itself had encountered a new threat: the subordination of questions of style and subject matter to the dictates of leftist political ideology, whether manifest in extreme abstraction or the new "academicism" exemplified by socialist realism. This cultural "decline," which Loisy labeled both "political and moral in origin," arose when "certain critics" and "creators" had begun assessing aesthetic value solely in terms of a political agenda. Under such circumstances art is no more than "a department of the political and criticism becomes an administrative service." To underscore the anticlassical

and Popular Front inflection of such thinking, Loisy referred his readers to the literary criticism of communist sympathizer André Gide,[121] who reportedly condemned Racine—Maulnier's quintessential classicist—for producing "sentimental refinements" that failed to touch "the essential in man." Referring to the visual arts Loisy drew attention to a critic for the journal *Marianne* (1932–1940) who had dismissed the art of Camille Corot as "petit-bourgeois." Such reductionism—all in the name of the proletariat—also led to an art of extremes, wherein the classical synthesis of "innovation" and "tradition" was torn asunder. In the early stages of the Soviet Union, the desire to efface all cultural references to the bourgeois past had produced a state-sanctioned cult of the machine, and artists were told to "submit to the machine, to its imitation and its glorification." Stripped of all ornamentation or symbolism, "limited to the evocation of science," this "totally abstract art" was "extremely dry and inhumane." However, the "excess" of abstraction, indicative of the Soviet Union's "revolutionary period" had now given way to a new "tyranny"—the "academicism" of socialist realism. France faced a similar peril, for under the Popular Front artists who had previously embraced abstraction in the name "revolution" were now enthusiastic practitioners of socialist realism. On an ominous note Loisy claimed that the doctrinaire abstraction that characterized the new buildings on the rue Mallet-Stevens (1925–1927), "préparerait probablement la revanche du style du Cercle militaire" (fig. 64).

However, this dire situation could be overcome if artists and critics acknowledged that the best artists are "at the same time great traditionalists and great revolutionaries." Such artists had "assimilated the laws" governing the art of their predecessors, but also adapted these laws to their own creative impulses. "Their science obliges them to be traditionalists, their curiosity to be revolutionaries, for tradition alone produces academicism, and revolution alone, anarchy."[122] Among those contemporary artists who had integrated "modern discoveries into the classical tradition" Loisy singled out the architect Auguste Perret, the composer Igor Stravinsky, and their predecessor the painter Paul Cézanne. In an article published in November 1936, Loisy would claim that Cézanne's failure to produce large-scale allegorical or religious painting on the model of Giovanni Bellini or Titian was attributable to an inability to attract such commissions, for he lived "in a decadent civilization, in a decapitated society."[123] Nevertheless, the humble still-lifes of Cézanne attested

Fig. 64. Rue Mallet-Stevens, Paris, 1926. Reproduced in Léon Moussinac, *Mallet-Stevens* (Paris: Editions G. Grès, 1931).

to his "idealist" penchant for "order," "harmony," and "form," which meant that his paintings' compositional elements most resembled those of Poussin and the religious art of El Greco. Thus Loisy joined Maulnier in defining classicism as a palingenetic synthesis of aesthetic innovation and tradition, whose adversaries championed one extreme value in the equation to the exclusion of the other. The machine aesthetics of bolshevism in its "revolutionary" phase, and now the socialist realism promoted under the auspices of the Popular Front exemplified this bifurcation. Classicism on the other hand successfully united "tradition" and "revolution" in the arts, just as the ideological (and classicizing) tenets of Sorelian royalism joined regenerated elements among the bourgeoisie and proletariat. By contrast the cultural and political policies of the Soviet Union and Popular Front only resulted in artistic "decadence" and class sectarianism. "Classical violence" alone could aestheticize politics and politicize aesthetics for the benefit of the French nation as a whole.

Robert Brasillach added his own voice to the chorus in a damning assessment of Socialist Realism and the Association des Ecrivains et Artistes Révolutionnaires's Maison de la Culture movement,[124] published in the July 1936 is-

sue of *Combat*.[125] Titled "Les pompiers avec nous!" Brasillach's article outlined the damaging aesthetic consequences of the class-based factionalism pervasive among the artists and critics affiliated with the Left. Like his colleagues he pitted freedom of expression against the politically driven aesthetics of *Combat* adversaries, as if to claim that the classicizing formulae promoted by the *Combat* group was free of the taint of ideological bias and best facilitated the creative imagination. In an opening salvo he labeled artists allied with the Popular Front and the AEAR's movement of antifascist intellectuals "pompiers" who had embraced "the conformisms in fashion" to further their careers. Brasillach characterized the promoters of socialist realism as either inane fools or authoritarians: thus Louis Aragon is labeled one of the "Candides of French culture," while the socialist art critic and poet Jean Cassou is awarded the title of "artistic dictator" for the Popular Front. The newly founded Maison de la Culture is identified as "a bizarre institution" where these pompiers "exposed their doctrine to the world." The Maison de la Culture was guilty of giving Aragon and Cassou a public forum for their curtailment of artistic freedom. Brasillach accused both Aragon and Cassou of proclaiming "proletarian themes" to be the only valid subject matter in the arts, and realism the only style antithetical to bourgeois aesthetic taste. In truth, states Brasillach, these proponents of socialist realism are nothing more than apologists for the Popular Front, and thus for the capitalist system they claim to oppose. Their state-sanctioned "conformism" in matters of culture actively suppressed rather than promoted revolutionary esprit. Brasillach therefore felt justified in claiming to have found "more revolution in the apples of Cézanne than in the naturalist novels of Aragon."[126]

Loisy augmented Brasillach's attack on the Maison de la Culture in a series of articles published in the March, April, and May editions of *Insurgé*.[127] In an article published in March 1937, Loisy mocked the Popular Front and the Maison de la Culture for their attempts to define and promote "l'art populaire." In Loisy's opinion the Maison had only succeeded in conflating "popular art" with "propaganda" for the "comrades," as evidenced by the multimedia spectacles funded by the Confédération Générale du Travail and held at the Maison de la Culture.[128] In another article (May 1937) Loisy argued that this concept of "popular art" proved that the French communists had further facilitated the capitalist destruction of "art by the people" by proclaiming an "art for

the people."[129] Under the Third Republic "industry without soul and a state without spirit" had conspired to bring mass production methods and goods to formerly autonomous regions of France, with the result that the indigenous artisanal skills and folkways of rural France had all but disappeared. In the absence of folk culture French communists now wanted to inculcate the masses with a concept of popular art that was nothing more than a tool of propaganda. There was no better example of this than the multimedia spectacles at the Maison de la Culture, whose titles—Loisy cites "La révolution française" and "La conquête de la liberté"—betrayed their ideological didacticism.[130] Elsewhere Loisy applied the label "pompier" to those artists he deemed guilty of technical incompetence and/or uninspired imitation of past masters, thus evoking Maulnier's *Revue universelle* critique of "technical decadence" in the visual arts.[131] Loisy politicized the label by designating those who painted Ingres-derived pastiches "pompiers de droite" while using the term "pompiers de gauche" to refer to the tertiary imitators of Cézanne, Braque, and Picasso. Loisy deployed this formulation in a review of the exhibition Les Maîtres de l'Art Indépendant, held at the Petit Palais. Having initially praised the exhibition's organizers for having banished the "pompiers de droite" from the premises, he went on to criticize them for including the "pompiers de gauche"; namely "les pompiers de fauvisme ou du cubisme." Loisy also had little sympathy for those associated with the Peintres de la Réalité en France Poétique, claiming that artists such as Roland Oudot (fig. 62) lacked the proper training to emulate the achievements of past masters. Loisy attributed Oudot's technical incompetence to a postwar climate that had encouraged "fierce individualism" at the expense of any serious study of Europe's artistic heritage.[132] Without the proper balance between tradition and self-expression, art would continue to be a battleground between the pompiers de droite and pompiers de gauche—only a classical mentality as defined by *Combat* could overcome the impasse. To be "neither right nor left" had aesthetic as well as political significance.

Combat's Classicists: Despiau, Maillol, Perret

Over the course of 1937 the *Combat* group closed ranks in support of three artists who presumably fulfilled their classical ideals: sculptors Charles Despiau and Aristide Maillol and the architect Auguste Perret. In his May 1937 as-

sessment of the World's Fair published in *Insurgé*, Maulnier instructed foreign visitors to avoid the shoddily constructed pavilions cluttering the Champs de Mars; instead they were told to visit Parisian churches, the Louvre, and to study "the admirable works of Despiau and Maillol."[133] The following month *Insurgé* published an effusive review of the sculpture of Despiau and Maillol then on display at the Maîtres de l'Art Indépendant exhibition in the Petit Palais.[134] *Insurgé* identified these two artists as the unrivaled "masters" of contemporary sculpture, who were the torchbearers of a French tradition going back to "the stone cutters of Chartres or Reims," as well as the classicists "of our seventeenth century." *Insurgé*'s endorsement of Despiau and Maillol was a logical one given their critical status as quintessential French "traditionalists," whose sculpture was regularly celebrated as the latest link in an unbroken line going back to classical antiquity. Despiau, whose plaster bust *Paulette* of 1907 (fig. 21) had first established his reputation, rose to prominence during the 1920s, when he began receiving commissions for classical figures, culminating in a five-meter high statue of Apollo designed for the terrace of the Musée d'Art Moderne at the 1937 World's Fair (fig. 65).[135] Critics in France between the wars fabricated a "classical" pedigree for Despiau by drawing comparisons between his sculpture and the poetry of Jean Moréas—the founder, with Maurras, of the *école romane*—and claiming that his portrait busts rose above human particulars in a manner comparable to archaic Greek art. Writing in 1922, the critic Roger Marx could proclaim Despiau "the enemy of romanticism," whose sculpture was governed by "calm rhythms and stable lines" circumscribed "within a form that is pure and geometric."[136]

Maillol in turn constantly referred to his Mediterranean and Catalan roots to highlight the "natural" links between archaic Greece and his native region in southern France following his sojourn to Greece in 1908.[137] To Maillol's mind this lineage accounted for his predilection for casting contemporary Catalan models in the guise of classicizing monumental nudes with titles such as *The Mediterranean* (1905), *Torso of the Ile de France* (1921) or *The Three Nymphs* (1930–1938) (fig. 66). In his 1925 monograph on Maillol, Maurice Denis added to the myth, asserting that "Maillol constructs ingeniously, perhaps unconsciously, classical syntheses. . . . By birth, by race, he belongs to the French Midi; he comes to us from the shores of the Mediterranean whose blue depths gave birth to Aphrodite."[138] *Combat* contributor Claude Orland further em-

Fig. 65. Charles Despiau, *Apollo*, 1937–1946. Bronze. Musée Municipal de Mont-de-Marsan, France. © 2006 ARTISTS RIGHTS SOCIETY (ARS), NEW YORK/ ADAGAP, PARIS.

bellished the Maillol legend in an article devoted to the sculptor in the November 1937 issue of the journal.[139] Orland identified Despiau and Maillol as "the only true geniuses of contemporary art" by virtue of their artisanal attention to craft, which led Orland to compare Maillol to the father of the Félibrige movement, Frédéric Mistral (1830–1914), and to that defender of the "ancients," the seventeenth-century poet Jean de La Fontaine (1621–1695).[140] Orland lauded Maillol for having steeped himself in classical literature, as evidenced by his woodcuts for the writings of Homer and Virgil then on display at the Petit Palais. Indeed, if one were to compare Maillol to a "great contemporary," it would be Charles Maurras, for both were "Greeks of our Midi," and Maillol's veneration for "the korai of the Erechtheion" reportedly bore a striking resemblance to that of Maurras, who had made his own pilgrimage to the Acropolis decades earlier.[141]

The *Combat* group's praise of Maillol as a modern "classic" arguably found

affirmation in Maillol's own aesthetic precepts, as well as in a broader literature that singled Despiau and Maillol out as the two sculptors most representative of an indigenous French tradition. According to Maulnier, true classicism, by subjecting Dionysian energy to the discipline of Apollonian order, could create an art that reconciled sensual particularity with the classical ideal and wedded the artistic imagination to the same aesthetic principles that guided the ancient Greeks. This definition fit well with Maillol's own aims, for his preferred models were the peasant women of his native region, whose features he then generalized into timeless emblems of the classical.[142] For instance, in developing his *Three Nymphs*, Maillol worked from a single model, whose features were departicularized and used as a template for all three figures in the sculptural group. The overall effect is as if one were looking at three different views of a single woman, a clear allusion to the classical motif of the Three Graces. Indeed, this obvious reference accounts for the fact that the work was mistitled *Three Graces* when an unfinished plaster version was exhibited at the Exposition des Maîtres de l'Art Indépendant in 1937. As with so many of Maillol's works, *The Three Nymphs* was developed over an extended period of time, undergoing repeated transformations over the eight-year period from 1930 to 1938.[143] Contemporary critics described this process of constant refinement as indicative of Maillol's classical method, for, in the words of Maurice Denis, "the ideal in art is condensation" and Maillol, in taking up "the same themes and the same models incessantly . . . perfects them; he polishes them; he brings them ever closer to his ideal."[144] Dionysian fervor therefore yielded to Apollonian form as Maillol distilled images of timeless, classical beauty out of sensual particulars, exemplified by contemporary Catalan women native to southern France.

The status of Maillol and Despiau as outsiders to both the beaux-arts tradition and the more innovative branches of avant-garde art also fits in well with the *Combat* group's cultural politics. As we have seen Maulnier and his colleagues defined their classicism in opposition to the state-sanctioned art of the Ecole des Beaux-Arts, the socialist realism promoted by communists affiliated with the Popular Front, and radical abstraction. In fact this adversarial concept of classicism was not unique to Maulnier's circle, but instead part of a conservative vocabulary shared by critics who championed modern classicism in sculpture. As Patrick Elliott has noted, critics throughout the 1930s labeled

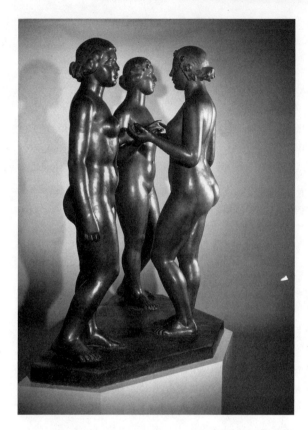

Fig. 66. Aristide Maillol, *The Three Nymphs*, 1930–1938. Lead, 158 × 146.5 × 79.5 in. Tate Gallery, London/Art Resource, N.Y. © 2006 ARTISTS RIGHTS SOCIETY (ARS), NEW YORK/ADAGAP, PARIS.

the classicizing work of Maillol and Despiau "independent sculpture" to indicate their liberation from the academic teaching of the Ecole des Beaux-Arts as well as their rejection of the avant-garde abstraction of cubist sculptors such as Jacques Lipchitz, Osip Zadkine, or Henri Laurens.[145] By the 1930s Despiau and Maillol had also become the favorites of xenophobic critics hostile to the École de Paris sculptors of Eastern European origin, even when the latter had adopted classicizing themes.[146] Thus at the 1937 World's Fair, where Despiau and Maillol were given pride of place in the Maîtres de l'Art Indépendant exhibit, the state's commissioning of Jacques Lipchitz's monumental statue *Prometheus Strangling a Vulture* was widely condemned as an affront to French classical taste and evidence of the Popular Front's predilection for bolshevism in the arts.[147] For politically conservative critics sympathetic to modernism, yet hostile to more abstract forms of avant-gardism, the antiacademic, yet self-consciously "indigenous" classicism of Maillol and Despiau proved highly at-

Fig. 67. Jacques Lipchitz, *Prometheus Strangling the Vulture*, 1937. Reproduced in *Le Figaro*, 17 October 1937.

tractive. The writers for *Combat* lent tacit support to this trend by declaring Despiau's and Maillol's work the embodiment of the French tradition without any mention of artists such as Osip Zadkine or Lipchitz, whose sculpture was also on view at the Petit Palais.

The third member of *Combat*'s classical entourage was Auguste Perret. Unlike Despiau and Maillol, Perret actually interacted with the *Combat* group: first by speaking at a conference devoted to "tradition and revolution" along with participants Bonnard, Gillouin, and Loisy in June 1936; then in lecturing alongside Maurice Denis at a January 1937 *Combat*-sponsored conference orchestrated by Bonnard and titled "The Upholding of Spirituality in Art." In January 1937 *Insurgé* launched its first issue with an illustrated article, "Exposition 1937: Paris n'aura pas d'acropole," devoted to the Republic's rejection of Perret's plans for the Palais de Chaillot, designed to replace the old Trocadéro (figs. 60–61).[148] Perret's architectural project was monumental: composed of four terraced museum buildings surrounding a vast open courtyard with a

panoramic view overlooking the Seine and the Champ de Mars, the structure was crowned by an open-air colonnade, conceived of as a sculpture museum. This colonnade was to be 625 feet long, and 98 feet wide, with columns 76 feet in height supporting a classical entablature. Just to the east of this central structure Perret planned to construct a semicircular theater modeled after classical precedents, with a seating capacity for ten thousand.[149] This classicizing structure was to be built out of reinforced concrete, the "signature" material that served to define Perret as an architectural pioneer. As I previously mentioned, Perret's initial plans for this Parisian "Acropolis" included sculpture by Despiau and Maillol as the traditionalist complement to his own aesthetic precepts. One can imagine the appeal this project had for the *Combat* group: Despiau, Maillol, and Perret were all aesthetic innovators steeped in the classical tradition, and the rejection of Perret's design purportedly testified to the Third Republic's cultural decadence. Maulnier launched the campaign in favor of Perret's Chaillot project in just those terms in a *Combat* article of April 1936, titled "Un régime, ennemi des arts"; over the course of 1937 Loisy joined the fray with a series of articles on the Paris World's Fair published in *Insurgé*.[150]

Such close contacts however, did not indicate the architect's strict allegiance to *Combat*'s ideological program. During the interwar years Perret advocated a theory of classicism that to his mind rose above the "contingencies" of a given era, including its factional cultural politics. As a result he was ready to participate in activities organized by the Popular Front as well as the radical right: for instance in 1936—the very year Maulnier claimed a "degenerate" Republic had killed Perret's Trocadéro project—Perret himself had joined the steering committee of the Association des Architects et Décorateurs de la Maison de la Culture.[151] On 25 June, 1936 Perret participated in a debate on "faith and revolution" held at the Maison de la Culture,[152] and late that year the Popular Front government chose Perret as architect for the Musée des Travaux Publics (1936–1948), in part as consolation for the failed Palais de Chaillot project.[153] However, such realities did not prevent the writers for *Combat* or their ideological counterparts in Fascist Italy from identifying Perret as one of their own. In Italy Perret's designs were celebrated by the doyen of fascist architects, Marcello Piacentini, while the founder of the Novecento movement, Marguerita Sarfatti, praised Perret for achieving the key aim of her

school: a successful fusion of the West's classical traditions with modernist innovation.[154] These connections were nurtured by Perret himself, who professed admiration for Mussolini's Italy following his participation in a Milanese conference, "The Formation of the Architect," in 1933. In his published reflections on this Italian sojourn, which appeared in the September 1933 issue of *Architecture d'aujourd'hui*, Perret drew a favorable comparison between Il Duce's interest in urbanism and that of the emperors who had built imperial Rome.[155] In 1936 Perret traveled to Milan again, this time for an exhibition of his own work at the Milanese Triennale.[156] Perret's interest in the "New Italy" continued unabated into early 1940, when he and the journalist Léandre Vaillat were commissioned by the French government to travel to Italy to assess the architecture built under Mussolini (the resulting manuscript, titled "Mussolini bâtisseur," was never published).[157]

The architect's own aesthetic theory proved especially conducive to the palingenetic definition of classicism promoted in *Combat*, for Perret claimed that his innovative use of reinforced concrete—a mid-nineteenth-century invention—signaled his avid embrace of the same architectural principles that had given birth to the Parthenon.[158] In a summary statement published in 1935, Perret outlined the precepts that guided his theory of classicism.[159] Perret argued that all buildings are governed by two kinds of conditions "some permanent, given by nature, others transitory, depending on human beings alone." Permanence encompassed "laws of stability, the nature of the material used, atmospheric variables" and what he termed "optical illusions," that is, perspectival axes and other site-specific criteria. Under the heading "Transitory Conditions" Perret included a building's "purpose, function, use" as well as ephemeral issues of "fashion." Perret's declared aim was to create buildings that embodied both conditions, but retained their sense of permanent value long after their original "purpose, function, use" had become obsolete. In his opinion "the most famous and most perfect example" meeting both criteria was the Parthenon, since the two categories had almost merged in an effort to fulfill the building's religious role. The architect's adherence to "natural and permanent conditions" had "given the structure its form and beauty": in the case of the Parthenon this resulted in "the slab or lintel system" of construction, which had originally been executed in wood. New "laws of stability," attuned to the materials in use were introduced with the invention of the vault.

In the east, vaulting reached perfection with the construction of Hagia Sofia; in the west Saint-Denis, Chartres, and the Sainte-Chapelle were the crowning achievements of that system of building. The introduction of iron in the eighteenth century had transformed buildings still further, but for Perret's generation the invention of "reinforced concrete" in France in 1849 had instituted new criteria with regard to the "permanent conditions" governing architecture. To Perret's mind reinforced concrete, through its use of wooden scaffolding, returned architecture to its classical roots, for the wooden frame "makes it resemble the architecture of the ancient world, in the sense that such architecture imitated building in timber, while reinforced concrete makes use of timber." Moreover, "repeated use of the straight line imposed by timber leads to a certain family resemblance." Thus the permanent "laws" governing reinforced concrete served to reinvigorate the classical tradition by instigating a rebirth of the "lintel" system's emphasis on the horizontal and vertical in architectural design. Perret's plans for the Palais de Chaillot—which used reinforced concrete in a classicizing design reminiscent of the "lintel" system—could be viewed as the very embodiment of these aesthetic aims.

This classicizing trend also governed Perret's conception of style, which to his mind should express a building's underlying structural properties, rather than serve as mere embellishment for its own sake. To back up this claim Perret cited Racine,[160] a literary choice that would have pleased Maulnier. "Style, states Racine, is thought expressed in the fewest possible words"; in a comparable spirit, a building's ornamental details should express its "load-bearing elements," just as its "cornices, string courses, jambs and mouldings" should serve to protect a façade "from the action of rain and dust." In this manner a building's "permanent conditions" could determine its stylistic elements, thus avoiding the pitfalls of excessive ornamentation and the ephemerality of fashion. Such choices would allow architects to create a sense of harmony, and "harmony is what the Greeks achieved by adapting perfectly to what is permanent: stability, atmospheric conditions, perspective, and so on." In using reinforced concrete "to meet permanent conditions," the architect "will make his work last, and will reconnect it to the past." Thus a revolution in the realm of architectural materials and adherence to tradition could be reconciled if contemporary architects remained true to the "permanent conditions" governing reinforced concrete, in emulation of the architectural precepts that had given birth to the Parthenon.

It was Jean Loisy who best assimilated Perret's ideas into *Combat's* agenda in his seminal essay "Art in Contemporary Society" (August–September 1936). In describing Perret as among those few artists embarked "on the heroic struggle to integrate modern discoveries into the classical tradition," Loisy quoted the architects' pronouncements on that "noble ideal," style: "Architecture obeys certain permanent laws that govern the stability and harmony of edifices. On the other hand the materials at the disposal of the architect vary with the location and the era, and the use of these materials is made following technical rules which are influential on the architecture. Finally the individual or group which commissions these buildings imposes a certain program on the architect corresponding to their needs, which vary according to the location, time period and purpose."[161] According to Loisy, Perret's adherence to architecture's "permanent laws" in the face of changing historical circumstances identified him as among the "traditionalists" by virtue of his attention to the work of past architects, and among the "revolutionaries" by virtue of his desire to experiment with new materials and other forms of innovation. The best artists were always "at the same time great traditionalists and great revolutionaries," and emulation of their example was particularly important "in times of trouble and change such as ours." The work of Perret, through its "magnificent reconciliation of the past and the present" was therefore exemplary of "a heroic battle to integrate modern discoveries into the classical tradition." Loisy and his colleagues fought this battle in the realm of politics *and* aesthetics, since they regarded these two spheres as integral. The classical violence that served to define the fascist mentality also governed the artistic imagination. Thus traditional and revolutionary impulses were joined in a single "heroic" endeavor, not only to transform art, but to overcome the decadence of a Republic riven by class strife and cultural decay.

Classical Violence, or the Freedom to Be Fascist

Combat's revolution encompassed three interrelated spheres: political institutions, human spirituality, and aesthetics. On the institutional front the group called for the replacement of parliamentary governance by an emerging version of fascism, modeled after the Cercle Proudhon's synthesis of Sorelian and Maurrassian precepts. Maulnier also claimed allegiance to the corporativism of Mussolini's Italy, but of a vastly improved sort, as defined by Spirito and La Tour du Pin. Before 1936 Maulnier not only admired Italian corporativ-

ism, he also shared the Maurrassian view that France should forge an alliance with Mussolini as a geopolitical counterweight to the rise of Nazi Germany.[162] Concurrently with Italy's invasion of Ethiopia in October 1935, Maulnier informed the readers of *Revue universelle* that the Italian Fascist "spirit of creation, of youth, of conquest" was a regenerative force for renewal that could counteract the "indolence and degeneration" that plagued Europe.[163] Maulnier thought that Franco-Italian corporativism, combined with this vitalist "spirit of conquest," was the institutional and metaphysical frame best able to unleash the creative potential of the individual, but that 'freedom' was defined as the "nebula of a kind of fascism" or fascism "without the name" that went under the rubric of classical violence. Classical violence amounted to an artistic quest for sublimity governed by a desire for the beauty entailed in order, and its origins resided in France, rather than in the fascism of foreign regimes. Evidence of those roots existed in the arena of French culture and well as politics: for instance Maulnier praised Racine for his classical synthesis of force and form, the aesthetic corollary to Dionysian energy and Apollonian order, while Andreu and Maulnier both looked to the Cercle Proudhon for a comparable merger in the ideological arena. Thus the Combat group fabricated a galvanizing myth of French fascism's European origins that reached beyond the Cercle Proudhon to the seventeenth century, and ultimately to classical Greece. In Maulnier and Loisy's opinion modern classicists such as Despiau, Maillol, and Perret carried on this project through their palingenetic fusion of radical innovation and tradition; for this reason the writers for *Combat* identified their art with the revolutionary spirit upheld by the Sorelian royalists of the Cercle Proudhon and of the *Combat* group itself. The classicism embraced by *Combat* obstensibly transcended the factional aesthetics of leftists associated with the Popular Front, whose endorsement of radical abstraction or of socialist realism served to exacerbate the very class divisions that continued to fragment the French body politic. Only the combined violence of an antidemocratic bourgeoisie and proletariat could heal the wound and overcome the cultural and political decay so rampant under the Third Republic. In 1936 Maulnier was ready to proclaim his revolution a kind of fascism that would safeguard individual freedom, even as it overthrew democratic ideology and its institutions. However, with the establishment of the Rome-Berlin axis in November, 1936, and Mussolini's visit to Germany in the fall of 1937, Maul-

nier was increasingly at pains to separate his homegrown ideology from the "collectivist" agenda upheld by foreign practitioners of fascism.[164] Thus when Maulnier called on France to embrace a "minimum fascism" in May of 1939 he did not define that option in terms of the classical violence so central to his own project, but instead as a "provisionary" measure designed to protect France from the specter of Nazi aggression, which had already resulted in the German annexation of Austria in March 1938 and the break up of Czechoslovakia in September 1938.[165] To counter that threat Maulnier counseled the nation to adopt fascist techniques to bolster the military and shore up French unity; however, such measures were meant not to prop up French democracy but to prepare France for the "advent of the new society,"[166] modeled after the *Combat* group's fascistic call for the resuscitation of classical violence.

Shortly before World War II *Combat* defended that agenda against an old adversary of the Cercle Proudhon: Julien Benda (fig. 29). In a March 1939 essay titled "Violence and Classicism" *Combat* contributors Laurent Cely and Jean-Serge Morel took issue with the definition of classicism developed in Benda's most celebrated book, *La trahison des clercs* (1927), and his related volume, *La fin de l'éternel* (1928).[167] In these texts Benda aligned classicism with a kind of intellectual detachment from worldly concerns, especially those he associated with "political passions." Race, class, and nation were all forms of political passion whose fundamental raison d'être resided in the material advantage or self-esteem of a particular group.[168] The morality stemming from political passions was "essentially military" since it amounted to a cult of conquest that marshaled human pride, courage, and aggression while advocating scorn for the rights of others.[169] Benda argued that the intelligentsia of every historical era should stand above such political contingencies in order to safeguard "the abstract quality of what is human" through rational reflection on universal human values, metaphysical concepts, and purely speculative modes of scientific inquiry.[170] By existing above the societal fray, the intelligentsia could be a restraining influence on "political passions," but if the "clercs" betrayed their mission by promoting these very passions, civilization itself would be overwhelmed by the barbarism of internecine warfare. Referring to his own era, Benda condemned the nationalist and class doctrines of the Action Française, Italian fascism, and Soviet bolshevism in just these terms. He also asserted that the rejection of rationalism and universal concepts by "particularists"

such as Bergson, Nietzsche, and Sorel served to justify advocates of "political passions," thereby accelerating Europe's rush toward the disasters of war and moral decadence.[171] Maurras, we are told, was in league with the latter group, for his authoritarian "classicism" was not classical at all, but instead celebrated the victory of Spartan militarism and Homeric virtues over the Athenian rationalism that was the bedrock of classic civil morality.[172] Benda even argued that Maurras's "classicism" was only the latest manifestation of a romanticism that valued feeling and an artistic sensibility over intellectual reflection, and worshiped force and grandeur at the expense of universal justice and democratic freedoms.[173] Classicism, by virtue of its rational and universalist underpinnings, was diametrically opposed to any doctrine expressive of "political passions" and their offspring, the cult of violence. Thus to conflate classicism and violence was to betray civilization itself: this was the "crime" of Maurras and Sorel.

Cely and Morel responded by asserting that "violence and enthusiasm" could not be detached from "intelligence," for to do so would either produce the romantic cult of unbridled passion, or Benda's own worship of "cold critical intelligence." "The classics, and it is this which differentiates them from various romantic maladies, place intelligence before the heart, but they do not exclude the latter."[174] By combining the "violence" of the creative imagination with the rigors of intellectual reflection the true classicist avoided the pitfall of Benda's "classicisme dégénéré," which drained the artistic process of all passion, and justified the resulting "dryness" by labeling it "pure spirit."[175] The allies of *Combat*, we are told, simply wanted to address "the entire man" through their synthesis of creativity, activism, and order, and once again Racine was cited as exemplary of the "classical ethics" they wished to promote.[176] By fusing the thought of Sorel and Maurras, their violence became beautiful, and their classicism a key myth in the war against a society in full-blown decay. The historical circumstances and ideological stakes that led to this attack on Benda differed dramatically from those that animated Edouard Berth in 1914, but the message was remarkably similar. Art was once again the central player in the call for an antidemocratic revolution.

CONCLUSION

Reflections on Violence

S orel's followers in France produced an extraordinary variety of fascisms, all of which were indebted to Sorelian precepts but bore a complex relation to the ideological program espoused by Sorel himself before, during, or after World War I. While these groups endorsed Sorel's instrumental approach to myth making, the myths themselves and their historical function differed dramatically. Between 1909 and 1939 Sorel and Berth's avant-guerre myth of the Jew as antiartist was displaced by Valois's post-war vision of la cité française, which in turn ceded to Lamour's machine aesthetics and the cult of youth, and then to the volte-face represented by Maulnier's myth of classical violence. Scholars have noted that the syndicalist Sorel originally valued myth for its ability to reinforce class consciousness, and with that, the revolutionary potential of the proletariat. However, once Sorel lost faith in syndicalism and sided with royalists and neo-Catholics, he and his col-

leagues thought the defense of culture itself could produce a new revolutionary constituency. In the pages of *L'Indépendance* (1911–1913) their image of culture was pitted against that mythic repository of societal and artistic decadence, the Jewish intellectual. This anti-Semitic project proved short-lived, and during World War I Sorel condemned the Catholic and royalist Right for participating in a plutocratic union sacrée that reduced violence to a form of barbarism. For Sorel, World War I had no mythic value, but for the royalist-turned-fascist Georges Valois, the Great War embodied a "spirit of victory" that augured the emergence of a new revolutionary community of wartime combatants, ready to take up the mantle of postwar producers. To focus their energies, Valois promulgated a myth of la cité française while studiously ignoring Sorel's own wartime and postwar prognoses on the subject. Instead Valois turned to three prewar sources for his notion of la cité: the concept of the citizen-soldier developed in Sorel's *Reflections on Violence*; the prospectus for the aborted *La Cité française* (1910); and the theory of class consciousness promoted in *Les Cahiers du Cercle Proudhon* (1912–1914). Although Valois fabricated a Sorelian genealogy for his movement, the Faisceau's mythic claim to the spiritual legacy of France's war dead was equally indebted to the secular religious rituals surrounding the cult of the fallen in Mussolini's Italy.

Valois's former ally Philippe Lamour found himself in a comparable situation when he founded the Parti Fasciste Révolutionnaire in 1928. As a junior member in Valois's Faisceau, Lamour was especially enamored of the Italian Fascist youth cult, and he performed radical surgery on Sorel's theory of class conflict by transforming Sorel's myth of syndicalist insurrection into an epic battle between his own generation and the gerontocracy governing interwar France. Pierre Andreu and Thierry Maulnier added yet another twist to our narrative by endorsing a myth of classical violence during the mid- to late 1930s. Their cultural program was modeled after the right-left synthesis forged by the Cercle Proudhon, but with a greater emphasis on the royalist rather than syndicalist dimension of that equation. For this reason the *Combat* group shared none of the procommunist sentiments extant in Lamour's Parti Fasciste Révolutionnaire, although they too hoped to unite the bourgeoisie and the proletariat in an antidemocratic alliance. In like fashion Valois's open warfare with Maurras had no equivalent in the cultural politics of *Combat*, which venerated Maurras as Sorel's equal in the fight against plutocracy.

Such divergences are particularly striking when we consider the key issue uniting these movements: their aestheticized theory of violence. In the pages of *L'Indépendance* Sorel and his colleagues conflated violent opposition to the state with the pathos of Aeschylean tragedy, Christian sacrifice, and a heroic defense of European civilization. This resulted in an aesthetic that drew parallels between the culture of classical Greece, the Catholic doctrine of vicarious suffering, and the tenets of a neomedieval version of symbolism as practiced by artists such as Maurice Denis, Ignacio Zuloaga, and Armand Point and stage-set designer Jean Variot. Sorel and his colleagues then deployed this aesthetic program against a mythic foe, the emancipated Jew, who came to symbolize the decadence of the Republic and the Enlightenment *tout court*. After World War I, changed historical circumstances caused Sorel's followers to subsume Sorelian violence within radically different mythic and cultural agendas. Georges Valois cloaked the violence of the Great War in the secular religious narrative of heroic sacrifice and martyrdom that culminated in a postwar "spirit of victory." He added a Catholic inflection to this equation by comparing the combatant's spiritual transformation to that of Joan of Arc, and even to that of the Virgin Mary as expressed in the Magnificat. The last remaining battle facing the fascist troops was the destruction of democracy itself and the creation of a new community defined in terms of the myth of the cité française. But in sharp contrast to Sorel, Valois's cité was constructed around the cult of the industrial producer, rather than the artisanal skills and symbolist aesthetics promoted in *L'Indépendance*. Valois endorsed the image of ultramodernism represented by Le Corbusier's technocratic Plan Voisin and the futurism of the Italian F. T. Marinetti. Le Corbusier's vision of the modern city therefore functioned as a mythic image meant to galvanize the fascist rank and file to forsake the past and orient themselves toward the postwar construction of a technological future.

Philippe Lamour retained Valois's enthusiasm for industrial production, but he replaced the Faisceau's spirit of victory with that of a generational revolt. Lamour thought Sorel's theory of violence the perfect expression of a new sensibility unleashed by the industrial revolution and embodied in the Italian Fascist cult of youth. Sorel's own literary method and the ethical violence he hoped to foment were declared the very incarnation of such youthful dynamism. Thus Lamour rejected Valois's faith in the combatants as the prin-

cipal revolutionary force, preferring instead to broaden his demographic constituency to encompass a younger generation of potential converts to fascism. When Lamour looked to contemporary society for mythic images adaptable to Sorel's theory of revolution, he conflated a future vision of an industrialized Europe organized by fascist producers with the machine aesthetics of the European avant-garde. In his book *Entretiens sous la tour Eiffel* Lamour intertwined images of syndicalist insurrection and of Fascist Italy with those expressive of the "dynamism" born of the industrial revolution. To Lamour's mind, montage techniques in film and photography, along with the technocratic architecture of Le Corbusier and Lurçat, constituted so many mythic images of this emerging machine age, equally expressive of the industrious and youthful energy native to the fascist sensibility. The dissemination of such machine aesthetics throughout society could therefore aid in the revolutionary process. As a result France would be reborn and enter into the Edenic state of fascist barbarism, heralded by the machine primitivism of the European avant-garde.

In the late 1930s Maulnier and the writers for *Combat* reimagined Sorelian violence in a manner that came closest to Sorel's own avant-guerre precepts. Like Sorel they declared ethical violence to be beautiful and an expression of the sublime, and they likewise turned to Greek tragedy and classical civilization to discover the regenerative wellsprings of European culture. However, the royalist roots of the *Combat* group resulted in fundamental differences. Whereas Sorel distanced himself from the national syndicalist synthesis forged by the Cercle Proudhon, the *Combat* group took up the mantle of the Cercle and that movement's major theoretician, Edouard Berth. On this basis they synthesized Maurras's attachment to beauty and order and Sorel's notion of the revolutionary sublime to create their doctrine of classical violence. For Andreu and Maulnier, the Cercle Proudhon itself took on mythic significance as the harbinger of an emerging fascism. The Cercle's revolt against the Third Republic constituted an epic moment in European history, when a revolutionary cadre possessed the same classical spirit that had once flourished in Homeric Greece. Ancient Greece and the Cercle Proudhon could therefore serve as sources of mythic inspiration for any future resurgence of classical violence under the auspices of *Combat*. Maulnier and his allies counseled artists to achieve the proper balance between innovation and tradition by em-

bracing this classical legacy, rather than succumbing to an aesthetics of extremes exemplified by the ultramodernism of the avant-garde during the early Soviet Union, or the doctrinaire academicism promoted under the rubric of socialist realism. This definition of classicism set *Combat*'s Sorelian program apart from the intransigent avant-gardism endorsed by the Faisceau and Lamour's *Grand'Route*. The "futurist" Faisceau identified Auguste Perret as an ally by virtue of his use of ferroconcrete, and Lamour's group praised Cézanne for having anticipated the rhythmic sensibility of the industrial age; by contrast the writers for *Combat* numbered Cézanne and Perret among those modernists whose art was steeped in the European tradition. A less pronounced, but equally definitive barrier separated Maulnier's cultural program from that promoted in Sorel's *L'Indépendance*. Whereas Sorel and his colleagues melded Greek tragedy, Catholic faith, and revolutionary consciousness into a cohesive ideology, Maulnier's group edited Catholicism out of their fascist equation. On the cultural front they avoided all references to medievalism or Catholicism, preferring instead to promote those modernists they deemed compatible with the classicism of ancient Greece and the literary precepts of Racine. Thus the Catholic-inflected aesthetics promoted by Sorel not did not fit under the rubric of classical violence. In addition the historical compass defining the *Combat* group's definition of tradition was much more restrictive. For instance, *L'Indépendance*'s categorization of sculptor Charles Despiau as the modern heir to the Renaissance primitives was replaced in *Combat* by a classicizing Despiau, who, along with Aristide Maillol, reportedly shared Maurras's enthusiasm for the culture of ancient Greece. This doctrinaire return to the French and classical roots of fascism was arguably a reaction to the collusion between Mussolini and Hitler that scarred the 1930s. Confronted with the Rome-Berlin axis, Maulnier was less able to cite the example of Fascist Italy when developing a definition of fascism suitable for his native France.

Another striking theme separating these groups was the temporal orientation guiding their theories of palingenetic ultranationalism. Sorel, Valois, Lamour, and Maulnier all declared their own era to be decadent and therefore in need of renewal, but their cultural solutions to the problem varied. The regenerative program posited by the alliance of Sorel, the royalists and Catholics associated with *L'Indépendance* was vast in scope, stretching back to include classical Greece, the religious art of medieval Europe and of the

Renaissance, and moving forward to the symbolist aesthetics of Sorel's own era. Maulnier's theory of classical violence was equally expansive, encompassing the art of ancient Greece, the classicism of the seventeenth century, and contemporary practitioners of classicism, whose aesthetic precepts were in line with those governing the architects of the Parthenon. In both instances the cultural signifiers endorsed by these movements were decidedly oriented toward a mythical past. The Faisceau and Lamour's circle, on the other hand, were resolutely futuristic in orientation. Both groups promoted mythic images of a technocratic future, and the regional syndicalist Lamour went so far as to posit a palingenetic return to Edenic origins, a new beginning that skipped over human history by positing an absolute break with all aspects of European civilization before the industrial revolution. Valois, by contrast, was plagued by a constituency within the Faisceau that disparaged his futurist endorsement of Le Corbusier's machine aesthetics, and clung to mythic images of an unchanging, rural France, exemplified by the "return to the soil" aesthetics of the former fauve Maurice Vlaminck. The chief promoter of the latter orientation was *Nouveau siècle*'s art critic, the royalist sympathizer Jean-Loup Forain. That Valois himself endorsed Le Corbusier as part of a broader shift from right to left within his movement is equally telling. Such evidence suggests that Sorelian fascists allied to the left-hand side of the political spectrum in France were more favorably disposed to an avant-gardism that celebrated machine technology at the expense of references to tradition. By contrast the Catholic and/or royalist leanings informing the ideology of *L'Indépendance*, the Cercle Proudhon, and the writers for *Combat* made for the endorsement of an avant-gardism responsive to tradition. Despite their claims to be neither right nor left, the political tensions within these Sorelian movements played themselves out in the sphere of mythic imagery.

However, despite these differences, there were at least two overarching themes that served to unite these groups. For one, palingenetic metaphors for the body politic permeated the discourse of the Sorelians from the pre-war era to 1939. Sorel and Berth set their theory of cultural regeneration against the emancipated Jew whom they pilloried as a mythic symbol of national decadence; Valois and Winter infused their fascist theory of urbanism with images of an ailing France and the hygienic benefits of their corporative vision; the dynamism of youth itself was the mythic motor driving Lamour's revolution

Fig. 68. "War is an element in the order ordained by God." Photograph and caption reproduced in Ernst Friedrich, *War against War!* (Seattle: The Red Comet Press, 1987), 73.

against a gerontocracy in full decline; while Maulnier and his colleagues declared their classicism a corollary for a mentally balanced and unified France, in contrast to the pathology and social fragmentation promoted by the Popular Front's allies among the surrealists and advocates of socialist realism. And above all else, these groups shared a common goal: nation renewal.

It was this faith in nationhood that separated the French Sorelians from those who employed images and the power of the general strike in the service of a radically different end: the renunciation of the myth of the nation itself. There is no better exemplar of the latter strategy than the anti-militarist Ernst Friedrich's multilingual book *War against War!*, first published in 1924. Friedrich's anarcho-pacifist manifesto combined word and image by juxtaposing World War I–era state propaganda, singing the praises of military heroism, with an unflinching photographic record of the grisly carnage inflicted on the battlefield as well as horrific images of the war's mutilated survivors. In contrast to the national revolution envisioned by Sorel's fascist acolytes, *War against War!* promoted an alternative image of the future: that of a global refusal to fight that would transcend international borders and instigate an

anticapitalist revolt against nation-states throughout Europe. Friedrich's campaign set out to reveal the truth of war in the hope that all images of aestheticized violence would be robbed of their effect, and that others would take up his pacifist convictions. By contrast, the Sorelians simply replaced one form of violence—that sanctioned by the Third Republic—with another, all the while declaring their violence creative, ethical, and aesthetic, and of the state brutal and brutalizing.

Thus the fascist revolution in France was a decidedly artistic affair, composed of mythic images of Catholic saints, technocratic cities, speeding automobiles, a modern "Acropolis," and classical Apollos and Venuses. The Sorelian fascists in France were studious in their avoidance of any references to actual violence; instead, the fascist war against democracy was cast in terms of aestheticized *representations* of violence. Sublimity, Aeschylean tragedy, martyrdom, the ethics of the producer, and the cult of youth all shrouded Sorelian violence in the comforting aura of the immemorial interests of European civilization. In this regard the French fascists were no different from their counterparts in Germany and Italy. That such fascist mythologizing had real-life consequences for those thousands of human beings on the wrong side of the regenerative ledger became abundantly clear when Nazi Germany and Fascist Italy invaded France in May and June of 1940. No amount of provisionary fascism or classical violence could stem the bloodshed that followed.

NOTES

Introduction

1. Owen's poem "Dulce et Decorum Est" can be found in Owen, *The War Poems*. Owen's poem, drafted in mid-October 1917, was conceived as a riposte to the recruiting verses of a Miss Jessie Pope, whose doggerel frequently appeared in the British right-wing press. For analyses of Owen's poem, see Owen, *The War Poems*, 24–26; and Hibberd, *Owen the Poet*, 114–116. Owen wrote the poem while he was convalescing at Craiglockhart War Hospital near Edinburgh. He was killed by machine-gun fire while attempting to cross the Sambre Canal on 4 November 1918.

2. Notable monographic studies of Sorel and his influence include Charzat, *Georges Sorel et la révolution au XXe siècle*; Guchet, *Georges Sorel, 1847–1922*; Horowitz, *Radicalism and the Revolt against Reason*; Jennings, *Georges Sorel*; Julliard and Sand, eds., *Georges Sorel et son temps*; Meisel, *The Genesis of Georges Sorel*; Roth, *The Cult of Violence*; Sand, *L'illusion du politique*; and Stanley, *The Sociology of Virtue*. The journal *Cahiers Georges Sorel* (1983–1988), now titled *Mil neuf cent: revue d'histoire intellectuelle* (1989–present) also contains valuable studies of Sorel and his legacy.

3. See Stanley, *The Sociology of Virtue*, for a comprehensive examination of Sorel's theory of morality.

4. Jennings, *Georges Sorel*, 36–55; and Stanley, "Sorel's Study of Vico."

5. See the chapter "The Decomposition of Marxism, 1897–1901" in Stanley, *The Sociology of Virtue*; and Sternhell et al., *The Birth of Fascist Ideology*, 36–91.

6. Jeremy Jennings cogently summarizes this phase of Sorel's development in Jennings, *Georges Sorel*, 116–142.

7. See, for example, the following analyses of this phase of Sorel's development: Guchet, *Georges Sorel, 1847–1922*, 191–226; Jennings, *Georges Sorel*, 143–159; Meisel, *The Genesis of Georges Sorel*, 203–215; Mazgaj, *The Action Française and Revolutionary*

Syndicalism, 96–127; Stanley, *The Sociology of Virtue*, 270–292; and chapters 8 and 9 in Sternhell, *La droite révolutionnaire*.

8. Sternhell's key publications are, in chronological order, *La droite révolutionnaire*; *Ni droite, ni gauche*, English ed., *Neither Right nor Left*; and (with Sznajder and Asheri) *Naissance de l'idéologie fasciste*, English ed., *The Birth of Fascist Ideology*.

9. Sternhell, "Fascist Ideology."

10. See Gentile, *Storia del partito fascista, 1919–1922*, 496.

11. I take issue here with Martin Jay's reading of aestheticized politics as derivative "from the *l'art pour l'art* tradition of differentiating a realm called art from those of other human pursuits, cognitive, religious, ethical, ecomomic, or whatever," which leads Jay to conclude that politics aestheticized "will be equally indifferent to such extra-artistic claims, having as its only criterion of value aesthetic worth." Jay, *Force Fields*, 72–73.

12. For Griffin's definition of fascism as a form of "palingenetic ultra-nationalism," permeated with Sorelian mythic structures, see Griffin, *The Nature of Fascism* 1994, 27–28 and 32–39. Griffin defines "palingenesis" as follows: "Etymologically, the term 'palingenesis', deriving from palin (again, anew) and genesis (creation, birth), refers to the sense of a new start or of regeneration after a phase of crisis or decline which can be associated just as much with mystical (for example the Second Coming) as secular realities (for example the New Germany)." Griffin employs it "as a generic term for the vision of a radically new beginning which follows a period of destruction or perceived dissolution." His term has been widely adopted as specifying a key concept of fascist ideology.

13. This argument is fully elaborated in Sternhell, *The Birth of Fascist Ideology*.

14. See Dasenbrock, "Paul de Man," 235.

15. See Gregor, *Young Mussolini and the Intellectual Origins of Fascism*.

16. Gregor, *Mussolini's Intellectuals*.

17. With few exceptions these assessments have been decidedly partisan, with some critics wishing to distance Sorel himself from any reactionary associations, while others are adamantly opposed to any suggestion that France possessed an indigenous fascism or that the French intelligentsia played a role in fascism's development. Advocates of the former position include critics of Sternhell associated with the journal *Cahiers Georges Sorel* (now *Mil neuf cent*), while the historiographical literature on France's supposed "immunity" to fascism has been cogently analyzed by Michel Dobry. See Dobry, "La thèse immunitaire face aux fascismes." For balanced overviews of the critical response to Sternhell's thesis, see Pinto, "Fascist Ideology Revisited: Zeev Sternhell and His Critics"; and Wohl, "French Fascism, Both Right and Left."

18. See Juillard, "Sur un fascisme imaginaire," in *Autonomie ouvrière*, 269–285. Robert Soucy has summarized much of the literature on the "Sternhell controversy" in his book outlining his version of French fascism in the 1930s. See Soucy, *French Fascism: The Second Wave*, 1–25.

19. Soucy, *French Fascism: The Second Wave*, 10.

20. This thesis is developed in an earlier volume devoted largely to the Faisceau: Soucy, *French Fascism: The First Wave*.

21. Ibid., xv–xvi.

22. Soucy numbers himself among the following scholars whom he identifies as claiming a right-wing genealogy for French fascism: William Sheriden Allen, Denis Mack Smith, S. William Halperin, Arno Mayer, Michael Kater, Charles Meier, John Weiss, William Irvine, Reinhard Kuhnl, Otto Bauer, and Jacques Juillard; they are in turn pitted against a list of proponents of the leftist reading of fascism that includes J. R. Talmon, Renzo de Felice, Eugen Weber, Ernst Nolte, René Remond, Philippe Machefer, Zeev Sternhell, Pierre Milza, Jean-Paul Brunet, Philippe Burin, Serge Bernstein, and Paul Mazgaj. See Robert Soucy, *French Fascism: The Second Wave*, 3. Soucy has examined the following movements in his two books: among the "first wave" of French fascists (1924–1933), Soucy numbers supporters of Antoine Rédier's Légion, the Jeunesses Patriotes headed by Pierre Taittinger, and Valois's Faisceau; the "second wave" (1933–1939) included the Solidarité Française, bankrolled by François Coty, Colonel de La Rocque's Croix de Feu movement, and Jacques Doriot's Parti Populaire Français.

23. See the chapter devoted to Valois's Faisceau in Sternhell, *Neither Right nor Left*.

24. For an analysis of Valois's differences with these industrialists, see Douglas, *From Fascism to Libertarian Communism*. Soucy, in *French Fascism: The First Wave*, concedes that Mathon clashed with Valois over his recruitment of leftists, and his rebuttal, in the name of corporativism, of Mathon's attempt to have "workers' unions directly under management's control"; however, he claims that Coty supported Valois because he "was less bothered by Valois's rhetoric than Mathon," the inference being that Valois's leftism was mere rhetoric, not to be taken seriously. See Soucy, *French Fascism: The First Wave*, 191.

25. See Paxton, "Radicals."

26. See the introduction to Milza, *Le fascisme français*.

27. Paxton, "Radicals," 52–53. Paxton upholds this view in his book *The Anatomy of Fascism*, arguing that "any assessment of fascism in France" should properly focus on Colonel de La Rocque's Croix du Feu or Henry Dorgères's Greenshirts, rather than on the ideological movements, journals, and intellectuals examined by Sternhell. See Paxton, *The Anatomy of Fascism*, 68–73; on Dorgère's movement, see Paxton, *Peasant Fascism in France*. In a related argument in *The Anatomy of Fascism* Paxton asserts that fascism most appealed to intellectuals "in its early stages . . . before its antibourgeois animus was compromised by the quest for power." He then argues—in contradistinction to Sternhell—that any attempt to define "fascism's intellectual and cultural origins" is no more than a quixotic "quest," for fascism's origins resided in little more than a cluster of ill-defined "mobilizing passions" (32–42). "Fascism" we are told "was an affair of the gut more than the brain" (42), which accounts in part for Paxton's core argument: "that what fascists *did* tells us at least as much as what

they *said*" (10). Paxton arguably goes to the extreme of characterizing fascist ideas as mere rhetorical slogans, designed to appeal to the inchoate discontents of the general populous (20).

28. The one exception in this regard is the Sorelian Hubert Lagardelle, founder of *Mouvement socialiste* (1899–1914), whose postwar doctrine of regionalist syndicalism had a profound impact on the architect Le Corbusier and the fascist ideologue Philippe Lamour when both were affiliated with the journal *Plans* (1931–1933). For valuable assessments of this aspect of Le Corbusier's theory and praxis, see McLeod, "Urbanism and Utopia"; McLeod, "Le Corbusier and Algiers," 53–85; and the chapter "Return to Man" in Golan, *Modernity and Nostalgia*. I will be drawing on the scholarship of McLeod and Golan in my own evaluation of Philippe Lamour's aesthetics. McLeod has also briefly examined Le Corbusier's involvement in Georges Valois's Faisceau (McLeod, "Urbanism and Utopia," 99–102). For an analysis of Lagardelle's regional syndicalism, see Levey, "The Sorelian Syndicalists."

29. See Kaplan, *Reproductions of Banality*; Lacroix, *De la beauté comme violence*; and Mehlman, *Legacies of Anti-Semitism in France*. Zeev Sternhell, in *Neither Right nor Left*, devotes a chapter to the "spiritualistic fascism" of Thierry Maulnier and writers associated with the journal *Combat*, including Drieu La Rochelle and Robert Brasillach. In the epilogue to *The Birth of Fascism*, Sternhell draws attention to the influence of Sorel on writers and artists such as the Italian futurist F. T. Marinetti, and English vorticists T. E. Hulme, and Wyndham Lewis, but he does not examine Sorel's artistic legacy in France. David Carroll has analyzed the literary fascism of Brasillach, Drieu La Rochelle, Louis-Ferdinand Céline, Lucien Rebatet, and Thierry Maulnier, with reference to those he identifies as "the fathers of French literary fascism": Maurice Barrès, Charles Péguy, and Charles Maurras. See Carroll, *French Literary Fascism*. Lacroix in turn has built on Carroll's work while seeking to integrate literary and political discourse through an examination of the shared aestheticized themes animating ideologues such as Mussolini and Jacques Doriot, and writers such as Drieu La Rochelle, Céline, and Brasillach. Mary Ann Frese Witt has added a new dimension to the discourse on French literary fascism by examining the impact of Maulnier's writings on Nietzsche and Racine on Drieu La Rochelle's *Le Chef* (1934), Brasillach's *Berenice* (1940), and wartime dramas by Henry de Montherland and Jean Anouilh. See Witt, *The Search for Modern Tragedy*.

30. Alice Kaplan has cogently touched on all these issues in her book *Reproductions of Banality*. In her chapter "Slogan-Text: Sorel" Kaplan notes that Sorel's political eclecticism meant that his followers across the political spectrum could claim allegiance to their own "version" of Sorel. Most important, Sorel's "Bergsonian" method—which exalted mythic images as the primary means of fomenting revolution—led his fascist followers in Italy and France to regard the "proper name" of Sorel himself as a galvanizing image. In addition these fascists were prepared to identify contemporary historical events as "images" full of the mythic potential to create converts to the fas-

cist cause. Kaplan cites Drieu La Rochelle's fictional description of the French riots of 6 February 1934 in his novel *Gilles* (1939) as one such mythic image. My own study builds on Kaplan's insights by examining the plurality of mythic images developed by Sorel and his fascist followers between 1909 and 1939.

31. See, for instance, Winock, *Nationalism, Anti-Semitism, and Fascism in France*, 197–205; and Charzat, "Sorel et le fascisme."

32. Griffin, *The Nature of Fascism*, 46–47, 93, 104, 110–111. Griffin employs the term "creative nihilism" to describe this paradigm.

33. Alice Kaplan has examined the "binding mechanism" native to fascist discourse in her book *Reproductions of Banality*; Barbara Spackman has drawn on Kaplan's model in her study Italian literary fascism, *Fascist Virilities*.

1. Fascism, Modernism, and Modernity

1. Barron, "1937." Barron's invaluable catalog includes essays by scholars in a variety of fields devoted to Nazi art and art policy. The catalog considers Nazis' responses to music, film, painting, and sculpture, as well as the imposition of Nazi policies and censorship on various state-sponsored cultural institutions, including precursors to the Entartete Kunst exhibition of 1937.

2. Barron, "1937," 12–13.

3. Grimm, "Emil Nolde."

4. Barron, "1937," 12. Goebbels, who held a doctorate in philosophy and literature, joined the German National Socialist Party (Nationalsozialistische Deutsche Arbeiterpartie) in 1924 and aided the self-proclaimed leftist Gregor Strasser in developing the party in the north. Goebbel's early cultural views were codified in his semiautobiographical novel *Michael: Diary of a German Destiny* (1931), which celebrated modern art, expressionism in particular, as the manifestation of a "Christian socialist" revival of the German people, who are diametrically opposed, we are told, to the "poisonous bacillus" of Judaism.

5. For a comprehensive survey of modernist art production in Italy under Mussolini (in power 1922–1943), see the essays by Philip Cannistraro, Joan Lukach, Enrico Crispolti, Emily Braun, Pia Vivarelli, and Luciano Caramel in Braun, ed., *Italian Art in the 20th Century*.

6. Heskett, "Modernism and Archaism in Design in the Third Reich," 127.

7. Hobsbawm, *Nations and Nationalism since 1780*; and H. Stuart Hughes, *Consciousness and Society*.

8. Birnbaum, "Catholic Identity, Universal Suffrage and 'Doctrines of Hatred.'"

9. Löwry and Sayre, "Figures of Romantic Anti-Capitalism."

10. Ibid., 55.

11. Löwry and Sayre, "Figures of Romantic Anti-Capitalism," 57–59.

12. According to Löwry and Sayre, what distinguished conservative or fascist proponents of romantic anticapitalism from progressive adherents was precisely the de-

gree to which their revolt was either past- or future-oriented. "Revolutionary and/or Utopian Romantics" such as Georg Lukács, Walter Benjamin, or Herbert Marcuse are said to reject "a pure and simple return to organic communities of the past" because they utilize precapitalist values "as a weapon in the struggle for the future." The "predominant" theme of "Fascist Romanticism" on the other hand "is hatred of the modern world and nostalgia for an organic community of the past," of which the prime example is the German Nazis' longing for "the old tribal and feudal Germany, for traditional peasant life in opposition to the big city." Although they acknowledge that fascist ideologies might contain "elements" that "are foreign or even hostile to Romanticism"—citing the example of Italian fascism's support of futurism—they nonetheless assert that the German Nazi vilification "of the modern world and nostalgia for an organic community of the past" is more typically fascist. See ibid., 56–57, 60–63, 69–72. In a revised version of this argument Sayre and Löwry modify their views to account for Jeffrey Herf's concept of "reactionary modernism," but they nevertheless continue to describe Nazi and Italian fascist references to the past as forms of "nostalgia." See Löwry and Sayre, *Romanticism against the Tide of Modernity*, 66–69.

13. See Herf, "Reactionary Modernism Reconsidered" and *Reactionary Modernism*. Herf's book considers the simultaneous embrace of "volkish ideology," "romantic irrationalist ideas," and "modern technology" on the part of such thinkers as Oswald Spengler, Ernst Jünger, and Carl Schmitt, Nazi ideologues Goebbels and Hitler, and an assortment of German engineers and professors of engineering concerned with the cultural ramifications of modern technology. In Herf's words, "The reactionary modernists were German nationalists who turned the revolt against capitalism and materialism away from backward-looking pastoralism. . . . They saw in technology a thing of beauty, a product of German creativity rather than of Jewish commercialism and internationalism, a phenomenon in tune with totalitarianism rather than with liberal democracy" (ibid., 134). Herf's research has conclusively refuted any simple association of the Nazis with a wholesale rejection of modernity; however, I agree with historian Roger Griffin that Herf does not sufficiently grasp the centrality of the myth of renewal to this "alternative" modernism in fascist ideology. See Griffin, *The Nature of Fascism*, 47.

14. See Jaskot, *The Architecture of Oppression*; and Barbara Lane, *Architecture and Politics in Germany, 1918–1945*. Lane refers to Hitler's speech, delivered at the annual Party Congress on 1 September 1933 and titled "German Art as the Proudest Justification of the German People." As Lane points out, the speech was made in reaction to the debate between Alfred Rosenberg and Goebbels over the value of modernism in art and architecture; as Lane demonstrates, Hitler sought a compromise between the two by endorsing modern technology and design in the realm of architecture while rejecting modern art. Of course the most horrific example of such thinking was the employment of rationalized bureaucratic systems to facilitate the Holocaust. See

Bauman, *Modernity and the Holocaust*. Jaskot's book is indicative of a new trend in fascist studies that focuses on the competition among various Nazi organizations for economic and cultural hegemony under the Third Reich as well as the "Nazification" of existing governmental institutions. Alan Steinweis has examined the latter subject in his comprehensive evaluation of the Reich Chamber of Culture (1933–1945) and its seminal role in the gradual Nazification of the arts in Germany; Marla Stone in turn has studied the complex evolution of state patronage in Fascist Italy. See Steinweis, *Art, Ideology, and Economics in Nazi Germany*; Stone, "The State as Patron" and *The Patron State*.

15. Gentile, "The Conquest of Modernity." Gentile's essay has been republished in an important collection of his essays: see Gentile, *The Struggle for Modernity*, 41–75.

16. Sternhell, ed., *The Intellectual Revolt against Liberal Democracy, 1870–1945*.

17. Sternhell, "Modernity and Its Enemies," 12.

18. Other important works by Griffin include *Fascism: Oxford Readers* and *International Fascism*. The former is an invaluable compilation of primary texts and critical analyses related to fascism as a global phenomenon; the latter book considers alternative definitions of fascism within the context of Griffin's own theoretical model.

19. Griffin, *The Nature of Fascism*, 26.

20. Sorel's *Reflections on Violence* first appeared in an abbreviated form in Italian in the Roman journal *Il divenire sociale*; it was then published as *Lo sciopero generale e la violenza* in 1906. This volume, combined with additional essays from the syndicalist journal *Le mouvement socialiste* and a new introduction, appeared in French under the title *Réflexions sur la violence* in 1908. For a survey of Sorel's myriad impact in France and Italy, see Roth, *The Cult of Violence*. For a cogent analysis of the reception of Sorelian thought across the political spectrum in Germany between the wars, see Gangl, "La force du mythe." Robert van Pelt has charted the assimilation of Sorel's concept of myth within the National Socialist understanding of mythos and its function in the Nazis' self-appointed role as the "bearers of culture" in the "uncivilized" East. See Van Pelt, "Bearers of Culture, Harbingers of Destruction."

21. Sorel, *Reflections on Violence*, 28; quoted in Griffin, *The Nature of Fascism*, 125. Unless stated otherwise, all translations are my own.

22. Sorel, *Reflections on Violence*, 127; quoted in Griffin, *The Nature of Fascism*, 28. Sorel relates his definition of myth as a "body of images" expressive of our faculty of "intuition" to Henri Bergson's theory of intuitive perception, defined by the latter as "empathetic consciousness," or a form of "instinct" that had become "disinterested." Bergson wished to stress the role of human will in this state of consciousness, which he related to our capacity for creative action and thought. For a succinct analysis of Bergson's impact on Sorel, see Vernon, *Commitment and Change*, 50–61.

23. Sorel, *Reflections on Violence*, 99; and *Réflexions sur la violence*, 130. The English translation uses the word "very fine" for Sorel's "très belle." I have substituted the word "beautiful," which is closer to the original French.

24. Sorel, *Reflections on Violence*, 111–112; and *Réflexions sur la violence*, 147.

25. Sorel, *Reflections on Violence*, 125; and *Réflexions sur la violence*, 165–166.

26. See Forgacs's important essay, "Fascism, Violence and Modernity."

27. Mussolini's statement is reported by his confidant Marguerita Sarfatti in her biography *Dux* (1928), and quoted in Forgacs, "Fascism, Violence and Modernity," 6.

28. Forgacs, "Fascism, Violence and Modernity," 11.

29. For a discussion of Sorel's notion of the producer and its impact on fascists in France and Italy, see Gregor, *Young Mussolini and the Intellectual Origins of Fascism*; Sternhell et al., *The Birth of Fascist Ideology*; and Antliff, "*La Cité française*." I discuss this theme at length in chapter 3 of this book.

30. As Griffin notes, by exalting heroic violence and military struggle as a core myth, fascism inevitably faced a crisis when it made the transformation from a self-declared revolutionary movement to a stable regime seeking to perpetuate itself. In this instance the need for social stability and order came in conflict with mythic signifiers premised on dynamism and change. One of the challenges facing fascists in Italy and Germany was reconciling these myths with reality once the "revolution" had been achieved and institutions identified with the old decadent order eliminated. The volatility of fascism's core myth accounts for what Griffin terms the "manic climate of 'permanent revolution'" and "Faustian restlessness" in Italian Fascists' and Nazis' simultaneous glorification of war abroad and never-ending search for sources of decadence internal to their geopolitical borders. See Griffin, *The Nature of Fascism*, 39–40.

31. For a concise statement of Zeev Sternhell's thesis, see Sternhell, "Fascist Ideology" and "The 'Anti-Materialist' Revision of Marxism as an Aspect of the Rise of Fascist Ideology." Sternhell demonstrates how, reproving the speculative and materialist capitalism of the international financier yet also rejecting the mechanistic foundations of Marxism, fascists such as Valois and Mussolini succeeded in uniting dissident antiparliamentarians from both left and right constituencies. The major difference separating Griffin from Sternhell is the latter's claim that Nazism differed fundamentally from fascism by virtue of its emphasis on racial theory; Griffin, on the other hand, sees racist eugenics as an aspect of its palingenetic or regenerative ultranationalist orientation.

32. On France, see Sternhell, *La droite révolutionnaire*, and *Neither Right nor Left*; on France and Italy see Sternhell, *The Birth of Fascist Ideology*.

33. For Sternhell's analysis of Sorel's disillusionment with syndicalism, his interest in royalism, and the syndicalist and monarchist groupings affiliated with *La Cité française*, *L'indépendance*, and *Cahiers du Cercle Proudhon*, see the final chapter in Sternhell's *La droite revolutionnaire*; the chapter titled "The Revolution of the Moralists" in his *Neither Right nor Left*; and the chapters "Georges Sorel and the Antimaterialist Revision of Marxism" and "Revolutionary Revisionism in France" in his *Birth of Fascist Ideology*.

34. Sternhell makes this argument in his introduction to *Neither Right nor Left*, 1–31.

35. "Pre-1914 fascism, like that of the interwar period, was the youngest, most non-conformist, and at the same time most unforeseeable ideology in the twentieth century. Because it rejected capitalism as well as Marxism, democracy as well as social democracy, and replaced them with national socialism, because it attacked all the weaknesses of the existing political and social system, because it aimed at destroying bourgeois culture, fascism had a strong fascination for large segments of a whole generation, and particularly for the young intellectuals searching for a solution to the crisis of liberalism." Sternhell, *Neither Right nor Left*, 215.

36. See Sternhell, *The Birth of Fascist Ideology*, 11, 131–140, 163–177, 233–258.

37. Günter Berghaus has analyzed the impact of anarchism and revolutionary syndicalism on Marinetti, the futurists' continued attraction to the syndicalist dimension of Sorelian politics after World War I, and the equivocation over fascism on the part of dissident factions in the futurist movement once Marinetti had publicly reconciled himself with Mussolini's regime after 1924. Such findings point to the important fact that anarchism, though equally opposed to Marxism and parliamentary politics, could serve as a leftist mode of resistance to fascism. See Berghaus, *Futurism and Politics*. For a scholarly challenge to Berghaus's reading of futurism's leftist opposition to fascism, see Claudio Fagio's insightful review of Berghaus's book in *Modernism/Modernity* (January 1997): 178–181. On the continued popularity of "Sorelismo" in both fascist and antifascist camps in Italy throughout the 1920s, see Roth, *The Cult of Violence*, 215–235.

38. Critical commentary on Sternhell's thesis has become something of a cottage industry and continues to the present day. Historian Robert Soucy has provided us with an extensive summary of the so-called Sternhell controversy in his book *French Fascism: The Second Wave, 1933–1939*, 1–25; and Robert Paxton has recently supplemented Soucy's account in his book *The Anatomy of Fascism*, 241–244; Matthew Affron and I have responded to Paxton, Soucy, and others in our own treatment of the issue in our introduction to Affron and Antliff, *Fascist Visions*, 3–9; and Michel Dobry has countered those among Sternhell's critics who claim that France was mysteriously "immune" to fascism in his important essay "La thèse immunitaire face aux fascismes."

39. Sternhell touches on this theme in the closing chapter of *The Birth of Fascist Ideology*. In that epilogue he cites the Italian futurists, the English vorticists T. E. Hulme and Ezra Pound, and French novelist Drieu la Rochelle as among those drawn to the reactionary dimension of Sorel's thinking. See Sternhell, "From Cultural Rebellion to Political Revolution," in *The Birth of Fascist Ideology*, 233–258.

40. Griffin, *The Nature of Fascism*, 32–33.

41. Griffin, "Nazi Art." The exhibition catalog in question is Hartley, ed., *The Romantic Spirit in German Art, 1790–1990*.

42. Griffin, "Nazi Art," 104.

43. Hinz, *Art in the Third Reich*, 108.

44. The integral relation of the Nazi theory of beauty and its degenerate antithesis has been cogently examined by historian George L Mosse. See Mosse, *Nationalism and Sexuality*; and Mosse, "Beauty without Sensuality/The Exhibition Entartete Kunst."

45. Ades et al., eds., *Art and Power*. Roger Griffin has noted this relation himself in a review of the exhibition. See Griffin, "Totalitarian Art and the Nemesis of Modernity."

46. Whyte, "National Socialism and Modernism." Whyte acknowledges the research of Werner Durth on modernist architecture under the Nazis as key to his own interpretation. See Durth, "Architektur und Stadtplanung im Dritten Reich."

47. Whyte, "National Socialism and Modernism," 258–263.

48. Ibid., 262.

49. Antliff, "*La Cité française*"; on Philippe Lamour's fascist aesthetic theory, see Antliff, "Machine Primitives." Revised and expanded versions of both essays appear as chapters 3 and 4 of this book.

50. Gentile, "The Conquest of Modernity," 74.

51. For analyses of Mussolini's plans for Rome see the section titled "Modernism and Fascism" in Etlin, *Modernism in Italian Architecture, 1890–1940*; and Benton, "Rome Reclaims Its Empire."

52. Benito Mussolini, "La nuova Roma" (25 December 1925), in *Opera Omnia di Benito Mussolini*, eds. E. and D. Susmel, vol. 20 (Florence, 1951–1963); quoted in Etlin, *Modernism in Italian Architecture, 1890–1940*, 392.

53. Benton, "Rome Reclaims Its Empire," 120–122.

54. Braun, *Mario Sironi and Italian Modernism*.

55. Ibid., 6.

56. Ibid., 188–190.

57. Ibid., 190.

58. See the chapter "The Urban Landscapes," in ibid., 44–67; and Braun, "Mario Sironi's Urban Landscapes."

59. Braun, *Mario Sironi and Italian Modernism*, 60–67.

60. Schnapp, *Staging Fascism*. The role of theater (and theatricality) in fascist cultural politics throughout Europe is the subject of a valuable anthology edited by Günther Berghaus. See Berghaus, ed., *Fascism and Theatre*. The volume contains an essay by Griffin that considers the palingenetic aspect of fascist theater and an important study by Emilio Gentile analyzing Italian fascist theater as a form of secular religion.

61. Hal Foster, "Forward: Mothertruckers," in Schnapp, *Staging Fascism*, xiii–xviii.

62. See Affron and Antliff, introduction *Fascist Visions*. For an overview of Benjamin's Marxist aesthetics, see Cohen, Pensky, and Weber, "Walter Benjamin."

63. As Russell Berman has noted, Benjamin argues that "the emancipatory potential of social modernization" is blocked by fascism, which "mobilizes aesthetic categories in order to impede the dissolution of traditional social order." Berman, *Modern Culture and Critical Theory*, 27–41.

64. Ibid., 38.

65. Ibid., 39.

66. Benjamin, "The Work of Art in the Age of Mechanical Reproduction," 254.

67. For a comprehensive study of French literary fascism that makes valuable use of Benjamin's thesis, see Carroll, *French Literary Fascism*.

68. See Jay, *Force Fields*, 71–83.

69. Historians should consult Christine Poggi's analyses of futurist collage, which relate that aesthetic to futurism's prewar and wartime political aims. See Poggi, *In Defiance of Painting*. More recently Alessandro Del Puppo and Poggi have drawn on the work of historians Walter Adamson and Zeev Sternhell in evaluations of the national syndicalist cultural politics of the journal *Lacerba* (1913–1915) and the art of its futurist contributors. See Del Puppo, *"Lacerba" 1913–1915*; and Poggi, *"Lacerba."*

70. Hewitt, *Fascist Modernism*, 134–135.

71. Ibid., 135.

72. Ibid., 137.

73. Ibid., 135–136.

74. Braun, *Mario Sironi and Italian Modernism*, 145–157.

75. Ibid., 153.

76. Ibid., 153–154.

77. Gentile, "The Myth of National Regeneration in Italy," 27.

78. Gentile's and Mosse's numerous publications have had a profound effect on the study of fascist cultural politics in Germany and Italy. See in particular Gentile, *Il culto del littorio*, translated as *The Sacralization of Politics*; as well as his *Fascismo e antifascismo*, *La Grande Italia*, *Le origini dell'ideologia fascista*, *Storia del partito fascista*, *Le religioni della politica*, *Storia del partito fascista*, and *Qu'est-ce que fascisme?* For an overview of Gentile's contribution to fascist studies, see the foreword by Stanley Payne in Gentile, *The Struggle for Modernity*, ix–xix; and Payne, "Emilio Gentile's Historical Analysis and Taxonomy of Political Religion." Gentile has recently clarified the distinction between his own anthropological approach to secular religion and that of Mosse. See Gentile, "Fascism, Totalitarianism and Political Religion." For Mosse see *The Crisis of German Ideology*, *The Fascist Revolution*, *Fallen Soldiers*, *Masses and Man*, *Nationalism and Sexuality*, and *The Nationalization of the Masses*.

79. See the chapter "The New Politics" in Mosse, *The Nationalization of the Masses*.

80. Mosse, *The Nationalization of the Masses*, 13–14.

81. Ibid., 7–8.

82. See the chapters "National Monuments" and "Public Festivals: Foundations and Development," in ibid.

83. Mosse, *The Nationalism of the Masses*, 70.

84. Ibid., 80.

85. Gentile, *The Sacralization of Politics in Fascist Italy*.

86. Gentile, "The Myth of National Regeneration," 28, 42–43.

87. Ibid., 28; and Gentile, *The Sacralization of Politics*, 3–9.

88. See the chapters "The Holy Militia" and "The Fatherland Dons the Black Shirt" in Gentile, *The Sacralization of Politics*.

89. For an analysis of Valois's Faisceau movement, see Douglas, *From Fascism to Libertarian Communism*.

90. Gentile, "Fascism as Political Religion."

91. Giuseppe Leonardi, "Siamo i superatori," *Il fascio* (2 April 1921); quoted in Gentile, *The Sacralization of Politics*, 21.

92. "For example," writes Gentile, "the blessing of the *gagliaretto*, which was the banner of the 'squads,' was initially adopted as a symbolic ritual of redemption of a community, brought back within the nation's faith" following the "liberation" of a district from the socialists. Gentile, "Fascism as Political Religion," 243; and Gentile, *The Sacralization of Politics*, 23–25.

93. Gentile, *The Sacralization of Politics*, 59.

94. New members were symbolically presented with a party card and rifle, calling to mind Mussolini's 1927 declaration that "the card is a symbol of our faith; the rifle is an instrument of our strength." Ibid., 64–66.

95. Gentile, "Fascism as Political Religion," 239; and Gentile, *The Sacralization of Politics*, 123–125.

96. Etlin, *Modernism in Italian Architecture*, 439–447; and Gentile, *The Sacralization of Politics*, 124–125.

97. Gentile, *The Sacralization of Politics*, 125.

98. Etlin, *Modernism in Italian Architecture*, 447.

99. For instance, see analyses of La Mostra della Rivoluzione Fascista by the following historians: Braun, *Mario Sironi*; Etlin, *Modernism in Italian Architecture*; Gentile, *The Sacralization of Politics*; Schnapp, "Epic Demonstrations"; Stone, *The Patron State*.

100. Braun, *Mario Sironi and Italian Modernism*, 147. Visitors passed under a building façade dominated by monumental fasces and entered a room devoted to the founding of Mussolini's paper *Il popolo d'Italia* (1914) and the start of World War I; subsequent rooms on the first floor documented the call by Mussolini and other nationalists for Italy's intervention in the Great War (1915), Italy's wartime efforts (1915–1918), and the period from the founding of the Fasci di Combattimento to the March on Rome (1919–1922).

101. Braun, *Mario Sironi and Italian Modernism*, 152.

102. Visser, "Fascist Doctrine and the Cult of the Romanità."

103. Schnapp, "Epic Demonstrations," 30.

104. Ibid., 25.

105. Gentile, *The Struggle for Modernity*, 109–124.

106. Adamson, *Avant-Garde Florence*. Adamson's theoretical approach to Florentine modernism and fascism is outlined in a number of important articles. See Adamson, "The Language of Opposition in Early Twentieth-Century Italy" and "Fascism and Culture."

107. Adamson, "Fascism and Culture," 423.

108. Adamson, *Avant-Garde Florence*, 18–27 and 94–101; and Adamson, "Soffici and the Religion of Art."

109. Ardengo Soffici, "Divagazioni sull'arte: le due prospettive," *La voce* (22 September 1910); see Adamson, "Soffici and the Religion of Art," 55–56.

110. Adamson, "Soffici and the Religion of Art," 48–49. On Cézanne's landscape imagery and its relation to conservative strands of Provençal regionalism, see Smith, "Joachim Gasquet, Virgil, and Cézanne's Landscape," 11–23.

111. Ardengo Soffici, "Religiosità e l'arte," *Il popolo d'Italia* (7 November 1922); and Ardengo Soffici, "Il fascismo e l'arte," *Gerarchia* (25 September 1922); both articles are discussed in Adamson, "Soffici and the Religion of Art," 61–63.

112. Adamson, "The Culture of Italian Fascism and the Fascist Crisis of Modernity"; and Braun, "Speaking Volumes."

113. Braun, "Speaking Volumes," 94–95.

114. Ibid., 96–98.

115. Ibid., 97–109.

116. Ibid., 98.

117. See Affron, "Waldemar George." Also see the chapter "Rusticizing the Modern," in Golan, *Modernity and Nostalgia*.

118. For a cogent analysis of this paradigm, see Mosse, "Beauty without Sensuality."

119. For an overview of these conflicting discourses, see Antliff and Leighten, "Primitive."

120. Berman, "German Primitivism/Primitive Germany."

121. This conflation also foregrounds the dual nature of Nolde's expressionism as "an emancipatory search for a greater range of experience and a regressive flight from the Enlightenment," which led him to uphold Nazism as a primitivizing alternative to the politics of bourgeois liberalism. See ibid., 60–65.

122. Alfred Rosenberg, quoted in ibid., 58.

123. For an overview of historical analyses of this dimension of fascist cultural politics, see the chapter "The Politics of Time and Modernity," in Antliff, *Inventing Bergson*, 168–184.

124. Harvey, *The Condition of Post-Modernity*. In part 3 of his book Harvey deals with the effect of the rise of capitalism on European conceptions of time and space from the eighteenth to the early twentieth centuries, 201–283.

125. Ibid., 228.

126. Ibid., 238–239.

127. Lukács, *History and Class Consciousness*, 88–90, quoted in Antliff, *Inventing Bergson*, 171–173.

128. In the sections of his book on Le Corbusier, Harvey does not discuss the architect's interest in Taylorism, though he does relate Le Corbusier's interest in corporativism to his alliance with the reactionary politics of Vichy France. See Harvey, *The Condition of Post-Modernity*, 21–23, 30–31, 34–36, 68–71, 115–116, 127–128, 271, and 282. For

an assessment of Le Corbusier's Taylorism, see McLeod, "'Architecture or Revolution.'"

129. Harvey, *The Condition of Post-Modernity*, 271.

130. Ibid., 273.

131. Ibid., 272.

132. Ibid.

133. For a study of Le Corbusier's corporativist period, see McLeod, "Le Corbusier and Algiers."

134. See Romy Golan's analysis of Le Corbusier's turn to organicist forms in his architecture and painting in the 1930s in *Modernity and Nostalgia*, 68–78.

135. Rabinbach, "The Aesthetics of Production in the Third Reich."

136. For a comprehensive analysis of Valois's corporativism, see Douglas, *From Fascism to Libertarian Communism*.

137. See Ghirardo, "Italian Architects and Fascist Politics," and *Building New Communities*; and Etlin, *Modernism in Italian Architecture*. Other valuable studies on the relation of fascism to architecture include Millon, "The Role of the History of Architecture in Fascist Italy," 53–59; Millon, "Some New Towns in Italy in the 1930's"; de Seta, *La cultura architettonica in Italia tra le due guerre*; Kostof, "The Emperor and the Duce"; Ciucci, *Gli architetti e il fascismo*; Doordan, *Building Modern Italy*; and Doordan, "The Political Content in Italian Architecture during the Fascist Era."

138. Etlin, *Modernism in Italian Architecture*, 256–258.

139. See Ghirardo, "Italian Architects and Fascist Politics," 122–126; and Etlin, "Le Corbusier, Choisy, and French Hellenism."

140. See Antliff, *Inventing Bergson*, 156–158, 169–170; Antliff, "The Jew as Anti-Artist"; and chapter 2 of this book.

141. Harvey, *The Condition of Post-Modernity*, 273.

142. Ibid., 209.

143. Weber, introduction to *The European Right*, 22–23.

144. Löwry and Sayre, "Figures of Romantic Anti-Capitalism," 58–59.

145. On anticapitalist anti-Semitism in France, see Birnbaum, *Le peuple et le gros*. "Les gros" was a term applied by such anti-Semites to a mythical group of international bankers whose mercantile speculation supposedly threatened the economic and political welfare of the French people.

146. On the Sorelian dimension of this discourse, see chapter 2 of the present volume; for an analysis of claims that the Jew lacked artistic capacities by virtue of pathological inadequacies, see Gilman, *The Jew's Body*; for studies of Hitler's self-fashioning as artist and its fundamental impact on his political vision, see Werckmeister, "Hitler as Artist"; and Eric Michaud's comprehensive analysis in *The Cult of Art in Nazi Germany*. Michel Lacroix has further nuanced Michaud's interpretation by noting the distinction made in fascist discourse between the fascist leader's protean role as the "sculptor" of the people, and as a poet able to regenerate the soul as well as the corporeal body of the nation. See Lacroix, *De la beauté comme violence*. Claims that

Jews were lacking in artistic ability were supplemented by the widely held belief that Judaism was hostile to the production of graven images, a myth that Kalman Bland has eloquently refuted in his book *The Artless Jew*.

147. Griffin, "The Fascist Quest to Regenerate Time."

148. Ibid., 15; Griffin refers to Walter Benjamin's "Theses on the Philosophy of History," in Benjamin, *Illuminations*, 252–253.

149. Griffin, "The Fascist Quest to Regenerate Time," 6. Here Griffin is drawing on the early scholarship of Herbert Schneider. See Schneider, *Making the Fascist State*.

150. Griffin, "The Fascist Quest to Regenerate Time," 8.

151. For a historical analysis of the generational cult of youth in France, Italy, and Germany, see Wohl, *The Generation of 1914*; for an essay devoted specifically to Italian fascism and the cult of youth, see Wanrooij, "The Rise and Fall of Italian Fascism as a Generational Revolt." For essays analyzing the aesthetic dimension of the youth cult as manifest in painting, sculpture, and advertising, see Malvano, "The Myth of Youth in Images"; and Michaud, "Soldiers of an Idea: Young People under the Third Reich."

152. See the chapter "Mussolini the Myth" in Falasca-Zamponi, *Fascist Spectacle*. Barbara Spackman and Andrew Hewitt have examined the fascist cult of virility and the heterosexual "crisis" provoked by fascism's homosocial and homosexual overtones. See Spackman's examination of such issues with reference to Gabriele D'Annunzio, Marinetti, and Mussolini, in *Fascist Virilities*; and Andrew Hewitt's study of subsequent critics of fascism (including Jean-Paul Sartre) in *Political Inversions*.

153. Griffin, "The Fascist Quest to Regenerate Time," 9. For a comprehensive analysis of fascist ritual politics in Verona, see the chapter "Colonizing Time: Rhythms of Fascist Ritual in Verona" in Berezin, *The Making of the Fascist Self*.

154. Griffin, in "The Fascist Quest to Regenerate Time," cites the following sources as especially important: Vondung, *Magie und Manipulation*; Goodrick-Clarke, *The Occult Roots of Nazism*; Theweleit, *Male Fantasies*; and Schulte-Sass, *Entertaining the Third Reich*.

155. This volume originally appeared in French as Michaud, *Un art de l'éternité*; also see Michaud, "National Socialist Architecture as an Acceleration of Time."

156. Michaud, *Un art de l'éternité*, 288–292; Michaud, *The Cult of Art in Nazi Germany*, 182–186.

157. Michaud, *Un art de l'éternité*, 292–303; Michaud, *The Cult of Art in Nazi Germany*, 186–195.

158. Michaud, *Un art de l'éternité*, 297–306; Michaud, *The Cult of Art in Nazi Germany*, 195–204.

159. See Michaud's analysis of works by Picco-Rückert, Winckler, and Straeger in *Un art de l'éternité*, 306–312; Michaud, *The Cult of Art in Nazi Germany*, 198–201.

160. Michaud, *Un art de l'éternité*, 312–315; Michaud, *The Cult of Art in Nazi Germany*, 199–200.

161. Scobie, *Hitler's State Architecture*.

162. Albert Speer, *Inside the Third Reich* (New York: Macmillan, 1970), 56; cited in Michaud, "National Socialist Architecture as an Acceleration of Time," 229. For a succinct analysis of this theory, see Scobie, *Hitler's State Architecture*, 93–96.

163. Michaud, *Un art de l'éternité*, 329–332; and Michaud, "National Socialist Architecture as an Acceleration of Time," 227–228. Kreis had previously designed the so-called Bismarck Towers, honoring the chancellor who had brought about German unity. Kreis erected five hundred such towers between 1900 and 1910, modeled after the classical tomb of the eastern Gothic king Theodoric the Great (ca. 454–526) at Ravenna (a ruler whom the Germans regarded as a national hero) or the Pantheon in Rome. See Mosse, *The Nationalization of the Masses*, 36–38.

164. Wilhelm Kreis, quoted in Michaud, "National Socialist Architecture as an Acceleration of Time," 227.

165. Ibid., 232.

166. Affron, "Waldemar George"; on Guilbeaux, see Goldberg, "From Whiteman to Mussolini."

167. On Lamour's postfascist promotion of Le Corbusier and regional syndicalism in the journal *Plans* (1931–1933), see McLeod, "Urbanism and Utopia"; and Golan, *Modernity and Nostalgia*, 76–78.

168. See Douglas, *From Fascism to Libertarian Communism*. Valois succumbed to a typhus epidemic at the Bergen-Belsen concentration camp in January 1945.

169. On the etymological and multivalent significance of the sublime, see Girons, "The Sublime from Longinus to Montesquieu."

170. See Iain Boyd Whyte, "Sublime," in Hartley, ed., *The Romantic Spirit in German Art, 1790–1990*, 138–146.

171. Adolf Hitler, *Mein Kampf* (1940); quoted in Michaud, *The Cult of Art in Nazi Germany*, 39–41.

172. Iain Boyd Whyte's conclusions serve as an important reminder to those who would restrict notions of sublime creativity to the fascist elite, while confining the masses to the role of sculptural clay or inert stone, to be molded or shaped by an all-powerful leader. Such an extreme bifurcation is posited by Falasca-Zamponi, who claims that Mussolini took on the role of "sublime," "God-like-creator" while subjecting Italian citizens to "depersonalization" and "deindividualization." In his role as "artist-politician," Mussolini could only identify "the 'masses' with dead matter, a block of marble to be shaped." See Falasca-Zamponi, *Fascist Spectacle*, 11–13.

173. See Sorel, *Reflections on Violence*, 243–251, 295.

174. For instance, Falasca-Zamponi in her book *Fascist Spectacle* has identified all aspects of fascist myth-making, including Sorelian myths, with Guy Debord's notion of a "society of the spectacle." By contrast, Emily Braun has developed a more complex approach to this issue by associating Sorel's myth of revolutionary violence with fascism's insurrectional beginnings, as encapsulated in Sironi's series Urban Landscapes (1919–1920). When she does refer to Debord it is with reference to the mon-

tage techniques employed in the Mostra della Rivoluzione Fascista (1932). Braun relates the impact of montage on the public to the "one-way direction of communication" that typifies Debord's spectacle, thus separating the fascist use of montage from the emancipatory associations Walter Benjamin attributed to that medium. Having questioned whether montage could indeed have any emancipatory effect, she categorically denies that fascist montage could ever elicit such a "participatory" reaction and instead claims that collage, in fascist hands, is evidence of the "potentially totalitarian powers of the media." This is a subtle argument, but I think Braun is too absolute in her disallowal of any ambivalence in the potential function of fascist montage as both "transformative" and "awe-inspiring." See Braun, *Mario Sironi and Italian Modernism*, 152–157; and Debord, *Society of the Spectacle*.

2. The Jew as Anti-Artist

1. See for instance, Jennings, *Georges Sorel*; Mazgaj, *The Action Française and Revolutionary Syndicalism*; Roth, *The Cult of Violence*; Sternhell, *The Birth of Fascist Ideology*; Sternhell, *La droite révolutionaire*.

2. While acknowledging Sorel's lifelong interest in art, historians have tended to focus on Sorel's writings before 1909, to emphasize those aspects of his aesthetic views most amenable to socialism and syndicalism. Sorel's Proudhonian claim that art should serve a moral function, that industrial production potentially contained an artistic dimension, and that the artisanal guilds of the Gothic era had a modern-day counterpart in syndicalism, has received the most attention. See, for instance, Jennings, *Georges Sorel*, 112–114; and Rebérioux, "Sorel et la valeur sociale de l'art." Most authors who have considered Sorel's comments and writings on art after 1909 have chronicled his interests without examining the paradigmatic relation of his theory of culture to his evolving theory of revolution and newfound interest in nationalism. It is this dimension of Sorel's thought that I will be exploring here. For brief, but valuable references to Sorel's views on art and culture after 1909, see Andreu, *Georges Sorel*, 227–236; Jennings, *Georges Sorel*, 112–115; and Meisel, *The Genesis of Georges Sorel*, 175–202.

3. See Sorel, *Les illusions du progrès*; and Sorel, *Réflexions sur la violence*. When referring to the English translations of Sorel's books I will use the English title in the endnote; when appropriate I will also include the original French.

4. Sorel's interest in the mythic dimension of religious belief was accompanied by an ongoing critique of the Catholic Church as an institution. For instance, Sorel valued the "pessimistic" Christianity of Jansenism, Pascal's endorsement of mystical belief, and that thinker's related critique of Descartes as a curative to the materialist opulence of Catholicism, particularly the Jesuit order. Sorel claimed that religious asceticism and a mystical impulse akin to that of Jansenism were key elements in the avant-guerre Catholic revival among the French. For a summary of Sorel's views on Jansenism, mysticism, and the Catholic Church, see Eastwood, *The Revival of Pas-*

cal; and Jennings, *Georges Sorel*, 83–112; on Sorel's associations with advocates of "national syndicalism," most notably Georges Valois and Edouard Berth, see Mazgaj, *The Action Française and Revolutionary Syndicalism*, 96–127; Sternhell, *La droite révolutionnaire*, 348–400; and Sternhell, *Neither Right nor Left*, 66–89.

5. In emphasizing the theoretical continuity uniting Sorel's syndicalist and nationalist phases I am following the interpretation of Jeremy Jennings, who has likewise noted the influence of Sorel's earlier theories on his nationalist writings. Thus Sorel could interpret the *Cité française* project as a continuation of work undertaken in his *Illusions of Progress* (1908), while his belief that the revival of Christian mysticism could result in moral regeneration dated to his syndicalist years. Religious faith, therefore, could function as a "myth" in the Sorelian sense. See Jennings, *Georges Sorel*, 107–112, 121, 138–139, 154.

6. Variot's literary career began in earnest with the creation of *L'Indépendance* (1911–1913); concurrently he designed stage sets for Paul Claudel's *L'Annonce faite à Marie* (The Tidings Brought to Mary) in 1912 (in 1923 he designed stage sets for Francis Jammes's *Brebis egarée* [The Lost Sheep]). From 1914 onward Variot published books on Alsatian folklore (his mother hailed from Alsace) and literary luminaries and wrote novels and plays. Variot served during World War I and was awarded a Croix de Guerre; after the war he took up editorial duties while remaining close to Maurras. By the 1930s he had become a fascist sympathizer, and in 1934 he began publishing regularly in *Je suis partout* (1930–1944), a fascist-leaning offshoot of Maurras's Action Française. In 1935 he published his memoirs related to Sorel, titled *Propos de Sorel*. During World War II he was a radio broadcaster and contributor to the collaborationist journal *Aujourd'hui* (1940–1944); after the liberation of France, Variot was formally censored by the French state. In 1950 he resuscitated his literary career, chiefly as a theater critic. For a summation of Variot's career, see Dioudonnat, *Les 700 rédacteurs de Je suis partout, 1930–1944*, 89; and Roman, "*L'Indépendance*," 173–174 n. 2.

7. Georges Valois had a tumultuous political career, during which he claimed to remain true to Sorel's legacy. Before 1914 Valois was instrumental in the formation of Sorelian royalist factions affiliated with the journals *Revue critique des idées et des livres* and *Cahiers du Cercle Proudhon*. For biographical information on Valois, see Rees, *Biographical Dictionary of the Extreme Right since 1890*, 399–400; and Douglas, *From Fascism to Libertarian Communism*. The cultural politics of Valois's Faisceau movement is the subject of chapter 3.

8. Valois's "Enquête sur la monarchie et la classe ouvrière" lasted from April 1908 to spring of 1909; it was later published as *La monarchie et la classe ouvrière*. For an analysis of the enquête, see Roth, *The Cult of Violence*, 88–89; and Mazgaj, *The Action Française and Revolutionary Syndicalism*, 76–79.

9. Valois, "Enquête sur la monarchie et la classe ouvrière," 145.

10. This argument is made by Roth. Sorel's essay, which had originally appeared in the

Italian journal *Le divenire sociale* (16 November 1907), appears in French as "Modernisme dans religion et dans le socialisme," 177–204. For a discussion of the Italian text and its French republication, see Roth, *The Cult of Violence*, 37, 89.

11. Variot, *Propos de Georges Sorel*. Variot's text has been the subject of debate as to its validity, chiefly due to Variot's attribution to Sorel of remarks that seemed to present Lenin and Mussolini as the chief purveyors of Sorelian myths after 1918 (ibid., 47–86). Variot addressed the issue of authenticity himself by stating that he had taken notes while Sorel spoke and then showed them to Sorel for his corrections and additions. The only section that Sorel reportedly did not evaluate was that "Sur Lenin," which contained comments made in 1922 (ibid., 66–86). According to Variot Sorel had requested that his statements only be published ten years after his death, which presumably accounted for the publication delay. Historians James Meisel, Paul Mazgaj, and Jack Roth have noted that, as a prewar royalist and later as a fascist sympathizer, Variot was hardly a disinterested party; however, they also add that Sorel's comments during the *Indépendance* era, as recorded by Variot, bear close resemblance to Sorel's published views at the time. Jeremy Jennings has also made judicious use of Variot's text, noting that the sense of detachment Variot attributed to Sorel was utterly compatible with Sorel's "pluralism" and tendency to equivocate (Jennings, *Georges Sorel*, 1–15). By contrast Shlomo Sand has dismissed the whole of Variot's book on the basis that Variot was alone in recording Sorel's supposed endorsement of Italian fascism and that Sorel's statements with other correspondents, and the memoirs of others in his circle, registered his negative response to Mussolini's movement. Sand also points to Variot's two mistaken references to Sorel's death date in *Propos de Sorel*, while ignoring any references in the book to Sorel's actual death date (e.g., *Propos de Sorel*, 66 n. 2). In my opinion, John Stanley has come closest to resolving the debate over Variot's representation of Sorel's reaction to Mussolini and Italian fascism. Stanley notes that Sorel's apparent inclination to "sympathize" with fascism amounted to a preliminary method of analysis that eventually enabled him to "criticize his subjects from within rather than from without." In the case of fascism, Sorel did not live long enough to move from a sympathetic stance to a critical conclusion. See Stanley, *The Sociology of Virtue*, 293–309. As I indicate in this chapter, Sorel's thought underwent a similar transition with regard to the mythic (and regenerative) potential of the versions of classicism, neo-Catholicism, and anti-Semitism developed in *L'Indépendance*. However I would argue that, for a time, Sorel fully endorsed the program mounted in *L'Indépendance*, which accounts for the theoretical continuity between his published essays in that journal and his prewar statements as recorded in Variot's *Propos de Sorel*. For representative arguments in favor of Variot's text, see Mazgaj, *The Action Française and Revolutionary Syndicalism*, 113–127; Meisel, *The Genesis of Georges Sorel*, 166–169; and Roth, *The Cult of Violence*, 87–92, 302 n. 23. For arguments against the validity of Variot's book, see in particular Sand, *L'illusion du politique*, 15–17, 21, 229 n. 40, 231 n. 68; and Sand,

"Legend, Myth, and Fascism," 51–65. Authors who argue for Sorel's impact on Mussolini and on Italian fascism include Gregor, *Young Mussolini and the Intellectual Origins of Fascism*; Roth, *The Cult of Violence*, 180–211; and Sternhell, *The Birth of Fascist Ideology*, 195–232.

12. Sorel's letters to Croce were published in issues of *La critica, rivista di letteratura, storia, e filosofia* between 1927 and 1930. For a summary of the Maurrasian-related correspondence, see Andreasi, "Il nazionalismo nelle lettere di Sorel a Benedetto Croce," 155–158. Sorel's 6 July 1909 letter to Maurras is reproduced in Andreu, *Notre maître, Georges Sorel*, 61, and cited in Stanley, *The Sociology of Virtue*, 272.

13. Sorel, "Socialistes antiparliamentaires."

14. Gilbert, "Une conversation avec M. Georges Sorel."

15. Sorel, "Le réveil de l'âme française." Sorel's article is analyzed in Roth, *The Cult of Violence*, 94–95; and Stanley, *The Sociology of Virtue*, 275–278.

16. Sorel, "Le réveil de l'âme française," 1–2, cited in Stanley, *The Sociology of Virtue*, 278.

17. See Stanley, *The Sociology of Virtue*, 278; and Vincent, "Citizenship, Tradition, and Antipolitics in the Thought of Georges Sorel," 7–16.

18. Stanley, *The Sociology of Virtue*, 278–279; and Steven Vincent's discussion of Péguy's impact on Sorel in "Citizenship, Tradition and Antipolitics," 12–13. Stanley cites Sorel's article on patriotism published in *Resto del Carlino* (28 September 1910), in which Sorel notes the ambiguity of Péguy's notion of mystique when compared to Sorel's own antirationist concept of myth. "Very often we define mystique as a mental illusion which makes us mistake an image or an abstraction for a reality; mystique thus understood is almost mystification; and this is exactly what sustains the friends of Maurras." As Stanley succinctly puts it, Sorel now thought that royalist mystique "was not immune" from degenerating into the realm of politique. See Sorel, "Le patriotisme actuel en France," cited in Stanley, *The Sociology of Virtue*, 278–279.

19. For detailed studies of the *Cité française* project, see Mazgaj, *The Action Française and Revolutionary Syndicalism*, 113–127; Roth, *The Cult of Violence*, 95–100; and Sternhell, *The Birth of Fascist Ideology*, 83–91.

20. For an analysis of the journal's prospectus, see Roth, *The Cult of Violence*, 97; and Sternhell, *The Birth of Fascist Ideology*, 83–84. I will discuss *La Cité française* in the context of Valois's theory of urbanism in chapter 3.

21. For a summary of the reaction of the republican Péguy, the syndicalist Lagardelle, and others in their circle, see Roth, *The Cult of Violence*, 97–100.

22. On the history of the Cercle Proudhon and their *Cahiers*, see Mazgaj, *The Action Française and Revolutionary Syndicalism*, 170–193; Roth, *The Cult of Violence*, 120–127; Sternhell, *La droite révolutionnaire*, 391–400; and Sternhell, *The Birth of Fascist Ideology*, 86–91.

23. Georges Sorel, preface to Berth, *Les Méfaits des intellectuels*, i–xxxviii. Sorel's preface took the form of a letter written to Berth and dated "January, 1914." Sorel's preface en-

dorsed Berth's philosophical allegiance to Bergson, Pascal, and Sorel's own notion of mythic regeneration, but it carefully avoided any mention of Maurras, or of Berth's own merger of Maurras and Sorel under the banner of royalist syndicalism.

24. Berth et al., "Déclaration," 1–2; quoted in Mazgaj, *The Action Française and Revolutionary Syndicalism*, 175–176.

25. "*L'indépendance* ne sera pas l'instrument d'un parti politique ou d'un groupement littéraire. Toutes les périodes de l'Histoire ont eu leurs erreurs. Si cependant la France a pu nous transmettre, en l'enrichissant, l'héritage classique de la Grèce et de Rome, c'est que, durant plusieurs siècles, ses penseurs, ses poètes, tous ses artistes se sont gardés de confondre le désorde avec la liberté, l'originalité avec le manque de goût. Il est possible que les malfaisants et les bouffons ne soient pas plus nombreux aujourd'hui qu'il ne le furent de tout temps; mais, par crainte, par ignorance ou par désir illusoire de nouveauté, on leur a laissé prendre une importance qu'ils n'ont jamais obtenue. *L'indépendance* fait donc appel à tous les hommes sages et de bonne culture, capable de lutter contre une telle aberration. Elle ne leur demandera ni sacrifice, ni concession qui diminue leur personnalité. Le négation et le regret du passé sont également stériles, mais la tradition, loin d'être une entrave, est le point d'appui nécessaire qui assure les élans les plus hardie." Le Comité, "Déclaration," *L'Indépendance* (1 March 1911). The editorial group consisted of Emile Baumann, René Benjamin, Vincent d'Indy, Paul Jamot, Ernest Laurent, Emile Moselly, Georges Sorel, Jérôme and Jean Theraud, and Jean Variot.

26. For studies of the evolution of *Indépendance*, see Netter, "Georges Sorel et *L'Indépendance*," 95–104; and Roman, "*L'Indépendance*," 173–193.

27. For a biographical overview of Laurent's career, see Hurel, "Ernest Laurent," 866–867.

28. Jamot's lifelong friendship with Denis is examined in Bouillon, *Maurice Denis, 1870–1943*, 110, 118, 169, 185. Jamot's early articles on Denis include "Une illustration des Fioretti, par Maurice Denis," 5–18; and "Le Théâtre des Champs-Elysées," 291–322.

29. Roman, "*L'Indépendance*," 179–183. Jamot's two publications in *Indépendance* were his "Préludes" (15 March 1911, 42–45) and a critical essay, "Les théories et les oeuvres" (15 April 1911, 126–139), on theories of classicism as applied to the visual arts. Ernest Laurent published one essay, "La tradition française en peinture" (15 May 1911, 212–214).

30. Point met Bourges in 1890; after Point had moved to the village of Marlotte near Fontainebleau, Bourges helped Point found the artisanal community Haute-Claire in 1896. See Fanica, "Armand Point (1860–1932)," 22–38; and Fanica, "Armand Point et Haute-Claire," 27–43.

31. Tharaud, "Un philosophe bourgeois de la révolution."

32. Roth, *The Cult of Violence*, 100.

33. See de Andia et al., *Charles Lacoste, 1870–1959*; and Thomson, *Monet to Matisse*, 118–119.

34. Stanley, *The Sociology of Virtue*, 270–282; Roman, "*L'Indépendance*," 188–191; Roth, *The Cult of Violence*, 105–106; Vincent, "Citizenship, Tradition, and Antipolitics," 10–16.

35. Sorel to Croce, 20 November 1912; quoted in Roth, *The Cult of Violence*, 105.

36. Roth, *The Cult of Violence*, 105. Historians have speculated that Sorel's break with Péguy in December 1912 might have been a catalyst for his abrupt disillusionment with the Catholic revival in France, and with Variot.

37. For instance, see Jennings, *Georges Sorel*, 154–157; Netter, "Georges Sorel et *L'Indépendance*," 95–104; Roman, "*L'Indépendance*," 173–193; and Vincent, "Citizenship, Tradition, and Antipolitics," 7–16. Although Sternhell concludes that the cultural and anti-Semitic program of *Indépendance* was almost indistinguishable "from the weekly *L'Action française*," he argues that Sorel remained fundamentally opposed to "the rationalist and positivistic aspects of the Maurrassian system." See Sternhell, *The Birth of Fascist Ideology*, 80–86.

38. Vincent makes this argument in his article "Citizenship, Tradition, and Antipolitics," asserting that Sorel's politics, "at this time, were reduced to a call for patriotic action and of defence of French Traditions" (13).

39. Sorel, "La rivolta ideale," 161–177. Sorel's article is based on his reading of Alfredo Oriani's nationalist tract, *La rivolta ideale* (1908). In May 1912, Mario Missiroli, editor of the Bologna daily *Resto del Carlino* and a contributer to *L'Indépendance*, published an article titled "Giorgio Sorel per Alfredo Oriani." As Roth reports, Missiroli drew comparisons between Oriani's views regarding the potential role of the family, Christianity, and the concept of a "new Italy" as regenerative forces and those of Sorel, adding that Oriani himself acknowledged a debt to Sorel. Missiroli then referred to Sorel's laudatory assessment of Oriani's moralism, his defence of tradition, and his attack on the rationalist underpinnings of democracy. Missiroli had corresponded regularly with Sorel from May 1910 onward, and from June to December 1910 Sorel utilized *Resto del Carlino* as a platform to announce his newfound enthusiasm for the rebirth of nationalist sentiments in France, and his equivocations over the possible role of Action Française in facilitating these developments. For a summary of Sorel's contributions to *Resto del Carlino*, see Roth, *The Cult of Violence*, 95–96, 131–132.

40. "Cette guerre de Libye pourrait bien avoir des conséquences auxquelles ne s'attendaient guère les politiciens qui l'ont décidée. On sait déjà qu'elle sera assez longue pour que l'armée soit soumise à des épreuves capables de lui donner de hautes vertus militaires; le peuple, sans se soucier des harangues des socialistes, suit avec passion les aventures de ses soldats; aux plus beaux jours du *risorgimento* le sentiment de la grandeur de la patrie n'avait pas été aussi fort qu'aujourd'hui." Sorel, "La rivolta ideale," 177.

41. Missiroli, "Le nationalisme italien," 419–435.

42. Berth (pseudonym Jean Darville), "Satellites de la Ploutocratie (December 1912),"

177–210. Berth's diatribe against French plutocracy and pacifism occurs on p. 179 in the context of extended praise for the "warrior" spirit animating Italy.

43. Netter, "Georges Sorel et *L'Indépendance*," 95–104. As Netter puts it: "Le contraste entre le itinéraires professionnels de ces hommes [the journal's other contributers], tous consacrés à l'art et littérature, et celui de Georges Sorel, consacré, lui, au socialisme et au syndicalisme révolutionnaire, est grand, à moins qu'il ne faille les considérer comme des créateurs, ce qu'ils sont en vérité, tout en mettant au premier rang leurs exigences une intelligibilité classique et universelle de la forme" (97–98).

44. Roman, "*L'Indépendance*," 173–193.

45. "Malgré la préponderance de Sorel et Variot, on en compte Sorel, en tête avec 132 articles et comptes rendus, soit 37% du total. Crée pour le philosophe, *L'Indépendance* est, en valeur relative, majoritairement rédigée par lui. Mais, avec une majorité absolue de 63% des papiers non écrits de sa main ni influencés par sa pensée, elle ne peut être considerée comme une revue sorélienne" (Roman, "*L'Indépendance*," 181). With such criteria one is left to speculate whether Sorel needed to write every article before *L'Indépendance* could be considered "Sorelian." In addition Roman makes no attempt to actually examine whether Sorel did have an impact on other contributors to *L'Indépendance*, or their possible influence on Sorel.

46. Roman, "*L'Indépendance*," 192. This assertion is made in response to Sternhell's alignment of *L'Indépendance* with the "revolutionary right" and my own earlier study of the anti-Semitic cultural politics of the journal. See Sternhell, *La droite révolutionnaire*, 390–400; Sternhell, *The Birth of Fascist Ideology*, 84–91; and Antliff, "The Jew as Anti-Artist," 50–67.

47. Roman, "*L'Indépendance*," 186.

48. Although Zeev Sternhell has examined Sorel's anti-Semitic writings for *L'Indépendance*, he describes the journal as a failed project that "did not succeed in distinguishing itself from the weekly *L'Action française*" (Sternhell, *The Birth of Fascist Ideology*, 84). On this basis he concludes that *Cahiers du Cercle Proudhon* was the true continuation of the ideological program mapped out for the *La Cité française* (1910) project. Mazgaj reaches similar conclusions, referring briefly to *L'Indépendance* as "almost an echo of the *Action française*" before embarking on an extensive examination of *Cahiers du Cercle Proudhon* (Mazgaj, *Action Française and Revolutionary Syndicalism*, 127). Sternhell's assessment of the anti-Semitism of *L'Indépendance* is valuable, and I will be building on his work in this chapter while reconfiguring the thought of Sorel and of his followers in the context of my own reading of the integral relation of creativity to Sorel's theory of revolution.

49. For a comprehensive study of the neo-Catholic revival that analyzes the writings of Baumann, Bourges, and Claudel, see Griffiths, *The Reactionary Revolution*.

50. Ibid., 149–222.

51. Birnbaum, "Catholic Identity, Universal Suffrage, and 'Doctrines of Hatred,'" 233–251.

52. Sternhell, *The Birth of Fascist Ideology*, 36–91; Antliff, "The Jew as Anti-Artist," 50–52.

53. See Mazgaj, *The Action Française and Revolutionary Syndicalism*.

54. For Bergson's views on the relation of human creativity to duration in the universe, see Bergson, *Matter and Memory*, 267–298; Bergson, *Creative Evolution*, 290–295; and Antliff, *Inventing Bergson*, 100–105; on the scientific implications of Bergson's theories, see Gunter, "Henri Bergson," 133–163.

55. On Sorel's critique of Enlightenment ideology, and his opinion that proponents of "the illusions of rationalism" find their adversary in "the teachings of Bergson," see Sorel, *Illusions of Progress*, 1–29; Sorel, *Reflections on Violence*, 28–30, 157; for a good synopsis of Sorel's Bergsonism, see Vernon, *Commitment and Change*, 50–61.

56. Sorel, *Reflections on Violence*, 284–285.

57. Berth, "Anarchisme individualiste, Marxisme orthodox, syndicalisme révolutionnaire," 6–35; rpt. in Berth, *Les Méfaits des intellectuels*, 87–130.

58. Berth, *Les Méfaits des intellectuels*, 95–119.

59. Ibid., 107.

60. Sorel, *The Illusions of Progress*, xi–xiv. "Nous savons aujourd'hui que cet homme abstrait n'était pas complètement fantaisiste; il avait été inventé pour remplacer, dans théories du droit naturel, l'homme du Tiers-Etat; de même que la critique historique a rétabli les personnages réels, elle doit rétablir les idées réelles, c'est à dire revenir à la considération des classes." Sorel, *Les Illusions duProgrès (Quatrième édition)*, 10.

61. Ibid., 49–50. "On peut simplifier les sociétés comme le physique et y trouver clarté atomistique, en supprimant les traditions nationales, la genèse du droit et l'organisation de la production, pour ne plus considérer que des gens qui viennent, sur la marché, échanger leurs produits et qui, en dehors de ces rencontres accidentelles, conservent leur pleine liberté d'action." Sorel, *Les Illusions duProgrès (Quatrième édition)*, 97. Sorel's reference to physics and the atomization of the social order as a consequence of republican notions of citizenship was a theme developed by Sorel's close friend and follower Edouard Berth. See Berth, "Anarchisme individualiste, Marxisme orthodox, syndicalisme révolutionnaire," 6–35; and Berth, *Les Méfaits des intellectuels*, 87–130.

62. Sorel, *The Illusions of Progress*, 12.

63. Ibid., 21.

64. Ibid., 20. "Le cartésianisme était résolument optimiste; ce qui devait beaucoup plaire à une société désireuse de s'amuser librement et agacée par la rigueur du jansénisme. D'autre part, il n'y a point de morale cartésienne.... Désormais la philosophie française demeurera marquée de caractères rationalistes, tout à fait spéciaux, qui la rendront agréable aux gens du monde.... [L]e cartésianisme restera toujours le type de la philosophie française parce qu'il était parfaitement adapté aux tendances d'une aristocratie pleine d'esprit, se piquant de raisonner et désireuse de trouver des moyens de justifier sa légèreté." Sorel, *Les illusions du progrès*, 48–49.

65. Sorel, *The Illusions of Progress*, 21. "Le progrès sera toujours un élément essentiel du grand courant qui ira jusqu'à la démocratie moderne, parce que la doctrine du progrès permet de jouir en toute tranquillité des biens d'aujourd'hui, sans se soucier des difficultés de demain." Sorel, *Les illusions du progrès*, 49.

66. Sorel, *The Illusions of Progress*, 150.

67. Ibid. 21.

68. Ibid., 150.

69. Ibid., 22.

70. Ibid., 22.

71. The Jansenist Pascal had critiqued Cartesianists for applying the laws of physics to the realm of human affairs, thereby recognizing that "pseudomathematical reasoning" is not applicable to "moral questions." "We must understand that in Pascal's eyes, the mathematical sciences form a very limited area in the whole field of knowledge, and that one exposes oneself to an infinity of errors in trying to imitate mathematical reasoning in moral studies." Sorel drew on Henri Poincaré's theory of conventionalism and Bergson's critique of the "instrumental" limitations of intellectual analysis to reach similar conclusions. See ibid., 15–16; Jennings, *Georges Sorel*, 96–99, 139–142.

72. Sorel, *The Illusions of Progress*, 22.

73. On Sorel's distinction between the productive and unproductive elements of the bourgeoisie, see Sorel, *Reflections on Violence*, 86–87, 252–295; and Stanley, *The Sociology of Virtue*, 262–266.

74. Sorel, *The Illusions of Progress*, 45. "C'est que la noblesse n'a plus, à cette époque, d'idéologie qui lui soit propre; elle emprunte au Tiers-Etat les sujets de dissertation et s'amuse des projets de rénovations sociale, qu'elle assimile à des récits de voyages merveilleux faits des pays de Cocagne." Sorel, *Les illusions du progrès*, 90.

75. On the battle between the ancients and moderns, see Cowart, *The Origins of Modern Musical Criticism*, 35–39; and Dejean, *Ancients against Modernse*.

76. Sorel, *The Illusions of Progress*, 1–3. "Riens ne nous parait plus étrange que le mauvais gôut de Perrault mettant systématiquement ses contemporains au-dessus des grands hommes de l'antiquité ou de la Renaissance, et, par example, préférant Lebrun à Raphael." Sorel, *Les illusions du progrès*, 16.

77. Sorel, *The Illusions of Progress*, 3–6.

78. Ibid., 6; *Les illusions du progrès*, 24.

79. Sorel, *The Illusions of Progress*, 7; *Les illusions du progrès*, 24.

80. Sorel, *The Illusions of Progress*, 7; *Les illusions du progrès*, 25.

81. Sorel, *The Illusions of Progress*, 7–8. "Une révolution moderne a établi une scission fondamentale entre deux groupes d'écrivains; les uns se vantent d'être devenus de bons ouvriers des lettres; ils se sont formés par un long apprentissage et ils travaillent extraordinairement leur langue;—les autres ont continué à écrire rapidement selon le gôut du jour. . . . Nos artistes contemporains de style sont les vrais successeurs de ce Boileau, si longtemps méprisé. . . . Si quelqu'un a senti le prix de la forme en

poésie, c'est Boileau.... Les hommes qui travaillent avec un patient labeur leurs écrits s'adressent volontairement à un public restreint; les autres écrivent pour les cafés-concerts et pour les journaux; il y a maintenant deux clientèles bien séparées et deux genres de littératures qui se mêlent guère." Sorel, *Les illusions du progrès*, 25–27.

82. Sorel, *The Illusions of Progress*, 103. "Condorcet est inintelligible. On pourrait se demander plutôt si l'influence des amis des lumières n'a pas été funeste à l'art durant la fin du XVIIIe siècle; cette influence contribua à ruiner des traditions de métier pour lancer l'art sur une voie factice en vue de l'expression de fantaisies philosophiques." Sorel, *Les illusions du progrès*, 192.

83. Sorel, *The Illusions of Progress*, 154–157.

84. Sorel, *Reflections on Violence*, 36. On Sorel's fusion of the productive and artistic *esprit*, and separation of proletarian culture from a bourgeois "aesthetic education," see Jennings, *Georges Sorel*, 112–115.

85. Sorel, *Reflections on Violence*, 39. On Proudhon's declaration that art must have a moral purpose, and that the edifying effects of art should also animate the workplace, see Woodcock, *Pierre-Joseph Proudhon*, 256–259; on Proudhon's influence on Sorel's theory of art, see Jennings, *Georges Sorel*, 112–115.

86. See Sorel, *Reflections on Violence*, 286–288.

87. Ibid., 286–287.

88. Berth, *Les Méfaits des intellectuels*, 126–128.

89. Fraser, "Grapes of Wrath."

90. Sorel, *The Illusions of Progress*, 155–156. "Tout d'abord, on doit signaler les sentiments d'affection qu'inspirent à tout travailleur vraiment qualifié les forces productives qui lui sont confiées. Ces sentiments ont été surtout observé dans la vie champêtre.... Il y a une agriculture grossière dans laquelle on chercherait vainement les vertus attribuées à la propriété; mais il y en a une autre qui, pendant de longs siècles, a été fort supérieure au plus grand nombre des métiers urbains, comme travail qualifié; c'est celle-là que les poètes ont célébrée, parce qu'ils en apercevaient le caractère esthétique.... [O]n a souvent signalé combien est observateur, raissonneur et curieux de nouveauté le vigneron, qui ressemble bien plutôt à l'ouvrier des ateliers progressifs qu'au laboureur; il lui serait impossible de se contenter de la routine, car chaque année apporte un tribut de difficultés nouvelles; dans les pays de grand crûs, le vigneron suit avec une attention minutieuse tous les épisodes de la vie de chaque plant." Sorel, *Les illusions du progrès*, 281–283.

91. Sorel, *Reflections on Violence*, 86–99.

92. Ibid., 126–139.

93. Ibid., 69–73, 84–91.

94. Ibid., 99, 286–295. "La violence prolétarienne, exercée comme une manifestation pure et simple du sentiment de lutte de classe, apparait ainsi comme une chose très belle et très héroique; elle est au service des intérêts primordiaux de la civilisation. ... Saluons les révolutionnaires comme les Grecs saluèrent les héroes spartiates qui

defendirent les Thermopyles et contribuèrent à maintenir la lumière dans le monde antique." Sorel, *Réflexions sur la violence*, 130–131.

95. Sorel, *Reflections on Violence*, 35, 243–244. "Mais l'enseignement de Bergson nous a appris que la religion n'est pas seule à occuper la région de la conscience profonde; les mythes révolutionnaire y ont leur place au même titre qu'elle. . . . Ces faits nous mettent sur la voie qui nous conduit à l'intelligence des hautes convictions morales; celles-ci ne dépendent point des raisonnements ou d'une éducation de la volonté individuelle; elles dépendent d'un état de guerre auquel les hommes acceptent de participer et qui se traduit en mythes précis. Dans les pays catholiques, les moines soutiennent le combat contre le prince du mal qui triomphe dans le monde et voudrait les soumettre à ses volontés; dans les pays protestants, de petites sectes exaltées jouent le rôle de monastères. Ce sont ces champs de bataille qui permettent à la morale chrétienne de se maintenir, avec ce caractère de sublime qui fascine tant d'âmes encore d'aujourd'hui." Sorel, *Réflexions sur la violence*, 49, 319–320.

96. Sorel, *The Illusions of Progress*, 186. "L'heure présente n'est pas favorable à l'idée de grandeur: mais d'autres temps viendront; l'histoire nous apprend que la grandeur ne saurait faire indéfinement défaut à cette partie de l'humanité qui possède les incomparables trésors de la culture classique et de la tradition chrétienne." Sorel, *Les illusions du progrès*, 335.

97. "La révolution dreyfusienne aurait été impossible si le patriotisme n'eut été rendu ridicule par les saltimbanques de l'opportunisme. Aujourd'hui la farce est terminée. . . . Et voici qu'un ancien Dreyfusard [Péguy] revendique pour les idées patriotiques le droit de diriger le pensée contemporaine." Sorel, "Le réveil de l'âme française," 1–2.

98. Ibid., 2.

99. "Le genre si heureusement choisi par Péguy comporte surtout des louanges enthusiastes, des lamentations et des supplications; il se rattache évidemment au genre prédramatique duquel procède le drame Eschylien. Les liturgies catholiques procédent aussi de la littérature pré-dramatique." Ibid.

100. "Dès que le lyrisme touche au surnaturel, il multiplie des doublets, les progressions d'images, les retours vers des idées exprimées; il semble s'inspirer plutôt des procédés musicaux des règles suivies par nos bons écrivains." Ibid.

101. Sorel describes myth as comprising "a body of images capable of evoking instinctively all the sentiments which correspond to the different manifestations of the war undertaken by Socialism against modern society. Strikes have engendered in the proletariat the noblest, deepest, and most moving sentiments that they possess; the general strike groups them all in a co-ordinated picture, and, by bringing them together, gives to each one of them its maximum of intensity; appealing to their painful memories of particular conflicts, it colours with an intense life all the details of the composition presented to consciousness. Thus we obtain that intuition of Socialism which language cannot give us with perfect clearness—and we obtain

it as a whole, perceived instantaneously." In a footnote on the same page, Sorel allies this intuitive "method" to the "global knowledge" [*connaissance parfaite*] of Bergson's philosophy. See Sorel, *Reflections on Violence*, 137; and Sorel, *Réflexions sur la violence*, 183. Bergson in his writings described intuition as an empathetic form of consciousness that enabled individuals to circumnavigate their innate predilection for rational thought. As a result they could discern the inner flux of their own duration in its sympathetic response to the durational properties of external stimuli, grasped as perceptual images, rhythmic patterns, and "dynamic" forms of thought. That intuitive response reportedly caused us to tap into our deepest memories, thus bringing our whole personality into play in actions and thought processes that were highly creative. For an analysis of the Bergsonian tenets of Sorel's theory of mythic images, see Vernon, *Commitment and Change*, 50–61; for an analysis of Bergson's theory of the perceptual image and its relation to memory and intuitive consciousness, see Matthews, "Bergson's Concept of a Person"; and Antliff, *Inventing Bergson*.

102. Sorel, "Le réveil de l'âme française," 2.

103. Sorel, "Critique de 'L'Otage,'" 391–398.

104. Sorel, *Reflections on Violence*, 288. In his chapter "The Ethics of the Producers," Sorel references Ruskin's *Seven Lamps of Architecture* (1849).

105. "Voici donc Maurice Barrès prêt à comprendre Tolède et le Greco. Ville sacredotale, oeuvre mystique; des élans hallucinés vers le ciel, une mélancholie exaltée. Le somptueux élève du Titian renonce vite à tant de luxe et de beauté mondaine: au delà de la science technique que lui enseigna l'Italie, il va retrouver les formes anciennes que lui a révélées sa jeunesse; et nous retrouvons bien dans les dernières oeuvres du Greco ces Vierges émaciées, aux yeux agrandis de fièvre, qui donnent un accent si tragique aux mosaïques byzantines." Fergan, "Greco, ou le secret de Tolède," 186–191. See Barrès, *Greco, ou le secret de Tolède*.

106. Barrès, *Greco, ou le secret de Tolède*, 148, 152, 164.

107. Milhou, "Portrait of Maurice Barrès (1913)," 198.

108. Stevens, "Bernard as a Critic" and "Introduction to Paintings and Drawings," in Stevens, ed., *Emile Bernard, 1868–1941*, 68–91, 105–118.

109. Milhou, "Zuloaga in France."

110. Georges Sorel in Variot, *Propos de Georges Sorel*, 227–234. Zuloaga's *Christ of the Blood* was based on his encounters with peasant penitents during his tour of the northern Basque and Castilian countryside from spring to autumn, 1911. He used a crucified Christ figure found in an abandoned Segovian convent as a model for the sculpted Christ in the painting. See de Caso, "The Christ of the Blood," 155.

111. Georges Sorel, cited in Variot, *Propos de Georges Sorel*, 230–234.

112. Jean-Paul Bouillon, in his superlative study of Maurice Denis, notes that Denis and his friend, the composer Vincent d'Indy, were affiliated with the "conseil de rédaction de 'L'indépendance,' tentative revue 'socialiste-nationaliste' pour rapprocher Maurras et Sorel," but does not analyze the significance of the relationship with Sorel. See

Bouillon, *Maurice Denis*, 169. Variot, in an undated letter to Denis, described the decision to join the board as "an elegant gesture" ("un geste élégant") that did not require strict adherence to a specific political program. Such qualification was in keeping with Sorel's wish to separate "mystique" from "politique" to safeguard the regenerative ideals he espoused. Variot's undated letter is in the Maurice Denis archive, Musée le Prieuré, Saint-Germain-en-Laye, ms. 11110, and is cited in Roman, "*L'indépendance*," 183 n. 30.

113. Sorel's rejection of impressionism in the name of Denis's conception of "form" also measures his distance from his syndicalist phase, when he identified the very formlessness of impressionism with a Bergsonian protest against the ossification of durational creativity into the fixed, intellectual formulas identified with state-sanctioned academic technique. Refering to written descriptions of art, Sorel concludes that "art flourishes best on mystery, half shades and indeterminate outlines; the more speech is methodical and perfect, the more likely is it to eliminate everything that distinguishes a masterpiece; it reduces the masterpiece to the proportions of an academic product. . . . It is to the credit of the Impressionists that they showed that these fine shades can be rendered by painting." As we shall see Sorel continued to endorse recourse to "half shades and indeterminant outlines" after 1910, but only in the context of the symbolist, neo-Catholic aesthetics of Claudel and Variot. See Sorel, *Reflections on Violence*, 159; for a discussion of Bergson's own application of a similar paradigm in his analysis of the art of Corot and Turner, see Antliff, *Inventing Bergson*, 58–59.

114. The poetic ode to Denis's painting was written by the poet Johannes Jörgensen in 1906, and translated from the Danish for the journal in April 1913. See Jörgensen, "Nôtre-Dame de l'Ecole," 73–74. For an analysis of the painting and its relation to the republican anticlerical campaigns of Emile Combes, see Marlais, *Conservative Echoes*, 212–214. As Jennings notes, Sorel's writings in *L'Independance* were frequently devoted to an attack on French education under the Republic, which had eradicated the influence of the church and tradition to the benefit of a "sterile rationalism." See Jennings, *Georges Sorel*, 156; and Sorel, "Lyripipii Sorbonici moralisationes," 111–125.

115. For a recent analysis of Point's artist's colony, Haute-Claire, see Laurent, "Armand Point."

116. Variot, "L'exposition de la Rose-Croix catholique." Founded by Joséphin Péladan in 1892, the Salon de la Rose + Croix held six exhibitions between 1892 and its supposed demise in 1897; the 1911 reappearance of the salon documented here is unrecorded in the secondary literature on the movement. Péladan's Rose + Croix exalted the art of the Italian Pre-Raphaelites and medieval Europe as evidence of the fervent Catholicism undermined by the advent of Renaissance humanism, and Péladan numbered Puvis de Chavannes, Gustave Moreau, and Armand Point among his artistic allies. For a summation of Péladan's aesthetic theories, see Michael Marlais, *Conservative Echoes*, 139–147. Variot stated that the art of the group reminded him of "Maurice Denis, dont l'exposition des Fioretti, chez Drouet, fut un événement et une joie pour

nous." Variot refers to Denis's spring 1911 exhibition of designs for Saint Francis of Assisi's *Fioretti*, which were published in book form in 1913. See Bouillon, *Maurice Denis*, 140.

117. Claudel, "Saint Philippe, Saint Jude Apôtre."

118. Variot, "L'exposition de la Rose-Croix catholique."

119. Bouillon, *Maurice Denis*, 140.

120. In his article of December 1912, Sorel claimed that Giotto and Fra Angelico (Denis's favorite artist) both benefited from exposure to Byzantine aesthetics. "Il me semble qu'on ne dépasserait pas les limites d'une juste hypothèse, si l'on ajoutait qu'Angelico a fait passer dans des sujets chrétiens tout le charme des idylles grecques; qu'il pouvait parfaitement connaître grâce à de magnifiques manuscrits byzantins dont les miniatures ont, jusqu'au Xe siècle, si bien conservé les traditions antiques. . . . Si on observe que les Grecs actuels conservent dans leurs décorations murales une notable quantité d'éphèbes antiques transformés en saints, on ne trouvera plus extrêmement paradoxal le parti adopté par Giotto: il faudra admettre seulement que cet artiste eut la révélation de son génie en admirant des miniatures grecques, qui de son temps ne manquaient pas en Italie." Sorel, "Histoire artistique des ordres mendiants (Louis Gillet)," 238–39.

121. For an analysis of Despiau's interest in such artists as Donatello and Antonio Rossellino, as well as Greek sculpture, see Judrin, *Charles Despiau*; and Elliot, "Sculpture in France and Classicism, 1910–1939."

122. Winock, "Jeanne d'Arc et les juifs."

123. On d'Indy's involvement in Sorelian circles, see Fulcher, *French Cultural Politics and Music*, 48–52, 133–136.

124. For an overview of d'Indy's career and the evolution of the Schola Cantorum, see Vallas, *Vincent d'Indy II*.

125. D'Indy, *Une école de musique répondant aux besoins modernes*, 3.

126. D'Indy and Sérieyx, *Cours de composition musicale*, 214; cited in Fulcher, *French Cultural Politics and Music*, 28–35.

127. Jean-Paul Bouillon notes that Denis's friendship with d'Indy dated from the early 1890s, when Denis encountered the composer while the latter was a student of César Franck; Fulcher in turn notes that Denis cited the Schola "as a model for the kind of institution he would conceive for artists," namely, one that emulated the Gothic era, when the profession of artists was a "calling" infused with "foi collective." See Bouillon, *Maurice Denis*, 43–44; and Fulcher, *French Cultural Politics and Music*, 48–49. Denis references the Schola Cantorum in his essay of 1919, "Les nouvelles directions de l'art chrétien." See Maurice Denis, *Nouvelles théories*, 239.

128. See Deculis and Reymond, *Le décor de théâtre en France*, 179–182; Quéant, ed., *Encyclopédie du théâtre contemporain*, 28–57; and Variot, "L'Annonce faite à Marie."

129. The program image is reproduced in Quéant, ed., *Encyclopédie du théâtre contemporain*, 28. Denis's painting also graced the cover of the special edition of *L'Oeuvre*

(October–December 1912) devoted to Claudel's play and Variot's set designs. It is that version that I have reproduced here.

130. Sorel, "'L'Otage' de Paul Claudel," 391–398.

131. For an analysis of the central role of the theme of vicarious suffering in Claudel's *L'annonce faite à Marie* (1910) and *L'Otage* (1909), see Griffiths, *The Reactionary Revolution*, 198–210.

132. Antliff, "The Jew as Anti-Artist," 56.

133. Fergan, "L'Annonce faite à Marie," 172–177; Variot, "La mise en scène de L'annonce faite à Marie," 177–187.

134. "La prosodie de Claudel est, en cela, voisine de la prosodie grecque ou latine, comme son vers est comparable au trimètre iambique des tragiques grecs." Fergan, "L'Annonce faite à Marie," 75–77.

135. Variot, "La mise en scène de L'Annonce faite à Marie," 184–187.

136. Variot, *Propos de Sorel*, 242–245.

137. "L'Annonce [est] ... une oeuvre philosophique et d'une orthodoxie profondément rigide. Des décors ordinaires, avec leur réalisme faux, décaleraient le drame du tout au tout. Si l'on voyait des portes s'ouvrir et se fermer, des sièges, des tables ... le spectateur ne serait pas dans l'ambiance de la pièce qui plane à des hauteurs qui donnent parfois le vertige.... Il y a là un sublime qui s'élève au-dessus de l'humain.... Il faut des choses directes pour les choses ordinaires. Pas pour L'Annonce.... C'est pourquoi, devant l'obligation où vous vous trouvez, je vous conseille de ne montrer que des ombres, des formes peu définies, d'où monte la parole de Claudel." Georges Sorel, quoted in Variot, *Propos de Sorel*, 1935, 243–244.

138. Variot, *Propos de Sorel*, 245–246.

139. Forgione, "'The Shadow Only.'"

140. "Sorel, depuis un an, est devenu claudelien intransigeant." Variot, *Propos de Sorel*, 243.

141. Sorel, *The Illusions of Progress*, 43.

142. Ibid., 62–64. Indeed, Georges Deherme and others associated with the *universités populaires* thought the Dreyfus affair played a crucial role in uniting bourgeois intellects and the working-class elite in the creation of these popular universities after 1899. For a recent evaluation of the movement, see Mercier, *Les universités populaires*.

143. Sorel, *The Illusions of Progress*, 62–63. The passage reads as follows: "A la suite de l'affaire Dreyfus, nous avons vu un délicat amuseur des boudoirs de la plaine Monceau transformé, par quelques badauds, en oracle du socialisme; il parait qu'Anatole France s'étonne d'abord beaucoup de cette métamorphose, mais qu'il a fini par se demander, tout de bon, si, vraiment, en contant ses petites drôleries aux belles dames et aux gentils messieurs de la finance, il n'avait pas découvert l'énigme de la question sociale." Sorel, *Les illusions du progrès*, 122.

144. Sorel, *The Illusions of Progress*, 115. "On s'est demandé souvent comment il se fait que

des Juifs riches aient tant de sympathies pour des utopies et parfois même se donnent des allures socialistes. Je laisse ici de côté naturellement ceux qui voient dans la socialisme un moyen nouveau d'exploitation; mais il y en a qui sont sincères. Ce phénomène n'est pas à expliquer par des raisons ethniques: ces hommes vivent en marge de la production; ils s'occupent de littérature, de musique et de spéculations financières; ils ne sont pas frappés de ce qu'il y a nécessaire dans le monde et leur témérité a la même origine que celle de tant de gentilshommes du XVIIIe siècle." Sorel, *Les illusions du progrès*, 213.

145. Sorel, "Aux temps dreyfusiens." For an overview of the pro-Dreyfus stance of the journal, see Halperin, *Félix Fénéon*, 319–323. Richard Sonn has pointed out that, ironically, the attempt to both transcend the politics of class and republicanism led factions at *La revue blanche* to briefly sympathize with royalism in the early 1890s. Thus Sorel's condemnation of *La revue blanche* in the name of French culture and Catholicism did not take account of the anti-Semitic and royalist leanings professed by some of the journal's contributors. See Sonn, *Anarchism and Cultural Politics in Fin-de-Siècle France*, 17–19, 40–43, 175–176, 185–186.

146. Venita Datta has examined the stereotype of the Jew as intellectual in prewar France and the espousal, by secular Jewish intellectuals, of "rationalism and universality" as ideals allied to a republican notion of citizenship (thus facilitating their integration into the French body politic). Although Datta has studied the role of *La revue blanche* in this discourse, she does not consider the thought of Sorel and his circle. See Datta, *The Birth of a National Icon*, 85–116.

147. "A la *Revue Blanche* se préparaient de merveilleuses anticipations de la pensée future; cette officine appartenait aux Natanson, deux Juifs venue de Pologne pour régénérer notre pauvre pays, si malheureusement encore contaminé par la civilisation chrétienne du XVIIe siècle." Sorel, "Aux temps Dreyfusiens," 52.

148. Fénéon was the journal's editorial secretary from January 1895 to 1903. See Halperin, *Félix Fénéon*, 299–323.

149. Sorel, "Aux temps Dreyfusiens," 51–56; Berth, "Anarchisme individualiste"; and Berth, *Les Méfaits des intellectuels*, 37–43.

150. "La paradoxale collaboration des classes que fit naître l'affaire Dreyfus, était seulement une imitation de ce qui se passait dans l'académie des Natanson. Je vais avoir, encore une fois, recours à Henry de Bruchard qui nous donne, en quelques lignes, une esquisse très accentuée de ce Parnasse: 'Salon d'anarchie cosmopolite, dit-il, où les esthètes coudoyaient les usuriers et les peintres impressionistes.'" Sorel, "Aux temps Dreyfusiens," 51–56.

151. For Denis's racist categorization of the 1899 Nabis exhibition at Durand-Ruel, see Denis, *Journal*, 150. Michael Marlais, in an excellent overview of Denis's politics, singles out the Dreyfus affair as an event that brought together anti-Semitic proponents of "nationalism and Catholicism," in an alliance of the conservative right. In the wake of the Dreyfus affair, Denis joined the royalist movement Action Française (founded in 1899) and turned against those symbolists associated with *La re-*

vue blanche when that journal's editors defended Captain Dreyfus. In Marlais's view, Denis's subsequent turn to Catholic themes, painted in the style of early Renaissance artists such as Fra Angelico, reflected a concomitant conservative turn in the realm of politics.

In this regard I would take issue with Marlais's affiliation of Denis with the politics of right-wing conservatism, for Denis's involvement in Sorel's *L'Indépendance* meant that he was briefly affiliated with a group that merged radical right and radical left ideologies in the guise of Sorel's mythic constructions. For an overview of Denis's political evolution before 1914, see Marlais, *Conservative Echoes*, 185–219. Jean-Paul Bouillon maintains that Denis's politics were ultimately subordinate to his more ethereal artistic concerns; I would follow Marlais in arguing that Denis's artistic views cannot be divorced from his politics, and that, in Denis's aestheticized politics, both art and politics are integral. For Bouillon's perspective on such issues, see Bouillon, "Politique de Denis."

152. Berth, *Les Méfaits des intellectuels*, 11.

153. Ibid., 18–19.

154. Ibid., 28–29.

155. Ibid. In effect Berth maps out, in Sorelian terms, all the anti-Semitic tropes of racial theory, for as Sander Gilman has demonstrated, fin-de-siècle scientific pathophysiology declared the Jew intrinsically unfit for military service, susceptible to feminine illnesses like hysteria, and thus not worthy of assimilation into the European body politic. Gilman, *The Jew's Body*, 38–59.

156. Berth, *Les Méfaits des intellectuels*, 37–43.

157. Ibid., 37–43.

158. This association of the Jew with the "disembodied" power of a pure intellect, devoid of creativity, is, to my knowledge, an understudied dimension of anti-Semitic discourse. For a study of the fin-de-siècle claim that Jews lacked creative ability by virtue of their pathological condition, see Gilman, *The Jew's Body*, 128–149.

159. For a full analysis of the play, see Fulcher, "Vincent d'Indy's 'Drame Anti-Juif.'"

160. For a study of the Solomonic order, see Ramirez, "Guarino Guarini, Juan Ricci, and the Complete Solomonic Order."

161. Thomson, *Vincent D'Indy and His World*, 183.

162. Vallas, *Vincent d'Indy*, 327. In a lecture of May 1919, Denis called for the creation of "une école d'arts religieux," which would be organized "sur le plan de la Schola cantorum ... autour d'une doctrine à la fois traditionelle et vivante," a sure indication of Denis's endorsement of d'Indy's cultural politics at this juncture. See Denis, "Pour l'art sacré," in Denis, *Nouvelles Théories*, 239.

163. See Birnbaum, *Les peuple et les gros*. Sorel's identification of the Jew with the state was a theme that pervaded anarchosyndicalist visual imagery, wherein republican ideology was regarded as a façade for *les gros*; Sorel went further in regarding democratic ideology and modern Jews as both "rationalist" and thus degenerative allies.

164. On the parameters of Drumont's anti-Semitism, see Birnbaum, *Anti-Semitism in France*, 85–95.

165. Sternhell has made the important point that the Sorelians's disavowal of anticlericialism existed even before they became allies of the Action Française. See Sternhell, *The Birth of Fascist Ideology*, 101.

166. Louzon, "La faillite du dreyfusisme ou le triomphe du parti juif," 197–198; cited in Sternhell, *La droite révolutionnaire*, 326.

167. For instance, see Riquier's essays, "Messieurs les intellectuels," which attacks the intellectualism of Jaurès's parliamentary socialist, and "L'École syndicaliste et l'école rationelle," which contrasts those anarchists who still advocated "Dreyfusism" with the class consciousness of those allied to syndicalism. On the national socialism of *La terre libre*, see Sternhell, *La droite révolutionnaire*, 385–392. In an article addressed "Aux prolétaires juifs," (1–15 April 1911) the editors of *La terre libre* cited the existence of Jewish working organizations as evidence that Jewish proletarians inevitably placed ethnic allegiances above those of class in a manner that echoed Dreyfusard politics. The same issue defended syndicalist leader Emile Pataud's anti-Semitic speech delivered at a meeting of syndicalists and nationalists organized by *La terre libre* on 3 April 1911. See Sternhell, *La droite révolutionnaire*, 389; for a study of Jewish labor organizations in France before 1914, see Green, "The Contradictions of Acculturation."

168. On the image of the "feminized" Jew in anti-Semitic discourse in France, see Birnbaum, *Anti-Semitism in France*, 147–177.

169. See the chapter titled "Strange Classicism: Aesthetic Vision in Winkelmann, Nietzsche, and Thomas Mann," in Mah, *Enlightenment Phantasies*, 70–97.

170. Ibid., 82.

171. Ibid., 80–82.

172. Ibid. Mah and Alex Potts have both analyzed the internal contradictions in Winckelmann's aesthetic formulations: Mah with reference to subjectivity, Potts with a primary focus on sexuality. See the chapter titled "Beauty and Sublimity" in Potts, *Flesh and the Idea*, 113–144.

173. See Le Goff, *Time, Work and Culture in the Middle Ages*, 29–42.

174. Andreu, *Georges Sorel, entre le noir et le rouge*, 239–268.

175. Sorel, "Dio ritorna (Dieu revient)"; cited in Andreu, *Georges Sorel, entre le noir et le rouge*, 248.

176. Sorel, "Les livres," 164–165. The article was a review of Raphael Cor's *Sur la sensibilité moderne* (1913).

177. "What we know of the prophets of Israel allows us to say that biblical Judaism owed its glory to religious experience. Modern Jews no longer see in their religion anything but rites resembling those of ancient magic superstitions. . . . Having been raised in a milieu almost totally devoid of spiritual life, they are scandalously incompetent when they speak of Christianity, which is completely nourished from the spiritual life." Sorel, *The Illusions of Progress*, 180–181.

178. For a summation of Sorel's views on the Jews, see Sand, "Sorel, les juifs et l'antisemitisme"; and Sternhell, *The Birth of Fascist Ideology*, 84–86.

179. Sorel to Delasalle, 21 January and 6 February 1918, in Sorel, *Lettres à Paul Delassalle, 1914–1921*; also cited in Andreu, *Georges Sorel*, 258; and Henri Bergson, "La significance de la guerre."

180. Datta, *Birth of a National Icon*, 103–116.

3. La Cité Française

1. On Le Corbusier's political evolution over the 1920s and 1930s, see McLeod, "'Architecture or Revolution,'" "Le Corbusier and Algiers," and "Urbanism and Utopia."

2. Notable exceptions in this regard include Mary McLeod, who was the first to explore this dimension of Le Corbusier's politics. Having noted that Valois's fascism was premised on corporatist models allied to the rational organization of production, she rightly concludes that Le Corbusier "identified with the Faisceau's advocacy of technical innovation and was undoubtedly flattered by the group's admiration of his program." More recently, William Curtis has argued that while Le Corbusier's "brief flirtation" with the fascists was the result of an attraction for "the idea of a strong leader as a means to realize the true plan," he was "troubled by a system that might destroy individual liberty." Among historians, Zeev Sternhell has noted Le Corbusier's connection with Valois's group, concluding that the "taste for modernity" extant among the Faisceau leadership "was expressed as much in the Faisceau's admiration for Le Corbusier as in Valois's enthusiasm for the "rational organization" of industrial production." See McLeod, "Urbanism and Utopia," 99–102; Curtis, *Le Corbusier*, 102; and Sternhell, *Neither Right nor Left*, 108.

3. For a summation of this theory, see Sternhell, "The 'Anti-Materialist' Revision of Marxism as an Aspect of the Rise of Fascist Ideology."

4. On French conceptions of *la cité*, see Rabinow, *French Modern*, 289, 320–321, 335. The significance of the concept for Sorel has been explored by Jennings, Vernon, and Stanley. See Jennings, *Georges Sorel*, 147–151; Vernon, *Citizenship and Order*, 146–168; and Stanley, *The Sociology of Virtue*, 260–266.

5. For an analysis of Valois's activities before World War I, see chapter 2. During World War I, Valois served as a second lieutenant and was awarded the Croix de Guerre and the Légion d'Honneur; in the wake of the war he returned to the Action Française in the role of economic theorist and advocate for war veterans. On 11 November 1925 Valois left the Action Française and formed the Faisceau des Combattants, des Producteurs et des Chefs de Famille. Valois's fascist movement lasted from November 1925 to spring 1928, when Valois denounced fascism and formed a new political entity, the Parti Républicaine Syndicaliste. Over the 1930s Valois advocated "libertarian communism"; after the fall of France in 1940 Valois joined the Resistance in Haute Savoie, which led to his arrest by the Gestapo and internment in Bergen-Belsen concentration camp, where he died on 8 February 1945. For a short biography

of Valois, see Rees, *Biographical Dictionary of the Extreme Right since 1890*, 399–400. For the most comprehensive study of Valois's political evolution, see Douglas, *From Fascism to Libertarian Communism*.

6. The Faisceau adherent Philippe Lamour identified the left-right synthesis achieved by the Cercle Proudhon as an anticipation of the fascist revolution realized by Mussolini and envisioned by Valois. See Lamour, "Un agitateur d'idées," 1. Lamour's own concept of fascist aesthetics will be the subject of chapter 4.

7. For a detailed analysis of the Action Française campaign against the Faisceau, see Douglas *From Fascism to Libertarian Communism*, 82–105, 139–146.

8. See, for instance, Oudard, "Le nouveau visage de la France: Reims, ville moderne," 1–2; and Oudard, "Le nouveau visage de la France: le Foire de Lyon," 1–2. Oudard's article on Reims focused on the building campaign to reconstruct that city, noting the special role of the American town planner George Forde in the reconstruction effort. In particular he celebrated the replacement of narrow streets destroyed by German bombardment with wide avenues that facilitated movement and opened up the area around the cathedral. In his article on Lyon, Oudard praised the reorganization of the Lyon market into areas of specialization to aid the consumer. Oudard was a laureate of the Académie Française who had written for conservative journals before joining Valois's movement. On Oudard, see Soucy, *Fascism: The First Wave*, 106–107.

9. Noé, "Un esthétique nouvelle." Noé's article recounted a conference and open debate concerning the pros and cons of American skyscrapers organized by the Société des Amateurs d'Art et Collectioneurs at the Salle Comoedia in Paris. The "M. Frankl" referred to in Noé's article was undoubtedly Paul Theodore Frankl (1886–1962), a recognized pioneer in modern design. Born in Prague, Frankl had spent time in Berlin and Copenhagen before emigrating to the United States in 1914. A self-described architect specializing in interior design, Frankl opened a gallery in New York in 1922, where he introduced his designs for "skyscraper furniture" in 1926. In the 1920s and 1930s he published a series of promodern texts with such titles as *New Dimensions: The Decorative Arts in Words and Pictures* (1928) and *Machine-Made Leisure* (1930). According to Noé's account Frankl was visiting Paris as part of a European lecture tour he had organized to promote modernism in architecture and interior design.

10. "Notre Paris devrait être la plus belle ville du monde, la ville la mieux organisée, la ville outillée avec les moyens de transport les plus modernes, la ville où un peuple immense d'ouvriers, de commis et de bourgeois devrait trouver les plus belles, les plus saines habitations." Valois, "Le Grand Paris doit être une unité administrative, économique et sociale," 1. Valois published a follow-up article on his plans for Paris in the same issue: "Il faut que le Grand Paris ait une constitution et une organisation dignes du siècle de l'automobile et de l'électricité," 1, 3. Georges Oudard published a lengthy critique of Paris suburban planning (or lack thereof) under the Third Republic in the same issue. See Oudard, "Pour une organisation rationnelle de la banlieue," 3.

11. See McLeod, "Urbanism and Utopia," 99–102.

12. Ibid., 169 n. 16. Winter's article concerned the relevance of Le Corbusier's text *Urbanisme* for any concept of "'greater Paris." See Winter, "Pour le grand Paris," 4.

13. Winter, "Les quartiers Frugès à Pessac," 1.

14. See Winter, "Pour le Grand Paris," 4; "Les animateurs: Le Corbusier," 1; Biver, "L'esprit nouveau," 1.

15. For a synopsis of Biver's involvement in the Faisceau, see Douglas, *From Fascism to Libertarian Communism*, 134–135.

16. Mary McLeod has analyzed this correspondence. See McLeod, "Urbanism and Utopia," 101, 169 n. 16, 107 nn. 17, 18.

17. See Soucy, *French Fascism: The First Wave*, 115–116.

18. Delagrange, "La cité de demain"; and Winter, "La ville moderne," 2. The articles appeared as a pair with a note stating that they were originally meant to appear in the 1 May 1927 issue devoted to "the city of tomorrow." On Delagrange's communist affiliation and status as a "left" fascist, see Douglas, *From Fascism to Libertarian Communism*, 76–77, 107–108.

19. See Le Corbusier, "Le Plan Voisin," 3; on Le Corbusier's slide presentation to the fascist rank and file at the inauguration of their new headquarters, see Valois, "La nouvelle étape du fascisme," 1.

20. For a history of Coty's involvement with the Faisceau, see Douglas, *From Fascism to Libertarian Communism*, 82–90, 132–346; Soucy, in *French Fascism: The First Wave* (190–194), claims that Valois's self-proclaimed leftward drift following the election of Poincaré in July 1926 was no more than "opportunism" and that his "leftism" was "still more petit-bourgeois than proletarian." For Soucy, Valois's concept of a society of "producers" structured along Sorelian lines was not sufficiently "leftist" to warrant that appellation. For an alternative view, see Sternhell, *Neither Right nor Left*, 105–118.

21. See Douglas, *From Fascism to Libertarian Communism*, 125–131, 134–139. For a brief history of the Cartel des Gauches, and Poincaré's ascendancy in July 1926, see McMillan, *Twentieth-Century France*, 91–96.

22. In May and June Valois proclaimed fascism to be a "new order" that aimed to construct a "new city" modeled after Le Corbusier's vision, while as late as July 1927, Le Corbusier was again numbered among "les animateurs," for having inspired the architecture of another modernist, Robert Mallet-Stevens. See Valois, "Sur la voie glorieuse," 3; "Le cycle des conférences hebdomadaires," 3; and "Les animateurs: M. Mallet-Stevens," 1.

23. Valois, "La nouvelle étape du fascisme," 1.

24. McLeod, "'Architecture or Revolution,'" 133–141.

25. Ibid., 143.

26. Ibid., 137.

27. On the nationalism of the Redressement Français and the Faisceau, see Kuisel, *Ernest Mercier, French Technocrat*, 59–61, 70–71. Mercier rejected the syndicalist and corporatist ideology that were the centerpiece of Valois's more radical program.

28. McLeod, "'Architecture or Revolution,'" 141–143.

29. See the chapter "Citizenship in Industry: Georges Sorel" in Vernon, *Citizenship and Order*, 146–168.

30. Ibid., 148.

31. Sorel, *Le procès de Socrate*, 172; quoted in Vernon, *Citizenship and Order*, 149.

32. Sorel, *La ruine du monde antique*, 311; quoted in Vernon, *Citizenship and Order*, 149.

33. Sorel, *Reflection on Violence*, 98–99.

34. Sorel, *La ruine du monde antique*, 317–318; quoted in Vernon, *Citizenship and Order*, 150.

35. Sorel, *Le procès de Socrate*; translation in Stanley, ed., *From Georges Sorel*, 69.

36. Ibid., 63.

37. Vernon, *Citizenship and Order*, 150. Sorel's reference to the "social poetry" of Marx occurs in Sorel's *Matériaux d'une théorie du prolétariat*, 189, while his description of the general strike as a form of "drama" appears in his *Réflexions sur la violence*, 173.

38. Sorel, *Reflections on Violence*, 70–71, 84.

39. Ibid., 86.

40. Ibid., 84.

41. Ibid., 86.

42. Ibid., 98–99.

43. Edouard Berth, Georges Sorel, Jean Variot, Pierre Gilbert, and Georges Valois, "Déclaration de la 'Cité française,'" reproduced in Andreu, *Notre maître, M. Sorel*, 327–328. For a history of the *Cité française* project, see Jennings, *Georges Sorel*, 150–152.

44. Berth, *Les Méfaits des intellectuels*, 261–264.

45. Berth, preface in ibid., 14–15. In an essay of 1912 published in *L'Indépendance*, Sorel interpreted foreign war to be a stimulus for proletarian regeneration, an indication that his allegiances, unlike Berth's, were still primarily with the working class. See Sorel, "La rivolta ideale," 177; cited in Jeremy Jennings, *Georges Sorel*, 155.

46. Sorel, *Reflections on Violence*, 82–83. Ironically, when Sorel wrote this he appended a footnote saying that "the hypothesis of a great European war seems far-fetched at the moment." When war did arrive in 1914 Sorel condemned it for causing the Left to capitulate to republican ideology. His association of World War I with "demogogic plutocracy" thus differed fundamentally from that of Valois. See Stanley, *Sociology of Virtue*, 293–297.

47. Sorel, *Reflections on Violence*, 94.

48. Ibid., 188.

49. Berth, *Les Méfaits des intellectuels*, 300–301.

50. Valois, "Bourgeois capitaliste"; reproduced in Valois, *Histoire et philosophie sociales*, 373–405.

51. Ibid., 402.

52. Ibid., 402–403.

53. Stanley, *The Sociology of Virtue*, 293; For Sorel's critique of Bergson, see Sorel, *Lettres à Paul Delasalle*, 125, 126.

54. Roth, *The Cult of Violence*, 145.

55. Ibid., 147.

56. Ibid., 147.

57. Sorel's theory of the city is elaborated in the chapter "Sur le genèse de la vérité," in Sorel, *De l'utilité de pragmatisme*, 115–186. I refer to the English translation of this chapter in Stanley, ed., *From Georges Sorel*, 257–290.

58. Stanley, ed., *From Georges Sorel*, 260–261.

59. Ibid., 265–266.

60. Ibid., 267.

61. Ibid., 263, 265.

62. Ibid., 267.

63. Ibid.

64. Stanley, ed., *From Georges Sorel*, 268.

65. Ibid.

66. Ibid., 268–269.

67. Ibid., 269.

68. Ibid., 277.

69. Ibid., 275.

70. Ibid., 275–277.

71. Ibid., 280.

72. Ibid., 279.

73. Valois, *Le fascisme*, 5. Valois's opening chapter had originally appeared in article form under the title "Origines françaises du fascisme," on page 1 of the 26 April 1926 edition of *Nouveau siècle*. In *Le fascisme* Valois identified "Jean Bertholin" as the author who first published Mussolini's declaration; in the article he identifies his source as an article by Bertholin that had been published in 1924 in *Le gaulois*.

74. Valois, *Le fascisme*, 5.

75. Ibid., 7–8.

76. Ibid., 7. The section from the *Reflections on Violence* quoted in *Le fascisme* is as follows, with italics added by Valois: "Everything may be saved if the proletariat, through their use of violence, manage to reestablish the division between classes, and *so restore to the middle class something of its former energy*; that is the great aim toward which the whole thought of men—who are not hypnotized by the event of the day, but who think of the conditions of tomorrow—must be directed. Proletarian violence, carried on as a pure and simple manifestation of the sentiment of class war, appears thus as a very fine and very heroic thing; it is at the service of the primordial interests of civilization; it is not perhaps the most appropriate method of obtaining immediate material advantages, but it may save the world from barbarism. We have a very effective reply to those that accuse syndicalists of being obtuse and

ignorant people. We may ask of them to consider the economic decadence for which they are working. Let us salute the revolutionaries as the Greeks saluted the Spartan heroes who defended Thermopylae and helped to preserve the civilization of the ancient world." See Sorel, *Reflections on Violence*, 98–99.

77. Valois's follower, Philippe Lamour, expressed this succinctly in his essay of 3 April 1927, on the legacy of Sorel's thought: "1914. La guerre. Les producteurs deviennent combattants. Et ils sauvent la nation consacrant ainsi leur souveraineté. Sorel avait raison." Lamour, "Un agitateur d'idées," 1.

78. Valois, *Le fascisme*, 15–18.

79. Ibid., 45–66.

80. Ibid., 48–54.

81. Ibid., 17.

82. Ibid., 12–14.

83. Ibid., 17.

84. Ibid., 17–18.

85. "Le fascisme doit ses conceptions ouvrières au christianisme et au socialisme, et surtout au socialisme sorélien. Mais Georges Sorel devait ses idées au christianisme vivant. Sa conception d'une classe ouvrière ardente, audacieuse, qui, par son ardeur, son audace, ses exigences même, oblige la bourgeoisie à se redresser, à grandir, à fournir de grands chefs, aimant le travail, se devouant à leur tâche, et n'étant plus esclaves de leur richesses, c'est toute le doctrine qui est inscrite aux versets du *Magnificat*." Ibid., 73.

86. Ibid., 63.

87. Barrès, "Le sentiment de la victoire," 3. For an account of the 11 November 1925 Armistice Day rally, see Douglas, *From Fascism to Libertarian Communism*, 88–89.

88. The rally included an overnight vigil at Douaumont, during which fascists swore allegiance to their fallen comrades, and a fascist procession in Verdun itself, culminating in the laying of wreaths at the tomb of seven unknown soldiers. See Douglas, *From Fascism to Libertarian Communism*, 106–107.

89. See Valois, "A Domrémy," 1. Valois called for his followers to act in "imitation" of Joan of Arc, concluding that "she is the patron, the guide for all those who envision for their country a destiny . . . whose certitude is inscribed in the mystery of being." The pilgrimage to Domrémy, we are told, would "fortify our belief in France, in our will and our certitude of success." Valois had evoked the "imitation" of Joan of Arc by comparing Joan's military exploits to those of the combatants even before the founding of the Faisceau. See Valois, "L'Imitation de Jeanne d'Arc," 1. Douglas, in his analysis of Valois's Domrémy rally, notes that it occurred in the context of Valois's campaign against his former ally Coty, who had helped launch an anticommunist "red scare" in the press in March and April 1927. Coty's published call for France to ally itself with Britain was countered by Valois with an appeal for Faisceau members to recall British treachery in the case of Joan of Arc. See Douglas, *From Fascism to Libertarian Communism*, 139–140.

90. This subtitle was emblazoned across the top of each edition of *Nouveau siècle*.

91. Sternhell, *The Birth of Fascist Ideology*, 224; and Gregor, *Young Mussolini and the Intellectual Origins of Fascism*, 218–219.

92. According to Mussolini, Italian fascism came from "streams which had their source in Sorel, Péguy, in the Lagardelle of the *Movement Socialiste*." See Giovanni Gentile and Benito Mussolini, "The Doctrine of Fascism (1932)," in Lyttelton, ed., *Italian Fascisms*, 45. Zeev Sternhell has dealt extensively with the Sorelian aspects of Mussolini's fascist ideology, noting that Mussolini embraced the Cercle Proudhon's conception of a corporatist society of producers. See the chapter "Mussolini at the Crossroads," in Sternhell, *The Birth of Fascist Ideology*, 195–232.

93. For instance, in his article "Origines françaises du fascisme," Valois noted Mussolini's stated indebtedness to Sorel, adding that the Italian fascists, unlike the Bolsheviks, had employed proletarian violence and corporatism to reinvigorate the "economic and social action of the Italian bourgeoisie." See Valois, "Origines françaises du fascisme," 1. In 1924 a French translation of Mussolini's writings, along with an essay by Pietro Gorgolini, was published under the title *La révolution fasciste*; it included a preface by Valois titled "Quelques réflexions sur le fascisme." Two years later, articles from *Nouveau siècle* were translated into Italian and collected into a volume with a preface by Mario Carli. See Valois, preface to Gorgolini, *La révolution fasciste*, vii–xii; and Valois, *Il fascismo francese*.

94. Rigny, "Les autostrades italiennes: les créations de l'économie fasciste," 1–2.

95. As a result the Italian rationalists, who had adapted Le Corbusier's precepts to fascist ideology by the late 1920s, were not represented in Valois's newspaper. For their part, while the Gruppo 7 admired the "Hellenic" dimension of Le Corbusier's architecture, they nevertheless declared it to be quintessentially French, and thus sought to create a style of their own modeled after Italian and Roman precedents. On the reception of Le Corbusier among the Italian rationalists, see Etlin, *Modernism in Italian Architecture, 1890–1940*, 249–254, 377–390.

96. Dumas, "L'Atelier et la cité," 5.

97. Douglas has drawn attention to an important distinction between Valois's "static" and Sorel's "dynamic" version of class antagonism. Valois's notion of corporativism—both in his monarchist and fascist phases—held each class in a state of "constant tension" by virtue of "social structures" that "would force conflicting interests into harmony." "With Sorel," states Douglas, "proletarian violence would stimulate the bourgeoisie into returning to the aggressive posture that made Marxist predictions of revolutionary conflict possible." See Douglas, *From Fascism to Libertarian Communism*, 26.

98. Mussolini's use of architecture in his campaign to associate fascism with the imperial glory of Rome has been thoroughly documented by Etlin. See Etlin, *Modernism in Italian Architecture, 1890–1940*, 391–348.

99. Valois, *La politique de la victoire*.

100. "Le réunion du 2 novembre, les orateurs: Marinetti," 1.

101. Valois, *L'État syndical et la représentation corporative.*

102. Ibid., xviii.

103. See Valois, "La politique de la victoire," 3–4.

104. Ibid. Allen Douglas has argued that Valois thought the bourgeoisie incapable of ruling under a fascist regime, and restricted their role to the realm of production "in the service of state and nation under the combattant." While it is certainly true that Valois wished to contain and channel the regenerative energy of the bourgeoisie under a fascist state, he did not divorce the ethics of the combatant from those of the regenerated bourgeois. Thus Sorel's association of productivist energy and the *esprit guerrier* with the militant capitalist was not lost on Valois, who connected the ethics of the *combattant* with those of the *producteur*. See Valois, *Le fascisme*, 143–144; and Douglas, *From Fascism to Libertarian Communism*, 68–69.

105. Valois, *Le fascisme*, 143–144.

106. Valois, "Origines françaises du fascisme," 1.

107. Valois, "Pour reconstituer la cité," 3.

108. Valois, *Le fascisme*, 77.

109. Anon., "Les animateurs: M. Henry Ford," 1. Ford's status as an "animateur" was premised on his productivism: "Ce qui fait que Ford est la voiture la moins chère du monde et que les ouvriers de Ford gagnent les plus hauts salaires du monde."

110. Valois *Le fascisme*, 80. The book referred to is by Bertram Austin and W. Francis Lloyd, *The Secret of High Wages*. It was published in French by Payot in 1926.

111. Valois, *Le fascisme*, 154.

112. Ibid., 155–156.

113. Ibid., 158.

114. Bernoville, "Le travail et l'artisan," 4.

115. "Le remède? Je le vois pour ma part dans le sentiment que l'ouvrier peut garder ou reconquérir de la grandeur du travail, si mécanique et machinal soit-il. Je le vois encore dans une organisation de plus en plus rationelle, équilibrée, conforme à la justice, de la profession. Si l'ouvrier ne peut plus, dans la majorité de cas, avoir cet orgueil de créateur qui animait l'artisan, il continue d'aimer sa profession, de sentir profondément le lien de solidarité qui l'unit aux autres membres de sa corporation, il sait dans quelle mesure essentielle la production dépend de lui. Il faut éveiller et traduire dans les faits, dans les intérêts, les sentiments de collaboration qui unit le chef d'enterprise à ses subordonnés." Bernoville, "Le travail et l'artisan," 4.

116. Valois, *L'Économie nouvelle* (1919), definitive edition in *L'Oeuvre économique*, 210–223. For a summation of Valois's economic theory at this juncture, see Douglas, *From Fascism to Libertarian Communism*, 38–46.

117. Bourgin, "La littérature du travail," 4.

118. For a brief biography of Bourgin and his initial relations with Valois, see Douglas, *From Fascism to Libertarian Communism*, 75; and Soucy, *French Fascism: The First Wave*, 114–115.

119. Bourgin, "Le littérature du travail," 4. "Si Proudhon montre les contradictions profondes du monde économique et heurte violemment les tendances qui les expliquent, il demeure constant dans sa glorification du travail libérateur, créateur de droits, fondateur de biens matériels et moraux, apanage et soutien de la famille. Le travail réclame la justice, et il droit la réaliser. Le travail conduit à la capacité politique, et, dans l'atelier même, il fonde la cellule organique de la cité. Proudhon engendre Sorel, et Sorel, Georges Valois. Le mutuellisme du premier suscite le syndicalisme révolutionnnaire du second qui appelle l'économie nouvelle et le fascisme du troisième. Mais ces conceptions nouvelles ne pouvaient s'épanouir que dans l'atmosphère de la victoire."

120. Valois, *Le fascisme*, 155.

121. Valois, "Notre politique ouvrière," 3.

122. Ibid.

123. Valois, "L'Explosion des partis," 2. In this article Valois expressed his solidarity with Mercier's group in the face of attacks on the redressement movement by his former ally Coty and the Action Française. Valois nevertheless maintained that while the Faisceau agreed with Mercier on "technical" issues, such as the "rationalization of industry," the fascists were opposed to the "economic" and "social" order promoted by Mercier, who wanted to "organiser ce progrès économique par les seuls chef d'entreprise."

124. Valois, "Sur la voie glorieuse et rude de la pauvreté et de la réussite," 1. In a related argument Valois praised the "great army of technicians and this great team of constructors of the modern world which goes from Baron Haussmann" to the "prodigious genius that is Le Corbusier." This technocratic elite, in conjunction with "the working class," were the force behind the "rational economic organization" that the Faisceau set out to develop. See Valois, "Sur la voie glorieuse et rude de la pauvreté et de la réussite," 3.

125. Michaud, *Histoire de l'art*, 119–145.

126. Winter, "La France au travail," 2.

127. For Pierre Winter's usage of Le Corbusier's theory of nomadism, see Winter, "Pour le Grand Paris," 4; Winter, "La ville moderne," 2; for the sections of Le Corbusier's *Urbanisme* reproduced in *Nouveau siècle*, see Le Corbusier, "Le Plan Voisin," 3, and Le Corbusier, *Urbanisme*, translated as *The City of Tomorrow and Its Planning*, 95–99, 276–280, 294–296.

128. Mussolini, quoted in Francesca Rigotti, "Il medico-chirurgo dello Stato nel linguaggio metaforico di Mussolini," in *Cultura e società negli anni del fascismo* (Milan, 1987). This citation is found in Forgacs, "Fascism, Violence and Modernity," 6.

129. Valois, "Fascisme ou communisme?" 1.

130. Valois, *Le fascisme*, 33–34.

131. Valois refers to La Tour du Pin's corporatist theory, developed in the wake of "the defeat of 1870" as prefiguring Valois's own attack on "economic anarchy" and his desire

to achieve "social justice" through a syndicalist and corporative economic system. See Valois, *Le fascisme*, 34. For an overview of La Tour du Pin's impact on Valois, see Douglas, *From Fascism to Libertarian Communism*, 31–33.

132. On Valois's theory of nomadism, see Douglas, *From Fascism to Libertarian Communism*, 24–28; and Valois, "L'Europe et l'Asie," 3. Valois's contrast between nomadic communism and Latin fascism was enshrined in regular adjacent columns titled "La horde": and "Les légions," found on the third page of the newspaper.

133. It is rather interesting that the fascists did not emphasize Le Corbusier's association of his modernism with Greco-Latin culture, since Valois himself claimed a Greco-Latin genealogy for the French esprit. I would conjecture that Valois's call for a total revolution, and hostility toward the Action Française, led him, in 1927, to emphasize the ultramodernism of Le Corbusier's project as the analog for a total break with past ideologies, including the Greco-Latinism of the monarchists. On Le Corbusier's "Hellenism," see Etlin, "Le Corbusier, Choisy, and French Hellenism"; on the cultural policies of the Action Française, their impact on French modernism, and Le Corbusier's attempt to negotiate his own relation to monarchist ideology, see Silver, *Esprit de Corps*, 17, 22–28, 103–104, 372–390.

134. For Forain's correlation of cubism with bolshevism and condemnation of modernists as so many "faux naïfs," vying for material success in the art market, see Forain, "Promenades artistiques," 4; for his exaltation of Vlaminck's rural landscapes as a sincere expression of his "naïveté," see Forain, "Vlaminck chez MM. Bernheim-Jeune," 3.

135. For a succinct analysis of the ideological and racial valences informing definitions of the *École française* and *École de Paris* in French art criticism of the 1920s and 1930s, see Golan, "The 'Ecole Française' vs. the 'Ecole de Paris,'" 81–87. Golan has further developed this thesis in her book *Modernity and Nostalgia*. Eric Michaud has also examined the anti-Semitic valences of such criticism. See Michaud, *Histoire de l'art*, 89–117.

136. Vlaminck, *Tournant dangereux*, 181, 268–229; cited in Golan, *Modernity and Nostalgia*, 56.

137. Golan, *Modernity and Nostalgia*, 9, 47.

138. Ibid., 40–60.

139. Le Corbusier, *The City of Tomorrow and Its Planning*, 100–101. In addition the extracts quoted in *Nouveau siècle* did not include Le Corbusier's stipulation (on p. 296 of *Urbanisme*) that plans to rebuild Paris could be financed by foreign capital, a scheme that would have been anathema to Valois.

140. Valois, "Il faut que le Grand Paris ait une constitution et une organisation dignes," 3.

141. Ibid.

142. Valois, "Le nouvelle étape du fascisme," 1. "C'est avec une intention très nette que nous avons demandé cette conference à M. Le Corbusier. J'ignore totalement encore les idées politiques de M. Le Corbusier, qui parle aussi bien à la C.G.T. que chez nous.

Ce que je sais, c'est que son oeuvre exprime magnifiquement, en images vigoureuses, la tendance profonde du Faisceau. Au départ du Faisceau, il y a eu des malentendus. Même par l'image. L'Arc du Triomphe sur la grande affiche du *Nouveau Siècle*, cela a fait penser à certains que nous faisions un nouveau groupe dont l'objet serait de défiler une fois l'an devant un monument du passé. Or, nous sommes des constructeurs, les constructeurs des villes nouvelles. Les conceptions de Le Corbusier traduisent nos plus profondes pensées. . . . Nos comarades ont d'abord eu, devant ses projections, un instant d'étonnement. Puis, ils ont compris. Et ils sont entrés tout simplement dans l'enthousiasme. Je dis: l'enthousiasme. Devant le Ville de demain, grande, belle, rationnelle, et pleine de foi, ils ont vu leur propre pensée matérialisée."

143. The passage from Sorel's text defines the general strike as follows: "we know that the general strike is indeed what I have said: the *myth* in which Socialism is wholly comprised, i.e. a body of images capable of evoking instinctively all the sentiments which correspond to the different manifestations of the war undertaken by Socialism against modern society. Strikes have engendered in the proletariat the noblest, deepest, and most moving sentiments that they possess; the general strike groups them all in a co-ordinated picture, and, by bringing them together, gives to each one of them its maximal intensity; appealing to their painful memories of particular conflicts, it colors with an intense life all the details of the composition presented to consciousness. We thus obtain that intuition of socialism which language cannot give us with perfect clearness—and we obtain it as a whole, perceived instantaneously." See Sorel, *Reflections on Violence*, 137. Valois's description of the psychological transformation of the fascist audience from "shock" to "enthusiasm" on seeing "their own thought materialized" in the guise of Le Corbusier's "forceful images" is clearly indebted to Sorel's Bergsonian theory concerning the role of myth in creating a revolutionary state of mind.

144. Valois, "La nouvelle étape du fascisme," 1.

145. Le Corbusier, *Urbanisme* (1925), translated as *The City of Tomorrow and Its Planning*, 49–53.

146. For an analysis of Le Corbusier's involvement in the Redressement Française, see McLeod, "'Architecture or Revolution,'" 141–144.

147. In this regard I would take issue with some aspects of Sternhell's antimaterialist thesis. In his essay on the French fascists' antimaterialist revision of Marxism, Sternhell claims that, on the eve of World War I, the proponents of Sorelian antimaterialism "lost faith in the revolutionary virtues of the proletariat," and therefore "turned towards the other historical force, the only one which could still serve as an agent of moral regeneration and social transformation: the Nation" (Sternhell, "The 'Anti-Materialist' Revision of Marxism," 380). As my discussion here makes clear, class conflict was still very much a part of Valois's postwar fascist plan for moral renewal, albeit "in order to rebuild the cité." Under fascism, proletarian pressure was still to

be exerted on the bourgeoisie, in order to galvanize the productive and warlike energies of that class. This conception of regeneration came directly from Sorel's *Reflections on Violence*, and serves to connect Valois's fascism to Sorel's revolutionary syndicalism. I would also question Sternhell's claim that Valois "waged a fierce campaign against the values and the way of life of the bourgeoisie's intellectual and moral dominance" or that fascism was to be "the gravedigger of all bourgeois virtues as of all the ills that the bourgeois order gave rise to" (Sternhell, *Neither Right nor Left*, 95). As Valois's early distinction between the "bourgeois français" and "bourgeois capitaliste" made clear, there were virtues native to that class worth retaining; moreover, for Valois, a reinvigorated bourgeoisie, animated by a productivist and combative esprit, was fundamental to the health of the greater whole, la cité francaise.

148. Le Corbusier, *The City of Tomorrow and Its Planning*, 70. For an analysis of this aspect of Le Corbusier's theory see Serenyi, "Le Corbusier, Fourier and the Monastery of Ema," 277–278. Paul Overy in his study of the metaphoric use of the term "cell" in Le Corbusier's theory of urbanism agrees with Serenyi's assessment. To quote Overy, Le Corbusier "was essentially concerned with the *single individual*," and "he saw the community as a collection of individuals, rather than of nuclear or extended *families*." See Overy, "The Cell in the City," 117–140.

149. As the Sorelian Hubert Lagardelle defined it in a July 1927 address to fascists in Toulouse: "Finally, there is the mystique of the producer, that is the intervention of a 'voluntarist' element in social life. The producer does not submit. He intervenes. He is the creator, the constructor who has something to say at all times, since it concerns the life of the country and his future" ["Enfin, c'est la mystique du producteur, c'est à dire l'intervention d'un élément 'volontariste' dans la vie sociale. Le producteur ne subit pas. Il intervient. Il est le créateur, le constructeur qui a quelque chose à dire à tout instant, puisqu'il est la vie du pays et son avenir"]. See "Toulouse: Diner du club," 5. Lagardelle, who had publicized Sorel's work in *Le mouvement socialiste* (1899–1914), had joined the Toulouse branch of the Faisceau in 1926. Sternhell notes that Lagardelle's involvement in the Faisceau was minimal, although his pedigree as a Sorelian gave him an exalted status within the movement. See Sternhell, *Neither Right nor Left*, 112. In the interwar period Lagardelle developed a theory of regional syndicalism that would prove highly influential. Philippe Lamour was a promoter of Lagardelle's theories in the Faisceau, and remained so when he left the movement to form the Parti Fasciste Révolutionnaire in 1928–1929. Lamour's own fascist trajectory will be the subject of chapter 4. In the arena of modernism, Le Corbusier became a strong advocate of Lagardelle's theories, which informed his writings and architectural projects throughout the 1930s. See McLeod, "Urbanism and Utopia," and "Le Corbusier and Algiers," 53–85.

4. Machine Primitives

1. Notable exceptions include Braun, "Expressionism as Fascist Aesthetic." In that article Braun analyzes Mario Sironi's expressionism within the context of mythic primitivism, and contextualizes his aesthetic in terms of German Marxist debates over the relation of expressionism to fascist politics. This analysis of fascist primitivism is also developed in Braun's important essay "Speaking Volumes" and her book, *Mario Sironi*. Historians examining this nexus in the context of German expressionism and Italian futurism include Berman, "German Primitivism/Primitive Germany"; and Gentile, "The Conquest of Modernity." Roger Griffin has analyzed this dimension of fascism in terms of its "mythic core," defined as "a palingenetic form of populist ultra-nationalism," in *The Nature of Fascism*.

2. For consideration of the nature of primitivism, see Antliff and Leighten, "Primitive."

3. See chapters 1, 2, and 6 in Golan, *Modernity and Nostalgia*.

4. Ibid., 24–25.

5. Ibid., 155–163.

6. See the chapters "A Crisis of Confidence: From Machinism to the Organic" and "The Return to Man" in ibid.

7. Ibid., 74–76.

8. Ibid., 62.

9. Emily Braun has examined an Italian variant of such "return to the soil" ideology in her analysis of the primitivizing aesthetics of the fascist journal *Il Selvaggio* (1924–1943), which actively promoted the rural and peasant imagery of Carlo Carrà, Giorgio Morandi, and Ardengo Soffici in the interwar period. Founded by the fascist ideologue Mino Maccari, *Il selvaggio* promoted the doctrine of Strapaese or "supercountry" in opposition to concepts of Stracittà (supercity), which Maccari associated with Mussolini's cult of Rome, and the art of the Novecento and futurist movements. As a result Maccari played the marginal role of cultural "dissident" in Fascist Italy. See my discussion in chapter 1 and Braun, "Speaking Volumes."

10. See Gentile, "Un'apocalisse nella modernità," and *The Sacralization of Politics in Fascist Italy*.

11. For instance, Robert Wohl, in his groundbreaking study *The Generation of 1914* has separate chapters devoted to generational theory in France and Italy, but he does not investigate the impact of the cult of youth propagated by Italian fascists on their French counterparts during the interwar years. More recently the multivolume anthology *A History of Young People* has reconsidered generational politics in a variety of European countries, but again the shared premises animating fascist youth movements in France and Italy are not discussed. See chapters 1 and 5 in Wohl, *The Generation of 1914*; for additional essays devoted to Italian fascism and the cult of youth, see Wanrooij, "The Rise and Fall of Italian Fascism as a Generational Revolt"; Mal-

vano, "The Myth of Youth in Images"; and Passerini, "Youth as a Metaphor for Social Change." The only book to date to examine the impact of the Nazi and Italian fascist cult of youth on French fascists is Lacroix's *De la beauté comme violence*. In a chapter titled "Le fascisme en culottes courtes" (155–234) Lacroix focuses primarily on the impact of the fascist cult of youth on Jacques Doriot's Parti Populaire Français and writers Robert Brasillach and Pierre Drieu La Rochelle, but he also points to the fascist orientation of Philippe Lamour's writings on youth in the journal *Plans*. Ruth Ben-Ghiat has recently analyzed the fascist cult of youth with reference to the Italian Fascist government's promotion and subsequent suppression of dissident youth movements during the 1930s. See Ben-Ghiat, *Fascist Modernities*, 93–122.

12. In the field of art history, Mary McLeod and Romy Golan have both noted Lamour's instrumental role in founding the journals *Grand'Route* (1930) and *Plans* (1931–1933), but have not examined Lamour's cultural criticism. Instead they have focused primarily on the impact of Hubert Lagardelle's doctrine of regional syndicalism on the journal *Plans* and on the art and architecture of its most famous contributor, Le Corbusier. Among historians Allen Douglas, John Hellman, and Robert Soucy have charted Lamour's role in the political evolution of Georges Valois's Faisceau, but again, Lamour's writings—this time for Valois's fascist newspaper, *Nouveau siècle* (1925–1928)—have been ignored. Jean-Robert Pitte, in a biographical study of Lamour, has examined Lamour's fascist tract *La république des producteurs* (1926) and Lamour's adaption of the tenets in that pamphlet to his later thought. I concur with Pitte's conclusion that Lamour's *Entretiens sous la tour Eiffel* (1929) and his journal *Plans* evidenced the continued impact of fascist precepts on his thinking. Pitte, however, does not examine Lamour's writings in *Nouveau siècle* or the theme central to this chapter: Lamour's adaptation of the fascist cult of youth to his promotion of "machine-age" aesthetics in the pages of *Entretiens sous la tour Eiffel* and *Grand'Route*. That said, Pitte's book is an engaging and highly nuanced study of Lamour's political odyssey from the 1920s to the early 1990s. See Golan, *Modernity and Nostalgia*, 68–78, 97–104; McLeod, "Urbanism and Utopia"; Douglas, *From Fascism to Libertarian Communism*, 116, 125, 135–136, 140–145; Hellman, *Emmanuel Mounier and the New Catholic Left, 1930–1950*, 57–58; Soucy, *French Fascism: The First Wave*, 114–117; and Pitte, *Philippe Lamour, 1903–1992*.

13. The futurists declared themselves "the primitives of a new sensitiveness" on the basis of their wholesale embrace of the dynamism of modern technology in the "Technical Manifesto" of futurist painting, published 11 April 1910. See Umberto Boccioni, Carlo Carrà, Luigi Russolo, Giacomo Balla, and Gino Severini, "Futurist Painting: Technical Manifesto, 1910," in Apollonio, ed., *Futurist Manifestos*, 27–31. Although I have found no evidence that Lamour actually read futurist texts, Marinetti's involvement with the Faisceau virtually guaranteed Lamour's familiarity with the movement (see references to Marinetti in chapter 3). As I will demonstrate, Lamour's machine primitivism was based on his own complex response to the writings of Georges Sorel and his intimate knowledge of fascist youth politics.

14. Lamour, *Le cadran solaire*, 51, 61.

15. Ibid., 57–58.

16. Ibid., 62, 87–88.

17. Ibid., 92–93.

18. Ibid., 93.

19. Ibid.

20. Ibid., 82, 94–99. See chapter 3 for a full discussion of Valois's Faisceau.

21. Lamour, *Le cadran solaire*, 100.

22. Ibid.

23. Ibid., 108–109.

24. Ibid., 113–115.

25. For an overview of Lamour's evolving fascist politics, see Soucy, *French Fascism: The First Wave*, 114–117; and Douglas, *From Fascism to Libertarian Communism*, 116, 125, 135–136, 140–145. Pitte has made a similar argument in his *Philippe Lamour*, 24–30.

26. Soucy, *French Fascism: The First Wave*, 114–115; and Lamour, "Sous le signe de la victoire," 3; "Section universitaire," 6.

27. Lamour, "Un agitateur d'idées," 1.

28. Lamour's three publications were a book on fascist monetary policy, *Formules de contrats usuels en franc-or* (1926); a pamphlet outlining his version of Sorelian fascism, *La république des producteurs* (1926); and an analysis of pedagogy (coauthored with Henri Bourgin), *Pour un enseignement français* (1928).

29. For a summation of the text, see Pitte, *Philippe Lamour*, 30–36.

30. Lamour, *La république des producteurs*, 3–13, 21.

31. Ibid., 20–21.

32. Ibid. 36–38.

33. Ibid., 30–32.

34. Douglas, *From Fascism to Libertarian Communism*, 134. Zeev Sternhell has also examined Valois's leftward trajectory. See Sternhell, *Neither Right nor Left*, 90–118.

35. Douglas, *From Fascism to Libertarian Communism*, 142.

36. The November 1928 edition of *La révolution fasciste* contained extracts from *La république des producteurs* on pp. 3 and 4 of the paper. See the articles by Lamour titled "Liberté religieuse," 4; "Communisme, fascisme, jeunesse," 3–4; and "Comment se sera la révolution?" 4.

37. According to Loubet del Bayle, Henry de Jouvenel asked Lamour to contribute to the journal because he was impressed by Lamour's *Entretiens sous la tour Eiffel*. It was through his connection with *La revue des vivants* that Lamour met Renaud de Jouvenel, who agreed to found *Grand'Route* along with André Cayatte and Eric B. Hurel. See Loubet del Bayle, *Les non-conformistes des années 30*, 94. Authors associated with *Grand'Route* published essays in *La revue des vivants* from September 1929 to June 1930, including a February 1930 essay by Eric Hurel titled "Grand'route" that would later appear as the opening article in the inaugural issue of *Grand'Route* (March 1930). The articles in *La revue des vivants*, in order of publication, are as

follows: Lamour, "La pensée des jeunes: sur une prétendue crise de l'esprit"; Lamour, "La pensée des jeunes: à propos d'un chien andalou"; Cayatte, "La pensée des jeunes: types"; Hurel, "La pensée des jeunes: Grand'route"; Lamour, "La pensée des jeunes: concert Colonne"; Lamour, "La pensée des jeunes: mars"; Cayatte and Lamour, "La pensée des jeunes: écrire obscur." Hurel was the author of at least two books: *Chambres noires* and *La lune d'octobre*. Cayatte, who would later become a well-known film director, collaborated with Lamour on at least seven books between 1934 and 1939. On Lamour's relations with Cayatte, see Pitte, *Philippe Lamour*, 17, 61, 89–91, 220.

38. Lamour, *Entretiens sous la tour Eiffel*, 139–150.

39. Ibid., 145.

40. Ibid., 142.

41. Ibid.

42. Ibid., 144.

43. Ibid., 145–148.

44. Lamour, "Première étape," 13–22.

45. Lamour, "Inventaires U.S.A.," 50–57.

46. Ibid., 50.

47. Ibid. In the same article Lamour argued that democracy in the United States differed fundamentally from European democracy inasmuch as America subordinated government and the ideology of individualism to the ethics of productivism. For this reason the United States, the Soviet Union, and above all else, Fascist Italy, foreshadowed the creation of a republic of producers. The United States, we are told, had "limited its institutions to their exact role: organization of the material world, that is, of production, of exchange, and consumption"; furthermore, politics were "economic politics" and politicians were "the shop clerks of producers." In short, despite its claims to democratic principles, in practice the sole aim of government policy in the United States was to enhance material production, and with it "the popular mystique of production and religion of well being." Adherents to this productivist ethic were not only opposed to the usage of capital in unproductive "speculation" on the stock market, they recognized the value of distributing wealth to further their aims. Reiterating the Fordism of Valois, Lamour claimed that industrial leaders had "discovered that the primary consumer was the producer" and that it [was] necessary to give him "the possibility of consuming the greatest portion of his production by giving him money, and time in order to consume, that is leisure time," as well as credit. Lamour lamented the separation of "manual and intellectual qualities" that occurred with the division and rationalization of labor in the American factory, but argued that greater leisure time and higher wages would allow for the "free development of the personality" outside of the work environment, and that the American system gave every producer "the chance to climb the ladder of command." Although Lamour upheld Sorel's claim that personal development was contingent upon creative labor, he was prepared to accept such a loss among some workers if it aided the

productivist aims of society as a whole. By recognizing their role in furthering pro-
ductive forces and the possibility for advancement to positions where "manual and
intellectual" capacities could be combined, individual workers would value their la-
bor despite its intellectual limitations. As Lamour put it, "rationalization and its poli-
tics of high salaries and credit, the religion of consumption and of well-being, have
suppressed the battle of classes by creating a unique class of producers." This argu-
ment resembles that developed by Gäetan Bernoville in his *Nouveau siècle* article "Le
travail et l'artisan," discussed in chapter 3.

48. See Hellman, *Emmanuel Mounier and the New Catholic Left*, 57–58; and Hellman,
 The Communitarian Third Way, 33–50.

49. Loubet del Bayle, *Les non-conformistes des années 30*, 81–104; Hellman, *Emmanuel
 Mounier and the New Catholic Left*, 52–70; and Hellman, *The Communitarian Third
 Way*, 29–32. Hellman notes that the "personalist" doctrine of Alexandre Marc and
 Emmanuel Mounier had a marked influence on the Ordre Nouveau, which resulted
 in an alliance between the group and Mounier following the demise of *Plans*. In
 the summer of 1932 Mounier told Marc he wanted "to found a review like *Plans*, in-
 spired by ideas close to Ordre Nouveau's—but Catholic,"—the result was the journal
 L'Esprit (Hellman, *Emmanuel Mounier*, 59; Hellman, *The Communitarian Third Way*,
 60–70). In his published response to Aron's and Dandieu's *Décadence de la nation
 française* (1931), Lamour numbered himself among the "personalists" by virtue of his
 own anti-individualism. See Lamour, "Lettre à Aron et Dandieu," 21.

50. Loubet del Bayle, *Les non-conformistes des années 30*, 97.

51. For evidence of Aron's and Dandieu's indebtedness to Sorel, see Roth, *The Cult of
 Violence*, 244–245.

52. Loubet del Bayle, *Les non-conformistes des années 30*, 92.

53. Ibid., 84–85.

54. See Mary Mcleod, "Urbanism and Utopia," 466; and Mcleod, "Le rêve transi de Le
 Corbusier."

55. Loubet del Bayle, *Les non-conformistes des années 30*, 98.

56. Ibid., 97.

57. See, Griffin, ed., *Oxford Readers*, 114–115; and Payne, *A History of Fascism, 1914–1945*,
 157–161. For an overview of left-wing Nazism, see Kele, *Nazi and Workers*. Following
 the demise of *Plans*, Alexandre Marc and Mounier promoted Strasser's anti-Hitler
 national socialism in the pages of Mounier's *L'Esprit*. As John Hellman notes, in the
 period leading up to Hitler's rise to power in 1933 *L'Esprit*'s contributors "attacked
 Hitler for his moderation" and "were more worried about the faults of the Weimar
 Republic, big capitalism, and parliamentary regimes." For an analysis of the fascist
 valences of *L'Esprit*, see Hellman, *Emmanuel Mounier and the New Catholic Left,
 1930–1950*, 56–65, and the chapter "Spiritual Fascism" in Sternhell, *Neither Right nor
 Left*, 213–265.

58. Hellman, *Emmanuel Mounier and the New Catholic Left*, 58–59.

59. Ibid., 58.

60. Loubet del Bayle, *Les non-conformistes des années 30*, 99–101; John Hellman notes that "Philippe Lamour and *Plans* also began distancing themselves from Alexandre Marc because of what they saw as his new soft-headed involvements with Catholics, and his relationship with the Jeune Droite." The Jewish Marc converted to Catholicism in September 1933 after two years of "spiritual counseling" by Jean Plaquevent, a priest who, like Marc, contributed regularly to *L'Esprit*. See Hellman, *The Communitarian Third Way*, 49–50, 78–82.

61. Lamour, "Sous le signe de la victoire," 3.

62. Ibid.

63. Lamour, "A ceux qui n'ont pas vingt-six ans," 1.

64. Ibid.

65. Lamour, "L'Assemblé Nationale de Reims," 1.

66. See Lamour, "Visite à l'Italie vivante: un peuple fasciste," 1; and Lamour, "Visite à l'Italie vivante: revue fasciste," 1.

67. For a comprehensive overview of this dimension of Mussolini's fascism, see Wohl, *The Generation of 1914*, 160–202.

68. Ibid., 175.

69. Ibid., 178.

70. Ibid. For a detailed study of Mussolini's political evolution and the function of Sorel's theory of myths in fascist ideology, see Sternhell, *The Birth of Fascist Ideology*, 195–232.

71. Passerini, "Youth as a Metaphor for Social Change," 288.

72. Wanrooij, "The Rise and Fall of Fascism as a Generational Revolt," 405.

73. Passerini, "Youth as a Metaphor for Social Change," 286.

74. Wanrooij, "The Rise and Fall of Fascism as a Generational Revolt," 417.

75. Passerini, "Youth as a Metaphor for Social Change," 293–294.

76. Ibid., 195–197.

77. Wohl, *The Generation of 1914*, 179–180.

78. Lamour, "Un agitateur d'idées," 1.

79. Ibid.

80. Pellizzi, *Problemi e realtà del fascismo*, 21; quoted in Sternhell, *The Birth of Fascist Ideology*, 231.

81. Sorel, *Reflections on Violence*, 50.

82. Ibid., 3–4.

83. Sorel, "Le syndicalisme révolutionnaire," *Le mouvement socialiste* 17 (1905): 273; quoted in Jennings, *Georges Sorel*, 120.

84. For a comprehensive analysis of Vico's impact on Sorel, see Stanley, "Sorel's Study of Vico." Sorel's most sustained analysis of Vico's writing is his "Etude sur Vico" in the October through December 1896 issues of *Devenir sociale*.

85. Sorel, "Etude sur Vico" (December 1896), 1023; cited in Piccolomini, "Vico, Sorel, and Modern Artistic Primitivism," 123–130.

86. Stanley, "Sorel's Study of Vico," 19.

87. Sorel, *Reflections on Violence*, 6.

88. Lamour, *Entretiens sous la tour Eiffel*.

89. Ibid., 184–186.

90. Ibid., 9–12.

91. Sorel, *Reflections on Violence*, 137.

92. Lamour, *Entretiens sous la tour Eiffel*, 65. For an analysis of Valois's own recourse to Sorel's theory of images in trumpeting the productivist import of Le Corbusier's urbanism, see chapter 3.

93. Lamour, *Entretiens sous la tour Eiffel*, 52.

94. Ibid., 55. Le Corbusier, *Urbanisme* (1925), translated as *The City of Tomorrow and Its Planning*, 8, 259–270.

95. Lamour, *Entretiens sous la tour Eiffel*, 64–65.

96. Ibid., 69–70.

97. Ibid., 178–190.

98. Since 1929 Henri de Jouvenel had been conducting a campaign in *La revue des vivants* for better relations with Italy; in 1932 his efforts were rewarded when premier Paul Boncour named him ambassador to Italy. On Henri de Jouvenel's complex political trajectory, see Binion, *Defeated Leaders*, 119–194.

99. Lamour, "La pensée des jeunes: sur une prétendue crise de l'esprit," 150–154.

100. Ibid., 153–154.

101. Lamour, "La pensée des jeunes: à propos d'un chien andalou," 636.

102. Ibid., 636.

103. Lamour, "Inventaires U.S.A.," 55; and Lamour, "L'art mécanique," 38.

104. Lamour, "L'Art mécanique," 38–39.

105. Ibid.

106. Ibid., 39.

107. Lamour, "Première étape," 13–22.

108. Hurel, "La confusion des arts," 71–74.

109. Ibid., 73. "Alors jetons nos yeux, et jetons l'oeil aussi de l'objectif, ô Germaine Krull! sur ces longues routes ferrées: le rail; sur ces fils appendus le long; dans ce domaine secret des ondes. Levons les yeux sur notre tour, la tour Eiffel, neuve Babel constructive, jeune clarté des langues, espéranto de fer, de ponts en treillis tressés, de trapèzes. Voyons le jeu, le feu des ateliers, le roulement mondial des turbines, et prêtons notre oreilles aux bruits impérieux, royaux, alternés, des courants, des volants. L'énorme rotation des cieux éveille enfin les forces de la terre. Et l'homme étonné court d'une source à l'autre, jaillissantes en énergies neuves et rares; inépuisables."

110. Ibid., 74.

111. Herbief, "L'Art de mentir," 72–73.

112. Ibid., 73–74.

113. Ibid., 75–77.

114. Herbiet, "Bons du trésor," 69–70.

115. Ibid., 70.

116. Herbiet, "Bons du trésor," 73–74.

117. Lamour, "Première étape," 19–21; Lurcat, "Esprit collectif et architecture"; and Le Corbusier and Jeanneret, "Analyse des éléments fondamentaux." This essay by Le Corbusier and Jeanneret on the maison minimum was a summary of their 1929 report to the Congrès Internationaux d'Architecture Moderne. See McLeod, "Urbanism and Utopia," 106–108.

118. On Le Corbusier's political evolution from his affiliation with technocratic conservatism of the Redressement Française movement in the late 1920s to his endorsement of regional syndicalism in the 1930s, see McLeod, "Urbanism and Utopia," 94–165; for Lurçat's contacts, during the late 1920s, with leftists such as Henri Barbusse and the communist Vaillant-Couturier, see Cohen, *André Lurçat, 1894–1970*, 143–144.

119. Lurçat, "Esprit collectif et architecture," 38–39.

120. Ibid., 39.

121. Ibid., 41.

122. Ibid., 44.

123. Ibid., 44–45.

124. Ibid., 48–49.

125. Ibid., 50.

126. Lamour, "Première étape," 20.

127. Ibid. For an overview of Lagardelle's concept of the "real man" and its political ramifications for French cultural politics in the 1930s, see Sternhell, *Neither Right nor Left*, 187–203; and Golan, *Modernity and Nostalgia*, 85–104.

128. For a comprehensive analysis of Lagardelle's impact on Le Corbusier while he developed the Plan Orbus, see McLeod, "Le Corbusier and Algiers," 53–85. For an analysis of the maison minimum, see McLeod, "Urbanism and Utopia," 106–108.

129. Le Corbusier and Jeanneret, "Analyse des éléments fondamentaux," 26.

130. Ibid., 27–28.

131. Ibid., 28.

132. Ibid., 28–29.

133. Ibid., 33–34.

134. Ibid., 36.

135. Ibid., 33–34.

136. Krull's political travails are outlined by Krull herself in her autobiography and in Kim Sichel's comprehensive monograph on the photographer. See Krull, *La vita conduce la danza*; and Sichel, *Germaine Krull: Photographer of Modernity*.

137. Bouqueret, "Germaine Krull, photographie 1924–1936," 11–13. For a historical analysis of the Leninist suppression of anarchist groups in Moscow and Leningrad, see Maximoff, *The Guillotine at Work*.

138. See Sichel, *Germaine Krull*, 20–28, 40–43, 67–82.

139. On Krull's relations with Fels, see chapters 5 and 6 in Sichel, *Germaine Krull*.

140. Papanikolas has analyzed the influence of the anarchoindividualist Gérard Lacaze-Duthiers on Fels and the critic's early writings in the anarchoindividualist magazines *La mêlée* (1918–20) and *Action* (1920–1922). See chapter 1, "Anarchism and Anarcho-individualism in Postwar France," in Papanikolas, "The Cultural Politics of Paris Dada, 1914–1922."

141. Krull, *La vita conduce la danza*, 154–155.

142. Bouqueret, "Germaine Krull, photographie 1924–1936," 13.

143. Sichel, *Germaine Krull*, 124–125.

144. Krull, *La vita conduce la danza*, 155–157.

145. Eisenstein, "La quatrième dimension au cinéma," 19–26. In his memoirs Eisenstein recalled being introduced to Lamour by Krull, and that it was Renaud de Jouvenel who had asked him to contribute an article to *Grand'Route*. Eisenstein also recorded his disapproval of Renaud's father, Henri de Jouvenel, due to the latter's fascist sympathies and diplomatic role in arranging "the entente cordiale with Mussolini." See Eisenstein, *Beyond the Stars: Memoirs of Sergei Eisenstein*, 205–206, 213. The article published in *Grand'Route* was based on an essay originally published in Russian in 1929 and subsequently translated into English under the title "The Fourth Dimension and the Kino" for the journal *Close Up* in its March–April 1930 issue.

146. Lamour, "La pensée des jeunes: sur une prétendue crise de l'esprit," 150–154.

147. Eisenstein, "La quatrième dimension au cinéma," 19–26.

148. For an analysis of the symbolist and synesthetic roots of Eisenstein's theory of the fourth dimension, see Michelson, "The Wings of Hypothesis."

149. Eisenstein, "The Cinematographic Principle and the Ideogram" (1929), reprinted in Eisenstein, *Film Form*, 38.

150. Sichel, *Germaine Krull*, 101–105.

151. Florent Fels, "Dans toute sa force," *Vu* (31 May 1928): 284; quoted in Sichel, *Germaine Krull*, 103–104.

152. Hurel, "La confusion des arts," 71–74.

153. Sichel, *Germaine Krull*, 106–110.

154. Danjou, "Les clochards dans les bas-fonds de Paris—ceux de La Maubert," 688–690. Krull, *La vita conduce la danza*, 149–150; quoted in Sichel, *Germaine Krull*, 107.

153. Sichel, *Germaine Krull*, 108–109. On the *trimardeur*, see Hutton, "'Les Prolos Vagabondent': Neo-Impressionism and the Anarchist Image of the Trimardeur," 296–309.

156. Ben-Ghiat, *Fascist Modernities*, 102–107.

157. The Italian rationalist movement began in 1926 with the publication of a series of articles in *Rassegna italiana*, signed by seven young architects: Ubalda Castagnoli, Luigi Figini, Guido Frette, Sebastiano Larco, Gino Pollini, Carlo Enrico Rava, and Giuseppi Terragni (Adalberto Libera replaced Castagnoli in 1927). The "Gruppo 7" claimed to represent a "new spirit" in architecture, akin to that which Le Corbusier was forging in France. On the history of the Gruppo 7, see Doordan, *Building Mod-*

ern Italy: Italian Architecture, 1914–1936; on the rationalists' adaptation of Le Corbusier's theories to fascism in the late 1920s and early 1930s, see Etlin, *Modernism and Italian Architecture, 1890–1940*, 249–254, 377–390.

5. Classical Violence

1. "Sans doute quand on se réfère à cette époque, a écrit Drieu La Rochelle, on s'aperçoit que quelques éléments de l'atmosphère fasciste étaient réunis en France vers 1913, avant qu'ils le fussent ailleurs. Il y avait des jeunes gens, sortis des diverses classes de la société, qui étaient animés par l'amour de l'heroïsme et la violence et qui rêvaient de combattre ce qu'ils appelaient le mal sur deux fronts: capitalisme et socialisme parlementaire, et prendre leur bien des deux côtés. Il y avait, je crois à Lyon, des gens qui s'intitulaieint socialistes-royalistes, ou quelque chose d'approchant. Déjà le mariage du nationalisme et du socialisme était projeté. Qui, en France, aux alentours de l'Action française et de Péguy, il y avait le nébuleuse d'une sorte de fascisme" [Undoubtedly, when one refers back to that period, wrote Drieu La Rochelle, one sees that certain elements of a fascist atmosphere came together in France around 1913, before they emerged elsewhere. They were young people, from various classes of society, who were animated by the love of heroism and of violence and who dreamed of combating what they called the evil on two fronts: capitalism and parliamentary socialism, and who were similarly disposed toward both. There were, I believe, people in Lyons who called themselves socialist-royalists, or something like that. A marriage of nationalism and socialism was already being envisaged. Yes, in France, among the groups surrounding the Action Française and Péguy, there was already the nebula of a sort of fascism]. Drieu La Rochelle, quoted in Andreu, "Fascisme 1913." Thierry Maulnier endorsed Andreu's text in his essay "Les deux violences." Zeev Sternhell has drawn attention to this text as well as other interwar testimonials claiming to locate the origins of national socialism in the avant-guerre confluence of the Left and Right exemplified by the Cercle Proudhon. See Sternhell, *Neither Right nor Left*, 7–33.
2. Formed out of an alliance of communists, socialists, and the newly reconfigured Confédération Générale du Travail, the Popular Front was headed by Léon Blum, leader of the Section Française de l'Internationale Ouvrière. For Maulnier, Blum was a modern-day Jaurès, who had joined the communists and syndicalists in betraying the revolutionary cause in a manner predicted by Sorel.
3. Thus Zeev Sternhell has described Maulnier as among those "fascistically inclined intellectuals who played a major role in undermining democracy in prewar France without assuming any direct responsibility for membership in a fascist party or organization." See Sternhell, *Neither Right nor Left*, 244.
4. See the chapter "A Literary Fascism beyond Fascism: Thierry Maulnier and the Ideology of Culture," in Carroll, *French Literary Fascism*.

5. Maulnier, "Le fascisme, l'antifascisme ou la France," and "Un fascisme minimum?"

6. Mussolini, "La dottrina del fascismo," 67–69; cited in Roth, *The Cult of Violence*, 248.

7. Roth, *The Cult of Violence*, 236–247. Roth cites Johannet, *Voyage à travers le capitalisme*; Lagardelle, "Le fascisme"; Lefèvre, "Une heure avec Jean Variot"; and Variot, *A propos de Sorel*.

8. Referring to both the Cercle Proudhon and the "Maulnier-Brassillach-Drieu group" Sternhell writes that "pre-war fascism, like that of the interwar period" rejected "capitalism as well as Marxism, democracy as well as social democracy, and replaced them with national socialism." See Sternhell, *Neither Right nor Left*, 215.

9. For Sternhell's analysis of the ideological agenda of *Combat*, and of Maulnier's related writings, see ibid., 221–265.

10. Mazgaj, "Engagement and the French Nationalist Right."

11. See ibid., 213–214, 218–229. Mazgaj has provided us with a subtle reading of Maulnier's ongoing response not only to the merging cultural politics of the Popular Front, but to political events in Europe between 1930 and the founding of *Combat* in 1936.

12. Roth, *The Cult of Violence*, 246–247; and Sternhell, *Neither Right nor Left*, 221–265. Although Roth and Sternhell have explored the impact of Sorelian ideology on the politics of *Combat*, neither has addressed the journal's cultural program. David Carroll has undertaken the latter project in his book on French literary fascism; however, he has not examined the Sorelian dimension of Maulnier's thought or the art promoted in *Combat* (1936–1939) and the related journal *Insurgé* (1937). See the chapter "A Literary Fascism beyond Fascism," in Carroll, *French Literary Fascism*. In this chapter I intend to build on the work of Roth, Sternhell, and Carroll by examining the artistic as well as the literary discourse of Maulnier and his colleagues.

13. See the chapter "Spiritualistic Fascism" in Sternhell, *Neither Right nor Left*; and the chapter "A Literary Fascism beyond Fascism" in Carroll, *French Literary Fascism*, 222–247. Mary Ann Frese Witt, like Carroll, has noted Maulnier's debt to Nietzsche in her brilliant analysis of Maulnier's theory of modern tragedy. Witt has demonstrated the centrality of tragedy in the development of the dramatic arts under Italian fascism, thus providing the broader ideological context for an understanding of Maulnier's writings on Greek tragedy and the tragedies of Racine in the 1930s. Witt also traces the impact of Maulnier's thought on dramatists Drieu La Rochelle, Robert Brasillach, Jean Anouilh, and Henry de Montherland. See Witt, *The Search for Modern Tragedy*. Jeffrey Mehlman has further explored the cultural legacy of *Combat* in his analysis of critic Maurice Blanchot's writings for that journal. See the chapter "Blanchot and Combat: Of Literature and Terror," in Mehlman, *Legacies of Anti-Semitism in France*.

14. The announcement appears in "L'activité de Combat." Gillouin's public campaign in 1937–1938 against the government's "canonization" of "foreigners" to the detriment of "native" French artists was inspired by the municipal government's sponsorship

of the exhibition Mâitres de l'Art Indépendant, which opened at the Petit Palais in May 1937 and closed in October of that year. For an analysis of the exhibition, and Gillouin's vitriolic criticism, see Herbert, *Paris 1937*, 99–109. The January 1937 issue of *Combat* contained an advertisement for yet another conference presided over by Abel Bonnard, titled "Le maintien de la spiritualité dans l'art"—once again Perret was a participant, along with the Catholic symbolist Maurice Denis.

15. For a succinct analysis of Perret's thwarted project, see Abram, "Perret et l'exposition"; and Lemoine, "Le palais de Chaillot."

16. Loisy, "Exposition 1937," 3.

17. See Roth, *The Cult of Violence*, 246.

18. Weber, *Action Française*, 180.

19. Ibid., 405; also see entries on Bonnard, Brasillach, Maulnier, and Maxence, in Rees, *Biographical Dictionary of the Extreme Right since 1890*.

20. On the journal, and Dominique Bertin's appeal to "national syndicalists" in the 3 February 1937 issue of *Insurgé*, see Weber, *Action Française*, 511; for Sorelian interpretations of the theme, also see Grandchamp, "Syndicalistes, nationalistes de tout le pays," 1; and Grandchamp, "Le syndicalisme sera antiparlementaire ou il mourra," 1.

21. Roditi, "L'homme nouveau"; cited in Roth, *The Cult of Violence*, 245.

22. See Roth, *The Cult of Violence*, 246; for Andreu's articles on Sorel, see Andreu, "Textes de Georges Sorel sur la morale et le socialisme," "Sorel et le procès de Socrate," and "Le socialisme de Sorel." For an overview of Spirito's trajectory, see Spirito, *Memoirs of the Twentieth Century*; and the chapters devoted to Spirito in Gregor, *Mussolini's Intellectuals*.

23. For a comprehensive study of Gentile's idealist philosophy and its relation to fascism, see Harris, *The Social Philosophy of Giovanni Gentile*.

24. Andreu published numerous articles lauding Spirito's concept of the producer, as well as translations of Spirito's own writings. See Andreu, "Positions de la jeunesse italienne"; Spirito, "Bureaucratie et Corporatisme"; Andreu, "Corporatisme et économie mixte"; Andreu, "Eléments d'une doctrine corporative"; Spirito, "Le corporatisme contre l'autarchie"; and Andreu, "Capitalisme et corporatisme." Andreu also drew comparisons between Spirito's corporativism and the Catholic corporativism of La Tour du Pin, noting on two occasions that Spirito's doctrine of corporative ownership was "anticipated by La Tour du Pin." See Andreu, "Eléments d'une doctrine corporative," and "Le corporatisme de La Tour du Pin."

25. Following Spirito's presentation of his theory of corporative ownership at the May 1932 Congress of Syndical and Corporative Studies in Ferrara, he was increasingly marginalized, culminating in his ouster from the chair of corporative studies at the University of Pisa and his internal "exile" to the University of Messina, Sicily, in 1935. Andreu remained ignorant of the fate of Spirito and his students until the spring of 1938, when he traveled to Italy. The Italian situation, combined with the dismemberment of Czechoslovakia in 1938, led to Andreu's disillusion with the politics of his

former allies. See Spirito, *Memoirs of theTwentieth Century*, 47–63, 111–118; Andreu, *Le rouge et le blanc*, 1928–1944, 135–136; and Gregor, *Mussolini's Intellectuals*, 134–139.

26. Andreu continued his practice, begun in *L'homme nouveau*, of publishing essays on Sorel as well as edited excerpts from Sorel's own writing. See Andreu, "Fascisme 1913," "Propos de Sorel," "Demain sur nos tombeaux. . . . ," "D'Aristote à Marx, par Georges Sorel," and "Texte à relire."

27. André Monconduit's articles include "Qu'est-ce que le fascisme?," "L'Organisation corporative italienne," and "Syndicats et corporations fascistes."

28. La revue universelle was cofounded by Maurras and Jacques Maritain to promote royalism and Thomist theology, with Jacques Bainville and Henri Massis as editors. Following Maritain's break with the *Action Française* in 1927, the journal continued to promote monarchism as the institutional structure best able to safeguard Western culture. For a history of the journal, see the chapter "The Defense of the West," in Keylor, *Jacques Bainville and the Renaissance of Royalist History in Twentieth-Century France*.

29. Maulnier "Le 'fascisme' et son avenir en France," 14–16.

30. "Cet événement extraordinaire peut survenir en France demain." Ibid., 16.

31. Ibid., 17.

32. Ibid., 19–20.

33. "Si les cadres des vieux partis tiennent encore, leur décomposition intérieure est assez avancée, le fossé qui sépare les vieux éléments conservateurs de la jeunesse novatrice et activiste est assez large, pour qu'un regroupement fasciste soit possible. Le mot est impopulaire; soit. Mais le chose peut naître sans le mot." Ibid., 22.

34. Ibid., 25.

35. Ibid., 26.

36. Maulnier, "Le socialisme antidémocratique de Georges Sorel," 370.

37. Ibid., 371–372.

38. Ibid., 372.

39. See Sorel, *Réflexions sur la violence*, 356–357; Sorel, *Reflections on Violence*, 271–272; Berth, *Les Méfaits des intellectuels*, 293; and Maulnier, *Nietzsche*, 21–22. Mary Ann Frese Witt has demonstrated the centrality of Nietzsche's *Birth of Tragedy* to Maulnier's concept of revolution, concluding that, for Maulnier, Nietzsche himself was the tragic figure par excellence, who embraced "heroism, sacrifice, self-transcendence and grandeur, opposing vitality to decadence" (Witt, *The Search for Modern Tragedy*, 140); see also 140–145.

40. Maulnier, "Le socialisme antidémocratique de Georges Sorel," 373–374.

41. "L'auteur des *Matériaux d'une théorie du prolélariat* [1919; rev. ed. 1921] n'a pas vécu assez longtemps pour voir le communisme entrer la voie ouverte par le socialisme, sombrer dans les combinaisons politiciennes, et obéissant aux consignes de cette même Russie nouvelle en laquelle Sorel avait espéré, entrer dans le Front populaire

pour le défense de la démocratie." Maulnier, "Le socialisme antidémocratique de Georges Sorel, 373.

42. Ibid., 374.

43. Maulnier, "A la recherche de l'état nouveau."

44. Maulnier, "Le socialisme antidémocratique de Georges Sorel," 373–374.

45. "Mais le principe d'une force révolutionnaire neuve au service d'un ordre national, politique, social véritable survivait; il le montrera, il l'a déjà montré." Ibid., 374.

46. Andreu, "Demain sur nos tombeaux"

47. In his *Reflections on Violence* Sorel repeatedly contrasted state-sanctioned violence with the ethical violence of the proletariat, arguing that the former had its basis in cruelty and greed. For instance in his critique of violence sanctioned by the state from the era of the Inquisition and the ancien régime to that of the contemporary Republic, Sorel argued that the judiciary engaged in acts of bloody persecution to augment state power; by contrast "proletarian acts of violence have no resemblance to these proscriptions" since they are "carried out without hatred and without the spirit of revenge" (121–122). See Sorel, *Reflections on Violence*, 108–122.

48. Andreu, "Textes à relire." See Sorel, *The Illusions of Progress*, 186.

49. Andreu, "Propos de Georges Sorel."

50. Andreu, "Fascisme 1913."

51. Berth, "Avant-propos," in *Les Méfaits des intellectuels*, 8–16; Berth singles out Benda, labeling him the epitome of the "modern intellectual" in a chapter titled "Tradition and Revolution" (38–44).

52. Berth, *Les Méfaits des intellectuels*, 23–24, 56–57.

53. Ibid., 45–47.

54. Ibid., 48.

55. Ibid., 45; for Sorel's own identification of classical tragedy and "that very ancient type, the Achaean type" with the continence of the modern revolutionary, see Sorel, *Réflexions sur la violence*, 357; and Sorel, *Reflections on Violence*, 271.

56. Berth, *Les Méfaits des intellectuels*, 329.

57. See the chapter "A Literary Fascism beyond Fascism: Thierry Maulnier and the Ideology of Culture," in Carroll, *French Literary Fascism*, 222–247.

58. Ibid., 223–224.

59. Ibid., 228. See Maulnier, *Nietzsche*; and Maulnier, *Racine*.

60. See Carroll's analysis of Maulnier's *Racine* in *French Literary Fascism*, 229–233.

61. Ibid., 226–227; and Witt, *The Search for Modern Tragedy*, 145–148. In Maulnier's estimation, Nietzsche was the "model tragic thinker in whom passion alters thought"; as a result his theory of classical tragedy captured "the tragic ideal of purity, . . . a Racinian purity." Maulnier, *Nietzsche*, 23, 47; cited in Carroll, *French Literary Fascism*, 226.

62. Maulnier, *Racine*, 23–24; cited in Carroll, *French Literary Fascism*, 230.

63. "Il faut crier bien haut, au contraire, que dans toute l'histoire humaine le plus grand

élan vital et le suprême épanouissement des énergies créatrices coïncident avec le triomphe de la perfection formelle." Maulnier, *Racine*, 24; quoted in Carroll, *French Literary Fascism*, 230.

64. Maulnier, *Nietzsche*, 241; quoted in Witt, *The Search for Modern Tragedy*, 143.

65. Maulnier described the unity of the Dionysian and Apollonian as that of "inspiration and technique, . . . the delirium of creative energy and the order instituted by the intelligence." Maulnier, *Racine*; quoted in Carroll, *French Literary Fascism*, 231.

66. Witt has also noted the Bergsonian vitalism underlying Maulnier's criticism. See Witt, *The Search for Modern Tragedy*, 143, 145.

67. Carroll, *French Literary Fascism*, 235–247.

68. Maulnier critiqued the "collectivism" of democracy, communism, and of Fascist Italy and Nazi Germany in his book *Mythes Socialistes*; Carroll has analyzed this aspect of Maulnier's thought in *French Literary Fascism*, 235–237, 241–242.

69. Carroll, *French Literary Fascism*, 236–237, and Maulnier, *Mythes Socialistes*, 56–59, 92.

70. Sorel, *Reflections on Violence*, 282–284; Berth, *Le Méfaits des intellectuels*, 87–130. See my discussion of this issue in the section titled "The Abstract Citizen" in chapter 2.

71. Maulnier, *Mythes socialistes*, 26, 100.

72. As Maulnier put it in his "Notes sur fascisme," published in the December 1938 issue of *Combat*, "Totalitarian regimes have given the state, as a political instrument, the servant of national destiny, an extraordinary efficacy. They have given . . . to the proletariat an organic participation in community life. They have invented an economic technique, which, in spite of imperfections, . . . has beaten capitalism . . . in the domain of productivity. They have invented a social morality in many respects very superior to the 'morality' of democratic states." Quoted in Carroll, *French Literary Fascism*, 243.

73. "Dans la mesure même où le fascisme a donné à nos voisins un extraordinaire puissance, une extraordinaire efficacité, une extraordinaire rapidité dans l'action diplomatique et militaire, que la démocratie ne connait pas, il nous faut, pour leur résister, accepter de subir, nous aussi, un minimum de 'fascisme.' Il ne s'agit pas ici de préférences idéologiques. Il s'agit de force." Elsewhere in the same article Maulnier states that he is not calling for emergence of another "union sacrée" in response to the Nazi threat. The "exceptional measures" taken should not result in a return to the old order once the threat has passed, instead they should lead to "the advent of the new society." See Maulnier, "Un fascisme minimum?" Maulnier had expressed similar views the previous month. See Maulnier, "Le fascisme, l'antifascisme ou la France?"

74. Maulnier, "Les deux violences."

75. "Le vieux lutteur prolétarien avait vu assez justement que, dans tout le champ des partis et des doctrines de l'avant-guerre, on ne trouvait plus la violence, c'est à dire le

courage des idées, l'irréspect et l'indépendance à l'égard de l'ordre établi, la volonté de rupture qu'à l'extrême droite maurrassienne." Ibid.,

76. Ibid.

77. Sternhell has also analyzed Maulnier's Sorelian contributions to *Combat* in Sternhell, *Neither Right nor Left*, 223–250.

78. For an overview of Blum's negotiations and the events leading up to the Matignon Agreements, see Bernard and Dubief, *The Decline of the Third Republic, 1914–1938*, 306–311.

79. Maulnier, "La fin d'un 'ordre.'"

80. Maulnier, "Les deux trahisons," 1, 3.

81. Maxence, "Pas de nationalisme valuable sans justice sociale," 1, 3.

82. Ibid.

83. For a concise analysis of the AEAR and its role in promoting socialist realism in France, see the chapter "The Beginnings of Socialist Realism," in Flower, *Literature and the Left in France*.

84. Ibid., 102–105.

85. Ibid., 105–108.

86. For a succinct analysis of Aragon's position, as related to the visual arts, see Green, *Art in France, 1900–1940*, 174–175.

87. Jean-Louis Garcin, "Exposition: les peintres de réalité en France au 17e siècle," *Commune, revue de l'Association des Peintres et des Artistes Révolutionnaires* (January 1935): 647; cited in Golan, *Modernity and Nostalgia*, 124.

88. Paris, Exhibition Internationale, Pavilyon SSSR na Mezhdunarodnut vystavke v Parizhe; cited in Golomstock, *Totalitarian Art*, 133.

89. See Golan, *Modernity and Nostalgia*, 123–128; Pignon was an active participant in the Maison de la Culture movement, along with artists Jean Lurçat, Boris Taslitzky, and André Fougeron. For a discussion of artists affiliated with the Maison de la Culture, see Green, *Art in France, 1900–1940*, 174–182.

90. See Golan, *Modernity and Nostalgia*, 123–128.

91. For historical overviews of the Popular Front era, see Bernard and Dubief, *The Decline of the Third Republic, 1914–1938*, 219–228, 285–333; Joll, "The Front Populaire—After Thirty Years," 27–42; and Ory, *La belle illusion*.

92. Cited in Joll, "The Front Populaire," 27.

93. Bernard and Dubief, *The Decline of the Third Republic*, 285–298.

94. Ibid., 316–320.

95. See Golan, *Modernity and Nostalgia*; Herbert, *Paris 1937*; Lebovics, *True France*; and Peer, *France on Display*.

96. Peer, *France on Display*, 27. For a comprehensive analysis of the cultural and political upheavals that hampered the fair's development, see the chapter "Shaping the Exhibition," in ibid., 21–51.

97. Ibid., 33–37.

98. For an analysis of the exhibition and its critical reception in the French press, see Herbert, *Paris 1937*, 83–99.

99. Abel Bonnard, "Le génie française," *Candide*, 22 July 1937; and Lucien Rebatet, "Les chefs d'oeuvre de l'art français," *Revue universelle* (15 August 1937), 5; both quoted in Herbert, *Paris 1937*, 84, 88–89.

100. James Herbert has analyzed this exhibition as well; see Herbert, *Paris 1937*, 99–109.

101. Gillouin, "La farce de l'art vivant," 271, 282–283. As Herbert notes, Gillouin's article was a condensed version of a diatribe he had published in the Paris Municipal Council's *Bulletin municipal officiel de la ville de Paris* on 17 December 1937.

102. Rebatet, Brasillach, and Maulnier all contributed to radical right, anti-Semitic publication *Je suis partout* (1930–1944); Bonnard, Gillouin, Brasillach, and *Combat*'s art critic Jean Loisy all spoke at the conference "Tradition and Revolution" organized by *Combat* on 29 June 1936. See "L'activité de *Combat*." *Combat* also published a laudatory review of Bonnard's attack on France's democratic institutions in his book *Les modérés* (1936). See de Fabrèques, "Abel Bonnard, Les modérés."

103. Peer, *France on Display*, 34.

104. See ibid., 34, 196 n. 62.

105. Léon Blum and Léon Jouhaux are cited in ibid., 34.

106. Maulnier, "Syndicalisme?" 1, 3.

107. Ibid., 1, 3.

108. "Paris défiguré," 1.

109. Richard, "La comédie de l'exposition," 1; cited in Peer, *France on Display*, 35–36.

110. Peer, *France on Display*, 40–42.

111. See in particular Maulnier, "Les essais," 110–114; Maulnier, "Un régime ennemi des arts"; Brasillach, " Les pompiers avec nous!"; Loisy, "L'art dans la société contemporaine."

112. Maulnier, "Inspiration et métier," 110–111.

113. "Rien de plus significatif que l'image anatomique choisie par Stravinsky pour signifier qu'on ne saurait concevoir le force créatrice, comme un torrent jaillissant sans contrôle, pour accepter ensuite la contrainte d'un ordre imposé, et que l'inspiration ou la création, doivent être, au contraire, conçues comme un développement organique, où l'oeuvre trouve la loi de son existence en même temps que son existence même, où elle naît des profoundeurs de l'âme par une sorte d'effort de définition. 'La création, c'est un besoin de l'ordre.' " Maulnier, "Inspiration et métier," 111.

114. Ibid., 112–113.

115. Ibid., 114.

116. Ibid., 113.

117. Maulnier, "Les conservateurs."

118. Maulnier, "A bas la culture bourgeois!"

119. Ibid.

120. Loisy, "L'art dans la société contemporaine."

121. Gide, who had visited the Soviet Union in 1935, was an ally of the Popular Front and AEAR's cultural policies from 1934 to the Popular Front's demise in 1938. On Gide's activities during this period see Fowler, *Literature and the Left in France*; and Ory, *La belle illusion*.

122. "Leur science les oblige à être traditionalistes, leur curiosité à être révolutionnaires, car la tradition, seule, produit l'académisme et la révolution, seule, l'anarchie." Loisy, "L'art dans la société contemporaine."

123. Loisy, "Notes sur Cézanne."

124. For an analysis of the maison de la culture movement and its role in literary and artistic circles during the Popular Front era, see the chapters "Convergence," "Livre," and "Arts plastiques," in Ory, *La belle illusion*.

125. Brasillach, "Les pompiers avec nous!"

126. "Je trouve plus de révolution dans les pommes de Cézanne que dans les romans naturalistes d'Aragon." Ibid.

127. Loisy, "Art pour le peuple," 5; Loisy, "L'Art français de 1895 à 1925," 5; Loisy, "Le 1 mai devait s'ouvrir l'exposition," 4.

128. Loisy, "Art pour le peuple," 5.

129. Loisy, "A propos de l'art populaire," 5.

130. Ibid.

131. Loisy, "L'Art français de 1895 à 1925," 5.

132. Ibid.

133. Maulnier, "Cherchez ailleurs l'Exposition," 1.

134. Aureillan, "Maillol et Despiau: gloires nationales," 5.

135. For an overview of Despiau's career, see Amann, *Charles Albert Despiau, 1874–1946*; and Elliot, "Sculpture in France and Classicism, 1910–1939," 283–295. Despiau's Apollo was not completed in time for the World's Fair and he continued to work on the project from 1937 to his death in 1946.

136. Elliot, "Sculpture in France and Classicism, 1910–1939," 100.

137. See ibid., 286–287; Elizabeth Cowling's catalog notes on Maillol in Cowling and Mundy, eds., *On Classic Ground*, 148–156; Walter, "Le comte Kessler, Maillol et Hofmannstahl en Grèce," 145–150; and Rinuy, "Maillol dans la sculpture française de l'entre-deux-guerres," 167–173.

138. Denis, *Aristide Maillol*, cited in Cowling and Mundy, eds., *On Classic Ground*, 148.

139. Orland, "Maillol."

140. On La Fontaine's role in the "ancients" verses "moderns" debate, see Dejean, *Ancients against Moderns*, 42–51.

141. "Il est un grand contemporain à qui Maillol fait souvent songer. C'est Charles Maurras. Chez ces deux Grecs de notre Midi, il y a beaucoup de résonances semblables. Devant les Koré de l'Erechtheion, Maillol se sent ému comme s'il retrouvait des soeurs aimées. . . . N'est-ce pas Maurras à Athènes? Il y a chez l'un comme chez l'autre . . . cette même chaleur de vie dans la création incorruptible." Orland, "Maillol."

142. See Green, "Classicism of Transcendence and of Transience."

143. See Elizabeth Cowling's note on Maillol's Three Nymphs in Cowling and Mundy, eds., *On Classic Ground*, 156.

144. Denis, *Aristide Maillol*, cited in Cowling and Mundy, eds., *On Classic Ground*, 156.

145. Elliott, "Sculpture in France," 289–291.

146. Ibid., 283–295.

147. Ibid., 290–291.

148. Loisy, "Exposition 1937," 3.

149. For a cogent analysis of Perret's design, see Britten, *Auguste Perret*, 206–207.

150. Maulnier, "Un régime ennemi des arts"; in addition to Loisy's article "L'Exposition 1937," *Insurgé*, 13 January 1937, see his other articles "Un temoignage de la démogogie française," 4; "Art pour le peuple," 5; and "Le 1 mai devait s'ouvrir l'exposition," 4.

151. Monnier, "Les commandes de l'état," in Cohen, Abram, and Lambert, eds., *Encyclopédie Perret*, 248–249.

152. Ory, *La belle illusion*, 871 n. 361.

153. Ibid., 254; and Britton, *Auguste Perret*, 170–178.

154. See the entries "Italie," by Michela Rosso, and "Margherita Sarfatti," by Scrivano Paolo, in Cohen, Abram, and Lambert, eds., *Encyclopédie Perret*, 275–276, 351–356.

155. Christian Freigang, "Politique," in Cohen, Abram, and Lambert, eds., *Encyclopedie Perret*, 252–253; and Perret, "M. Auguste Perret nous dit . . . ," 5–7.

156. Michela Rosso, "Italie," in Cohen, Abram, and Lambert, eds., *Encyclopédie Perret*, 353.

157. For details on this manuscript, see Scrivano Paolo, "Mussolini bâtisseur," in Cohen, Abram, and Lambert, eds., *Encyclopédie Perret*, 252–253.

158. See the entries "Classicisme versus romanticisme" (Christian Freigang), "Antiquité" (Hubert Lempereur), "Parthenon" (Panayotis Tournikiotis), and "Grèce" (Panayotis Tournikiotis) in Cohen, Abram, and Lambert, eds., *Encyclopédie Perret*, 41–43, 348–350.

159. Perret, "L'Architecture," 41–50; translation in Britten, *Auguste Perret*, 237–243. As Britten notes, the essay was based on a lecture given at the Institut d'Art et d'Archéologie, Paris, on 30 May 1933.

160. Perret, "L'Architecture," 241.

161. "L'architecture obéit à certaines lois permanentes qui régissent la stabilité et l'harmonie des édifices. Avec les lieux et les époques, au contraire, varient les matériaux dont dispose l'architecte et l'emploi de ces matériaux se fait suivant des règles techniques qui influent sur l'architecture. Enfin l'individu ou la collectivité qui commande ces édifices à l'architecte lui impose par là même un certain programme correspondant à des besoins, donc variable suivant les lieux, les époques, et les destinations." Auguste Perret, quoted in Loisy, "L'Art dans la société contemporaine." I have been unable to trace the original source for this quotation.

162. Mazgaj, "Engagement and the French Nationalist Right," 223–227.

163. Maulnier, "Suicide de Europe?" *La revue universelle* (1 October 1935): 103; quoted in Mazgaj, "Engagement and the French Nationalist Right," 226.

164. For a succinct analysis of Italy's shift into the orbit of Nazi Germany following the end of the Ethiopian war in May 1936, see Neville, *Mussolini*, 136–161.

165. Maulnier closed his article with the following declaration: "Nous pouvons n'accepter qu'un 'fascisme minimum.' Nous ne pouvons accepter qu'un 'fascisme provisoire.'" Maulnier, "Un fascisme minimum?"

166. "Les mesures exceptionnelles dont la France a besoin aujourd'hui, ne doivent pas avoir pour terme naturel, et inévitable, une fois le danger passé, le retour au régime d'hier, mais l'avènement de la société nouvelle." Maulnier, "Un fascisme minimum?"

167. Benda, La trahison des clercs; English translation by Aldington as *The Betrayal of the Intellectuals* (1928). For Combat's critique, see Cely and Morel, "Violence et classicisme." For a comprehensive analysis of Benda's *La trahison des clercs* and related texts, see the chapter "Political Passions" in Nichols, *Treason, Tradition, and the Intellectual.*

168. Benda, *La trahisons des clercs*, 20–29; cited in Nichols, *Treason, Tradition, and the Intellectual*, 96.

169. Benda, *La fin de l'éternel*, 203–204; cited in Nichols, *Treason, Tradition, and the Intellectual*, 97.

170. Benda, *La trahison des clercs*, 61–63; cited in Nichols, *Treason, Tradition, and the Intellectual*, 99.

171. Benda, *La trahison des clercs*, 59–74, 77–80; cited in Nichols, *Treason, Tradition, and the Intellectual*, 105–106.

172. Benda, *La trahison des clercs*, 98–119, cited in Nichols, *Treason, Tradition, and the Intellectual*, 109–110, 113.

173. Benda, *La trahison des clercs*, 135–143, 188; cited in Nichols, *Treason, Tradition, and the Intellectual*, 113–115.

174. "Les classiques, et c'est ce qui les différencie des malades romanitiques, placent l'intelligence avant le coeur; mais ils n'excluent pas ce dernier." Cely and Morel, "Violence et classicisme."

175. "Les romantiques ont amoindri l'homme en acceptant la servitude des passions, en la glorifiant. Mais il est aussi dangereux de se contenter de la froide intelligence critique; il est trop aisé d'excuser sa sécheresse naturelle en se disant esprit pur. Ces différentes conceptions de l'homme, qu'un romantisme exacerbé et un classicisme dégénéré nous proposent, sont, de points de vue différents, d'égales multilations de l'esprit. . . . Qui nous délivrera de ces mensongères synthèses humaines, pour nous permettre de retrouver et de reconnaître l'homme entier?" [The romantics have diminished humanity by accepting the servitude of passions, by glorifying it. But it is also dangerous to be satisfied with cold critical intelligence; it is too easy to excuse its natural dryness by calling it pure spirit. These different conceptions of mankind that an exacerbated romanticism and a degenerate classicism propose to us, are, from

different perspectives, both mutilations of the spirit. . . . Who will deliver us from these false human syntheses, to allow us to regain and to recognize the entire man?]. Cely and Morel, "Violence et classicisme."

176. Cely and Morel mock Benda's claim to pursue "classical ethics" by noting that the authors Benda cites in this regard are "Nicole et Pellisson"—minor figures in the classical pantheon. To counter Benda's argument Cely and Morel pronounce themselves to be "modestement contentés de relire quelques préfaces de Racine" for evidence of the passion and activism native to the classical mentalité. Cely and Morel, "Violence et classicisme."

BIBLIOGRAPHY

Abram, Joseph. "Perret et l'exposition." In *Paris 1937 cinquantennaire: Exposition Internationale des arts et des techniques dans la vie moderne*, edited by Bertrand Lemoine, 66–71. Paris: Institut Français d'Architecture, 1987.

"L'activité de *Combat*." *Combat* (July 1936).

Adamson, Walter. *Avant-Garde Florence: From Modernism to Fascism*. Cambridge, Mass.: Harvard University Press, 1993.

———. "The Culture of Italian Fascism and the Fascist Crisis of Modernity—The Case of *Il Selvaggio*." *Journal of Contemporary History* (October 1995): 555–575.

———. "Fascism and Culture: Avant-Gardes and Secular Religion in the Italian Case." *Journal of Contemporary History* 24 (1989): 411–435.

———. "The Language of Opposition in Early Twentieth-Century Italy: Rhetorical Continuities between Prewar Florentine Avant-Gardism and Mussolini's Fascism." *Journal of Modern History* 64 (March 1992): 22–51.

———. "Soffici and the Religion of Art." In *Fascist Visions: Art and Ideology in France and Italy*, edited by Matthew Affron and Mark Antliff, 46–72. Princeton: Princeton University Press, 1997.

Ades, Dawn, Tim Benton, David Elliot, and Iain Boyd Whyte, eds. *Art and Power: Europe under the Dictators, 1930–45*. London: Thames and Hudson, 1995.

Affron, Matthew. "Waldemar George: A Parisian Art Critic on Modernism and Fascism." In *Fascist Visions: Art and Ideology in France and Italy*, edited by Matthew Affron and Mark Antliff, 171–204. Princeton: Princeton University Press, 1997.

Affron, Matthew, and Mark Antliff. Introduction to *Fascist Visions: Art and Ideology in France and Italy*, edited by Matthew Affron and Mark Antliff, 3–24. Princeton: Princeton University Press, 1997.

Amann, A. H. *Charles Albert Despiau, 1874–1946*. Marsan: Collections du Musée municipal de Mont-de-Marsan, 1974.

Andreasi, Annamaria. "Il nazionalismo nelle lettere di Sorel a Benedetto Croce." *Georges Sorel: studi e recerche* (1974): 155–158.

Andreu, Pierre. "Capitalisme et corporatisme." *Combat* (August–September 1937).

———. "Corporatisme et économie mixte." *L'homme nouveau* (1 February 1935).

———. "Le corporatisme de La Tour du Pin." *L'homme nouveau* (1 April 1935).

———. "D'Aristote à Marx, par Georges Sorel." *Combat* (June 1936).

———. "Demain sur nos tombeaux. . . ." *Combat* (April 1936).

———. "Eléments d'une doctrine corporative." *L'homme nouveau* (1 March 1935).

———. "Fascisme 1913." *Combat* (February 1936).

———. *Georges Sorel: entre le noir at le rouge*. Paris: Editions Syros, 1982.

———. *Notre maître, Georges Sorel*. Paris: Editions Bernard Grasset, 1953.

———. "Positions de la jeunesse italienne." *L'homme nouveau* (1 October 1934).

———. "Propos de Sorel." *Combat* (March 1936).

———. *Le rouge et le blanc, 1928–1944*. Paris: La Table Ronde, 1977.

———. "Le socialisme de Sorel." *L'homme nouveau* (June 1935).

———. "Sorel et le procès de Socrate." *L'homme nouveau* (1 May 1935).

———. "Texte à Relire: Georges Sorel." *Combat* (July 1936).

———. "Textes de Georges Sorel sur la morale et le socialisme." *L'homme nouveau* (1 March 1935).

"Les animateurs: M. Henry Ford." *Nouveau siècle* (13 March 1927): 1.

"Les animateurs: Le Corbusier." *Nouveau siècle* (9 January 1927): 1.

"Les animateurs: M. Mallet-Stevens." *Nouveau siècle* (31 July 1927): 1.

Antliff, Mark. "*La Cité française*: Georges Valois, Le Corbusier, and Fascist Theories of Urbanism." In *Fascist Visions: Art and Ideology in France and Italy*, edited by Matthew Affron and Mark Antliff, 134–170. Princeton: Princeton University Press, 1997.

———. *Inventing Bergson: Cultural Politics and the Parisian Avant-Garde*. Princeton: Princeton University Press, 1993.

———. "The Jew as Anti-Artist: Georges Sorel, Anti-Semitism, and the Aesthetics of Class Consciousness." *Oxford Art Journal* 20.1 (1997): 50–67.

———. "Machine Primitives: Philippe Lamour, Germaine Krull, and the Fascist Cult of Youth." *Qui parle* (Fall/Winter 2001): 57–102.

Antliff, Mark, and Patricia Leighten. "Primitive." In *Critical Terms for Art History*, rev. ed., edited by Robert Nelson and Richard Shiff, 217–233. 1996; Chicago: University of Chicago Press, 2003.

Apollonio, Umbro, ed. *Futurist Manifestos*. London: Thames and Hudson, 1973.

Aureillan, Etienne. "Maillol et Despiau: gloires nationales." *Insurgé* (23 June 1937): 5.

Austin, Bertram, and W. Francis Lloyd. *The Secret of High Wages*. New York: Dodd, Mead, 1926.

Barrès, Maurice. *Greco, ou le secret de Tolède*. Paris: Emile-Paul, 1912.

———. *Le jubilé de Jeanne d'Arc*. Paris: Editions de l'Indépendance, 1913.

Barrès, Philippe. "Le sentiment de la victoire." *Nouveau siècle* (12 November, 1925): 3.

Barron, Stephanie. "1937: Modern Art and Politics in Prewar Germany." In *"Degenerate Art": The Fate of the Avant-Garde in Nazi Germany*, edited by Stephanie Barron, 9–31. New York: Abrams and Los Angeles County Museum of Art, 1991.

Bauman, Zygmunt. *Modernity and the Holocaust*. Ithaca, N.Y.: Cornell University Press, 1989.

Benda, Julien. *La fin de l'éternel*. Paris: Gallimard, 1928.

———. *La trahison des clercs*. Paris: Grasset, Les cahiers verts (1927). Translated by Richard Aldington as *The Betrayal of the Intellectuals* (1928); reprint, Boston: Beacon Press, 1955.

Ben-Ghiat, Ruth. *Fascist Modernities: Italy, 1922–1945*. Berkeley: University of California Press, 2001.

Benjamin, Walter. *Illuminations*. Translated by Harry Zohn. New York: Schocken, 1969.

Benton, Tim. "Rome Reclaims Its Empire." In *Art and Power: Europe under the Dictators, 1930–45*, edited by Dawn Ades, Tim Benton, David Elliot, and Iain Boyd Whyte, 120–129. London: Thames and Hudson, 1995.

Berezin, Mabel. *The Making of the Fascist Self: The Political Culture of Interwar Italy*. Ithaca, N.Y.: Cornell University Press, 1997.

Berghaus, Günther, ed. *Fascism and Theatre: Comparative Studies on Aesthetics and Politics of Performance in Europe, 1925–1945*. Providence: Berghahn Books, 1996.

———. *Futurism and Politics: Between Anarchist Rebellion and Fascist Reaction, 1909–1944*. Oxford: Berghahn Books, 1996.

Bergson, Henri. *Creative Evolution*. Translated by Arthur Mitchell. New York: Random House, 1944.

———. *Matter and Memory*. Translated by N. M. Paul and W. S. Palmer. New York: Humanities Press, 1978.

———. "La signification de la guerre." *Le temps* (17 January 1915).

Berman, Russell A. "German Primitivism/Primitive Germany: The Case of Emil Nolde." In *Fascism, Aesthetics, and Culture*, edited by Richard J. Golsan, 56–66. Hanover, N.H.: University Press of New England, 1992.

———. *Modern Culture and Critical Theory: Art, Politics, and the Legacy of the Frankfurt School*. Madison: University of Wisconsin Press, 1989.

Bernard, Philippe, and Henri Dubief. *The Decline of the Third Republic, 1914–1938*. Cambridge: Cambridge University Press, 1985.

Bernoville, Gäetan. "Le travail et l'artisan." *Nouveau siècle* (1 May 1927): 4.

Berth, Edouard. "Anarchisme individualiste, Marxisme orthodox, syndicalisme révolutionnaire." *Le mouvement socialiste* (May 1905): 6–35.

———. *Les Méfaits des intellectuels*, 1914. Reprint. Paris: Marcel Rivière, 1926.

——— (pseudonym Jean Darville), Henri Lagrange, Gilbert Maire, René De Marsan, André Pascalon, Marius Riquier, Georges Valois, Albert Vincent. "Déclaration." *Cahiers du Cercle Proudhon* (January–February 1912): 1–2.

——— (pseudonym Jean Darville). "Satellites de la Ploutocratie (December 1912)." *Cahiers du Cercle Proudhon* 5–6 (1913): 177–210.

Binion, Rudolph. *Defeated Leaders: The Political Fate of Caillaux, Jouvenel, and Tardieu.* New York: Columbia University Press, 1960.

Birnbaum, Pierre. *Anti-Semitism in France: A Political History from Léon Blum to the Present.* Translated by Miriam Kochan. Cambridge, Mass.: Cambridge University Press, 1992.

———. "Catholic Identity, Universal Suffrage and 'Doctrines of Hatred.'" In *The Intellectual Revolt against Liberal Democracy, 1870–1945,* edited by Zeev Sternhell, 233–251. Jerusalem: Israel Academy of Sciences and Humanities, 1996.

———. *Le peuple et les gros: histoire d'un mythe.* Paris: Grasset, 1979.

Biver, Charles. "L'Esprit nouveau: M. Le Corbusier présente un plan de la cité moderne." *Nouveau siècle* (20 March 1927): 1.

Bland, Kalman. *The Artless Jew: Medieval and Modern Affirmations and Denials of the Visual.* Princeton: Princeton University Press, 2000.

Bouqueret, Christian. "Germaine Krull, photographie 1924–1936." In *Germaine Krull,* edited by Christian Bouqueret, 11–13. Céret: Musée d'Art Moderne, 1988.

Bourgin, Hubert. "La littérature du travail." *Nouveau siècle* (1 May 1927): 4.

Bouillon, Jean-Paul. *Maurice Denis, 1870–1943.* Geneva: Skira, 1993.

———. "Politique de Denis." In *Maurice Denis, 1870–1943,* edited by Guy Gogeval, 95–104. Lyons: Musée des Beaux-Arts, 1994.

Brasillach, Robert. "Les pompiers avec nous!" *Combat* (July 1936).

Braun, Emily. "Expressionism as Fascist Aesthetic." *Journal of Contemporary History* (April 1996): 273–292.

———, ed. *Italian Art in the 20th Century.* Munich: Prestel-Verlag, 1989.

———. *Mario Sironi and Italian Modernism: Art and Politics under Fascism.* Cambridge: Cambridge University Press, 2000.

———. "Mario Sironi's Urban Landscapes: The Futurist/Fascist Nexus." In *Fascist Visions: Art and Ideology in France and Italy,* edited by Matthew Affron and Mark Antliff, 101–133. Princeton: Princeton University Press, 1997.

———. "Speaking Volumes: Giorgio Morandi's Still Lifes and the Cultural Politics of Strapaese." *Modernism/Modernity* (September 1995): 89–116.

Britten, Karla. *Auguste Perret.* London: Phaidon, 2001.

Carroll, David. *French Literary Fascism: Nationalism, Anti-Semitism, and the Ideology of Culture.* Princeton: Princeton University Press, 1995.

Cayatte, André. "La pensée des jeunes: types." *La revue des vivants* (January 1930): 217–218.

Cayatte, André, and Philippe Lamour. "La pensée des jeunes: écrire obscur." *La revue des vivants* (June 1930): 883–884.

Cely, Laurent, and Jean-Serge Morel. "Violence et classicisme." *Combat* (March 1939).

Charzat, Michel. *Georges Sorel et la révolution au XXe siècle.* Paris: Hachette, 1977.

———. "Sorel et le fascisme: elements d'explication d'une légende tenace." *Cahiers Georges Sorel* (1983): 37–51.

Ciucci, Giorgio. *Gli architetti e il fascismo: architettura e città, 1922–44.* Turin: Giulio Einaudi, 1989.

Claudel, Paul. "Saint Philippe, Saint Jude Apôtre: patron des causes désespérées, images saintes de bohème: Saint Wencelas, roi et martyr, Saint Jean Népomucène." *L'Indépendance* (15 November 1911): 147–157.

Cohen, Jean-Louis. *André Lurçat, 1894–1970: autocritique d'un moderne.* Liège: Pierre Mardaga, 1995.

Cohen, Jean-Louis, Joseph Abram, and Guy Lambert, eds. *Encyclopédie Perret.* Paris: Editions du patrimoine, 2002.

Cohen, Margaret, Max Pensky, and Samuel Weber. "Walter Benjamin." In *Encyclopedia of Aesthetics,* vol. 1, edited by Michael Kelly, 254–264. Oxford: Oxford University Press, 1998.

Le Comité. "Déclaration." *L'Indépendance* (1 March 1911).

Cowart, Georgia. *The Origins of Modern Musical Criticism: French and Italian Music, 1600–1750.* Ann Arbor: U.M.I. Press, 1981.

Cowling, Elizabeth, and Jennifer Mundy, eds. *On Classic Ground: Picasso, Léger, and the New Classicism, 1910–1930.* London: Tate Gallery Publications, 1990.

Curtis, William. *Le Corbusier: Ideas and Forms.* New York: Rizzoli, 1986.

Danjou, Henri. "Les clochards dans les bas-fonds de Paris—ceux de La Maubert." *Vu* (17 October 1928): 688–690.

Dasenbrock, Reed Way. "Paul de Man: The Modernist as Fascist." In *Fascism, Aesthetics and Culture,* edited by Richard J. Golsan, 229–241. Hanover, N.H.: University Press of New England.

Datta, Venita. *The Birth of a National Icon: The Literary Avant-Garde and the Origins of the Intellectual in France.* Albany: State University of New York Press, 1999.

de Andia, Béatrice, ed. *Charles Lacoste, 1870–1959: 60 ans de peinture entre symbolisme et naturalisme.* Bordeaux: Galerie des Beaux-Arts, 1985.

de Caso, Gomez. "The Christ of the Blood." In *Ignacio Zuloaga, 1870–1945,* edited by Maria Rosa Suárez Zuloaga, 155. Dallas: Meadows Museum, 1990.

de Fabrèques, Jean. "Abel Bonnard, *Les modérés* (Paris: Grasset, 1936)." *Combat* (July 1936).

de Seta, Cesare. *La cultura architettonica in Italia tra le due guerre.* Rome: Laterza, 1972.

Debord, Guy. *Society of the Spectacle.* Detroit: Black and Red, 1983.

Deculis, Nicole, and Suzanne Reymond. *Le décor de théâtre en France.* Paris: Compagnie française des arts qraphiques, 1953.

Dejean, Joan. *Ancients against Moderns: Culture Wars and the Making of a Fin-de-Siècle.* Chicago: University of Chicago Press, 1997.

Delagrange, Marcel. "La cité de demain: rajeunissons nos municipalités." *Nouveau siècle* (8 May 1927): 2.

Del Puppo, Alessandro. *"Lacerba" 1913–1915: arte e critica d'arte.* Bergamo: Lubrina, 2000.

Denis, Maurice. *Aristide Maillol.* Paris: G. Crès, 1925.

————. *Journal*, vol. 1. Paris: La Colombe, 1957.

————. *Nouvelles théories: sur l'art moderne, sur l'art sacré, 1914–1921*. Paris: Rouart et Waterlin, 1921.

d'Indy, Vincent. *Une école de musique répondant aux besoins modernes*. Paris: Bureaux d'Edition de la Schola, 1900.

d'Indy, Vincent, and Auguste Sérieyx. *Cours de composition musicale*, vol. 1. Paris: A. Durand et Fils, 1903.

Dioudonnat, Pierre-Marie. *Les 700 rédacteurs de Je Suis Partout, 1930–1944*. Paris: Sedopols, 1993.

Dobry, Michel. "La thèse immunitaire face aux fascismes: pour une critique de la logique classificatoire." In *Le mythe de l'allergie française au fascisme*, edited by Michel Dobry, 17–67. Paris: Editions Albin Michel, 2003.

Doordan, Dennis. *Building Modern Italy: Italian Architecture, 1914–1936*. New York: Princeton Architectural Press, 1988.

————. "The Political Content in Italian Architecture during the Fascist Era." *Art Journal* (Summer 1983): 121–131.

Douglas, Allen. *From Fascism to Libertarian Communism: Georges Valois against the Third Republic*. Berkeley: University of California Press, 1992.

Dumas, Pierre. "L'Atelier et la cité." *Nouveau siècle* (3 January 1926): 5.

Durth, Werner. "Architektur und Stadtplanung im Dritten Reich." In *Nationalsozialismus und Modernisierung*, edited by Michael Prinz and Rainer Zitelmann, 20–30. Darmstadt: Wissenschaftliche Buchgesellschaft, 1991.

Eastwood, Dorothy Margaret. *The Revival of Pascal: A Study of His Relations to Modern French Thought*. Oxford: Oxford University Press, 1936.

Eisenstein, Sergei. *Beyond the Stars: Memoirs of Sergei Eisenstein*. Calcutta: Seagull Books, 1995.

————. *Film Form: Essays in Film Theory*. New York: Meridian Books, 1957.

————. "La quatrième dimension au cinéma." *Grand'Route* (May 1930): 19–26.

Elliot, Patrick. "Sculpture in France and Classicism, 1910–1939." In *On Classic Ground: Picasso, Léger, de Chirico and the New Classicism, 1910–1930*, edited by Elizabeth Cowling and Jennifer Mundy, 283–295. London: Tate Gallery, 1990.

Etlin, Richard. "Le Corbusier, Choisy, and French Hellenism: The Search for a New Architecture." *Art Bulletin* (June 1987): 264–278.

————. *Modernism in Italian Architecture, 1890–1940*. London: M.I.T. Press, 1991.

Falasca-Zamponi, Simonetta. *Fascist Spectacle: The Aesthetics of Power in Mussolini's Italy*. Berkeley: University of California Press, 1997.

Fanica, Pierre-Olivier. "Armand Point (1860–1932)." *Les amis de Bourron-Marlotte*, no. 30 (Autumn–Winter 1992): 22–38.

————. "Armand Point et Haute-Claire." *Les amis de Bourron-Marlotte*, no. 31 (Spring–Summer 1993): 27–43.

Fergan, André. "Greco, ou le secret de Tolède." *L'Indépendance* (15 May 1912): 186–191.

Flower, J. E. *Literature and the Left in France.* New York: Metheun, 1983.

Forain, Jean-Loup. "Promenades artistiques: 37e Exposition des Indépendants." *Nouveau siècle* (20 March 1926): 4.

———. "Vlaminck chez MM. Bernheim-Jeune." *Nouveau siècle* (17 December 1925): 3.

Forgacs, David. "Fascism, Violence and Modernity." In *The Violent Muse: Violence and the Artistic Imagination, 1910–1939,* edited by Jana Howlett and Rod Mengham, 5–21. Manchester: Manchester University Press, 1994.

Forgione, Nancy. "'The Shadow Only': Shadow and Silhouette in Late Nineteenth-Century Paris." *Art Bulletin* 81.3 (1999): 490–512.

Fraser, Laura L. "Grapes of Wrath: Vineyard Workers, Labor Unions, and Strike Activity in the Aude, 1860–1913." In *Class Conflict and Collective Action,* edited by Louise A. Tilly and Charles Tilly, 185–206. London: Sage, 1981.

Friedrich, Ernst. *War against War!* Seattle: The Red Comet Press, 1987.

Fulcher, Jane. *French Cultural Politics and Music: From the Dreyfus Affair to the First World War.* Oxford: Oxford University Press, 1999.

———. "Vincent d'Indy's 'Drame Anti-Juif' and Its Meanings in Paris, 1920." *Cambridge Opera Journal* 2.3 (1990): 295–319.

Gangl, Manfred. "La force du mythe: l'impact de Georges Sorel sur les intellectuels allemands dans l'entre-deux-guerres." In *Ni gauche, ni droite: les chassés-croisés idéologiques des intellectuels française et allemands dans l'entre-deux-guerres,* edited by Gilbert Merlio, 71–89. Paris: Laplante, 1995.

Gentile, Emilio. "Un'apocalisse nella modernità: la Grande Guerra e il mito della rigenerazione della politica." *Storia contemporanea* (October 1995): 733–787.

———. *The Conquest of Modernity: Nationalism, Futurism, and Fascism.* London: Praeger, 2003.

———. *Il culto del littorio: la sacralizzazione della politica nell'Italia fascista.* (1993).

———. "Fascism as Political Religion." *Journal of Contemporary History* 25 (May–June 1990): 229–251.

———. "Fascism, Totalitarianism and Political Religion: Definitions and Critical Reflections on Criticism and Interpretation." *Totalitarian Movements and Political Religions* (December 2004): 47–55.

———. *Fascismo e antifascismo: i partiti italiani fra le due guerre.* Florence: Laterza, 2000.

———. *La Grande Italia: ascesa e declino del mito della nazione nel ventesimo secolo.* Milan: Modaroli, 1997.

———. "The Myth of National Regeneration in Italy: From Modernist Avant-Gardism to Fascism." In *Fascist Visions: Art and Ideology in France and Italy,* edited by Matthew Affron and Mark Antliff, 25–45. Princeton: Princeton University Press, 1997.

———. *Le origini dell'ideologia fascista, 1918–1925.* Rome and Bari: Laterza, 1975; rev. ed. 1996.

———. *Le religioni della politica: fra democrazie e totalitarianismi.* Rome and Bari: Laterza, 2001.

———. *The Sacralization of Politics in Fascist Italy*. Translated by Keith Botsford. Cambridge, Mass.: Harvard University Press, 1996.

———. *The Struggle for Modernity: Nationalism, Futurism, and Fascism*. London: Preager, 2003.

———. *Qu'est-ce que fascisme?: histoire et interprétation*. Paris: Gallimard, 2002.

———. *Storia del partito fascista, 1919–1922: movimento e milizia*. Rome and Bari: Laterza, 1989.

Ghirardo, Diane. *Building New Communities: New Deal America and Fascist Italy*. Princeton: Princeton University Press, 1989.

———. "Italian Architects and Fascist Politics: An Evaluation of the Rationalist Role in Regime Building." *Journal of the Society of Architectural Historians* 39 (May 1980): 109–127.

Gilbert, Pierre. "Une conversation avec M. Georges Sorel: Ferrer et Briand." *Action française* (29 September 1909).

Gillouin, René. "La farce de l'art vivant." *La revue hebdomadaire* (15 January 1938): 271, 282–283.

Gilman, Sander. *The Jew's Body*. New York: Routledge, 1991.

Girons, Baldine Saint. "The Sublime from Longinus to Montesquieu." In *Encyclopedia of Aesthetics*, vol. 4, edited by Michael Kelly, 322–326. Oxford: Oxford University Press, 1998.

Golan, Romy. "The 'Ecole Française' vs. the 'Ecole de Paris': The Debate about the Status of Jewish Artists in Paris between the Wars." In *The Circle of Montparnasse: Jewish Artists in Paris, 1905–1945*, edited by Kenneth E. Silver and Romy Golan, 81–87. New York: Universe, 1985.

———. *Modernity and Nostalgia: Art and Politics in France between the Wars*. New Haven: Yale University Press, 1995.

Goldberg, Nancy. "From Whiteman to Mussolini: Modernism in the Life and Work of a French Intellectual." *Journal of European Studies* (June 1996): 153–173.

Golomstock, Igor. *Totalitarian Art in the Soviet Union, the Third Reich, Fascist Italy and the People's Republic of China*. New York: Icon Editions, 1990.

Goodrick-Clarke, N. *The Occult Roots of Nazism*. Wellington: Aquarian Press, 1985.

Grandchamp, Maurice. "Le syndicalisme sera antiparlementaire ou il mourra." *Insurgé* (3 February 1937): 1.

———. "Syndicalistes, nationalistes de tout le pays: unissez-vous!" *Insurgé* (27 January 1937): 1.

Green, Christopher. *Art in France, 1900–1940*. New Haven: Yale University Press, 2000.

———. "Classicism of Transcendence and of Transience: Maillol, Picasso, and De Chirico." In *On Classic Ground: Picasso, Léger, and the New Classicism, 1910–1930*, edited by Elizabeth Cowling and Jennifer Mundy, 267–282. London: Tate Gallery Publications, 1990.

Green, Nancy. "The Contradictions of Acculturation: Immigrant Oratories and Yiddish

Union Sections in Paris before World War I." In *The Jews in France*, edited by Frances Malino and Bernard Wasserstein, 54–77. London: University Press of New England, 1985.

Gregor, A. J. *Mussolini's Intellectuals: Fascist, Social and Political Thought*. Princeton: Princeton University Press, 2005.

———. *Young Mussolini and the Intellectual Origins of Fascism*. Berkeley: University of California Press, 1979.

Griffin, Roger. *Fascism: Oxford Readers*. Oxford: Oxford University Press, 1995.

———. "The Fascist Quest to Regenerate Time." *Electronic Seminars in History* (November 1998): *http://ihrinfo.ac.uk/esh/quest.html*.

———, ed. *International Fascism: Theories, Causes and the New Consensus*. London: Arnold Press, 1998.

———. *The Nature of Fascism*. London: Routledge, 1994.

———. "Nazi Art: Romantic Twilight or (Post) Modernist Dawn?" *Oxford Art Journal* 18.2 (1995): 103–106.

———. "Totalitarian Art and the Nemesis of Modernity." *Oxford Art Journal* 19.2 (1996): 122–124.

Griffiths, Richard. *The Reactionary Revolution: The Catholic Revival in French Literature, 1870–1914*. New York: Frederick Ungar Publishing, 1965.

Grimm, Dagmar. "Emil Nolde." In *'Degenerate Art': The Fate of the Avant-Garde in Nazi Germany*, edited by Stephanie Barron, 315–320. New York: Abrams and Los Angeles County Museum of Art, 1991.

Guchet, Yves. *Georges Sorel, 1847–1922: "serviteur désintéressé du prolétariat."* Paris: L'Harmattan, 2001.

Gunter, P. A. Y. "Henri Bergson." In *Founders of Constructive Postmodern Philosophy: Pierce, James, Bergson, Whitehead, and Hartshorne*, edited by David Ray Griffin, 133–163. New York: State University of New York Press, 1993.

Halperin, Joan. *Félix Fénéon: Aesthete and Anarchist in Fin-de-Siècle Paris*. New Haven: Yale University Press, 1988.

Harris, H. S. *The Social Philosophy of Giovanni Gentile*. London: University of Illinois Press, 1966.

Hartley, Keith, ed. *The Romantic Spirit in German Art, 1790–1990*. London: Thames and Hudson, 1994.

Harvey, David. *The Condition of Post-Modernity: An Enquiry into the Origins of Social Change*. Cambridge, Mass.: Basil Blackwell, 1989.

Hellman, John. *The Communitarian Third Way: Alexandre Marc and Ordre Nouveau, 1930–2000*. Kingston: McGill-Queen's University Press, 2002.

———. *Emmanuel Mounier and the New Catholic Left, 1930–1950*. Toronto: University of Toronto Press, 1981.

Herbert, James. *Paris 1937: Worlds on Exhibition*. Ithaca: Cornell University Press, 1998.

Herbiet, Georges. "L'Art de mentir." *Grand'Route* (March 1930): 70–81.

———. "Bons du trésor." *Grand'Route* (April 1930): 69–70.

Herf, Jeffrey. "Reactionary Modernism Reconsidered: Modernity, the West and the Nazis." In *The Intellectual Revolt against Liberal Democracy, 1870–1945*, edited by Zeev Sternhell, 131–158. Jerusalem: Israel Academy of Sciences and Humanities, 1996.

———. *Reactionary Modernism: Technology. Culture, and Politics in Weimar and the Third Reich*. Cambridge: Cambridge University Press, 1984.

Heskett, John. "Modernism and Archaism in Design in the Third Reich." In *The Nazification of Art: Art, Design, Music, Architecture and Film in the Third Reich*, edited by Brandon Taylor and Wilfred van der Will, 110–143. Winchester, England: Winchester Press, 1990.

Hewitt, Andrew. *Fascist Modernism: Aesthetics, Politics, and the Avant-Garde*. Stanford: Stanford University Press, 1993.

———. *Political Inversions: Homosexuality and the Modern Imaginary*. Stanford: Stanford University Press, 1996.

Hibberd, Dominic. *Owen the Poet*. London: MacMillan, 1986.

Hinz, Berthold. *Art in the Third Reich*. New York: Pantheon Books, 1979.

Hobsbawm, Eric. *Nations and Nationalism since 1780: Program, Myth, Reality*. Cambridge: Cambridge University Press, 1990.

Horowitz, Irving Louis. *Radicalism and the Revolt against Reason: The Social Theories of Georges Sorel*. New York: Humanities Press, 1961.

Hughes, H. Stuart. *Consciousness and Society: The Reorientation of European Social Thought, 1890–1930*. New York: Vintage Books, 1958.

Hurel, Eric. *Chambres noires*. Abbeville: F. Paillart, 1930.

———. "La confusion des arts." *Grand'Route* (May 1930): 71–74.

———. *La lune d'octobre*. Paris: Plon, 1956.

———. "La pensée des jeunes: Grand'route." *La revue des vivants* (February 1930): 348–349.

Hurel, Roselyne. "Ernest Laurent." In *The Dictionary of Art*, vol. 18, edited by Jane Turner, 866–867. New York: Grove, 1996.

Hutton, John. "'Les Prolos Vagabondent': Neo-Impressionism and the Anarchist Image of the Trimardeur." *Art Bulletin* 72 (1990): 296–309.

Jamot, Paul. "Une illustration des Fioretti, par Maurice Denis." *Gazette des Beaux-Arts* (July 1911): 5–18.

———. "Préludes." *L'Indépendance* (15 March 1911): 42–45.

———. "Le Théâtre des Champs-Elysées: les peintres de Maurice Denis." *Gazette des Beaux-Arts* (May 1913): 291–322.

———. "Les théories et les oeuvres." *L'Indépendance* (15 April 1911): 126–139.

Jaskot, Paul. *The Architecture of Oppression: The ss, Forced Labour and Nazi Monumental Building Economy*. London: Routledge, 2000.

Jay, Martin. *Force Fields: Between Intellectual History and Cultural Critique*. New York: Routledge, 1993.

Jennings, J. R. *Georges Sorel: The Character and Development of His Thought.* New York: St. Martin's Press, 1985.

Johannet, René. *Voyage à travers le capitalisme.* Paris: Editions Spes, 1934.

Joll, James. "The Front Populaire—After Thirty Years." In *The Left-Wing Intellectuals between the Wars, 1919–1939,* edited by Walter Laqueur and George Mosse, 27–42. Harper Torchbooks: New York, 1966.

Jörgensen, Johannes. "Nôtre-Dame de l'École." *L'Indépendance* (April–May 1913): 73–74.

Judrin, Claude. *Charles Despiau: sculptures et dessins.* Paris: Musée Rodin, 1974.

Juillard, Jacques. *Autonomie ouvrière: études sur le syndicalisme d'action directe.* Paris: Editions du Seuil, 1988.

Juillard, Jacques, and Shlomo Sand, eds. *Georges Sorel et son temps.* Paris: Editions du Seuil, 1985.

Kaplan, Alice. *Reproductions of Banality: Fascism, Literature, and French Intellectual Life.* Minneapolis: University of Minnesota Press, 1986.

Kele, Max. *Nazi and Workers: National Socialist Appeals to German Labor, 1919–1933.* Chapel Hill: University of North Carolina Press, 1972.

Keylor, William. *Jacques Bainville and the Renaissance of Royalist History in Twentieth-Century France.* Baton Rouge: Louisiana State University Press, 1979.

Kostof, Spiro. "The Emperor and the Duce: the Planning of Piazzale Augusto Imperatore in Rome." In *Art and Architecture in the Service of Politics,* edited by Henry Millon and Linda Nochlins, 270–325. Cambridge, Mass.: M.I.T. Press, 1978.

Krull, Germaine. *La vita conduce la danza.* Florence: Giunti Gruppo Editoriale, 1992.

Kuisel, Richard. *Ernest Mercier, French Technocrat.* Berkeley: University of California Press, 1967.

Lacroix, Michel. *De la beauté comme violence: l'esthétique du fascisme française, 1919–1939.* Montreal: Les Presses de l'Université de Montréal, 2004.

Lagardelle, Hubert. "Le fascisme: doctrines, institutions." In *Encyclopédie Française,* vol. 10, ch. 3, pt. 2 (June 1935), 5–15.

Lamour, Philippe. "Un agitateur d'idées: Georges Sorel." *Nouveau siècle* (3 April 1927): 1.

———. "L'Art mécanique: naissance d'un art collectif." *Grand'Route* (March 1930): 37–40.

———. "A ceux qui n'ont pas vingt-six ans." *Nouveau siècle* (21 February 1926): 1.

———. "L'Assemblée Nationale de Reims." *Nouveau siècle* (28 June 1926): 1.

———. *Le cadran solaire.* Paris: R. Laffont, 1980.

———. "Comment se sera la révolution?" *La révolution fasciste* (November 1928): 4.

———. "Communisme, fascisme, jeunesse." *La révolution fasciste* (November 1928): 3–4.

———. *Entretiens sous la tour Eiffel.* Paris: La Renaissance du livre, 1929.

———. "Inventaires U.S.A." *Grand'Route* (March 1930): 50–57.

———. "Lettre à Aron et Dandieu." *Plans* (October 1931): 21.

———. "Liberté religieuse." *La révolution fasciste* (November 1928): 4.

———. "La pensée des jeunes: à propos d'un chien andalou." *La revue des vivants* (December 1929): 634–636.

———. "La pensée des jeunes: concert Colonne." *La revue des vivants* (March 1930): 463–464.

———. "La pensée des jeunes: mars." *La revue des vivants* (April 1930): 604–606.

———. "La pensée des jeunes: sur une prétendue crise de l'esprit." *La revue des vivants* (September 1929): 150–154.

———. "Première étape." *Grand'Route* (June 1930): 13–22.

———. *La république des producteurs*. Paris: Librairie Valois, 1929.

———. "Sous le signe de la victoire." *Nouveau siècle* (3 December 1925): 3.

———. "Visite à l'Italie vivante: un peuple fasciste." *Nouveau siècle* (20 September 1926): 1.

———. "Visite à l'Italie vivante: revue fasciste." *Nouveau siècle* (14 October 1926): 1.

Lane, Barbara. *Architecture and Politics in Germany, 1918–1945*. Cambridge, Mass.: Harvard University Press, 1985.

Laurent, Ernest. "La tradition française en peinture." *L'Indépendance* (15 May 1911): 212–214.

Laurent, Stéphane. "Armand Point: un art décoratif symboliste." *Revue de l'art* 116 (1997): 89–94.

Lebovics, Herman. *True France: The Wars over Cultural Identity, 1900–1945*. Ithaca: Cornell University Press, 1992.

Le Corbusier. "Le Plan Voisin." *Nouveau siècle* (1 May 1927): 3.

———. *Urbanisme* (1925). Translated as *The City of Tomorrow and Its Planning* (1929). New York: Dover, 1987.

Le Corbusier and Pierre Jeanneret. "Analyse des éléments fondamentaux du problème de la maison minimum." *Grand'Route* (March 1930): 26–39.

Lefèvre, Frédéric. "Une heure avec Jean Variot." *Nouvelles littéraires* (4 February 1933).

Le Goff, Jacques. *Time, Work and Culture in the Middle Ages*. Translated by Arthur Goldhammer. Chicago: University of Chicago Press, 1980.

Lemoine, Bertrand. "Le Palais de Chaillot." In *Paris 1937 cinquantennaire: Exposition Internationale des arts et des techniques dans la vie moderne* (1937), 86–99. Paris: Institut Français, 1987.

Levey, Jules. "The Sorelian Syndicalists: Edouard Berth, Georges Valois, and Hubert Lagardelle." Ph.D. dissertation, Columbia University. Ann Arbor: University Microfilms, 1967.

Loisy, Jean. "A propos de l'art populaire: le radicalisme a tué l'art par le peuple, le marxisme crée l'art pour le peuple." *Insurgé* (31 May 1937): 5.

———. "L'Art dans la société contemporaine." *Combat* (August–September 1936).

———. "L'Art français de 1895 à 1925: les deux pompiérismes." *Insurgé* (14 April 1937): 5.

———. "Art pour le peuple, ou art pour les comarades?" *Insurgé* (3 March 1937): 5.

———. "Exposition 1937: Paris n'aura pas d'Acropole." *Insurgé* (13 January 1937): 3.

———. "Le 1 mai devait s'ouvrir l'exposition." *Insurgé* (5 May 1937): 4.

———. "Notes sur Cézanne." *Combat* (November 1936).

———. "Un témoignage de la démogogie française: l'Exposition de 1937." *Insurgé* (3 February 1937): 4.

Loubet del Bayle, Jean-Louis. *Les non-conformistes des années 30.* Paris: Editions du Seuil, 1969.

Louzon, Robert. "La faillite du dreyfusisme ou le triomphe du parti juif." *Le mouvement socialiste*, no. 176 (July 1906): 197–98.

Löwry, Michael, and Robert Sayre. "Figures of Romantic Anti-Capitalism." *New German Critique* 32 (Spring–Summer 1984): 42–92.

———. *Romanticism against the Tide of Modernity.* Durham: Duke University Press, 2001.

Lukács, Georg. *History and Class Consciousness: Studies in Marxist Dialectics.* Translated by Rodney Livingston. 1922; Cambridge, Mass.: M.I.T. Press, 1990.

Lurcat, André. "Esprit collectif et architecture." *Grand'Route* (April 1930): 38–50.

Lyttelton, Adrian, ed. *Italian Fascisms: From Pareto to Gentile.* New York: Jonathan Cape, 1975.

Mah, Harold. *Enlightenment Phantasies: Cultural Identity in France and Germany, 1750–1914.* Ithaca: Cornell University Press, 2003.

Malvano, Laura. "The Myth of Youth in Images: Italian Fascism." In *A History of Young People*, vol. 2, *Stormy Evolution to Modern Times*, edited by Giovanni Levi and Jean-Claude Schmitt, 232–256. Cambridge, Mass.: Harvard University Press, 1997.

Marlais, Michael. *Conservative Echoes in Fin-de-Siècle Parisian Art Criticism.* University Park: Penn State University Press, 1992.

Matthews, Eric. "Bergson's Concept of a Person." In *The New Bergson*, edited by John Mullarkey, 118–134. New York: Manchester University Press, 1999.

Maulnier, Thierry. "A bas la culture bourgeois!" *Combat* (October 1936).

———. "A la recherche de l'état nouveau." *La revue universelle* (1 August 1936): 365–370.

———. "Charles Maurras et le socialisme." *La revue universelle* (1 January 1937): 166–171.

———. "Cherchez ailleurs l'exposition." *Insurgé* (25 May 1937): 1.

———. "Les conservateurs." *Combat* (May 1936).

———. "Les deux trahisons." *Insurgé* (21 April 1937): 1, 3.

———. "Les deux violences." *Combat* (February 1936).

———. "Les essais: inspiration et métier." *La revue universelle* (1 April 1936): 110–114.

———. "Le 'fascisme' et son avenir en France." *La revue universelle* (1 January 1936): 13–26.

———. "Le fascisme, l'antifascisme ou la France." *Combat* (March 1939).

———. "Un fascisme minimum?" *Combat* (May 1939).

———. "La fin d'un 'ordre.'" *Combat* (July 1936).

———. *Mythes socialistes.* Paris: Gallimard, 1936.

———. *Nietzsche.* Paris: Gallimard, 1936.

———. "Notes sur fascisme." *Combat* (December 1938).

————. *Racine*. Paris: Gillimard, 1936.

————. "Un régime ennemi des arts." *Combat* (April 1936).

————. "Le seul combat possible." *Combat* (June 1936).

————. "Le socialisme antidémocratique de Georges Sorel." *La revue universelle* (1 February 1936): 370–374.

————. "Syndicalisme? OUI, démocratie? NON." *Insurgé* (7 February 1937): 1, 3.

Maxence, Jean-Pierre. "Pas de nationalisme valuable sans justice sociale." *Insurgé* (14 April 1937): 1, 3.

Maximoff, Gregory Petrovich. *The Guillotine at Work: The Leninist Counter-Revolution*. 1940; Summerville: Black Thorn Books, 1979.

Mazgaj, Paul. *The Action Française and Revolutionary Syndicalism*. Chapel Hill: University of North Carolina Press, 1979.

McLeod, Mary. "'Architecture or Revolution': Taylorism, Technocracy and Social Change." *Art Journal* 43.2 (Summer 1983): 132–147.

————. "Le Corbusier and Algiers." *Oppositions* 19–20 (Winter–Spring 1980): 53–85.

————. "Le rêve transi de Le Corbusier: l'Amérique catastrophe féerique." In *Américanisme et modernité: l'idéal américain dans architecture*, edited by Jean-Louis Cohen and Hubert Damisch, 209–227. Paris: Flammarion, 1993.

————. "Urbanism and Utopia: Le Corbusier from Regional Syndicalism to Vichy." Ph.D. dissertation, Princeton University. Ann Arbor: U.M.I., 1985.

McMillan, James. *Twentieth-Century France: Politics and Society, 1898–1991*. New York: Edward Arnold, 1992.

Mehlman, Jeffrey. *Legacies of Anti-Semitism in France*. Minneapolis: University of Minnesota Press, 1983.

Meisel, James. *The Genesis of Georges Sorel: An Account of His Formative Period Followed by a Study of His Influence*. Ann Arbor: George Wahr Publishing, 1951.

Mercier, Lucien. *Les universités populaires: 1899–1914*. Paris: Ouvrières, 1986.

Michaud, Eric. *Un art de l'éternité: l'image et le temps du national-socialisme*. Gallimard: Paris, 1996.

————. *The Cult of Art in Nazi Germany*. Stanford: Stanford University Press, 2004.

————. *Histoire de l'art: une discipline à ses frontières*. Paris: Hazan, 2005.

————. "National Socialist Architecture as an Acceleration of Time." *Critical Inquiry* (Winter 1993): 220–233.

————. "Soldiers of an Idea: Young People under the Third Reich." In *A History of Young People*, vol. 2, *Stormy Evolution to Modern Times*, edited by Giovanni Levi and Jean-Claude Schmitt, 257–280. Cambridge, Mass.: Harvard University Press, 1997.

Michelson, Annette. "The Wings of Hypothesis: On Montage and the Theory of the Interval." In *Montage and Modern Life, 1919–1945*, edited by Mathew Teitelbaum, 61–81. London: M.I.T. Press, 1992.

Milhou, Mayi. "Portrait of Maurice Barrès (1913)." In *Ignacio Zuloaga, 1870–1945*, edited by Maria Rosa Suárez Zuloaga, 198. Dallas: Meadows Museum, 1990.

———. "Zuloaga in France." In *Ignacio Zuloaga, 1870–1945*, edited by Maria Rosa Suárez Zuloaga, 41–59. Dallas: Meadows Museum, 1990.

Millon, Henry. "The Role of the History of Architecture in Fascist Italy." *Journal of the Society of Architectural Historians* 24 (March 1965): 53–59.

———. "Some New Towns in Italy in the 1930's." In *Art and Architecture in the Service of Politics*, edited by Henry Millon and Linda Nochlin, 53–59. Cambridge, Mass.: M.I.T. Press, 1978.

Milza, Pierre. *Le fascisme français: passé et présent*. Paris: Flammarion, 1987.

Missiroli, Mario. "Giorgio Sorel per Alfredo Oriani." *Resto del Carlino* (4 May 1912).

———. "Le nationalisme italien." *L'Indépendance* (1 August 1911): 419–435.

Monconduit, André. "L'Organisation corporative italienne." *Combat* (November 1937).

———. "Qu'est-ce que le fascisme?" *Combat* (June 1937).

———. "Syndicats et corporations fascistes." *Combat* (January 1937).

Mosse, George L. "Beauty without Sensuality/The Exhibition Entartete Kunst." In *"Degenerate Art": The Fate of the Avant-Garde in Nazi Germany*, edited by Stephanie Barron, 25–31. New York: Abrams and Los Angeles County Museum of Art, 1991.

———. *The Crisis of German Ideology: Intellectual Origins of the Third Reich*. New York: Grosset and Dunlap, 1964.

———. *Fallen Soldiers: Reshaping the Memory of the World Wars*. Oxford: Oxford University Press, 1990.

———. *The Fascist Revolution: Toward a General Theory of Fascism*. New York: Howard Fertig, 1999.

———. *Masses and Man: Nationalist and Fascist Perceptions of Reality*. Detroit: Wayne State University Press, 1980.

———. *Nationalism and Sexuality: Middle-Class Morality and Sexual Norms in Modern Europe*. Madison: University of Wisconsin Press, 1985.

———. *The Nationalization of the Masses: Political Symbolism and Mass Movements in Germany from the Napoleonic Wars through the Third Reich*. Ithaca, N.Y.: Cornell University Press, 1975.

———. *Nationalism and Sexuality: Middle-Class Morality and Sexual Norms in Modern Europe*. Madison: University of Wisconsin Press, 1985.

Mussolini, Benito. "La dottrina del fascismo." In *Scritti e discorsi*, vol. 8, 67–69. Milan: Hoepli, 1934.

Netter, Marie Laurence. "Georges Sorel et *L'Indépendance*." *Cahiers Georges Sorel* 5 (1987): 95–104.

Neville, Peter. *Mussolini*. London: Routledge, 2004.

Nichols, Ray. *Treason, Tradition, and the Intellectual*. Laurence: Regent's Press of Kansas, 1978.

Orland, Claude. "Maillol." *Combat* (November 1937).

Ory, Pascal. *La belle illusion: culture et politique sous le signe du Front populaire, 1935–1938*. Paris: Plon, 1994.

Oudard, Georges. "Le nouveau visage de la France: la Foire de Lyon." *Nouveau siècle* (6 January 1926): 1–2.

———. "Le nouveau visage de la France: Reims, ville moderne." *Nouveau siècle* (7 December 1925): 1–2.

———. "Pour une organisation rationnelle de la banlieue." *Nouveau siècle* (12 May 1926): 3.

Overy, Paul. "The Cell in the City." *Architecture and Cubism*, edited by Eve Blau and Nancy Troy, 117–140. Cambridge, Mass.: M.I.T. Press, 1997.

Owen, Wilfred. *The War Poems*, edited by Jon Silkin. London: Sinclair-Stevenson, 1994.

Papanikolas, Theresa C. "The Cultural Politics of Paris Dada, 1914–1922." Ph.D. dissertation, University of Delaware. Ann Arbor: University Microfilms, 1999.

"Paris défiguré." *Insurgé* (7 February 1937): 1, 3.

Passerini, Luisa. "Youth as a Metaphor for Social Change: Fascist Italy and America in the 1930s." In *A History of Young People*, vol. 2, *Stormy Evolution to Modern Times*, edited by Giovanni Levi and Jean-Claude Schmitt, 281–340. Cambridge, Mass.: Harvard University Press, 1997.

Payne, Stanley. "Emilio Gentile's Historical Analysis and Taxonomy of Political Religion." *Totalitarian Movements and Political Religions* (Summer 2002): 122–130.

———. *A History of Fascism, 1914–1945*. Madison: University of Wisconsin Press, 1995.

Paxton, Robert. *The Anatomy of Fascism*. New York: Alfred A. Knopf, 2004.

———. *Peasant Fascism in France*. New York: Oxford University Press, 1997.

———. "Radicals." *New York Review of Books* (23 June 1994): 51–54.

Pellizzi, Camillio. *Problemi e realtà del fascismo*. Florence: Vallecchi, 1924.

Peer, Shanny. *France on Display: Peasants, Provincials and Folklore in the 1937 Paris World's Fair*. Albany: State University of New York Press, 1998.

Perret, Auguste. "L'Architecture." *Revue d'art et d'esthetique*, nos. 1–2 (1935): 41–50.

———. "M. Auguste Perret nous dit. . . ." *L'Architecture d'aujourd'hui* (8 September 1937): 5–7.

Piccolomini, Manfredi. "Vico, Sorel, and Modern Artistic Primitivism." *Vico Studies* 4 (1986): 123–130.

Pinto, Antonio Costa. "Fascist Ideology Revisited: Zeev Sternhell and His Critics." *European History Quarterly* 16 (1986): 465–483.

Pitte, Jean-Robert. *Philippe Lamour, 1903–1992: Père de l'aménagement du territoire en France*. Paris: Fayard, 2002.

Poggi, Christine. *In Defiance of Painting: Cubism, Futurism, and the Invention of Collage*. New Haven: Yale University Press, 1992.

———. "*Lacerba*: Interventionist Art and Politics in Pre–World War I Italy." In *Art and Journals on the Political Front, 1910–1940*, edited by Virginia Hagelstein Marquardt, 17–62. Gainsville: University of Florida Press, 1997.

Potts, Alex. *Flesh and the Ideal: Winckelmann and the Origins of Art History*. New Haven: Yale University Press, 1994.

Quéant, Gilles, ed. *Encyclopédie du théâtre contemporain*, vol. 1, *1850–1914*. Paris: Collection théâtre de France, 1957.

Rabinbach, Anson. "The Aesthetics of Production in the Third Reich." In *International Fascism: New Thoughts and Approaches*, edited by George Mosse, 189–122. London: Sage Publications, 1979.

Rabinow, Paul. *French Modern: Norms and Forms of the Social Environment*. Cambridge, Mass.: M.I.T. Press, 1989.

Ramirez, Juan Antonio. "Guarino Guarini, Juan Ricci, and the Complete Solomonic Order." *Art History* 4.2 (1981): 175–185.

Rebérioux, Madeleine. "Sorel et la valeur sociale de l'art." In *Georges Sorel*, edited by Michel Charzat, 56–63. Paris: Editions de la Herne, 1986.

Rees, Philip. *Biographical Dictionary of the Extreme Right since 1890*. Toronto: Simon and Schuster, 1990.

Richard, Guy. "La comédie de l'Exposition." *Insurgé* (7 April 1937): 1.

Rigny, Fernand. "Les autostrades italiennes: les créations de l'économie fasciste." *Nouveau siècle* (13 May 1926): 1–2.

Rinuy, Paul-Louis. "Maillol dans la sculpture française de l'entre-deux-guerres." In *Aristide Maillol*, edited by Ursel Berger et Jörge Zutter, 167–173. Paris: Flammarion, 1996.

Riquier, Marius. "L'école syndicaliste et l'école rationelle." *La terre libre* (15 June–1 July 1910): 1–2 .

———. "Messieurs les intellectuels." *La terre libre* (28 February–15 March 1910): 1.

Roditi, Georges. "L'homme nouveau." *L'homme nouveau* (2 June 1935).

Roman, Thomas. "*L'Indépendance*, une revue traditionaliste des années 1910." *Mil neuf cent: revue d'histoire intellectuelle (Cahiers Georges Sorel)* 20 (2002): 173–193.

Roth, Jack. J. *The Cult of Violence: Sorel and the Sorelians*. Berkeley: University of California Press, 1981.

Saillenfest, Jean. "Fascisme et syndicalisme." *Combat* (October 1936).

Sand, Shlomo. *L'illusion du politique: Georges Sorel et le débat intellectuel 1900*. Paris: Editions La Découverte, 1985.

———. "Legend, Myth, and Fascism." *European Legacy* 3.5 (1998): 51–65.

———. "Sorel, les juifs et l'antisemitisme." *Cahiers Georges Sorel* (1984): 7–36.

Schnapp, Jeffrey. "Epic Demonstrations: Fascist Modernity and the 1932 Exhibition of the Fascist Revolution." In *Fascism, Aesthetics, and Culture*, edited by Richard J. Golsan, 1–37. Hanover, N.H.: University Press of New England, 1992.

———. *Staging Fascism: 18 BL and the Theater of the Masses for the Masses*. Stanford: Stanford University Press, 1996.

Schneider, Herbert. *Making the Fascist State*. New York: Howard Fertig, 1968.

Schulte-Sass, Linda. *Entertaining the Third Reich: Illusions of Wholeness in Nazi Cinema*. Durham: Duke University Press, 1996.

Scobie, Alex. *Hitler's State Architecture: The Impact of Classical Antiquity*. London: Penn State University Press, 1990.

"Section universitaire." *Nouveau siècle* (7 December 1925): 6.

Serenyi, Peter. "Le Corbusier, Fourier and the Monastery of Ema." *Art Bulletin* (December 1967): 277–278.

Sichel, Kim. *Germaine Krull: Photographer of Modernity.* London: M.I.T. Press, 1999.

Silver, Kenneth. *Esprit de Corps: The Art of the Parisian Avant-Garde and the First World War, 1914–1925.* Princeton: Princeton University Press, 1989.

Smith, Paul. "Joachim Gasquet, Virgil, and Cézanne's Landscape: 'My Beloved Golden Age.'" *Apollo* (October 1998): 11–23.

Sonn, Richard D. *Anarchism and Cultural Politics in Fin-de-Siècle France.* Lincoln: University of Nebraska Press, 1989.

Sorel, Georges. "Aux temps dreyfusiens." *L'Indépendance* (10 October 1912): 51–56.

———. "Critique de 'L'Otage.'" *L'Indépendance* (15 July 1911): 391–398.

———. *De l'utilité de pragmatisme.* Paris: Marcel Rivière, 1928.

———. "Dio ritorna (Dieu revient)." *Resto del Carlino* (25 November 1910).

———. "Etude sur Vico." *Devenir social* (October 1896): 785–817; (November 1896): 906–941; (December 1896): 1011–1046.

———. *From Georges Sorel: Essays in Socialism and Philosophy,* edited by John L. Stanley. New York: Oxford University Press, 1976.

———. "Histoire artistique des ordres mendiants (Louis Gillet)." *L'indépendance* (December 1912): 232–240.

———. *Les illusions du progrès,* 1908, revised 1910; 4th ed. 1927. Paris: Marcel Rivière.

———. *The Illusions of Progress.* Translated by John and Charlotte Stanley. Berkeley: University of California Press, 1969.

———. *Lettres à Paul Delassalle, 1914–1921.* Paris: Editions Bernard Grasset, 1947.

———. "Les livres." *L'Indépendance* (15 November 1912): 164–165.

———. "Lyripipii Sorbonici moralisationes." *L'Indépendance* (15 April 1911): 111–125.

———. *Matériaux d'une théorie du prolétariat.* Paris: Marcel Rivière, 1919.

———. "Modernisme dans religion et dans le socialisme." *Revue critique des idées et des livres* (10 August 1908): 177–204.

———. "Le patriotisme actuel en France." *Resto del Carlino* (28 September 1910).

———. "Préface." In Edouard Berth, *Les Méfaits des intelectuels.* Paris: Marcel Rivière, 1926.

———. *Le procès de Socrate.* Paris: Alcan, 1889.

———. *Reflections on Violence.* Translated by T. E. Hulme. 1908; London: Collier-Macmillan, 1961.

———. *Réflexions sur la violence.* Paris: Marcel Rivière, 1946.

———. "Le réveil de l'âme française." *Action française* (14 April 1910).

———. "La rivolta ideale." *L'Indépendance* (1 April 1912): 161–177.

———. *La ruine du monde antique.* Paris: Marcel Rivière, 1933.

———. "Socialistes antiparliamentaires: un article de Georges Sorel." *Action française* (22 August 1909).

Soucy, Robert. *French Fascism: The First Wave, 1924–1933*. New Haven: Yale University Press, 1986.

———. *French Fascism: The Second Wave, 1933–1939*. New Haven: Yale University Press, 1995.

Spackman, Barbara. *Fascist Virilities: Rhetoric, Ideology, and Social Fantasy in Italy*. Minneapolis: University of Minnesota Press, 1996.

Spirito, Ugo. "Bureaucratie et corporatisme." *L'homme nouveau* (1 December 1934).

———. "Le corporatisme contre l'autarchie." *L'homme nouveau* (July–August 1935).

———. *Memoirs of the Twentieth Century*, edited by Anthony G. Constantini. Atlanta: Rodopi Press, 2000.

Stanley, John L. *The Sociology of Virtue: The Political and Social Thought of Georges Sorel*. Berkeley: University of California Press, 1981.

———. "Sorel's Study of Vico: The Uses of Poetic Imagination." *European Legacy* (September 1998): 17–34.

Steinweis, Alan. *Art, Ideology, and Economics in Nazi Germany: The Reich Chambers of Music, Theatre, and the Visual Arts*. Chapel Hill: University of North Carolina Press, 1993.

Sternhell, Zeev. "The 'Anti-Materialist' Revision of Marxism as an Aspect of the Rise of Fascist Ideology." *Journal of Contemporary History* 22.3 (1987): 379–400.

———. *La droite révolutionnaire: les origines françaises du fascisme, 1885–1914*. Paris: Editions du Seuil, 1978.

———. "Fascist Ideology." In *Fascism: A Reader's Guide*, edited by Walter Laqueur, 315–376. Berkeley: University of California Press, 1978.

———, ed. *The Intellectual Revolt against Liberal Democracy, 1870–1945*. Jerusalem: Israel Academy of Sciences and Humanities, 1996.

———. "Modernity and Its Enemies: From the Revolt against the Enlightenment to the Undermining of Democracy." In *The Intellectual Revolt against Liberal Democracy, 1970–1945*, edited by Zeev Sternhell, 11–29. Jerusalem: Israel Academy of Sciences and Humanities, 1996.

———. *Neither Right nor Left: Fascist Ideology in France*. Translated by David Maisel. Princeton: Princeton University Press, 1995.

———. *Ni droite, ni gauche: l'idéologie fasciste en France*. Paris: Editions du Seuil, 1983.

Sternhell, Zeev, with Mario Sznajder and Maia Asheri. *The Birth of Fascist Ideology: From Cultural Rebellion to Political Reaction*. Translated by David Maisel. Princeton: Princeton University Press, 1994.

———. *Naissance de l'idéologie fasciste*. Paris: Librairie Arthème Fayard, 1989.

Stevens, Mary Anne, ed. *Emile Bernard, 1868–1941: A Pioneer of Modern Art*. Amsterdam: Van Gogh Museum, 1990.

Stone, Marla. *The Patron State: Culture and Politics in Fascist Italy*. Princeton: Princeton University Press, 1998.

———. "The State as Patron: Making Official Culture in Fascist Italy." In *Fascist Visions:*

Art and Ideology in France and Italy, edited by Matthew Affron and Mark Antliff, 205–238. Princeton: Princeton University Press, 1997.

Tharaud, Jérôme, and Jean Tharaud. "Un philosophe bourgeois de la révolution." *Eclair* (27 August 1910).

Theweleit, Klaus. *Male Fantasies,* vols. 1 and 2. Minneapolis: University of Minnesota Press, 1987.

Thomson, Andrew. *Vincent D'Indy and His World.* Oxford: Oxford University Press, 1996.

Thomson, Richard. *Monet to Matisse: Landscape Painting in France, 1874–1914.* Edinburgh: National Gallery of Scotland, 1994.

"Toulouse: Diner du club." *Nouveau siècle* (31 July 1927): 5.

Vallas, Léon. *Vincent d'Indy II: la maturité, la vieillesse, 1886–1931.* Paris: Editions Albin Michel, 1950.

Valois, Georges. "A Domrémy." *Nouveau siècle* (15 May 1927): 1.

———. "Bourgeois capitaliste." *Cahiers du Cercle Proudhon* (September–December 1912): 214–248.

———. "Le cycle des conférences hebdomadaires." *Nouveau siècle* (19 June 1927): 3.

———. "Enquête sur la monarchie et la classe ouvrière: quelques réflexions de M. Georges Sorel." *Revue critique des idées et des livres* (10 May 1908): 145.

———. *L'État syndical et la représentation corporative.* Paris: Librairie Valois, 1927.

———. "L'Europe et L'Asie." *Nouveau siècle* (25 June 1925): 3.

———. "L'Explosion des partis: une campagne contre le redressement française," *Nouveau siècle* (13 November 1927): 2.

———. *Le fascisme.* Paris: Nouvelle Librarie Nationale, 1927.

———. "Fascisme ou communisme?" *Nouveau siècle* (3 December 1925): 1.

———. *Il fascismo francese.* Rome: Marino, 1926.

———. "Il faut que le Grande Paris ait une constitution et une organisation dignes du siècle de l'automobile et de l'électricité." *Nouveau siècle* (12 May 1926): 3.

———. "Le Grand Paris doit être une unité administrative, économique et sociale, pourvue d'une direction propre." *Nouveau siècle* (12 May 1926): 1.

———. *Histoire et philosophie sociales.* Paris: Nouvelle Librarie Nationale, 1924.

———. "L'Imitation de Jeanne d'Arc." *Nouveau siècle* (7 May 1925): 1.

———. *La monarchie et la classe ouvrière.* Paris: Nouvelle Librairie Nationale, 1909.

———. "Notre politique ouvrière: pour la nouvelle organisation économique." *Nouveau siècle* (1 May 1927): 1–3.

———. "La nouvelle étape du fascisme." *Nouveau siècle* (29 May 1927): 1.

———. *L'Oeuvre économique,* vol. 1. Paris: Nouvelle Librairie Nationale, 1924.

———. "Origines françaises du fascisme." *Nouveau siècle* (26 April 1927): 1.

———. "La politique de la victoire." *Nouveau siècle* (12 November 1925): 3–4.

———. *La politique de la victoire.* Paris: Nouvelle Librairie Nationale, 1925.

———. "Pour reconstituer la cité." *Nouveau siècle* (30 July 1925): 3.

―――. Preface to Pietro Gorgolini, *La révolution fasciste*, translated by Eugène Marsan. Paris: Nouvelle Librairie Nationale, 1924.

―――. "Sur la voie glorieuse et rude de la pauvreté et de la réussite." *Nouveau siècle* (29 May 1927): 1, 3.

Van Pelt, Robert. "Bearers of Culture, Harbingers of Destruction: The Mythos of the Germans in the East." In *Art, Culture, and Media under the Third Reich*, edited by Richard Etlin, 98–135. Chicago: University of Chicago Press, 2000.

Variot, Jean. "L'Annonce faite à Marie au Théâtre de l'Oeuvre, 20 décembre 1912." *Table ronde* (April 1955): 63–65.

―――. "L'exposition de la Rose-Croix catholique." *L'Indépendance* (July 1911): 399–401.

―――. "La mise en scène de L'Annonce faite à Marie pour les représentations du Théâtre de l'Oeuvre: quelques considérations." *L'Oeuvre* (October–December 1912): 177–187.

―――. *Propos de Georges Sorel*. Paris: Gallimard, 1935.

Vernon, Richard. *Citizenship and Order: Studies in French Political Thought*. Toronto: University of Toronto Press, 1986.

―――. *Commitment and Change: Georges Sorel and the Idea of Revolution*. Toronto: University of Toronto Press, 1978.

Vincent, Steven. "Citizenship, Tradition, and Antipolitics in the Thought of Georges Sorel." *European Legacy* 3.5 (September 1998): 7–16.

Visser, Romke. "Fascist Doctrine and the Cult of the Romanità." *Journal of Contemporary History* 27 (January 1992): 5–22.

Vlaminck, Maurice. *Tournant dangereux: souvenirs de ma vie*. Paris: Stock, 1929.

Vondung, Karl. *Magie und Manipulation: Ideologischer Kult und politische Religion des Nationalsozialismus*. Göttingen: Vandenhoek and Ruprecht, 1971.

Walter, Sabine. "Le Comte Kessler, Maillol et Hofmannstahl en Grèce." In *Aristide Maillol*, edited by Ursel Berger and Jörge Zutter, 145–150. Paris: Flammarion, 1996.

Wanrooij, Bruno. "The Rise and Fall of Italian Fascism as a Generational Revolt." *Journal of Contemporary History* 22 (1987): 401–418.

Weber, Eugen. *Action Française: Royalism and Reaction in Twentieth-Century France*. Stanford: Stanford University Press, 1962.

―――. Introduction to *The European Right: A Historical Profile*, edited by Hans Rogger and Eugen Weber, 1–28. Berkeley: University of California Press, 1965.

Werckmeister, O. K. "Hitler as Artist." *Critical Inquiry* (Winter 1997): 270–297.

Whyte, Iain Boyd. "National Socialism and Modernism." In *Art and Power: Europe under the Dictators, 1930–45*, edited by Dawn Ades, Tim Benton, David Elliot, and Iain Boyd Whyte, 258–269. London: Thames and Hudson, 1995.

Winock, Michel. "Jeanne d'Arc et les juifs." *Histoire* (November 1979): 227–237.

―――. *Nationalism, Anti-Semitism, and Fascism in France*. Stanford: Stanford University Press, 1998.

Winter, Pierre. "La France au travail: les 'quartiers Frugès' à Pessac." *Nouveau siècle* (3 September 1926): 2.

―――. "Pour le Grand Paris: la ville moderne." *Nouveau siècle* (16 May 1926): 4.

―――. "Les quartiers Frugès à Pessac." *Nouveau siècle* (3 September 1926): 1.

―――. "La ville moderne." *Nouveau siècle* (8 May 1927): 2.

Witt, Mary Anne Frese. *The Search for Modern Tragedy: Aesthetic Fascism in Italy and France*. Ithaca: Cornell University Press, 2001.

Wohl, Robert. "French Fascism, Both Right and Left: Reflections on the Sternhell Controversy." *Journal of Modern History* 63 (1991): 91–98.

―――. *The Generation of 1914*. Cambridge, Mass.: Harvard University Press, 1979.

Woodcock, George. *Pierre-Joseph Proudhon: A Biography*. Montreal: Black Rose, 1987.

Yvan, Noé. "Un esthéthique nouvelle: New York et l'architecture moderne." *Nouveau siècle* (2 March 1926): 1.

Zuloaga, Maria Rosa Suárez, ed. *Ignacio Zuloaga, 1870–1945*. Dallas: Meadows Museum, 1990.

INDEX

Mark Antliff is a professor of art, art history, and visual studies at Duke University. He is the author of *Inventing Bergson: Cultural Politics and the Parisian Avant-Garde*, the co-author (with Patricia Leighten) of *Cubism and Culture,* and the coeditor (with Matthew Affron) of *Fascist Visions: Art and Ideology in France and Italy*.

Library of Congress Cataloging-in-Publication Data
Antliff, Mark, 1957–
Avant-garde fascism : the mobilization of myth, art, and culture in France, 1909–1939 / Mark Antliff.
p. cm.
Includes bibliographical references and index.
ISBN 978-0-8223-4015-7 (cloth : alk. paper)
ISBN 978-0-8223-4034-8 (pbk. : alk. paper)
1. Avant-garde (Aesthetics)—France—History—20th century. 2. Fascism and art—France—History—20th century. 3. Fascism and culture—France—History—20th century. 4. France—Civilization—20th century. 5. Fascism—France—History—20th century. 6. Sorel, Georges, 1847–1922. I. Title.
BH301.A94A58 2007
700.1'03094409041—dc22 2007004105